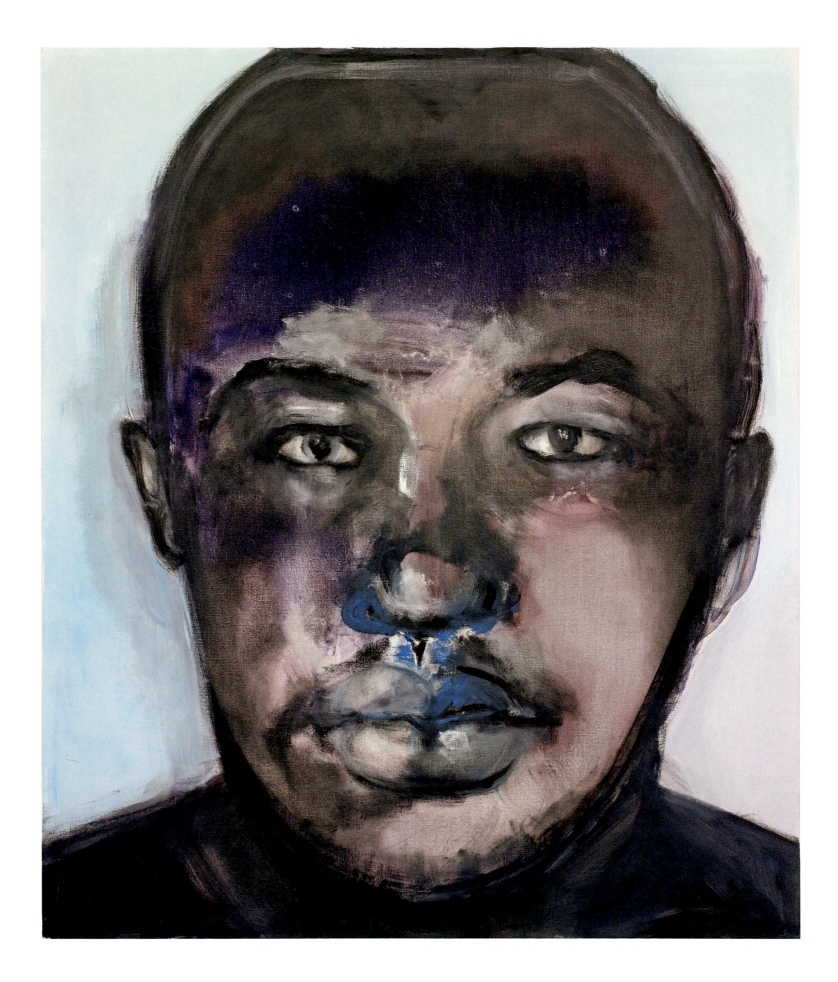

marlene dumas measuring your own grave

organized by

CORNELIA BUTLER

texts by

CORNELIA BUTLER, MARLENE DUMAS, LISA GABRIELLE MARK,
MATTHEW MONAHAN, AND RICHARD SHIFF

the museum of contemporary art, los angeles

d.a.p. / distributed art publishers, inc.

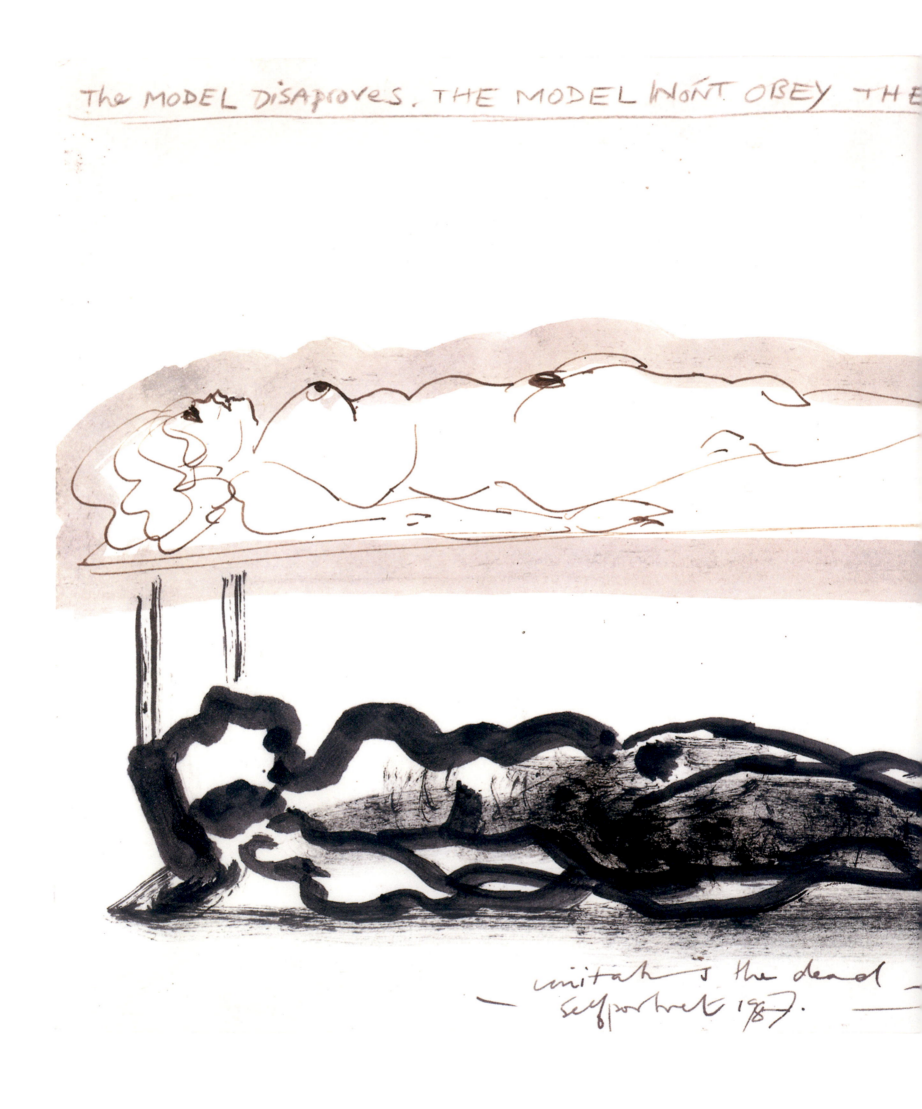

The MODEL DISAPROVES. THE MODEL WON'T OBEY THE

imitate the dead
selfportret 1987.

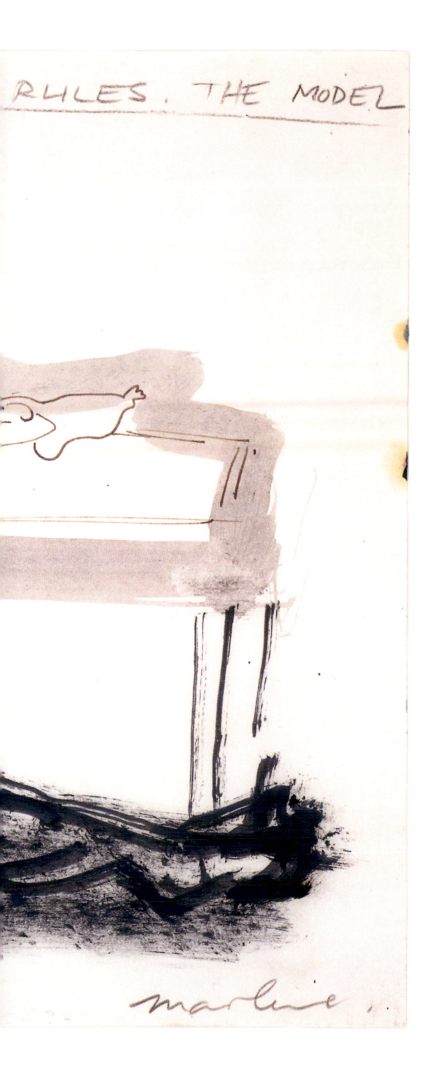

RULES. THE MODEL

marlene.

contents

Imitating the Dead—Self-Portrait, 1987; watercolor,
ink, and pencil on paper; 9⁷/₁₆ x 12¹/₂ inches;
The Over Holland Collection

Director's Foreword

JEREMY STRICK

Since the 1990s, globalization has resulted in greater access to and an increased fluency in the art and socio-political realities of divergent cultures and contexts. A South African artist living in Amsterdam since 1978, Marlene Dumas emerged in the United States during the early 1990s, a time when the art world was embroiled in a range of critiques concerning race, sexuality, and power. Dumas's troubling and beautiful paintings of contemporary subjects—including infants, strippers, and supermodels, as well as figures, both living and dead, culled from the media—arrested the attention of an American audience after she had already established a high degree of visibility and critical support in Europe and elsewhere. It is all the more surprising, then, that Dumas has not received a full-scale museum retrospective in North America until now, and it is with great pleasure that The Museum of Contemporary Art, Los Angeles (MOCA), presents her work in depth to a United States audience for the first time.

I extend my profound gratitude to Ahmanson Curatorial Fellow Cornelia Butler for organizing this important and long-overdue exhibition. Before assuming the role of Robert Lehman Chief Curator of Drawings at the Museum of Modern Art, New York, she served as curator at MOCA, organizing exhibitions such as "Tracing the Figure: Willem de Kooning" (co-organized with MOCA Chief Curator Paul Schimmel); "Rodney Graham: A Little Thought" (co-organized with Jessica Bradley, then of the Art Gallery of Ontario, and Grant Arnold of the Vancouver Art Gallery); and, most recently, the landmark "WACK! Art and the Feminist Revolution." This retrospective would not have been possible without the efforts of key MOCA staff; I thank Chief Curator Paul Schimmel for his unwavering commitment to this exhibition and for his support of Dumas's work, Assistant Curator Rebecca Morse for her invaluable assistance with the MOCA presentation, and Director of Publications Lisa Gabrielle Mark for overseeing the catalogue.

I am deeply indebted to MOCA's visionary board of trustees for supporting such an ambitious project and allowing us, once again, to break new ground with our programming. We are also extremely grateful to those who helped fund "Marlene Dumas: Measuring Your Own Grave," including Brenda R. Potter and Michael C. Sandler; Mondriaan Foundation, Amsterdam; Blake Byrne; Mark Fisch; Steve Martin; The MOCA Contemporaries; the Barbara Lee Family Foundation; the Robert Lehman Foundation; the Pasadena Art Alliance; Elizabeth A. Sackler, JCF, Museum Educational Trust; Jack and Connie Tilton; Netherland-America Foundation; Linda and Jerry Janger; Dr. S. Sanford Kornblum and Mrs. Charlene S. Kornblum; B. J. Russell Mylne; and Jerome and Ellen Stern, as well as the Ahmanson Foundation through the Ahmanson Curatorial Fellowship. Brenda Potter Sandler and her late husband Michael Sandler have long championed the work of South Africa's leading artists. We are grateful for their underwriting of this exhibition, and its success is a tribute to Michael's memory and his devotion to the museum. Blake Byrne has long been committed to Dumas's work and spearheaded an effort to raise funds for this retrospective at MOCA. For his longstanding commitment and generosity to the museum and exemplary and enthusiastic dedication towards this project, I am deeply grateful. The Museum of Modern Art, New York, enthusiastically embraced the exhibition, and I thank their board of trustees and Director Glenn D. Lowry for their outstanding support.

Finally, I take this opportunity to express my appreciation to Marlene Dumas for her extreme generosity and close collaboration in bringing this presentation to fruition. Her works are beautiful, moving, and provocative, leading us to reflect deeply on the issues of our time.

Binders containing Dumas's image bank in her studio in Amsterdam, 2008

Acknowledgments

CORNELIA BUTLER

It is a great privilege and honor to present Marlene Dumas's work at mid-career to an American audience. "Marlene Dumas: Measuring Your Own Grave" is the artist's first major solo exhibition in North America, and a presentation of this scale involves many people. First, I thank the Museum of Contemporary Art, Los Angeles (MOCA), the organizing institution, for supporting the project from its inception. MOCA's staff consistently works miracles; they are unfailing in their enthusiasm for and dedication to great contemporary art. I thank Director Jeremy Strick and Chief Curator Paul Schimmel—who first introduced me to Dumas—for their support of the exhibition during my tenure at MOCA and after, when it became a joint venture with the Museum of Modern Art, New York (MoMA). I had the pleasure to work with Assistant Curator Rebecca Morse who, with invaluable help from Curatorial Assistant Christine Robinson, coordinated the exhibition at MOCA. Rebecca proved an expert in navigating the exhibition budget and installation. I thank Director of Exhibitions Management Susan Jenkins for smoothly administering the exhibition and its tour; Director of Exhibitions Production Brian Gray for overseeing the installation; Exhibitions Designer Sebastian Clough for his experienced and sensitive counsel on the design of the show; Senior Associate Registrar Rosanna Hemerick for coordinating the shipping and handling of an unexpectedly complex group of objects; Director of Communications Lyn Winter for orchestrating the media outreach for the exhibition; and Director of Education Suzanne Isken and Senior Education Program Manager Aandrea Stang for developing adjunct educational programming. I also wish to acknowledge my curatorial colleagues at MOCA, Ann Goldstein, Philipp Kaiser, Brooke Hodge, Alma Ruiz, and Bennett Simpson, as well as Librarian Lynda Bunting.

I also wish to highlight the devoted efforts of Director of Publications Lisa Gabrielle Mark and her incredible team of Senior Editor Jane Hyun, Editor Elizabeth Hamilton, and Publications Assistant Dawson Weber, who are always a pleasure to work with. They, together with extraordinarily talented graphic designer Bethany Johns, have created a publication of great depth, scholarship, and beauty. I also thank writers Lisa Gabrielle Mark, Matthew Monahan, and Richard Shiff, who contributed insightful texts that lend this publica-

tion a rich and fresh reading of Dumas's important work. Special gratitude goes to Bryonie Wise and Klaus Prokop of Dr. Cantz'sche Druckerei for their special attention to the production of this catalogue.

At MoMA, it was thrilling to find a receptive and eager audience for Dumas's work and a desire to situate her among leading international artists. I thank Director Glenn D. Lowry for his generous support of the exhibition, its scholarship, and the passion behind the whole endeavor. I am also extremely grateful to Senior Deputy Director of Exhibitions, Collections, and Programs Jennifer Russell; Senior Deputy Director of External Affairs Mike Margitich; Senior Deputy Director of Curatorial Affairs Peter Reed; Associate Director Kathy Halbreich; and Coordinator of Exhibitions Maria DeMarco Beardsley, who provided crucial administrative support. Assistant Registrar Kerry McGinnity, Director of Exhibition Design & Production Jerry Neuner, and Designer/Production Manager Betty Fisher orchestrated a beautiful and sensitive installation; it has been my great privilege to work with such committed and professional colleagues. Director of Communications, Advertising, and Graphics Kim Mitchell and Manager of Communications Daniela Stigh gracefully handled the promotion of the exhibition. I thank my curatorial colleagues museum-wide for their support in bringing this exhibition to MoMA. I extend special appreciation and gratitude to my incredible team in the drawings department; without them, none of this would have been possible. Department Manager John Prochilo and Curatorial Interns Chloe Chelz, Carmen Hermo, Lotte Meijer, and Jenna Moss provided steadfast administrative and research assistance. Curatorial Assistant Esther Adler coordinated the loans for the exhibition and provided critical catalogue assistance with grace, efficiency, and intelligence. Her collaboration was a joy and essential to the success of this project.

We are honored to count the participation of the Menil Collection in Houston in completing the tour of the exhibition. I am indebted to Director Josef Helfenstein and Curator Franklin Sirmans for introducing Dumas's work to a wider audience and for bringing it into dialogue with their prestigious collection of painting.

A career of the breadth and length of Dumas's is always supported by the efforts of many passionate

individuals. I thank gallerist Paul Andriesse—as well as his staff, Adriana González, Willem ter Velde, and Milka van der Valk Bouman of Galerie Paul Andriesse, Amsterdam—whose relationship with Dumas dates from her early career. Special thanks go to Jack Tilton—with Janine Cirincione, Bianca Cabrera, and Elisabeth Schneider—of Tilton Gallery, New York, who introduced Dumas's work to the United States; his commitment to Dumas's career and to this exhibition has been remarkable. Frank Demaegd of Zeno X Gallery, Antwerp, and his partners Eliane Breynaert, Rose Van Doninck, and Koen Van den Brande have strengthened Dumas's international representation, and Jane Hamlyn with Dale McFarland of Frith Street Gallery, London, have brought the work to a new audience. More recently, David Zwirner and Hanna Schouwink of David Zwirner, New York, have provided critical support.

Many of the paintings in this exhibition have never been on view in North America, and I am deeply indebted to the many collectors in the United States and Europe who lent generously out of a genuine commitment to the artist. In particular, I acknowledge Blake Byrne, whose long-standing relationship with the artist has been expressed in many ways, including through his support of this project. His collection is exemplary for his embrace of certain international artists long before it was fashionable, and his dedication specifically to Dumas's work is very personal and heartfelt. Without his leadership, this exhibition would not have been possible. I further thank Directors Jill and Dennis A. Roach of the Buddy Taub Foundation for their early support of Dumas and for facilitating the acquisition of important works by American museums. I am also indebted to dear friends Brenda Potter and her belated husband, Michael Sandler, for their generous support of this exhibition.

The following funders contributed generously to the project, and I am deeply grateful for their extraordinary contributions: Brenda R. Potter and Michael C. Sandler; Mondriaan Foundation, Amsterdam; Blake Byrne; Mark Fisch; Steve Martin; The MOCA Contemporaries; the Barbara Lee Family Foundation; the Robert Lehman Foundation; the Pasadena Art Alliance; Elizabeth A. Sackler, JCF, Museum Educational Trust; Jack and Connie Tilton; Netherland-America Foundation; Linda and Jerry Janger; Dr. S. Sanford Kornblum and Mrs. Charlene S. Kornblum; B. J. Russell Mylne; and Jerome and Ellen Stern. Thanks to Jerry I. Speyer and Katherine G. Farley for their support of the exhibition at MoMA; special appreciation goes to Marty and Rebecca Eisenberg and Henry and Marie-Josée Kravis for their generous support of the artist's work in MoMA's collection.

Dumas's network of friends and admirers extends far and wide. On behalf of the artist we recognize Dan Cameron, who invited her to participate in a group show in New York in 1990 and later presented her drawings at the New Museum. Loretta Yarlow, formerly of the Art Gallery of York University, Toronto, and Irene Tsatsos, then at the Arts Club of Chicago, were early supporters as well.

Without the patience, expertise, and good humor of her studio and family members, this exhibition would have been impossible to realize. I thank Jolie van Leeuwen, who organized Dumas's 1993 exhibition at the Van Abbemuseum, which was then brought to the United States by Patrick Murphy of the Philadelphia Institute of Contemporary Art and Elsa Longhauser at Moore College of Art and Design. A longtime colleague in the Dumas studio, Jolie's advice and deep knowledge of the work was invaluable. Of vital importance to the artist is Rudolf Evenhuis, who provided myriad administrative assistance and produced extensive film documentation of her work. In organizing this exhibition, it has been my pleasure to know Jan Andriesse and Helena Dumas Andriesse; I thank them for sacrificing many evenings with Marlene and providing critical emotional support.

On a personal note, I thank my husband David Schafer and two little boys, who have cheerfully endured my frequent trips to Amsterdam and who lift my spirits and my work profoundly and daily. Finally, Marlene has become a hugely influential part of the intellectual and emotional constellation of artists whose work and friendship has changed my way of thinking about the world. It has been a singular privilege to know her and her deeply beautiful and moving oeuvre, and I thank her for her vast contribution to this project.

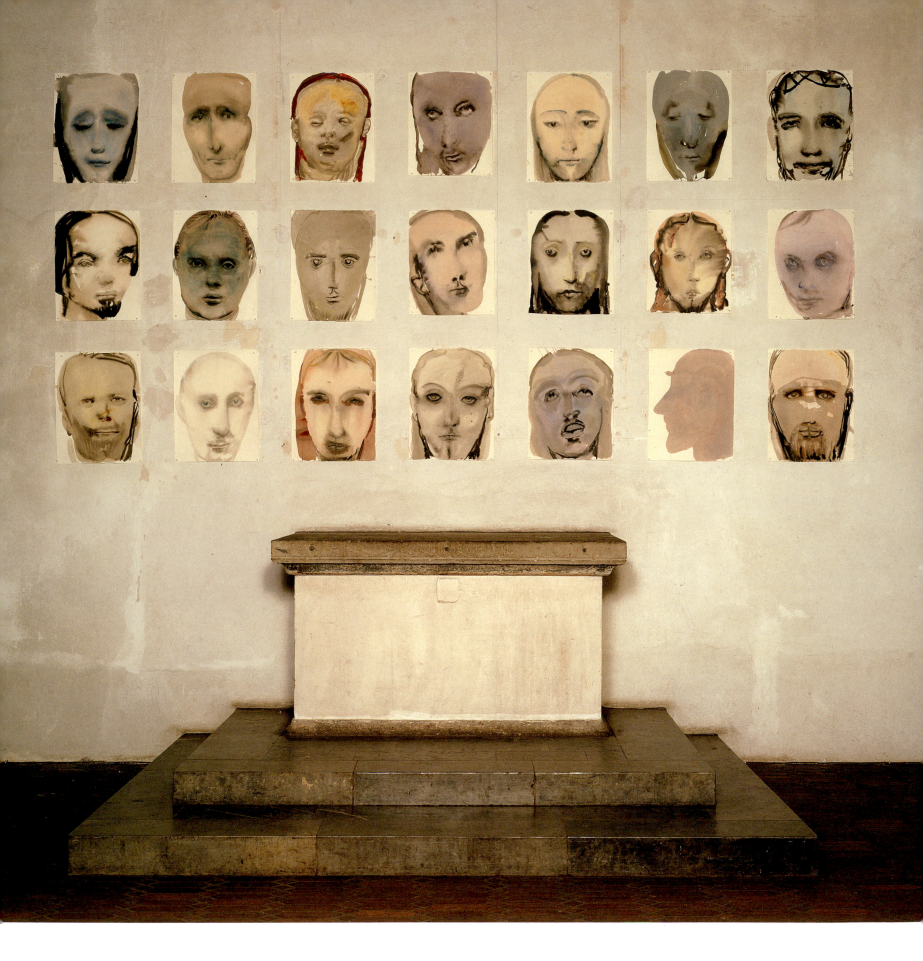

Jesus—Serene, 1994; ink, watercolor, and pencil on paper;
twenty-one sheets: approximately 25 $^9/_{16}$ x 19 $^{11}/_{16}$ inches
each; collection Victoria and Henk de Heus, The Netherlands;
installation in "Männeransichten" at Kunst-Station Sankt Peter,
Cologne, Germany, 1994

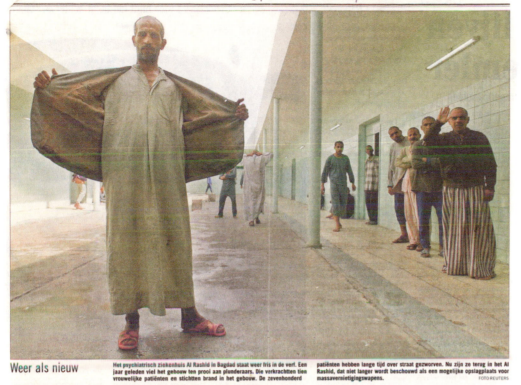

31 maart 2004.

Weer als nieuw
Het psychiatrisch ziekenhuis Al Rashid in Bagdad staat weer fris in de verf. Een jaar geleden viel het gebouw ten prooi aan plunderaars. Die verkrachtten tien vrouwelijke patiënten en stichtten brand in het gebouw. De zevenhonderd patiënten hebben lange tijd over straat gezworven. Nu zijn ze terug in het Al Rashid, dat niet langer wordt beschouwd als een mogelijke opslagplaats voor massavernietigingswapens.
FOTO REUTERS

Left: Source image from *De Volkskrant*, 31 March 2004, for *The Prophet*, 2004; caption reads: "Just Like New: The psychiatric hospital in Baghdad is freshly painted again. A year ago this building was attacked by looters. They raped 100 female patients and set fire to the building. The 700 patients wandered the streets for a long time. Now they're back in the Al Rashid, which is no longer considered to be a possible storage place for weapons of mass destruction."

Below: "Marlene Dumas: The Second Coming," installation at Frith Street Gallery, London, 2004

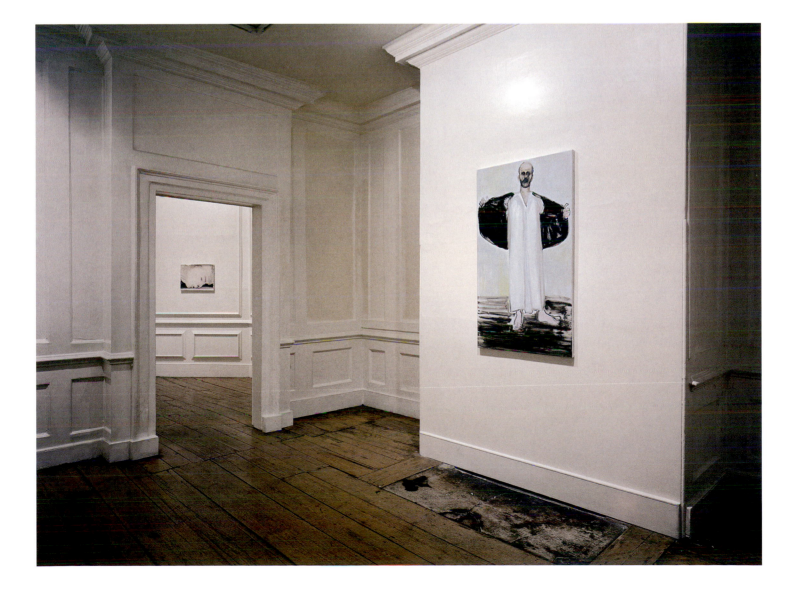

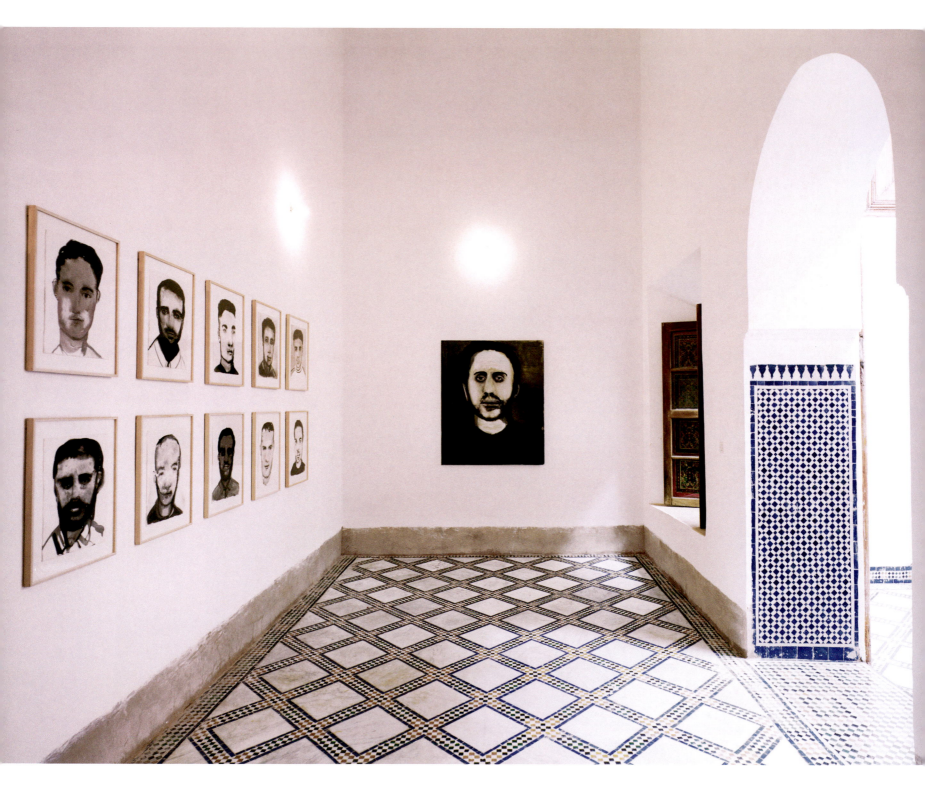

"Respect! Forms of Community: Contemporary Art from The Netherlands,"
installation at Musée Dar Si Saïd, Palais el-Badi, Marrakesh, Morocco, 2005

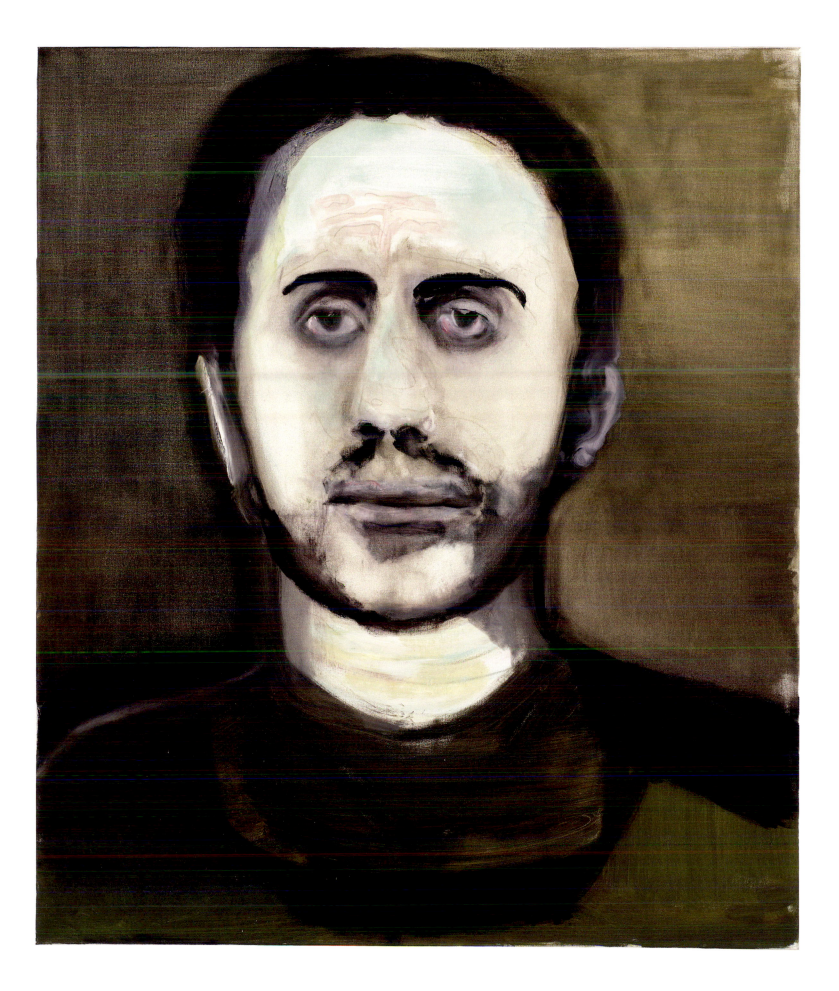

The Believer, 2005; oil on canvas; 51 3/16 x 43 5/16 inches; Stedelijk Museum, Amsterdam, on long-term loan from The Monique Zajfen Collection of The Broere Charitable Foundation

Man Kind, 2006; oil on canvas; 39 3/8 x 35 7/16 inches; Centraal Museum, Utrecht, with support of The Mondriaan Foundation

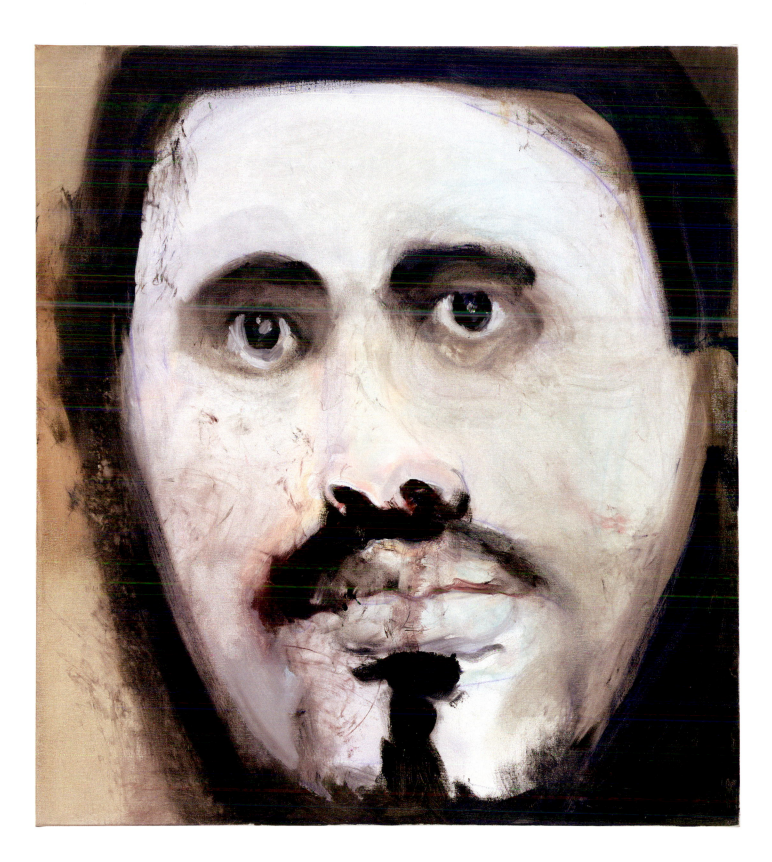

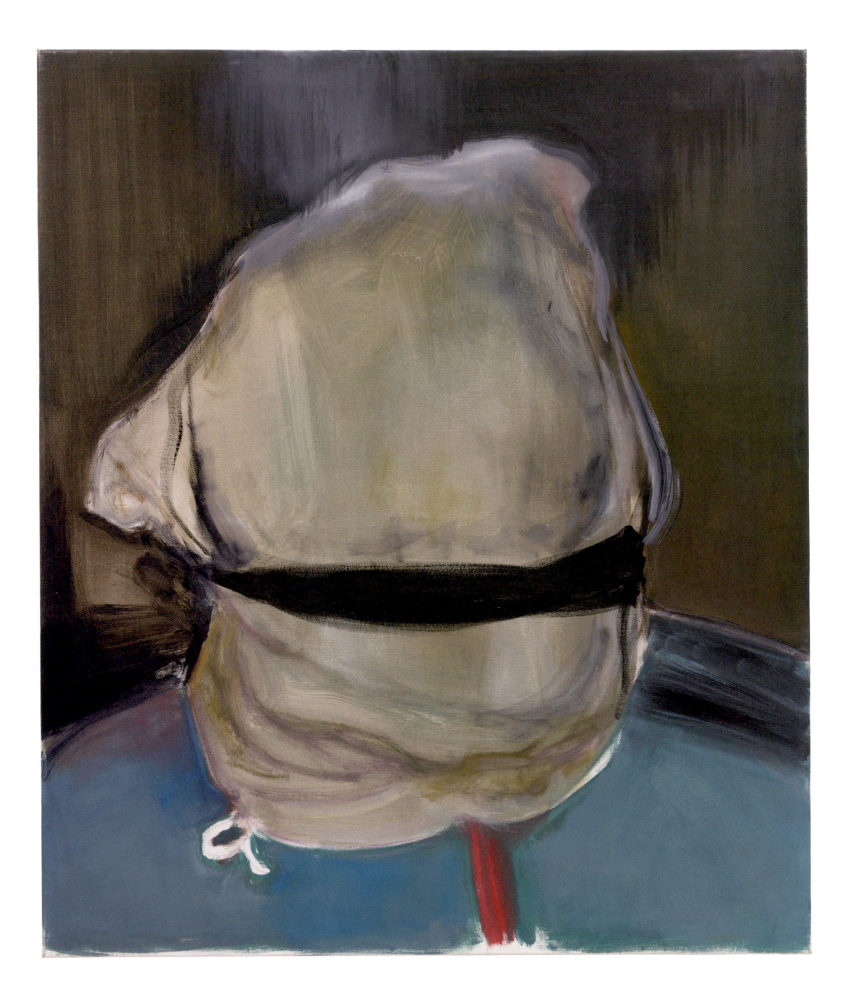

Duct Tape, 2002–05; oil on canvas; 51 3/16 x 43 5/16 inches; private collection, New York

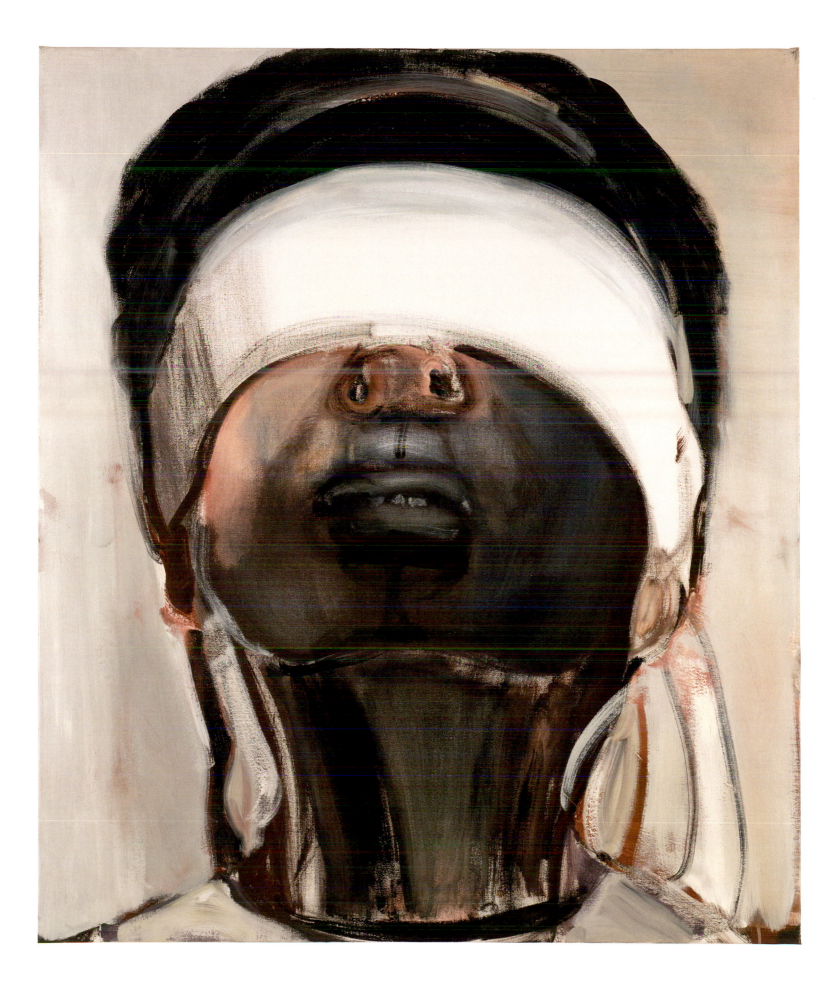

Blindfolded, 2002; oil on canvas; 51 ³/₁₆ x 43 ⁵/₁₆ inches; collection Thomas Koerfer, Zürich

Following spread: *The Blindfolded*, 2002; oil on canvas; triptych: 51 ³/₁₆ x 43 ⁵/₁₆ inches each panel; Hauser & Wirth Collection, Switzerland

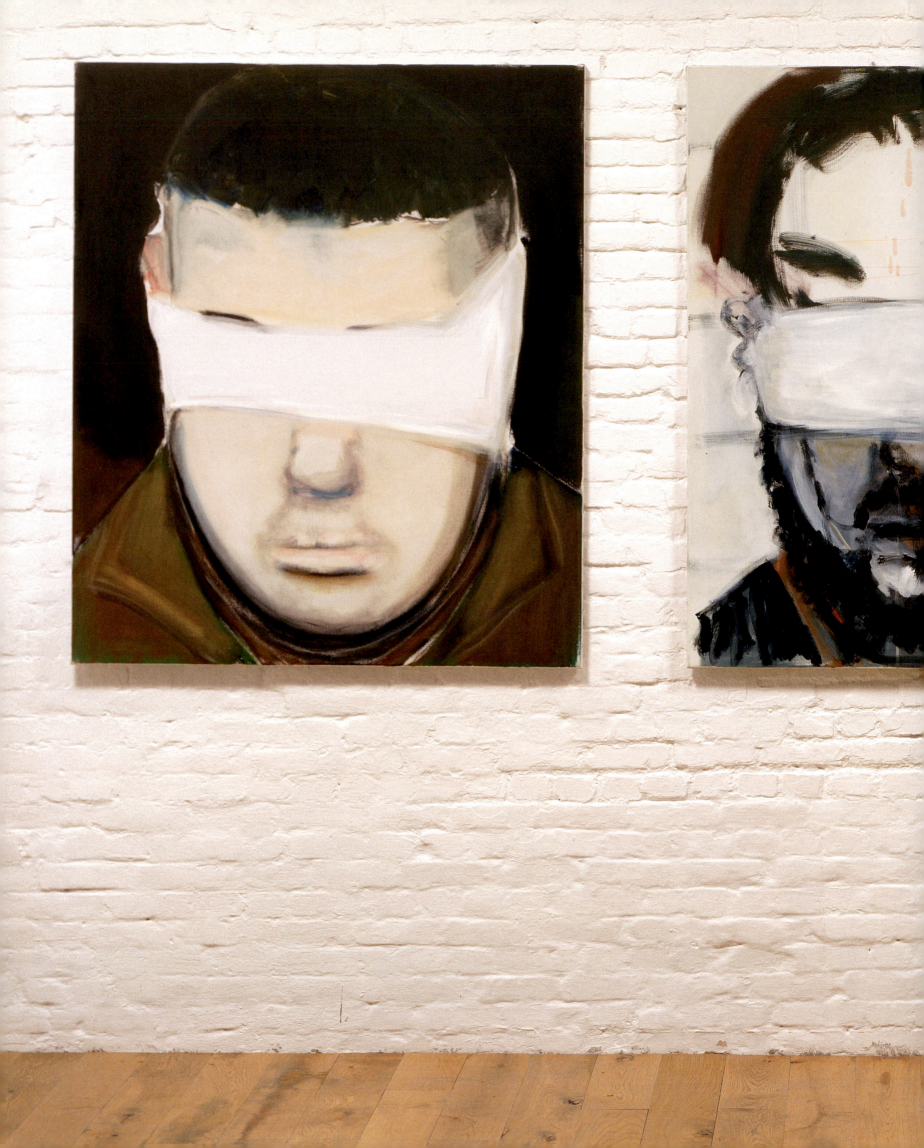

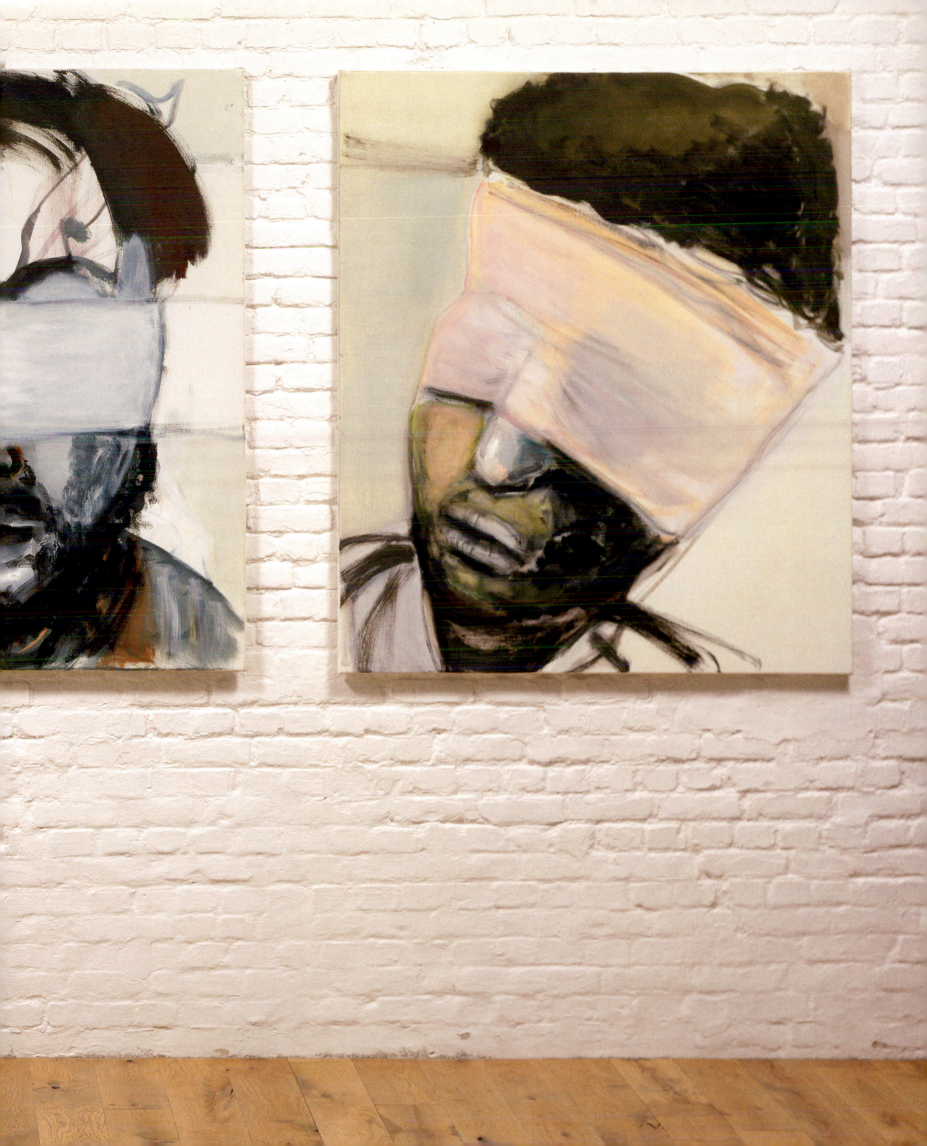

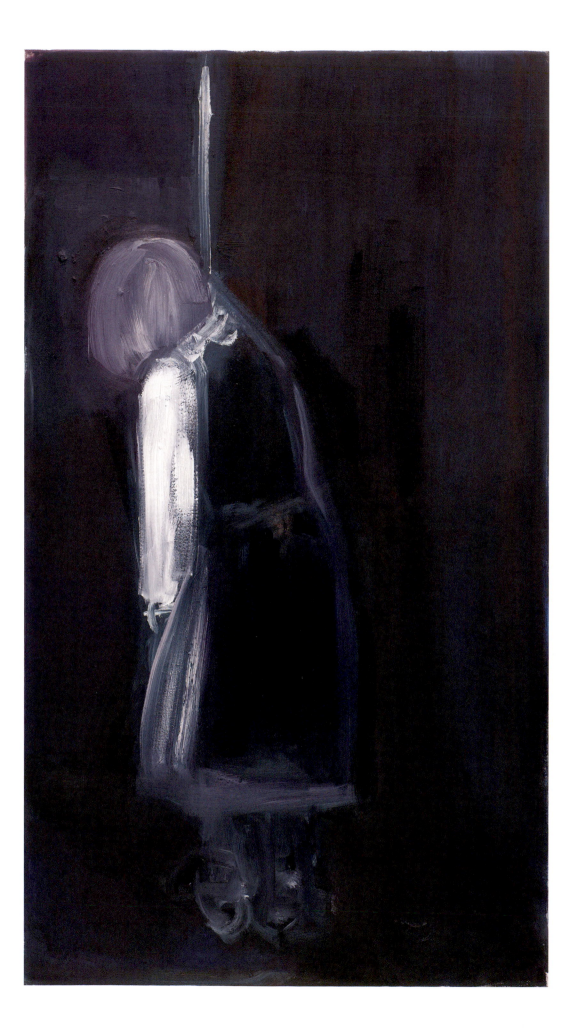

Imaginary 4, 2003; oil on canvas; 49³/₁₆ x 27⁹/₁₆ inches; private collection, courtesy Galerie Paul Andriesse, Amsterdam

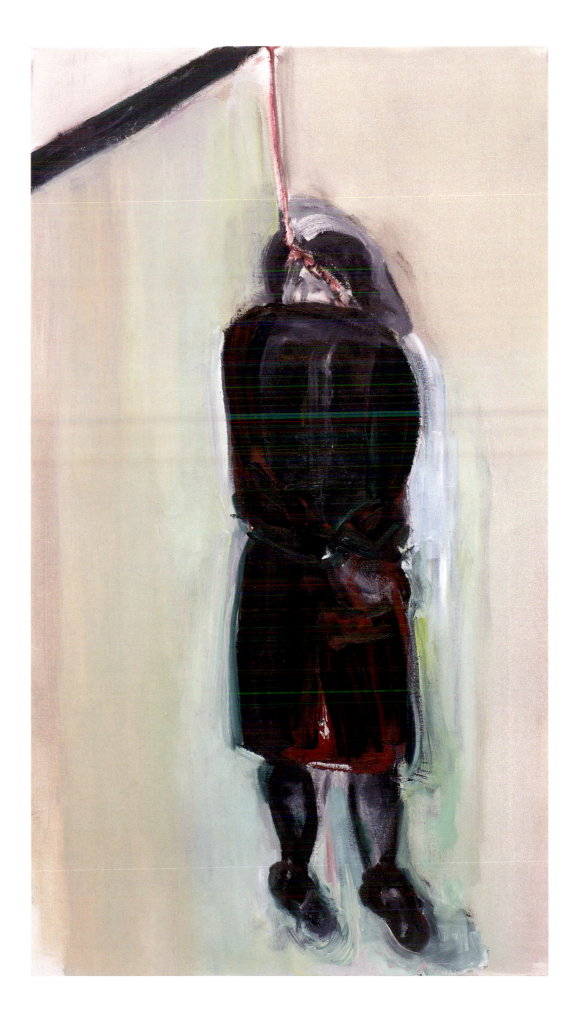

Imaginary 3, 2003; oil on canvas; 49³/₁₆ x 27⁹/₁₆ inches; collection Craig Robins, Miami, Florida

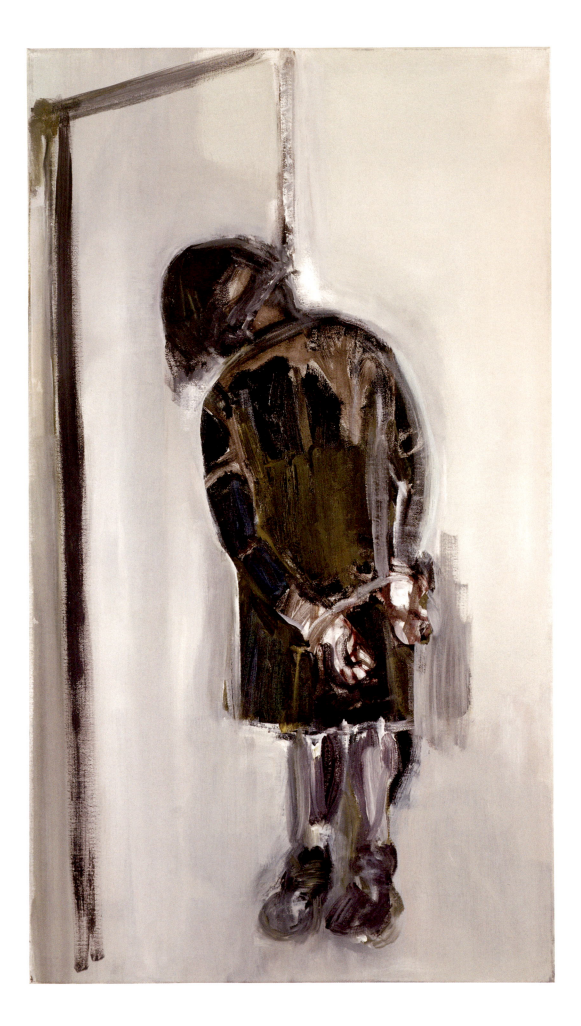

Imaginary 2, 2002; oil on canvas; 49³/₁₆ x 27⁹/₁₆ inches; Rubell Family Collection, Miami

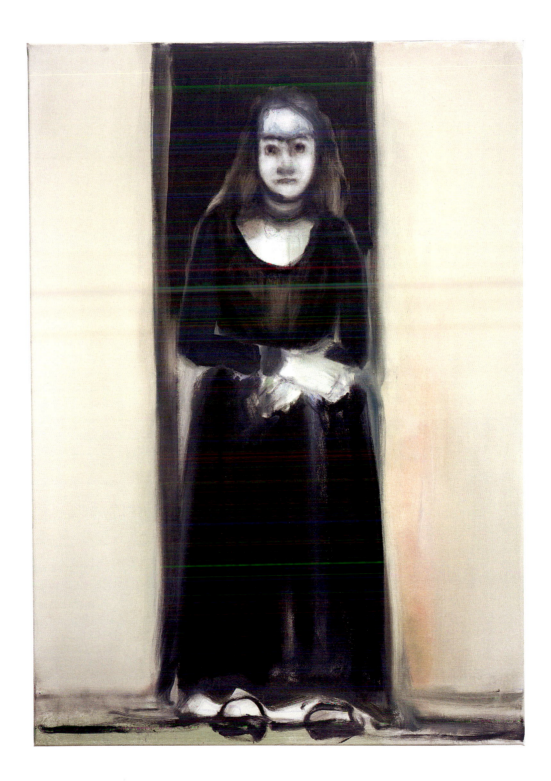

The Survivor, 2004; oil on canvas; 39 3/8 x 27 9/16 inches; collection Blake Byrne, Los Angeles

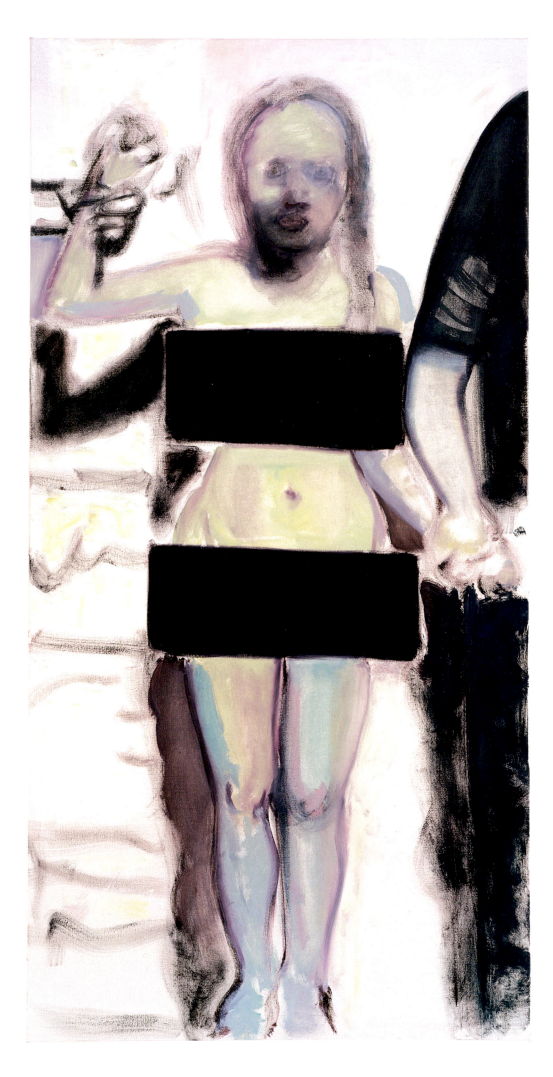

The Woman of Algiers, 2001; oil on canvas; 78 3/4 x 39 3/8 inches; The Museum of Contemporary Art, Los Angeles, and The Nasher Museum of Art at Duke University, Durham, partial and promised gift of Blake Byrne

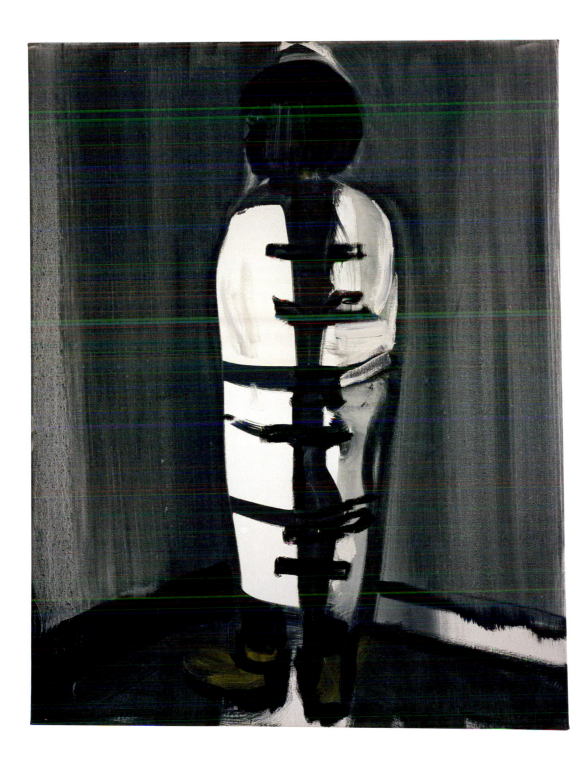

Straitjacket, 1993; oil on canvas; 35 7/$_{16}$ x 27 9/$_{16}$ inches; private collection, courtesy Zeno X Gallery, Antwerp

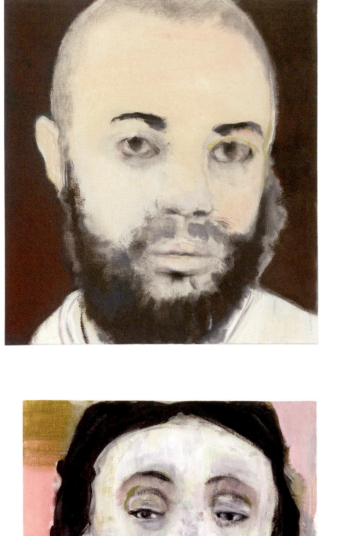
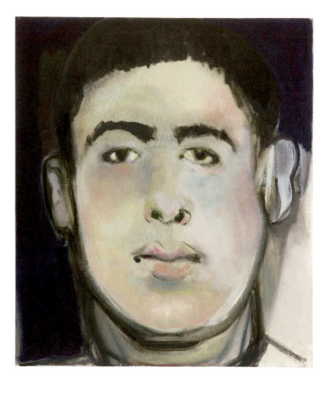
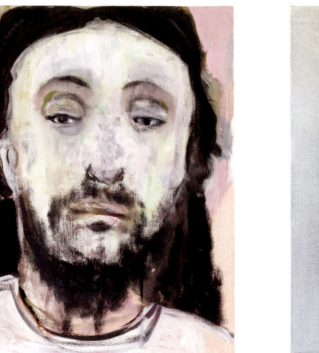
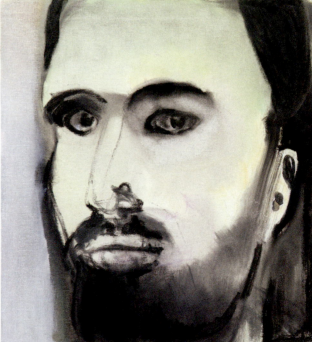

Clockwise, from top left:
The Neighbour, 2005; oil on canvas; 39 3/8 x 35 7/16 inches; Stedelijk Museum, Amsterdam,
gift of the artist and Galerie Paul Andriesse
The Look-Alike, 2005; oil on canvas; 51 3/16 x 43 5/16 inches; private collection
The Semite, 2006; oil on canvas; 43 5/16 x 35 7/16 inches; courtesy Paul Andriesse, Amsterdam
The Mediator, 2006; oil on canvas; 51 3/16 x 43 5/16 inches; private collection

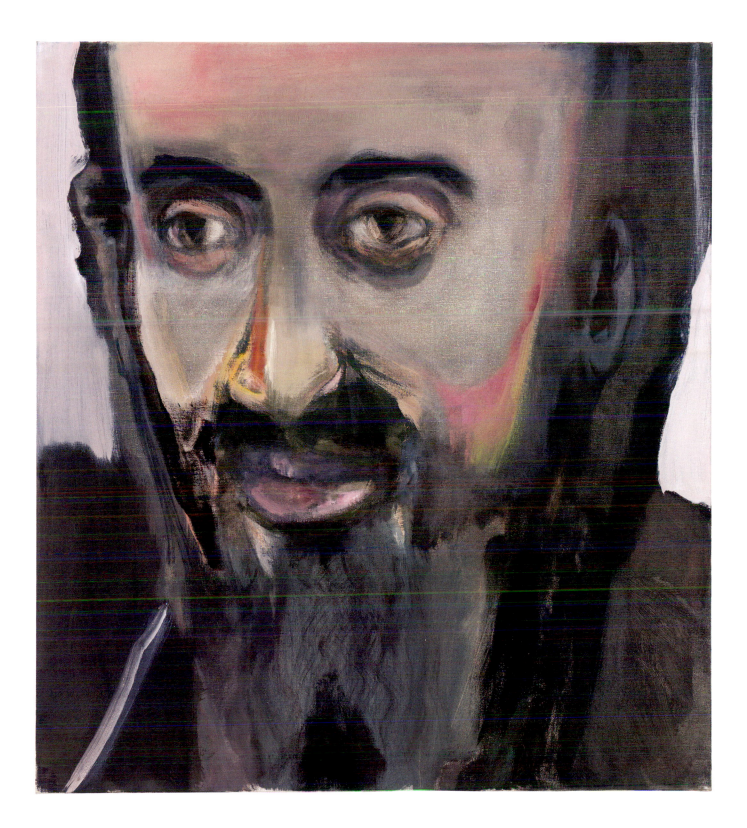

The Pilgrim, 2006; oil on canvas; 39 3/8 x 35 7/16 inches; private collection

Liberation (1945), 1990; oil on canvas; 51 $\frac{3}{16}$ x 43 $\frac{5}{16}$ inches; collection of the artist

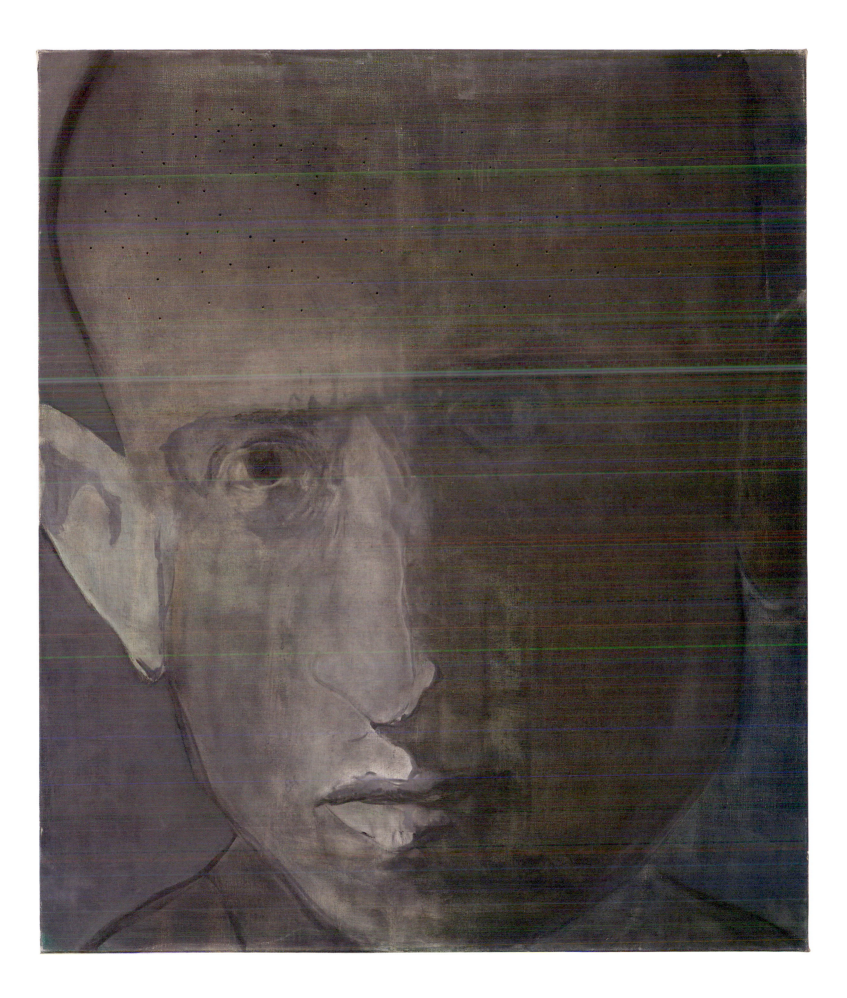

Skull (of a Woman), 2005; oil on canvas; 43 $^5/_{16}$ x 51 $^3/_{16}$ inches; collection de Bruin-Heijn

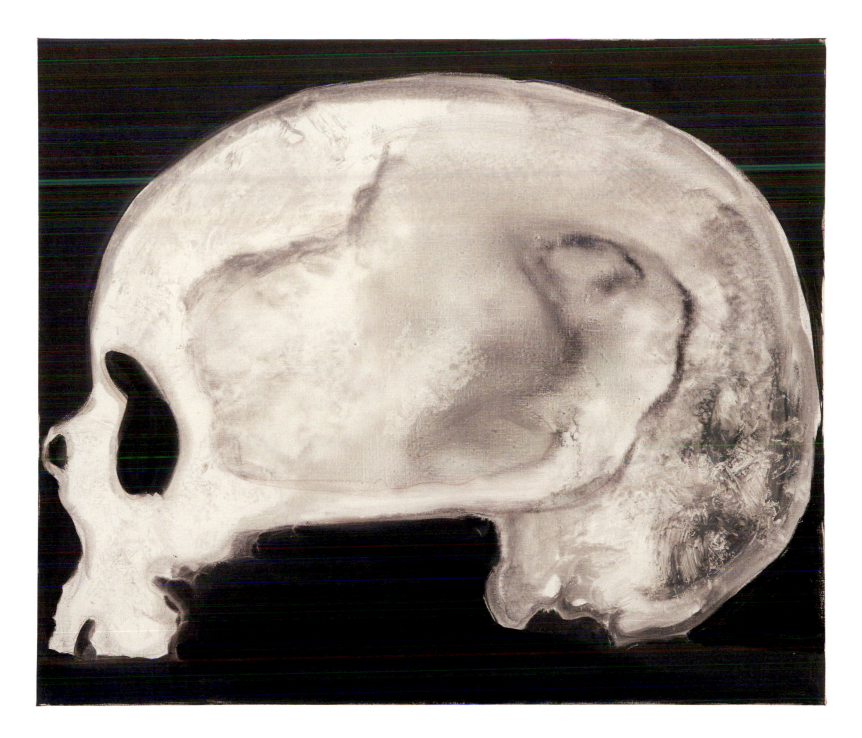

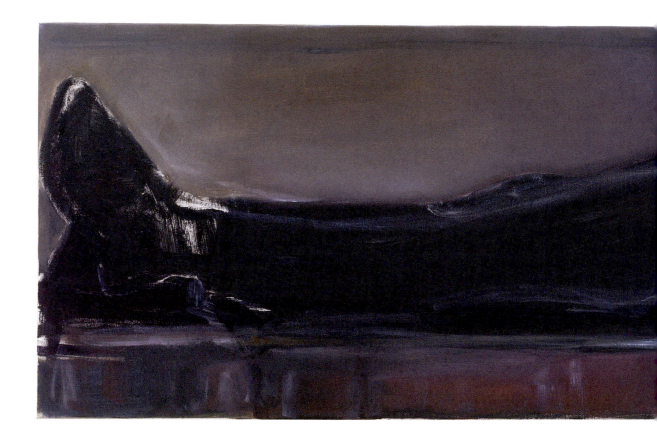

The Missionary, 2002–04; oil on canvas; 23 5/8 x 90 9/16 inches; Centre Pompidou, Paris, Musée national d'art moderne/Centre de création industrielle, gift of the Clarence Westbury Foundation, 2005

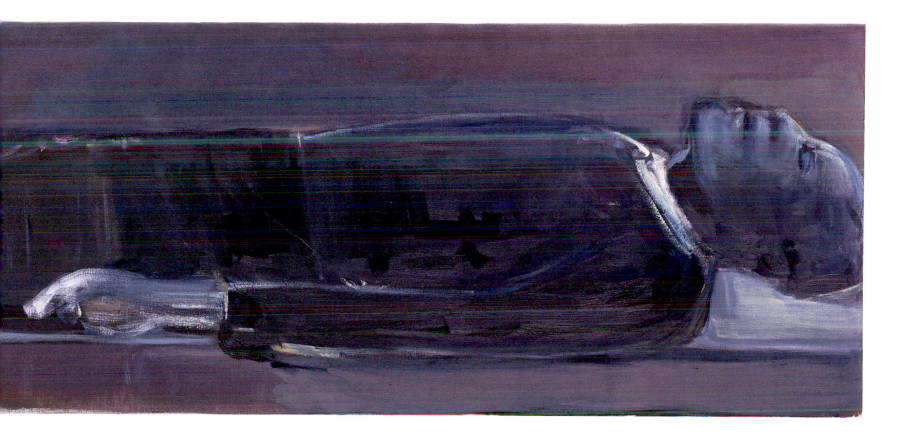

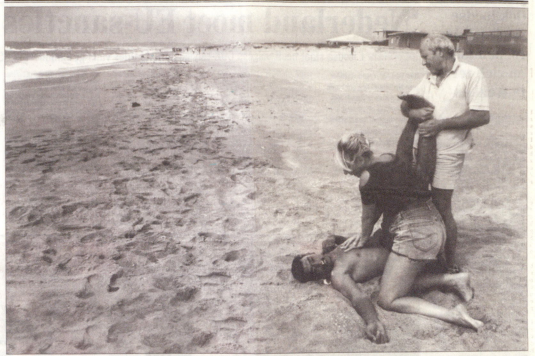

Dinsdag 24 september 2002 **de Volkskrant**

Aankomst in het Beloofde Land

Voorbijgangers proberen een drenkeling te reanimeren die zondag aanspoelde op het strand van Scoglitti, in het zuiden van Sicilië. In totaal werden die dag negen mannen dood aangetroffen op het strand. Een drenkeling bleek nog in leven, maar overleed onderweg naar het ziekenhuis. Volgens de Italiaanse autoriteiten ging het om Tunesiërs die met een motorboot de Middellandse Zee probeerden over te steken. Ze zouden door een mensensmokkelaar gedwongen zijn midden op zee overboord te springen. De politie beschikt over getuigenver-klaringen. Slechte weersomstandigheden bemoeilijkten de zoektocht met heli-kopters naar meer eventuele slachtoffers. Wel slaagde de politie erin de bestuurder van de gewraakte motorboot op zee te arresteren. Jaarlijks brengen mensensmokkelaars duizenden immigranten uit Noord-Afrika clandestien over zee naar Italië. Meestal zetten zij de immigranten kilometers buiten de kust overboord. Veel immigranten overleven dit niet. Italië heeft de EU om hulp gevraagd bij de aanpak van deze mensensmokkel.

Source image (left) from *De Volkskrant*, 24 September 2002, for *Drowned*, 2003 (below); oil on canvas; 31 1/2 x 27 9/16 inches; collection Craig Robins, Miami, Florida

Opposite, top: Photograph accompanying article in *De Volkskrant* titled "After the Crossing," 19 June 2003

Bottom: Dumas in her studio, Amsterdam, 2004

Beaches Ain't What They Used To Be: The Tourist Meets the Fugitive

As the newspapers inform us:
Daily, immigrants are washed ashore
on the coast of southern Spain.
Illegal African immigrants trying to get to Europe.
Dead bodies on the beach.
Arriving in the promised land.
Bystanders trying to reanimate a body
on a beach of southern Sicily.
The European Union is worried.
The Italian Minister of Reform
said that after the third warning, just shoot,
otherwise we will never get rid of this.

—M. D.

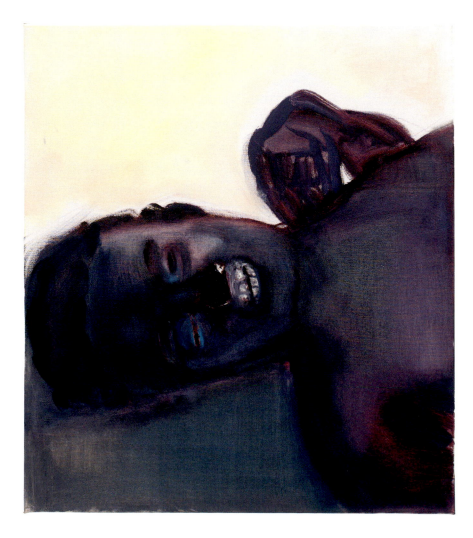

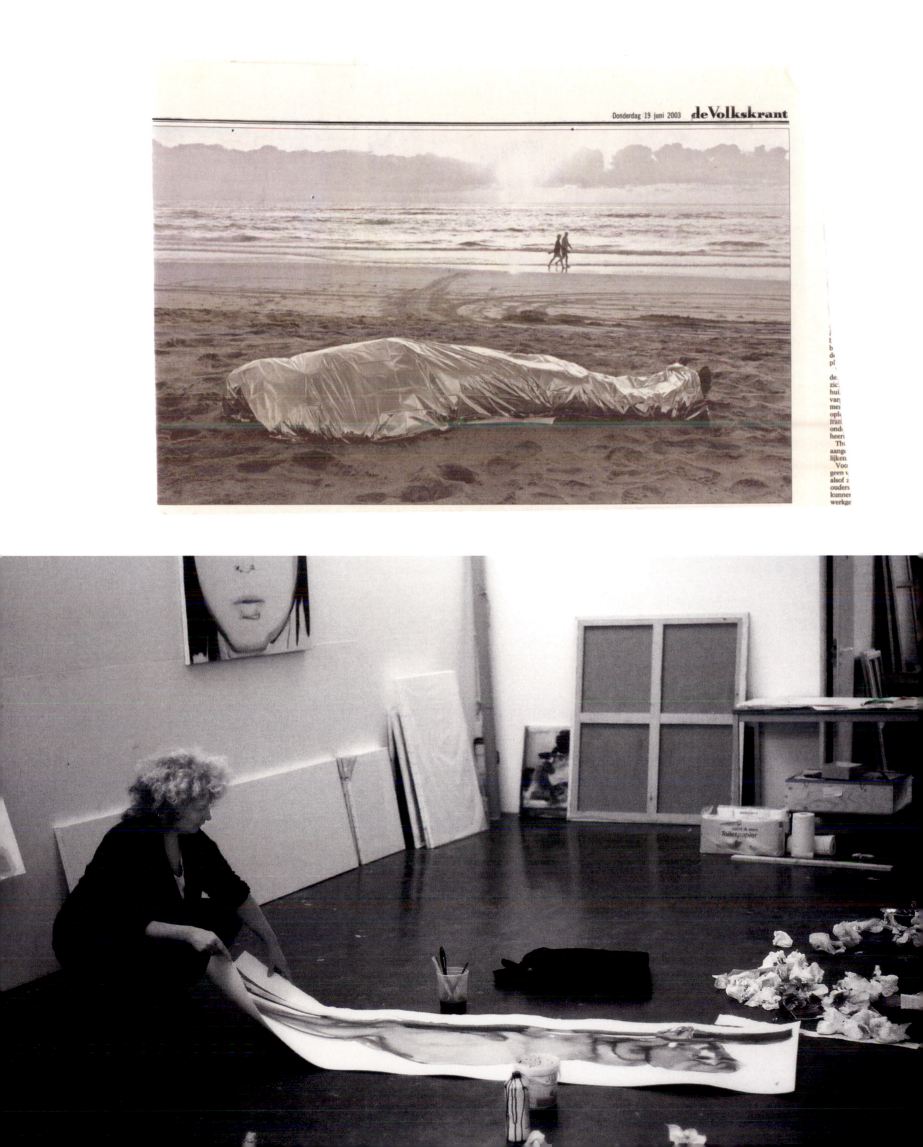

Sunday Times Jan. 1993

TOP medical experts, outraged at the horrifying death of a young woman prisoner who was constrained in a straitjacket for 23 hours, have labelled the practice of trussing up prisoners a "form of torture" which has no place in modern society.

The sequel to the death in July 1989 of 20-year-old Carol Anne Meyers, known to close family and friends as Debbie, was played out this week when an inquest magistrate found that Pollsmoor Prison staff and a district surgeon had been "irresponsible and inhuman" as well as "grossly negligent".

The woman had been serving a two-year sentence for robbery and other minor charges. She was strapped into the jacket — padded with blankets as it was apparently too big — after she was overheard discussing suicide with a cellmate. She died of kidney failure and extensive bleeding.

Professor Solly Benatar, professor of medicine at the University of Cape Town, expressed "horror that this could have happened". From a medical point of view, he said, strapping a patient into a straitjacket could be classified as "a form of torture".

"Confining someone to a straitjacket is similar to confining someone to a mental institution against his or her will. You only do that when someone is a great danger to themselves or to society — and then only under psychiatric observation.

"It is possible in this modern era, by assessing or sedating, not to resort to such barabaric methods."

He called for an opening up of the whole question of how and why straitjackets were used.

"Any kind of restraint should be used in the rarest of circumstances," he said.

He added it would still be absolutely necessary for all precautions to be taken to ensure the person was safe.

"It is inconceivable to put someone in a straitjacket and not to see that they are cared for."

Professor Benatar said no medical practitioner should have anything to do with such a practice. If the police felt it was necessary to restrain a patient they considered dangerous, they should not do so before consulting a psychiatrist.

Professor Tuviah Zabow, principal psychologist at Valkenberg Hospital and at UCT, told Weekend Argus that only once in the last 20 years had he resorted to the use of a straitjacket — when a patient believed he had to cut his throat by midnight and exhausted staff could no longer restrain him.

He stressed that straitjackets should never be used as punishment — and certainly never by a doctor to support punishment.

He had first seen a straitjacket four or five years ago and "prior to that only in the movies". Valkenberg Hospital had only one straitjacket, which had been made for teaching purposes.

"In theory, the only time I think it's viable to use such a method is in exceptional cases — when a patient is driven by psychotic forces to self-mutilate on the grounds of mental illness.

"Straitjackets are certainly not used routinely on the South African clinical scene."

The fate of prison staff and district surgeon Dr Peter Fisher, who were involved in the incident, is in the hands of Attorney-General Mr Frank Kahn. A spokesman for his office yesterday said the inquest report had not yet been submitted. It was "expected shortly and will be considered".

Inquest magistrate Mr N H Jones ordered that copies of his findings be sent not only to the Attorney-General but also to the officer commanding Pollsmoor Prison, the South African Medical and Dental Council, the South African Nursing Council and the superintendents of Groote Schuur and Victoria hospitals.

Registrars for the SA Nursing Council and the SA Medical and Dental Council reported this week that the findings would be investigated by preliminary committees. Should they recommend disciplinary action, those involved would have to face full hearings.

The heaviest penalty which the councils can impose is to strike a person's name from the roll of professional practitioners. They can also stop a person practising for a specified period.

In a statement to Weekend Argus, Department of Correctional Services spokesman Lieutenant-Colonel Barry Eksteen refused to comment on the magistrate's findings, saying that the Attorney-General had still to make a decision.

But on the subject of the department's policy on straitjackets, he said that these were used "as an instrument of restraint in South African prisons in accordance with the relevant stipulations of the internationally accepted standard minimum rules for the treatment of prisoners".

Straitjackets were not used as punishment but to restrain uncontrollable prisoners threatening violence or self-injury or damaging property. Prisoners were kept in straitjackets for as long as was absolutely necessary under strict and continuous supervision.

"It should be stressed that the decision to use a straitjacket is taken with great circumspection and only in those cases where there is no alternative," said Colonel Eksteen.

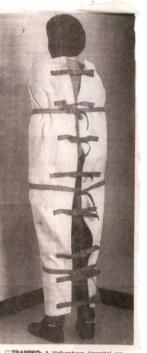

☐ **TRAPPED:** A Valkenberg Hospital employee demonstrates the institution's only straitjacket — made for teaching purposes and not for use on patients. The jacket is apparently almost identical to those used in prisons.

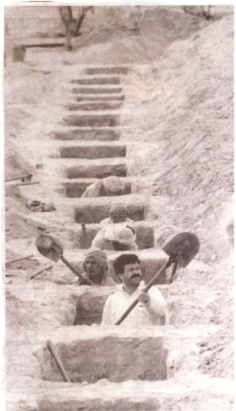

Arbeiders delven nieuwe graven op de begraafplaats Raqqa in Koeweit-stad voor slachtoffers van de Iraakse bezetting die nog worden gevonden, maar ook voor de doden die na vallen bij afrekeningen na de bevrijding. (Foto AP)

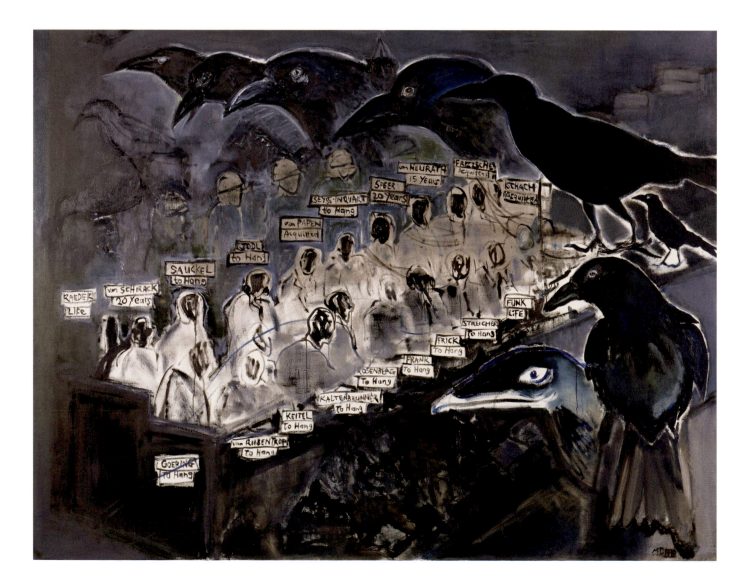

Opposite, top: Source image (left) for *Straitjacket*, 1993, and photograph (right) captioned: "Workers digging graves at the Ragga graveyard in Kuwait City for victims of the Iraqi occupation who are still being discovered as well as those who have died during the retaliation after the liberation."

Bottom: *De bevrijding (The Nuremberg Trials)*, 1990; oil on canvas; 61 x 78 3/4 inches; Jewish Historical Museum, Amsterdam

Right: Postcards from Dumas's image bank, clockwise from top left: Jacques Callot, "La Pendaison," from *Les grandes misères de la guerre*, 1633; Joseph Beuys on his way to America, 1974: later that year he returned to perform the action *I Like America and America Likes Me*, saying, "I wanted to isolate myself and see nothing of America other than the coyote"; Giotto, *Massacre of the Innocents*, 1305, Scrovegni Chapel, Padua, Italy; and Francesco Simonini, *L'arbre aux pendus*, after the print by Jacques Callot, Musée Historique Lorrain-Nancy, France

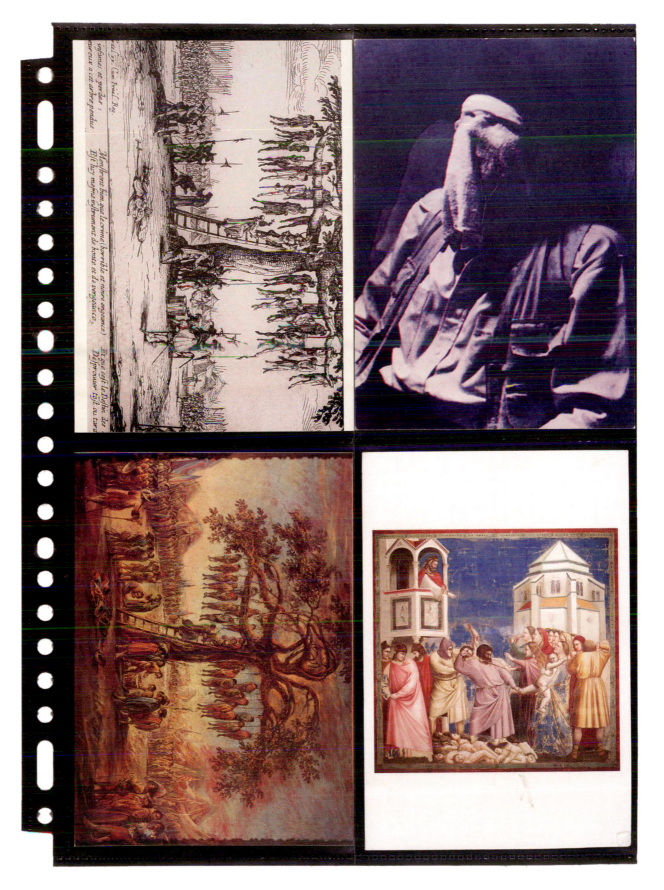

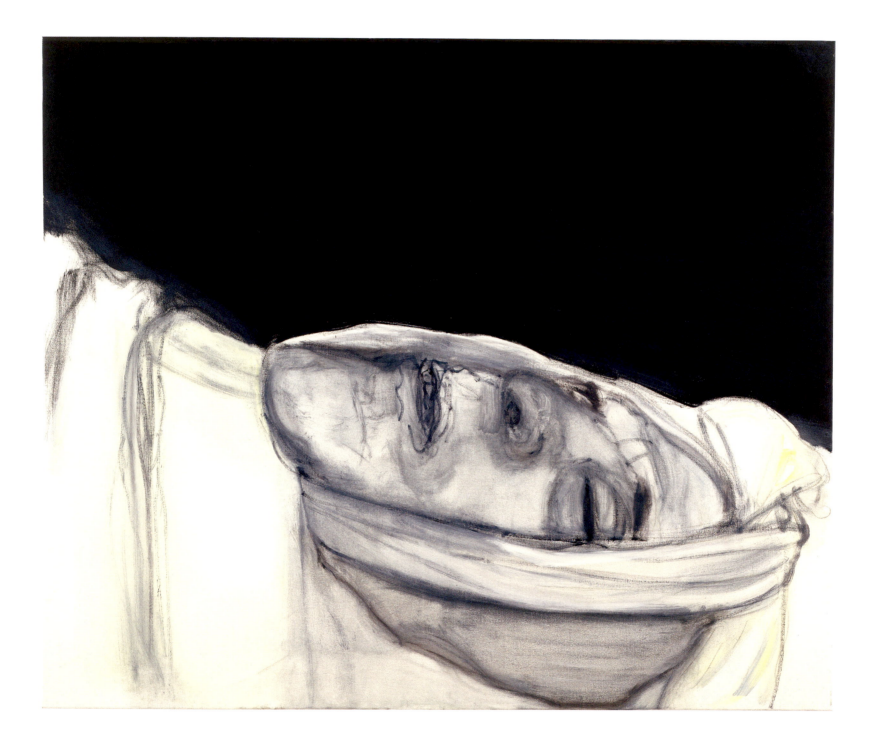

The Deceased, 2002; oil on canvas; 43 5/16 x 51 3/16 inches; collection Howard and Donna Stone

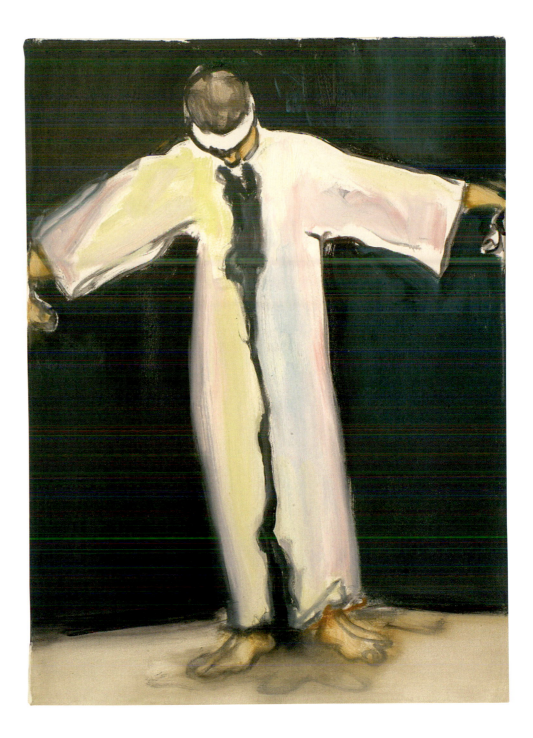

Anonymous, 2005; oil on canvas; 27 $^{9}/_{16}$ x 19 $^{11}/_{16}$ inches; Garnatz Collection, Cologne

Give the People What They Want, 1992; oil on canvas; 15 3/4 x 11 13/16 inches; private collection, courtesy Zeno X Gallery, Antwerp

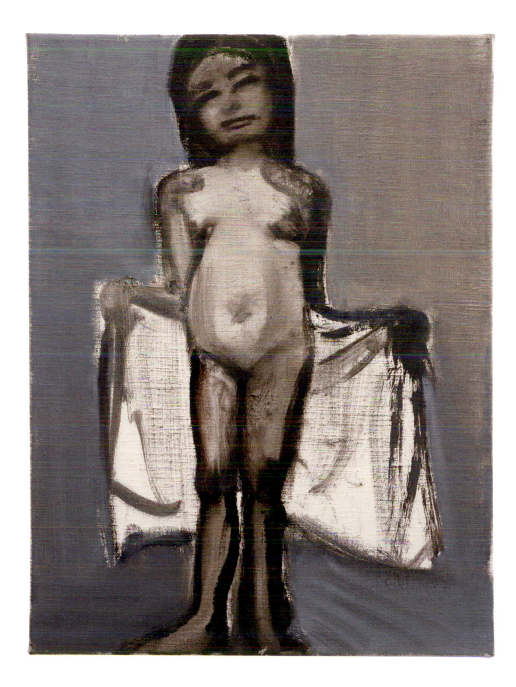

Painter as Witness

CORNELIA BUTLER

I was looking for images to somehow show the coruscating nature of what the world was about—in a way, survival, you see? And the savagery of war and the savagery of human relations in general.... My dilemma was in the world of events, the event-world. How to make contact. —LEON GOLUB[1]

The Painting of the Real

Portraits of the living, portraits of the dead, horizontals, groups, dead girls, big babies, crying women—this is the shorthand, the typology of subjects that Marlene Dumas has used in her ongoing exploration of portraiture. An artist for more than thirty years, Dumas has only recently begun to articulate her practice as a visual accounting of our time through the representation of individuals or, rather, of bodies and souls as they move through the incidents of life, politics, and art. Born in 1953 in Cape Town, South Africa, and a resident of Amsterdam in a kind of self-imposed exile since 1976, Dumas has lived through colonial and postcolonial periods and witnessed the collision of worlds that has taken place with Western Europe's recent influx of immigrants. Choosing to move to Amsterdam rather than New York in part because race relations in the United States reminded her of the apartheid she was fleeing, Dumas has spoken of her understanding of identity, both personal and cultural, as constantly in flux.[2]

Always vigilant about the political uses of language as a result of her experiences with apartheid, she ironically described her own hybrid identity as *allochtoon*, a Dutch demographic term the artist dislikes meaning "to originate from another country." Introduced in 1971 as a euphemism for "immigrant," the word has since served to stigmatize many described as such. (She uses *allochtoon* as opposed to *autochtoon*, meaning "to originate from the same country"—a term designating those from the Netherlands that is seldom used but often "presumed" in much the same way one rarely hears anyone explicitly described as "Anglo-American" in the United States.) The arc of Dumas's life and career is that of a woman born in a former Dutch (and British) colony who later moved to the Netherlands: "We were, because of the language, Dutch but not quite Dutch. We were not *allochtoon* for the same reason, until we became it."[3] A white person living in Amsterdam who is not Dutch but whose life and language were long ago fully contaminated by her trans-cultural experience, she explained that *allochtoon*, a term once applied to her own status, is now a pejorative used to describe non-Western persons who are black or Muslim: "Ik is een allochtoon," she once proclaimed on a T-shirt, embracing her own outsider status and making allegiance with those citizens of darker color whose images she would later paint.

Almost exclusively focused on bodies, figures, and approximate likenesses, Dumas's production is bracketed by two groups of works that constitute her most explicit commitment to portraiture. While the Eyes of the Night Creatures (1984–85), made when she was in her early thirties, is an overtly autobiographical gathering of personal and artistic influences from her formative years, Man Kind (2002–06) is more public in its address of her adopted homeland's move toward a dangerous and racist cultural hegemony. Moreover, this latter body of work—made as if to restore a moment in which the personal and the political could be articulated, a punctum in the propagandistic distortion of the corporate image world—is a powerful statement about a culture experiencing radical transition. Since 9/11, very few aesthetic statements have gone so far in penetrating the scope and drastic impact of monumental violence, loss, and fear.

Dumas's studio, Amsterdam, 1991

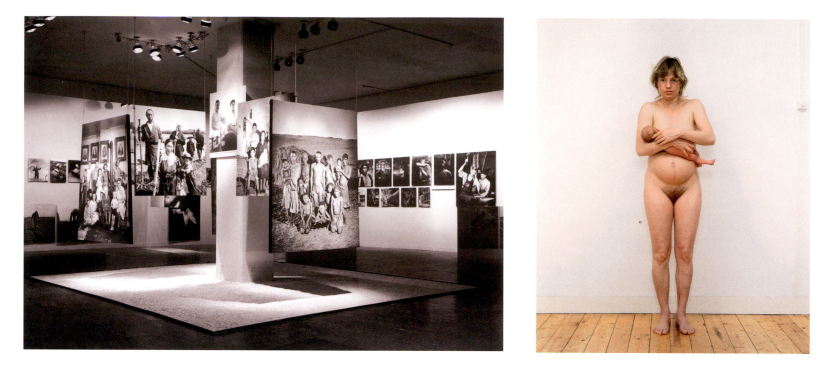

The paintings of men that comprise Man Kind, mostly anonymous but made under the rubric of portraiture, have titles such as *Young Men* (2002–05), *The Believer* (2005), *The Look-Alike* (2005), *The Semite* (2006), *The Neighbour* (2005), *The Mediator* (an elusive distant Christ) (2006), and (provocatively, since it shows a benign-looking Osama bin Laden) *The Pilgrim* (2006). Dumas said of this group:

> When I look back into this recent history through my archive of images, which I collected unsystematically and for different reasons, I still see a pattern emerging. I see a picture of a dead terrorist, hijacker, or kamikaze.... The "other" is also a mirror image of ourselves! Look in the mirror and talk to Al Qaeda.[4]

In a poem written to accompany the Man Kind paintings, Dumas invoked Edward Steichen's famous Family of Man photographic project from 1955: "This is not the times/for The Family of Man's smiles./We travel in disguise, so how would you know/friend from foe?"[5] Elsewhere, she claimed, "For me a good portrait conveys a point where attraction and alienation meet."[6] Seizing on the dual problems of personal and public identity as emblematic of both the hollowness of the image world and the obliteration of individual identity, Dumas embraces portraiture—both its history and its current state—as a way to structure her project. Like Alberto Giacometti, Francis Bacon, Leon Golub, and others before her, she uses the space of the canvas as an arena of psychological tension and the face or body as a container for meaning. In referencing Steichen, Dumas was also implying that the average consumer of images still thinks of photography as conveying some objective truth about identity. Yet, as a painter who almost exclusively uses photographic source material, she is aware of the medium's inadequacy in capturing real experience in real time. Edvard Munch famously declared that photography could never compete with painting because of its inability to represent heaven or hell. In close-up portrayals of birth, sex, death, and their attendant sensualities and fluids, Dumas is the court painter of these realms.

Hunting and Gathering: The Painter and the Photograph

In the twentieth century, the tradition of photographic portraiture was most often revisited in practices such as those of Tina Mondotti, Diane Arbus, and Richard Avedon, or, more recently, Thomas Ruff and Rineke Dijkstra, a Dutch compatriot whose images of teenagers or of women holding their newborn babies hours after giving birth are unforgettable reflections on the tran-

Left: "The Family of Man," installation at The Museum of Modern Art, New York, 1955

Right: Rineke Dijkstra, *Tecla, Amsterdam, The Netherlands, May 16, 1994*, 1994; C-print; 60 1/4 x 50 3/4 inches; courtesy of the artist and Marian Goodman Gallery, New York

sience of intimacy and the transformation of the body. Dijkstra deliberately uses conventional compositional devices, and the color and light of her photographs are steeped in the traditions of Northern European painting. Dumas may be inspired by a love of art history, particularly of painting, but she derives her subjects from Polaroid photographs, personal snapshots, torn sheets, notes, drawings, and thousands of media images that she keeps in her ever-evolving image bank. She tackles the difficulty of representing those who are either too close or too distant to actually see, capturing the exquisite shock of an infant after birth, the tension in the body of an almost-pubescent child, the imposing flesh of a grandmother's neck, the doppelganger effect of seeing one's aging naked figure reflected in a mirror, the impossibility of pregnancy, the face of a terrorist, the face of a savior, the face of the boy next door.

Her choice to paint from photographs is a political one, a way of engaging in the beautiful disturbing pageantry of contemporary social life. "The source materials," Dumas said, "are about the political choices one faces. They are of the time they are made in. They are about whose side are you on."[7] Far from an organized atlas, the contents of Dumas's archive function as a filter, constantly reshuffled in the artist's imagination and waking consciousness. In a restless, generous, and heartily discursive spirit, she mines the images that have informed a collective understanding of our era. A visit to Dumas's studio is an excavation: the time spent in front of any painting in progress is matched by that spent following a lively narrative of stories, ambivalences, and productively circuitous routes around her photographic sources. Her notebooks of images, arranged and rearranged by type or visual sympathy, constitute years of research. There are photographs of strippers, some of them taken by the artist, others cold, jarring hardcore magazine images of inflated and enhanced bodies in a kind of athletic ecstasy. More recent research for a future body of work on crying women begins with notes on and images of Pablo Picasso's *Guernica* (1937); the album cover of the original soundtrack from *For Whom the Bell Tolls* (1943), which

PHOTOGRAPHER RICHARD AVEDON IN A SELF-PORTRAIT; ARTIST JUNE LEAF

features a close-up still of a crying Ingrid Bergman; an old sketchbook collage of a loving Coretta Scott King embracing her husband, clipped to another photograph of her as a grieving widow; and media images of wailing mothers, wives, sisters, and daughters of men and boys slaughtered in the numbing and obliterating wake of terror. Dumas's hunting and gathering of pictures of all kinds is an almost entropic way to create visual knowledge, the end result being a painting. It is as if, aware of living in a time of extreme obfuscation, she is attempting to maintain vigilance as a citizen through a persistent sorting of media.

This requires the kind of engaged viewing that Laura Mulvey called a "curious spectatorship," as opposed to a pensive or passive one. Recuperating images by appropriating, projecting, altering, and painting them is a way of being in the world, of bearing witness and making contact through the invention of a visual language based on a productive distortion and restoration of still images. For Mulvey, the curious spectator is:

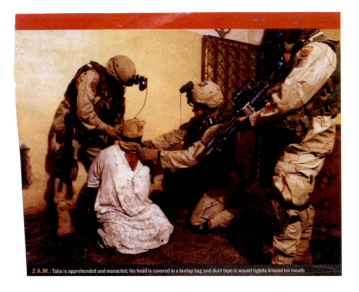

2 A.M.: Taha is apprehended and manacled; his head is covered in a burlap bag and duct tape is wound tightly around his mouth

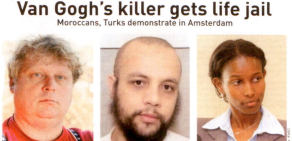

Van Gogh's killer gets life jail
Moroccans, Turks demonstrate in Amsterdam

Theo van Gogh was brutally murdered Mohammed Bouyeri, the remorseless killer MP Aayan Hirsi Ali under police protection

an intellectual, informed by feminism and the avant-garde. The idea of curiosity as a drive to see, but also to know, however, still marked a utopian space in the cinema that might answer to the human mind's long-standing interest in puzzles and riddles.... I have...adapt[ed] Bellour's concept of the pensive spectator to evoke the thoughtful reflection on the film image now possible by seeing into the screen's images, stretching them into new dimensions of time and space. The pleasure in the fragment leads to the pleasure in the still itself.... Now, perhaps, the magical moment, perversely and paradoxically, comes with a reversal of direction: a new fascination comes into being when the moving image is stilled.[8]

There is almost no painting in Dumas's oeuvre without a traceable photographic source. Even her many references to and appropriations of films are recycled through the gathering of stills. When she addresses the privacy of death, she references image typologies including the first nineteenth-century post-mortem pictures, newsreels, journalistic photographs, and other public images of the dead that both proliferate in and are censored from our twenty-first-century gaze. What are the differences, she asks, in the experience of events from cultural positions that manage the news differently, conveying it and withholding it to varying degrees? We in the United States, for example, are not allowed to see photographs of dead American soldiers returning in coffins from Iraq. Culling from sources with editorial policies as disparate as *Al Jazeera*, *Time*, and *De Volkskrant*, Dumas has amassed hundreds of images of the dead on which she has based paintings that have a

place in her work equal to that of her portraits of the living. (Indeed, some subjects are almost brought back to life.) Identity becomes a construction as mutable as a faded Polaroid, and the acrid colors and murky shades of snapshots gone bad appear in both the flesh and the watery, almost amniotic environs of many of Dumas's suspended bodies. The artist's sensuous washes and brushstrokes return her excerpted subjects to the liquid realm of the photograph. It is as if she has painted them back to life while simultaneously reenacting the death implicit in the photographic moment. As witness to modern life, she returns the touch of the painter's hand to the symbolic.

The sources for the Man Kind series are images from both the news media and her personal collection of snapshots—headshots, really—of men who populate our visual memory and chart what Maria Hlavajova called the condition of fear in the West.[9] A composite of a Moroccan actor and a Palestinian martyr whose visage was lifted from a poster, *The Look-Alike* stares blankly at the viewer, and yet his face seems familiar. The tension in this work lies in the unsettling combination of the individual and the stereotype; the young man's flushed cheeks and full pink lips are sensuously accented with a birthmark—a mark of specificity that would be called a beauty mark on a girl but here might signify a swarthy appearance. Both *The Look-Alike* and *The Pilgrim* are richly colored and indelibly present. Often misunderstood as a painter of somber monochromes, Dumas beautifully renders translucent flesh in colors that speak directly to her complex sense of race and identity.

Left: Photograph from a *Newsweek* article, c. 2003, and source material for *Duct Tape*, 2002–05 (second stage)

Right: Clipping from the German magazine *The African Courier*, 2005, and source material for *The Neighbor*, 2005

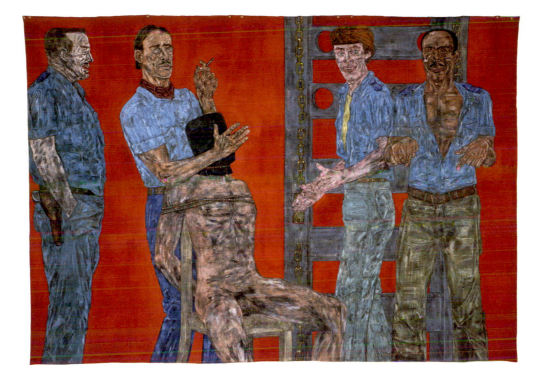

Another portrait from Man Kind, *Duct Tape* (2002–05), shows the torso of a hooded figure that recalls the photographs of Abu Ghraib prisoners widely circulated in the media in 2004. Constructed from almost flat planes of color derived from the vivid hues of the subject's jogging suit, the work's source is a photograph of a captured Palestinian blindfolded on a bus; the artist added the duct tape later.

Dumas painted the full figure in *Anonymous* (2005). While the source for this painting is a performer extracted from a Hermann Nitsch Actionist event, Dumas's painting is haunting and still—gone are the messy theatrics of bodies and fluids. The anonymous figure seems wilted by the dehumanizing experience of being rendered sightless, his body limp and seemingly crucified.[10] Like images of the territorial struggle in the Gaza strip, which for Dumas has yielded a constant stream of painful yet irresistible source material—mothers and sons, families divided, and generations of men in combat—the prurient images from Abu Ghraib are strangely anonymous and pale in color. The yellow lights of the prison interior at night, the way the news photos paint the Iraq desert an anemic beige: will Americans care about death in a land that appears lifeless?

Duct Tape's shrouded, presumably male victim serves as a foil to the head in *Skull (of a Woman)* (2005), also sightless and anonymous, yet dignified and silent. In fact, the painting was inspired by Charlotte Corday, the French revolutionary who assassinated Jean-Paul Marat in 1793 but whose life (and death) has remained much less renowned. (A photograph of the top of her skull inspired one of the works in Dumas's much earlier *Black Drawings* [1991–92].) This gaping skull in forensically detailed profile constitutes the one female presence in the Man Kind group, standing in for the countless women who have undergone much worse kinds of injury, including erasure from history. Here the artist seems to assert that women, even when they have been instigators of evil, are still the parenthetical gender in a world of men.

The traffic of images, the unabated ebb and flow of visual information, has now swamped our ability to distinguish reality from fiction, extract truth from a photograph. How do we recognize one another? The works of Time and Again, in their particular mix of references, enact the mobility of identities that fascinates Dumas. Another meditation on the dead, the series was exhibited at Zeno X Gallery in Antwerp in 2002 and shown again at the Art Institute of Chicago in 2003. Dumas's *Dead Man* (1988) appeared with a later work, *Dead Girl* (2002); their subjects were each based on young hijackers killed during a hostage situation, detailed in a newspaper clipping Dumas had saved for twenty years. In the present context of female terrorists and suicide bombers, one might read the dead girl

Tina, 2006; oil on canvas; 43 $^5/_{16}$ x 51 $^3/_{16}$ inches; private collection, New York

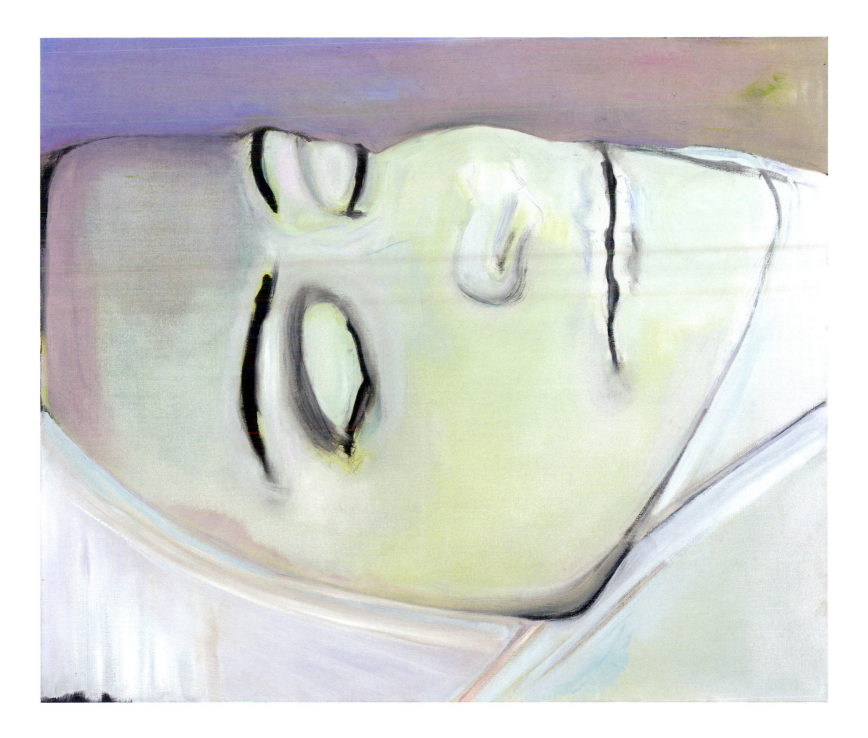

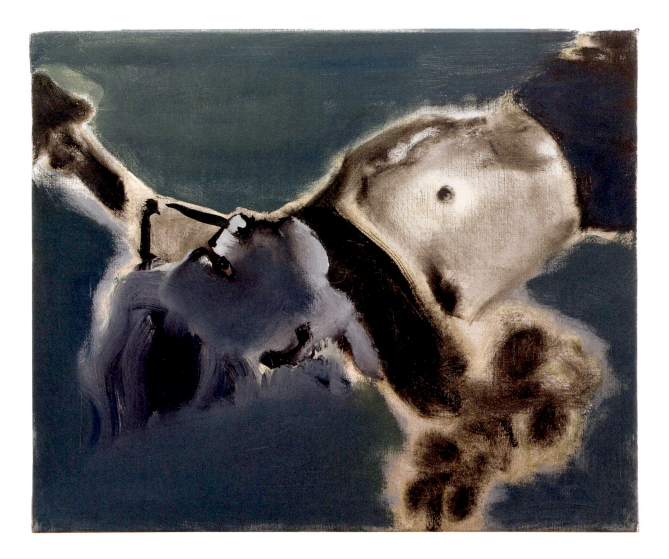

Dead Man, 1988; oil on canvas; 19 11/16 x 23 5/8 inches; private collection

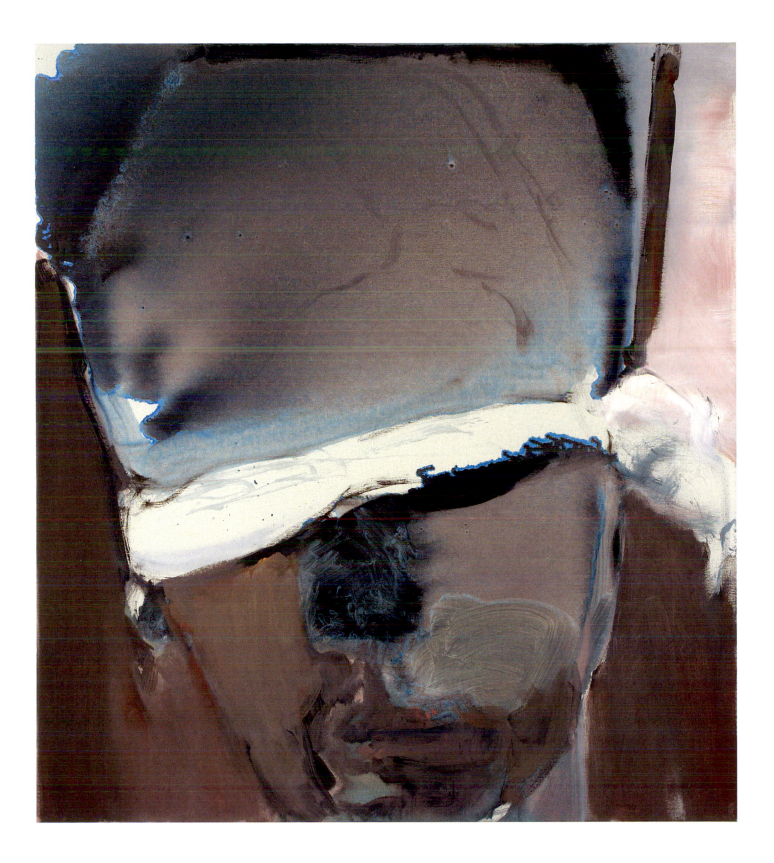

The Blindfolded Man, 2007; oil on canvas; 39 3/8 x 35 7/16 inches; courtesy the artist and David Zwirner, New York

differently, and this slippage of victims and perpetrators, bodies and images, is critical to the way meaning functions in the paintings' open-ended system. Johan Grimonprez's *Dial H-I-S-T-O-R-Y* (1995–97), a work Dumas admires, deals with this relativity of cultural reactions to violence and changes in the reception of media images by presenting an avalanche of footage from hijackings of the 1970s set to disco music, a soundtrack that makes these particular episodes seem more quaint than horrific. Mediated by information, the physical realities of both public and private life are silhouetted, disintegrated, inaccessible, and can be understood only through representation. We have become addicted to the aural and visual tracking of live experience and immune to a lived relationship with time and the kinesthetic reality of what it means to exist in our own bodies. In her famous treatise *On Photography* (1973), read by Dumas as well as a generation of young artists coming to terms with the photographic image and its hold over our attention, Susan Sontag wrote of the vulnerability of the viewer as witness:

> Like a pair of binoculars with no right or wrong end, the camera makes exotic things near, intimate; and familiar things small, abstract, strange, much farther away. It offers, in one easy, habit-forming activity, both participation and alienation in our own lives and those of others— allowing us to participate, while confirming alienation. War and photography now seem inseparable, and plane crashes and other horrific accidents always attract people with cameras.... One is vulnerable to disturbing events in the form of photographic images in a way that one is not to the real thing.[11]

Dumas herself has made reference to Sontag's more recent essay "Regarding the Torture of Others" (2004), in which the writer examined the public's reception of the Abu Ghraib pictures. When reconsidered today, four years later as the Iraq war rages on, the text functions as an admonition, warning the reader not to forget those pictures, their subjects, or their authors. "To live is to be photographed, to have a record of one's life, and therefore to go on with one's life oblivious, or claiming to be oblivious, to the camera's nonstop attentions. But to live is also to pose. To act is to share in the community of actions recorded as images."[12] It is the implied resolution of the still photograph—the permission or closure that it gives the viewer in relationship to the recorded event or moment—that Dumas seeks to disturb, deeply. It is as if the indelible realness of her early experience in a situation of trauma, the whitewashing of political unrest, has haunted her desire and ability to craft a painting practice that flaunts an emotional realism even as it participates in a conceptual and strategic relationship to photographic distancing.

Giving Up My Tail for Legs: Early Career

During the late 1960s, when artists of the postmodern period were beginning to subject the mediated image to radical examination, Dumas was a teenager exploring her own aesthetic and political allegiances. South Africa was under a media blackout during the Vietnam War— television came to South Africa in 1976, the year of the Soweto uprising—but Dumas had already begun to make journals of both found images and those she made herself. In *Miss World* (c. 1963), which also provided the title for a 1989 exhibition at Galerie Paul Andriesse, bikini-clad girls line up for a beauty pageant; the drawing reveals a kind of proto-feminist consciousness of the ways in which female identity is shaped by the media. The concerns and composition of this drawing turn up twenty years later in *Exotic Lingerie* (1983) and *We Were*

All in Love with the Cyclops (1997), though the subjects have become coy naked pin-ups that flirt with the camera and the viewer. In between, a lovely drawing inspired by Hans Christian Andersen's Little Mermaid is a self-portrait of sorts in which a mermaid loses her innocence. In the original fairytale (as opposed to the Disney version), the mermaid trades her fins for legs but in return gives up her voice and, with it, the ability to declare her love. *Mijn staart voor benen (Giving Up My Tail for Legs)* (1979–80) and the related drawing *Gesluierde vrouw (Veiled Woman)* (1982) play with this allegory to depict the artist's own personal and political transformation.

The uneasy marriage of the personal and political that ignited the feminist movement in the West during the 1970s is where the tension has resided in Dumas's work throughout her career. *Drie vrouwe en ek (Three Women and I)* (1982), a collaged drawing typical of the artist's oeuvre during these years, is an homage to Winnie Mandela, then-wife of Nelson Mandela; Betty Shabazz, wife of Malcolm X; and Pauline Lumumba, who walked bare-breasted through the streets in mourning for her slain husband, Congolese prime minister Patrice Lumumba, a voice of the anti-colonial Pan-African movement, Dumas was interested in capturing the private grief of these women, and her resulting work is an antecedent to her representations of women murdered for political reasons. The collage *Couples* (1978) treats mythologized couples such as Simone de Beauvoir and Jean-Paul Sartre with a sly humor that Dumas often applies to themes of sexuality and sexual identity. For the minimalist *Don't Talk to Strangers* (1977), the artist excerpted love letters, both real and made up. Anticipating Sophie Calle's works centered on a breakup with a real or fictitious lover or Tracey Emin's *Everyone I Have Ever Slept With* (1993–95), Dumas played with a diaristic approach, exploring both formal possibilities and conceptual text-based art-making to arrive at the work's reductive format. She was particularly interested in the rupture between the personal realities and the public identities of women,

in gender and the feminine as mediated and controlled by images. Journal entries from Dumas's youth reveal conflicted feelings about the sexism in South African society. How to navigate the hegemonic history of painting and its oppressive relationship to her own desires as a young artist? Can one paint and be political at the same time? "There has to be a way to make an art about being in love,"[13] she said years later, articulating her early experiments with content and form.

Dumas's flirtation with the strategies and politics of Conceptual art and the formal tropes of Minimalism and Process art between 1976 and 1983 is worth highlighting briefly because they trace the struggles of a young artist aesthetically educated primarily through reproductions of works of art and at a distance from capitals of art production. Sketchbook pages and documentary snapshots record experiments such as *Sculpture in a Landscape* (c. 1973), a "sculptural event" staged in Cape Town outside Michaelis School of Fine Art involving a melting block of ice and lots of discussion over the course of a day. *Sculpture to Keep the Walls from Falling Down* (1974) comprised four corners of the exhibition space slathered with grease. In some ways typical art-school provocations of the time, these projects also

Opposite: *Mijn staart voor benen (Giving Up My Tail for Legs)*, 1979–80; colored pencil on snakeskin-patterned paper; 44 7/8 x 39 3/8 inches; partially destroyed

Above: Notes and images on the assassination of Dr. Martin Luther King from Dumas's image bank

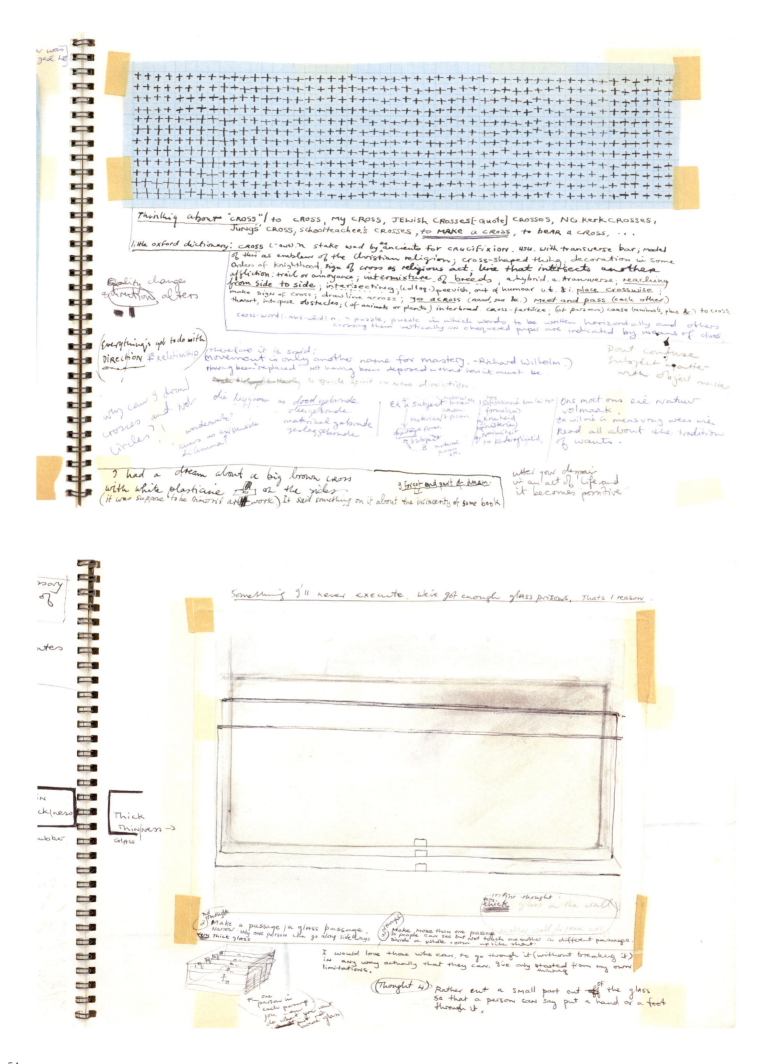

Thinking about "CROSS"/ to CROSS, my CROSS, JEWISH CROSSES[quote] CROSSES, N.G. Kerk CROSSES,
Jungs' CROSS, schoolteacher's CROSSES, to MAKE a CROSS, to BEAR a CROSS, ...

little oxford dictionary: CROSS (-aws).n. stake used by *ancients for crucifixion. *su. with transverse bar; model
of this as emblem of the Christian religion; cross-shaped thing, decoration in some
orders of knighthood, sign of cross as religious act. line that intersects another
affliction; trial or annoyance; intermixture of breeds, a hybrid. a. transverse, reaching
from side to side; intersecting; (colloq.) peevish, out of humour v.t. & i. place crosswise;
make sign of cross; draw line across; go across (road, sea &c.) meet and pass (each other)
thwart, interpose obstacles; (of animals or plants) interbreed. cross-fertilize. (of persons) cause (animals, plants &c.) to cross

cross-word (-aws-waid) n. ~ puzzle, puzzle in which words to be written horizontally and others
crossing them vertically on chequered paper are indicated by means of clues

Quality changes
a direction alters

Everything's got to do with
DIRECTION & Relationship

therefore it is said:
Movement is only another name for mastery. —Richard Wilhelm.)
Having been "replaced" not having been deposed — that how it must be

to guide spirit in new direction.

Don't confuse
subject matter
with object matter

why can I draw
crosses and not
circles?!
undercuts?
knows as existential
dilemma?

die liggaam as doodgebonde
- vleesgebonde
materiaal gebonde
geslaggebonde

Ek 'n subject materiaal
 binding
 Materiaal + persoon

objectiewe form

S subject
B materiaal
 ek.

Sofistikasie van leiter
formalism
krankheid
histerie
naïwiteit
to kinderagtigheid

Ons moet ons eie Natuur
volmaak.
Ek wil nie in mensvorm wees nie
Read all about the tradition
of wants.

I had a dream about a big brown cross
with white plasticine on the sides
(it was suppose to be maurits's art work) It said something on it about the incinerity of some book.
I forgot end part of dream.

After your despair
in an act of life and
it becomes positive.

Something I'll never execute. We've got enough glass prisons. Thats 1 reason.

in
ck(ness
ubber

Thick
Thin/ness →
GLASS

(1) First thought
thick glass in the wall

1st thought
Make a passage / a glass passage.
Narrow only one person can go along sideways
thick glass

(thought)
Make more than one passage another wall to have a wall
so people can see but not touch one another in different passages
Divide a whole room up like that.

I would love those who can, to go through it (without breaking it)
in any way actually that they can. I've only started from my own
limitations.

(Thought 4) Rather cut a small part out of the glass
so that a person can say put a hand or a foot
through it.

one
person in
each passage
you never can
do what you can't
cracked glass

belie an early political sensibility, albeit one embedded in a Minimalist formalism, that calls to mind later charged yet equally reductive works like Mona Hatoum's *Hot Room* (1993). They also evince Dumas's repeated attempts to resist the historical legacy of painting and the stylistic overkill of those she has referred to as the "big artists," her 1980s Neo-Expressionist contemporaries. Like works by Belgian artist Luc Tuymans, with whom she is often compared but whose palette and approach to mark-making differs significantly, Dumas's paintings are products of the contemporary image world—that is, they are drawn directly from the events of our time, abstracted to resonate in content and form. What is striking about her works made roughly between 1975 and 1979—first shown in Paris in 1979 at Galerie Annemarie de Kruyff and then in 1983 in "Unsatisfied Desire," her first exhibition at Paul Andriesse's gallery (then called Galerie Helen van der Meij) in Amsterdam— is the profound imprinting of South Africa's racial politics. That legacy was cycled through her anti-image/ anti-object Conceptual art experiments as part of a struggle to find a medium that might join the power of her subjects with her desire and ability to make beautiful marks and moving painterly statements.

After a five-year break from painting between 1979 and 1984, during which she primarily made works on paper and completed a year of study at the Psychological Institute in Amsterdam, Dumas returned with the break-through body of work the Eyes of the Night Creatures, exhibited at Galerie Paul Andriesse in 1985. The series weaves together her history in South Africa, a place of great personal nostalgia and searing political memory, and her presence as an emerging artist participating in the international discourse of painting during the 1980s.[14] While portraits of friends and family by artist peers Chuck Close, Eric Fischl, Alex Katz, and Alice Neel, or even those by spiritual mentors such as van Gogh, may approach their subjects within the frame-work of humanism, Dumas's work adds a dimension of watchfulness and menace. The "eyes" of the title refer both to the startling eyes of a group of raccoons in a source image and to the direct gazes of the sixteen portraits, all frontal, almost all female. The paintings

are roughly square (approximately fifty-one by forty-three inches), a favorite format of the artist that harkens back to the exquisite courtly portraits of Frans Hals and other seventeenth-century predecessors and distinguishes them from the work of many of Dumas's contemporaries. The pictures do not foreground their own scale as a means of accessing content. Their format and the uneasy way the heads barely fit into the frames inspired her to experiment with their hanging—the faces become the landscape. Looming high above the viewer, the haunting creatures hover in a mural-size space of almost filmic proportion. Two large diptychs (coupled self-portraits) from this group, *The Space Age* and *Occult Revival* (both 1984), are vertical and extend the space of painting into some other phenomenological realm, confronting the viewer with a boldness that seeks to share, if not threaten, both physical space and the space of memory. Their titles and color may hint at the subjects' relationship to the artist but obscure it at the same time; Dumas's titles are often playful or oblique and her paint handling frequently radically alters, even obliterates, her subjects' identities.

Dumas's three Martha paintings (all 1984) honor the artist's grandmother by representing her and others who share her name. The women represented in this group constitute the artist's personal constellation of philosophical and literary matriarchs. Dumas described *Martha—my ouma* as being as imposing as a portrait of God as a woman[15]; *Martha—die bediende* pictures a domestic worker employed for a time by Dumas's mother; and *Martha—Sigmund's Wife* signals the lineage of women to whom the artist feels some intellectual and spiritual kinship. Each Martha is of a different cultural origin; the model for *Martha—die bediende* in particular emblematizes the problem of identity in South Africa—she adopted the name because her given African name was too hard for whites to pronounce. Names and naming, as part of the problem of language, are the subjects of these works and a preoccupation for Dumas. This early collection of women is both a loving homage to and an exorcism of her motherland. It also looks forward to a much more complex understanding of personal identity and artistic allegiance,

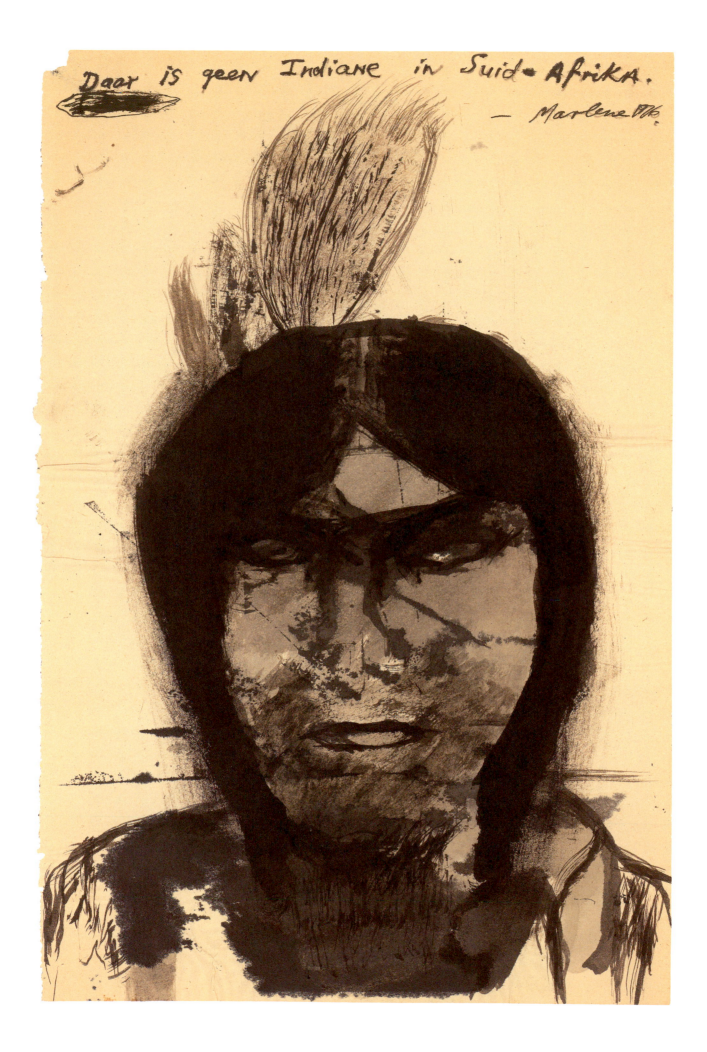

Daar is Geen Indiane in Suid-Afrika, 1976; ink on paper;
14 3/4 x 9 13/16 inches; collection of the artist

58

Untitled, 1976, details; ink on paper; twenty-two sheets:
14 3/4 x 9 5/8 inches each; collection of the artist

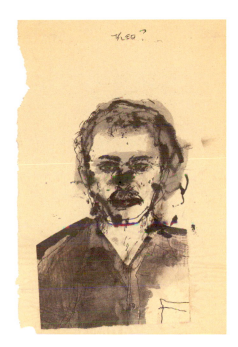

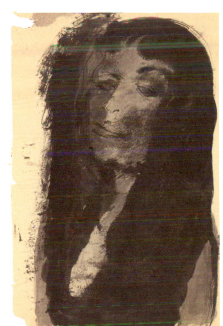

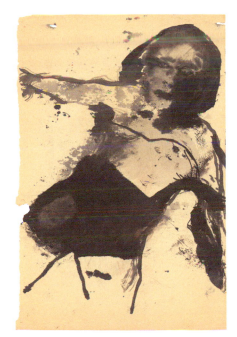

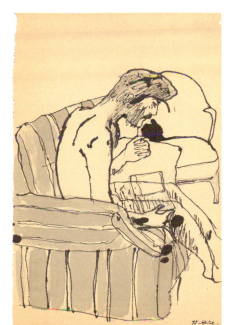

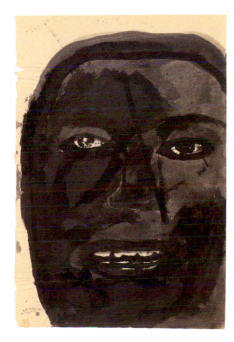

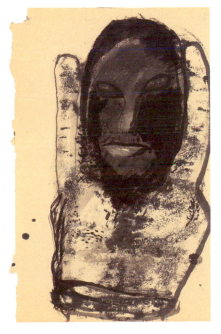

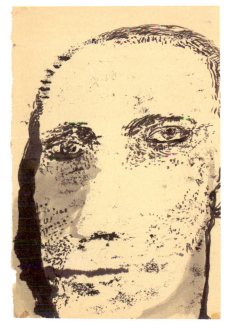

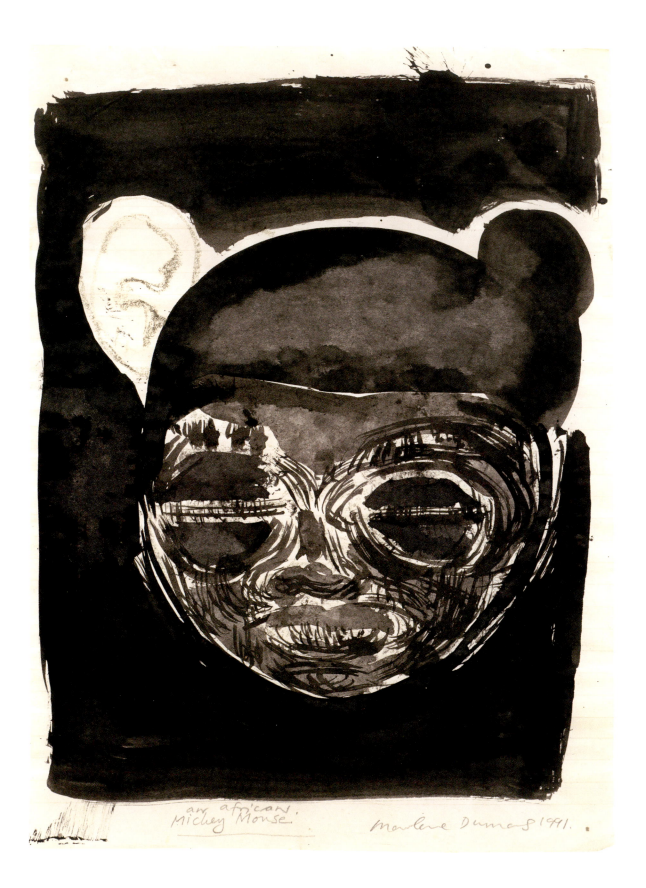

An African Mickey Mouse, 1991; ink on paper; 11 7/$_{16}$ x 8 1/$_{4}$ inches; private collection, courtesy Galerie Paul Andriesse, Amsterdam

Drie Vroue en ek (Three Women and I), 1982; mixed-media collage; 82 11/$_{16}$ x 51 3/$_{16}$ inches; Museum voor Moderne Kunst Arnhem/Instituut Collectie Nederland

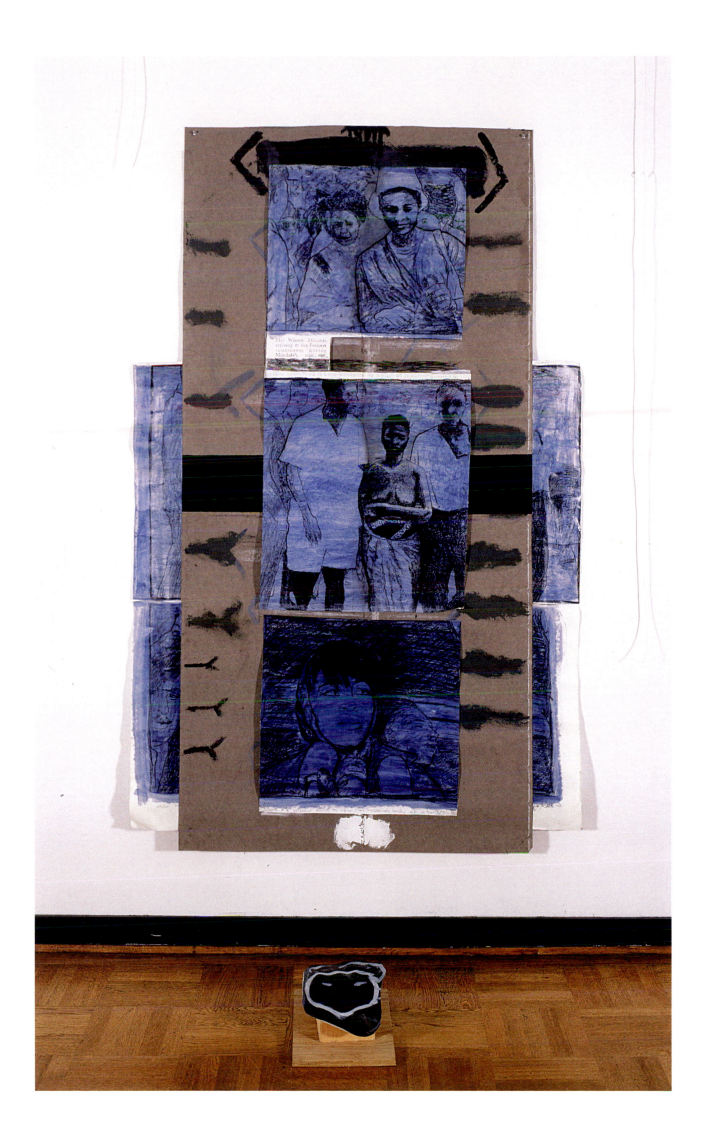

brought full circle in the artist's carefully orchestrated publication in conjunction with her retrospective exhibition "Marlene Dumas: Intimate Relations," held at Iziko South African National Gallery in Cape Town in 2007 and the Standard Bank Gallery, Johannesburg, in 2008.

The painting from the Eyes of the Night Creatures most often discussed is Dumas's self-portrait *Het Kwaad is Banaal (Evil Is Banal)* (1984). Rendered as a chalky white face with an orange shock of hair, the artist looks beguilingly out into the distance, just past the viewer's gaze. Together, *Het Kwaad is Banaal* and what may be the tour de force of the group, *The White Disease* (1985), pointedly address the symbolic power of race and the delicate conditions of ethnic identity and intolerance, conditions that perhaps more than any other have epitomized evil in the twentieth century. *Het Kwaad is Banaal* seems to anticipate Jean Baudrillard's idea of the "transparency of evil," both in its spirit and in its warning of the late-twentieth-century global outbreak of racial and religious hatred. Indeed, the transparency Dumas attains by using translucent paints and watercolors to render skin in thin multicolored layers is a metaphor for the covering and exposure of evil. Though actually quite bluish, as if stained by a dirty purple hand, the lily-white self-portrait belies a certain kind of white affliction: the damning complicity that binds every white person in South Africa to the legacy of apartheid.[16]

Based on a medical headshot of a woman suffering from an affliction of the skin, *The White Disease* makes an interesting companion to *Albino* (1986), which presents a negroid albino man. There is a sickly green cast to his chalky skin, so that the skin itself becomes a metaphor for race—the underlying tinge of color reveals itself in spite of the pale complexion, signaling a layer of identity independent from surface appearance. No one escapes their own skin. In both *Het Kwaad is Banaal* and *Albino*, the subjects appear watchful yet vulnerable; like the Invisible Man, both seem on the verge of disappearing into themselves, a sense conveyed by the thickening of the paint on the images' surfaces

and the mask-like quality of their sunken gazes. While the young woman of *Het Kwaad is Banaal* guards her affliction, the damage is exteriorized in *The White Disease*. Her piercing blue gaze recalls the hollow and terrified eyes of the concentration camp victims in the ethnic cleansing commemorated by Dumas in another haunting image of existential human longing, *Liberation (1945)* (1990). (See also *De bevrijding (The Nuremberg Trials)* [1990].)

During the late 1980s, Dumas elaborated her exploration of identity in group portraits, exhibiting them at Galerie Paul Andriesse in 1987 as "The Private versus the Public." In that presentation, group portraits of children and adolescents were juxtaposed with several large and striking images of men. Looming intentionally close to *The Turkish Schoolgirls*, for example, was Dumas's first attempt at the male nude, *The Particularity of Nakedness* (both 1987), a gentle portrait of her lover, rendered languidly horizontal with a gaze that meets that of the viewer. Much less anonymous and menacing than the groups of children, he is very much alive and present, inviting the viewer to take in his form. For her group portraits, Dumas again drew on iconic images from another time. *The Teacher (sub a)*, *The Teacher (sub b)*, *The Turkish Schoolgirls*, and *The Schoolboys* (all 1987) are psychologically charged images of childhood and adolescence. The all-white faces of the Teacher paintings, again not so much lily white as eerily red, blue, orange, or chalky white, are those of the artist's childhood. Another, more distant reference for Dumas is South African artist Irma Stern's early painting *The Eternal Child* (1916). The piercing stares of Dumas's schoolchildren, their clusters of white knees and little black ties, are described by a tight network of brushstrokes. Writing about these class pictures, Ulrich Loock described the act of double representation performed by Dumas—the painting of the subject and the self-conscious portrayal of a type of picture which is virtually universal:

> This being-seen-through-the-lens-of-the-camera is painted into the picture of a school class posing for the photographer. The point is not that the arrangement of the subjects,

their physical posture, the direction of their gaze should unmistakably demonstrate that this is a painting after a conventional class photograph; rather we are confronted here with the representation of the photographic essence of the picture. The consequences of a photographic approach to the world—the thingness, the accessibility of what is photographically grasped—have been painted into this picture.[17]

These are truly disturbing pictures in no small measure because they comprise what Loock called "painting in order to implement and undermine the photographic flatness of the world."[18] Here again, Dumas painted to resist, to comprehend, and to insist upon, for herself and for her viewer, the knowledge of what is not laid bare by the photograph.

Waiting for Meaning

What Dumas's experiments in representing groups seem to have yielded for the artist is a fascination with the mechanics of the gaze, a central concern in any discussion of portraiture. As the little children stare out chillingly, some reckoning must pass between the viewer and them. Their group psychology, the scrutiny in their stares, becomes emblematic of the power relationships built into the acts of viewing and being viewed. There is also some rejection of structure and control, two basics of conventional academic education and certainly fundamental tenets of painting. This dynamic is played out further in later paintings that are almost allegories of viewing, such as *Group Show I* and *Group Show II* (both 1993), images of naked people huddled around some spectacle just outside our view. Who is doing the viewing here? Are the viewers the naked spectators of the "group show," the bane of most artists' careers? Or are the viewers themselves the ones on view? (Another work, *Hell (The People of the Artworld in Monet's Lake of the Searoses)* [1987–90], brings home the point.) The theme culminates spectacularly when it returns to the realm of gender and

the construction of female modes of beauty in *Models* (1994), a magnificent group of one hundred drawings.

Reflecting on the status of painting in the 1980s with the goal of reintroducing content intact, Dumas introduced her own crisis of representation with the following preamble:

> There is a crisis with regard to Representation.
> They are looking for Meaning as if it was a Thing.
> As if it was a girl, required to take her panty off
> as if she would want to do so, as soon as the true
> interpreter comes along.
> As if there was something to take off.[19]

The paintings *Waiting (For Meaning)* and *Losing (Her Meaning)* (both 1988) are pivotal in terms of unpacking the problem of the female body. Introducing *Waiting (For Meaning)*, Dumas declared, "After having used confrontational and frontal compositions for a long time (the big eyes and faces), it was time to turn the gaze away."[20] Time, she claimed, to move from faces to bodies. The work is a raw and starkly painted picture of a lanky black body stretching or resting on some kind of raised bed or sepulcher. Though one might assume it is female in its nakedness, it is sexless and unidentifiable, somehow stripped not only of its identity but its life. It is, one might imagine, a hide.[21] Borrowed from a 1970s David Hamilton photograph of a nubile pubescent girl, the borderline-pornographic imagery evokes the limp bodies associated with 1990s "heroin chic." The artist was struck, as she often is after the fact, when another latent reference later surfaced in a Henri de Toulouse-Lautrec drawing *Alone* (1896), which depicts a woman in black stockings in a similar pose.

This study in dark and light was further explored in a heavily worked and conceptually complex group of paintings that includes *Snow White and the Broken Arm*, *The Guilt of the Privileged*, *Snow White in the Wrong Story* (all 1988), and *The Ritual* (1988–91). While Snow White has often been written about as referring autobiographically to the artist's ethnicity and her specific experience of privilege and whiteness in South Africa, the titles in fact relate to her early work in a mental-health facility.

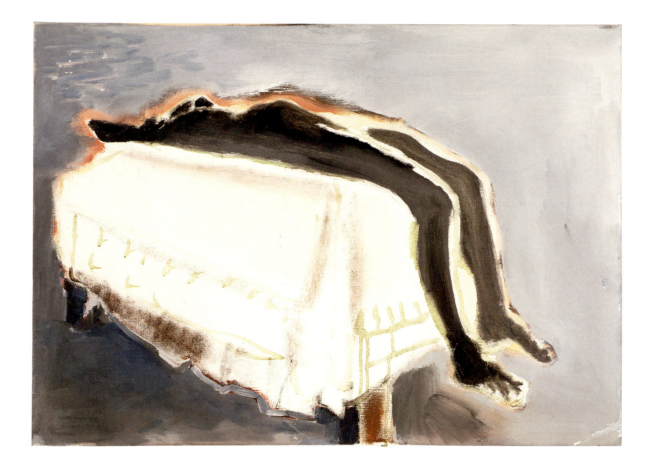

Waiting (For Meaning), 1988; oil on canvas; 19 11/16 x 27 9/16 inches; Kunsthalle zu Kiel, Germany

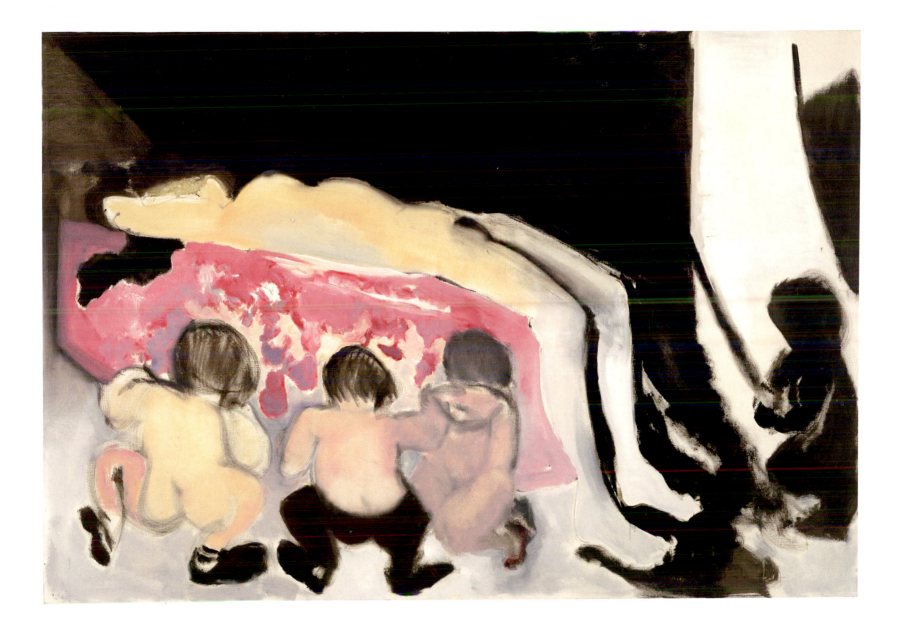

Snow White and the Next Generation, 1988; oil on canvas; 55 ¹/₈ x 78 ³/₄ inches; Centraal Museum, Utrecht

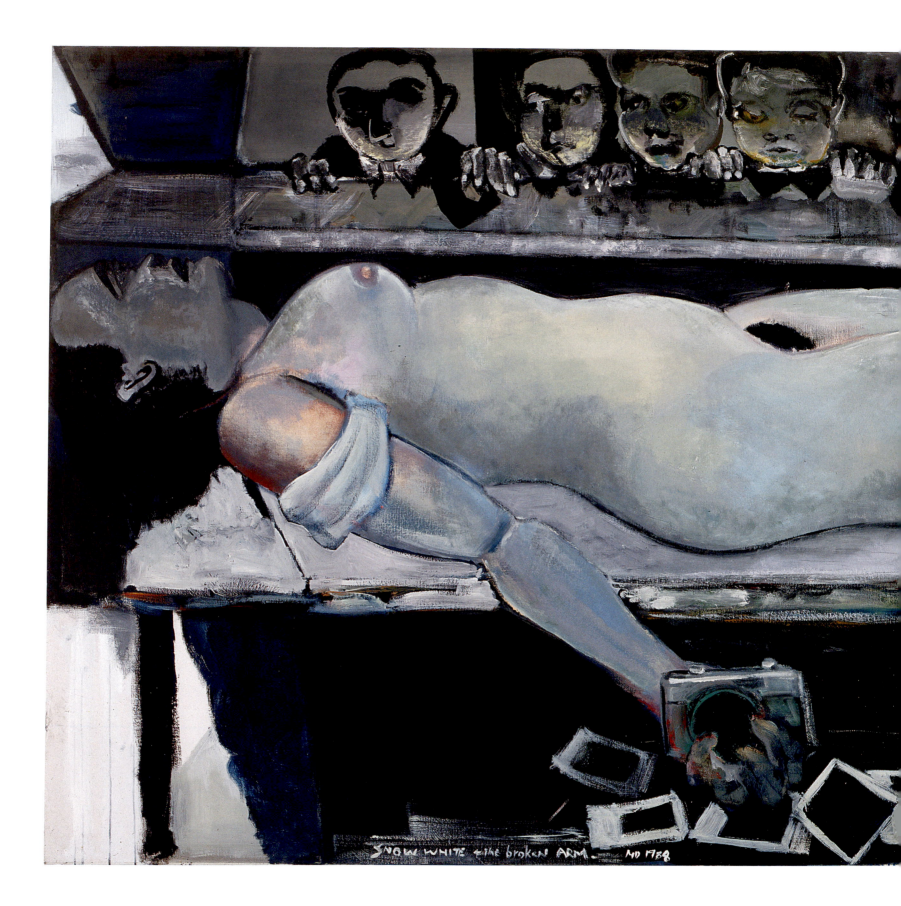

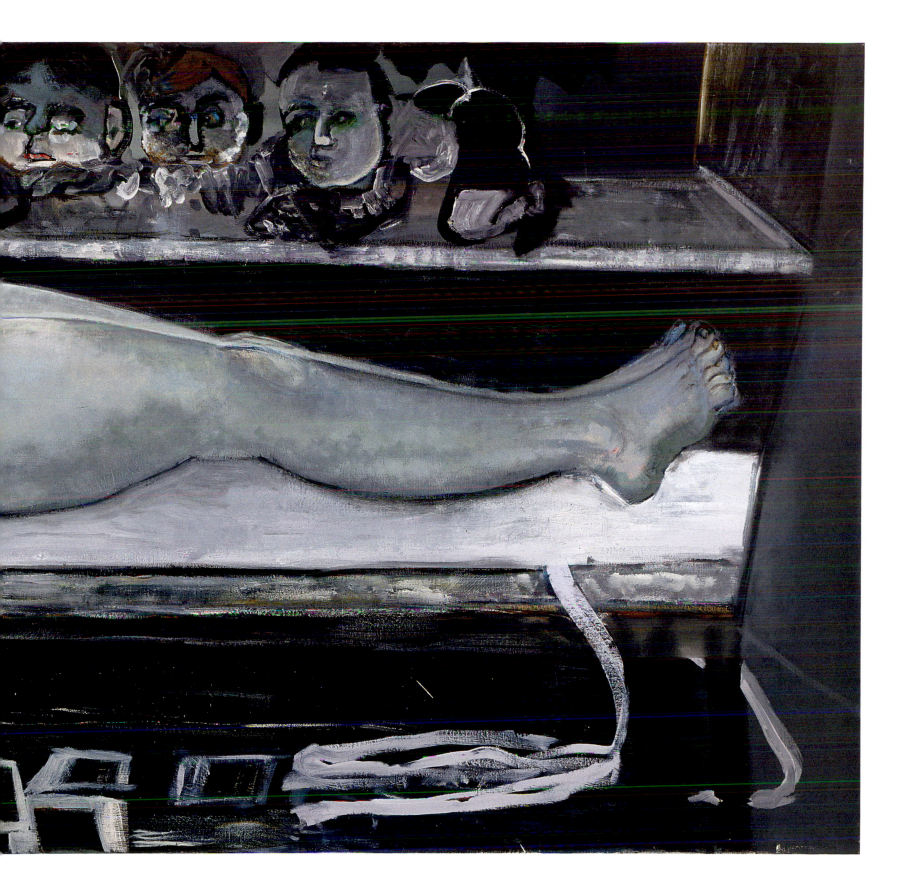

Snow White and the Broken Arm, 1988; oil on canvas; 55 1/8 x 118 1/8 inches; Gemeentemuseum, The Hague

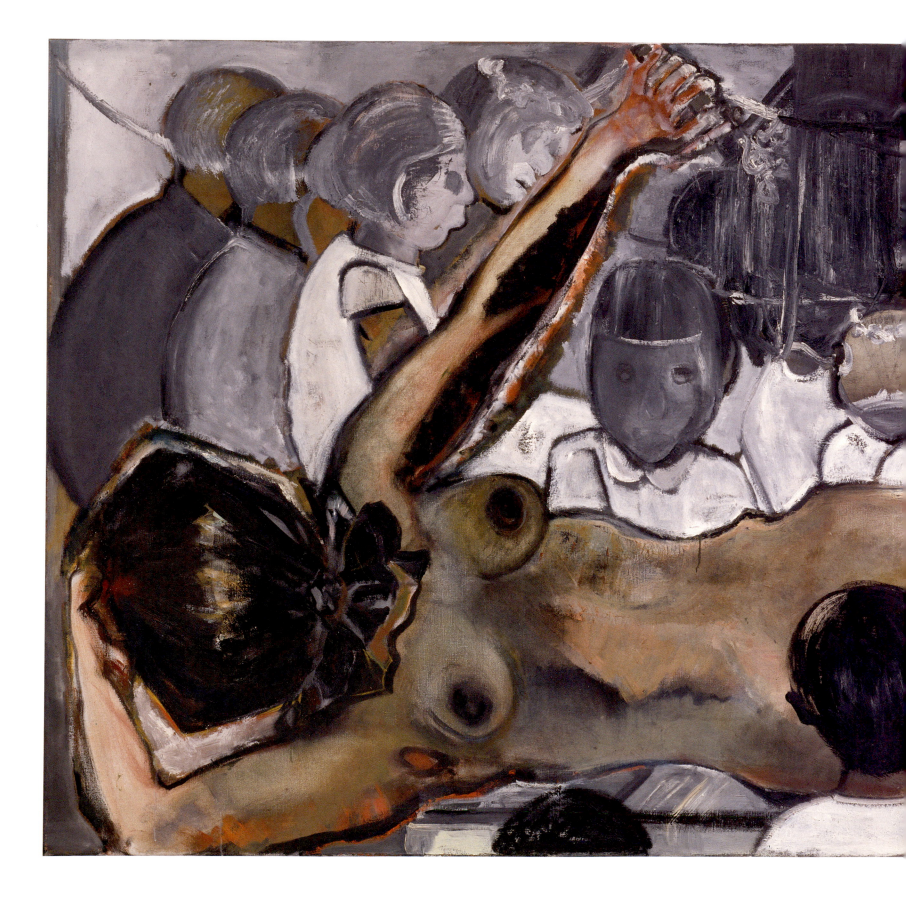

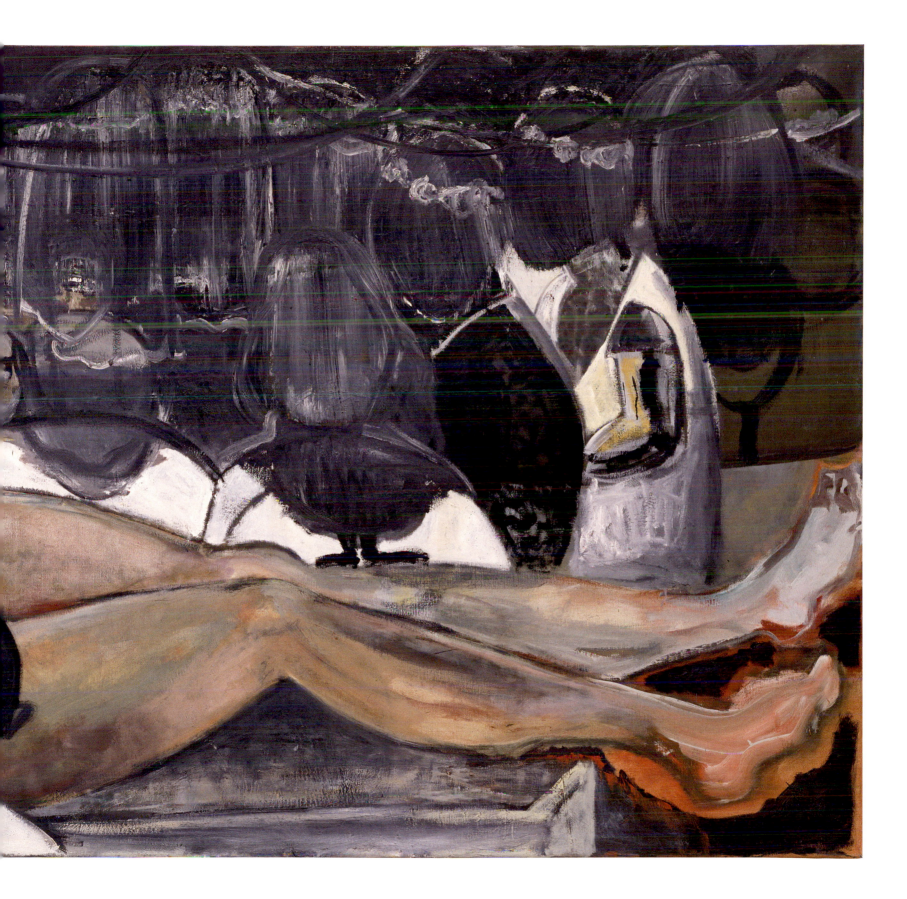

The Ritual, 1988–91; oil on canvas; 55 1/8 x 118 1/8 inches; Musées de la Ville de Strasbourg, France

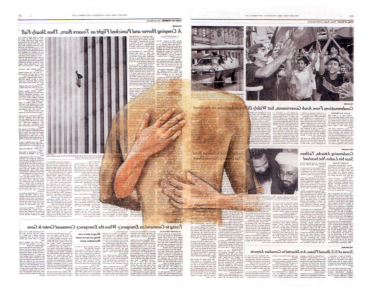

Portraiture, Pain, Politics, Painting, and Back Again

Democracy came to South Africa in 1994; apartheid, the form of government that had made segregation and racial violence a way of life in that country, officially ended with elections that year. Dumas had been living in Amsterdam for over fifteen years, having moved there to study. She was by then an established member of a generation of European artists—including René Daniëls, Juan Muñoz, Thomas Schütte, and Rosemarie Trockel—that emerged during the late 1980s. She had also exhibited widely at European venues including Documenta VII in Kassel, Germany, in 1982. However, during the 1990s Dumas's reputation in the United States was still in a nascent stage. She came to attention there beginning in 1991, when she was included in "The Interrupted Life," a group exhibition "exploring the theme of death in the Western World" at the New Museum of Contemporary Art, New York, which also included Nayland Blake, Sophie Calle, Sarah Charlesworth, Jimmie Durham, Peter Greenaway, Mona Hatoum, Andy Warhol, and David Wojnarowicz, among others. Her first one-person museum show—"Miss Interpreted," organized by the Van Abbemuseum, Eindhoven, the Netherlands, in 1992—traveled to the Institute of Contemporary Art, Philadelphia, in 1993. Her first solo gallery show in the United States, "Not From Here," took place at Jack Tilton Gallery, New York, in 1994. While her work steadily found a receptive American audience eager for a return to content and subjectivity after overindulging in the market-driven commodity fetishism of the 1980s, her provocative representations of race and sexuality were filtered through the same critical backlash that met the so-

called political biennial at the Whitney Museum of American Art, curated by Elisabeth Sussman in 1993, and the identity politics that led to that museum's "Black Male: Representations of Masculinity in Contemporary American Art" organized by Thelma Golden in 1994. Dumas's work was popularly understood to be all about sex and skin.

Also significant to the reception of Dumas's work was the AIDS crisis, which played out in the art world in many ways, such as in the government-sanctioned censorship of Robert Mapplethorpe's homerotic photographs. This was also a context, however, in which both male and female artists and critics were dealing in more complex and often subtle ways with the embedded cultural politics of the situation. In the catalogue that accompanied "Black Male," bell hooks highlighted the racism inherent in a range of responses to Mapplethorpe's images of black men, both from detractors and admirers.[22] And in her introduction to the Whitney Biennial catalogue, Sussman discussed Robert Gober's *Newspaper (The Serious Bride)* (1992), a sculpture comprising stacks of handmade newspapers bundled with twine, the topmost paper on the pile featuring an image of the artist wearing a wedding gown under the headline "Vatican Condones Discrimination Against Homosexuals":

Left: Robert Mapplethorpe, *Bob Love*, 1976; gelatin-silver print; 16 x 20 inches; Robert Mapplethorpe Foundation, courtesy Art+Commerce

Right: Robert Gober, *Untitled*, 2005; photolithography on acid-free paper with pastel and graphite; 22 x 26 1/2 inches; courtesy of the artist and Matthew Marks Gallery, New York

I consider Gober's newspapers paradigmatic of the 1990s. For although sexual, ethnic, and gendered subjects motivate the content of recent art, these identities fragment but do not destroy the social fabric.... Hence the Gober newspapers are also a record...of the everyday: of the communities and the individuals which make up those communities, the economic, environmental, and political struggles of our time.[23]

What interests me in Sussman's description is the notion of a quiet yet fervent recycling and deciphering of the mediated images of our time to understand and somehow account for everyday lived experience. The kind of archiving of news images that Gober continued with his 9/11 project of 2005 surely compares to Dumas's obsessive, largely unsystematic culling of images as sources for her paintings. Leaving aside for the moment her aesthetic relationship to photography and casual practice of taking Polaroid photographs as visual and formal notes for her paintings, it is important to decipher this initial impulse to collect and sort and re-sort images from the news. In his powerful body of work on the 9/11 tragedy, Gober made photolithographs of newspapers published immediately after the destruction of the World Trade Center towers and layered on top of their searing images delicate renderings of embracing bodies. These fragile forms counter the smothering violence of the news pictures in startling ways: as we attempt to comprehend the destruction behind them, we are slowed down by the erotics of comfort and reverie superimposed on them, simultaneously horrified by our own prurient need to see horror and touched by the artist's simple gesture of preventing this from happening. His gesture restores the viewer's power to understand him- or herself as witness rather than as passive receiver of visual information.

If Gober's newspaper stacks and collages involve an attempt to reinsert the personal into a numbing proliferation of media images that voraciously yet inadequately document violence and inhumanity, Dumas's erotic paintings and drawings reflect an effort to literally reposition anonymous characters and acts in order to

disturb our own projections and fantasies of sexuality, birth, and death. Gleaning from the numbing vapidity of pornography whatever residual trace of eroticism and emotionality is left there, Dumas restores meaning to the acrobatics of the pornographic body. In 1993, noting that her subjects are female bodies other than her own, critic Ingrid Schaffner asked, "Is Dumas's pornography critical or collaborative?"[24] It is both. Like Gober, Dumas seeks to recuperate in her viewer, in the public, a sense of the raw violence and physicality of bodily existence, the nakedness of life, sex, birth, and death. Reminiscent of the Act Up slogan "Silence=Death," Dumas has often said that painting is about the silence of death or the picturing of death or the unknown; in her practice, she has been committed to confronting what it means to address the present political reality.

If God Were a Woman

One of Dumas's primary tools is a color Xerox machine—one often returns from visiting her carrying oversized reproductions of vivid images or articles that tend to linger in the mind, papering one's floor much as they do in her studio. The lurid mechanical color of these Xeroxes immediately declares itself as one source of Dumas's palette (much as the blurs in Gerhard Richter's representational pictures declare their origin in photography). Looking through them, what is striking is that the artist is interested not only in the political issues at stake but in their visual tricks and tropes, the lexicon through which we read them. Dumas banks form and content, medium and message. The reading is complicated and it is the difficulty, the stumbling, that interests her.

Among the articles and clippings in the artist's archive is one from *Newsweek* titled "Women of Al Qaeda," the opening line of which reads, "Very little is known about the first woman to become a suicide bomber for Al Qaeda in Iraq, except that she dressed as a man."[25] As an average Western reader, I am struck by how little I know about Middle Eastern countries whose names and regions run together in my mind. How imperialistic is my lack of focus? Reading "Women

NOTES

The author extends her appreciation to David Frankel for his early editorial advice.

1. Leon Golub, interview with David Levi Strauss, "Where the Camera Cannot Go: A Conversation with Leon Golub on Painting and Photography," in *Between the Eyes: Essays on Photography and Politics* (New York: Aperture, 2003), 144.

2. Marlene Dumas, email to the author, 12 December 2007. Dumas wrote, "Art-wise, since the 1950s everyone interested in modern art looked up to New York. As I once wrote, 'My mother thought art was French, because of Picasso.' I thought art was American, because of *Artforum*. Yet I did not go to New York to study in 1976 because I was too unsure of myself, but ALSO because it reminded me too much of South Africa. It was not because I had such high principles; it was more intuitive, maybe.... America's racial past (and present) and differences between rich and poor. For me, Amsterdam stood for a freer, more tolerant society."

3. Dumas, in Maria Hlavajova, "'Ik is een allochtoon': A Conversation with Marlene Dumas," in Rosi Braidotti, Charles Esche, and Hlavajova, eds., *Citizens and Subjects: The Netherlands, For Example* (Zürich, Switzerland: JRP/Ringier; and Utrecht, The Netherlands: Basis voor actuele Kunst, 2007), 111–12. The inclusion of Dumas in this anthology is telling in terms of the way her paintings have been perceived in the Netherlands as contributing to the political discussion there. Like Aernout Mik, she is seen as an artist whose work addresses global politics and the discourse around race, specifically the relationship between Islamic and Dutch cultures. It is partly my desire here to resituate Dumas's oeuvre as a political one for an American audience.

4. Ibid., 109.

5. Dumas, "Man Kind (Or Here's to Those that Inspire Me)," in *Man Kind*, exh. cat. (Amsterdam: Paul Andriesse, 2006), 3.

6. Dumas, in Hlavajova, "Ik is een allochtoon," 108.

7. Dumas, from unpublished notes for a talk delivered at the Art Institute of Chicago, 25 February 2003.

8. Laura Mulvey, "Stillness in the Moving Image: Ways of Visualising Time and Its Passing," in Tanya Leighton and Pavel Büchler, eds., *Saving the Image: Art After Film* (Glasgow, Scotland: Centre for Contemporary Arts; and Manchester, England: Manchester Metropolitan University, 2003), 87–89.

9. Hlavajova, "'Ik is een allochtoon,'" 107.

10. Dumas stated that she herself was not shocked by the Abu Ghraib images, believing the violence they portray to be an all too common by-product of situations of war. She further pointed out that what shocked Americans the most was probably the fact of having to admit that they are indeed capable of dehumanizing acts. The current controversy in the United States around torture and the civil rights of prisoners is evidence that such methods have been used far more widely and habitually than previously acknowledged by the government.

11. Susan Sontag, "The Image-World," in *On Photography* (New York: Farrar, Straus, and Giroux, 1977), 167–68.

12. Sontag, "Regarding the Torture of Others," *The New York Times Magazine*, 23 May 2004. For another interesting text that discusses photography's role in human rights, see Thomas Keenan, "Mobilizing Shame," *South Atlantic Quarterly* 103, nos. 2–3 (spring–summer 2004): 435–49. I thank Media Studies Chair Peter Krapp at the University of California, Irvine, for this reference.

13. Dumas, "Lovesick" (1994), published in Dumas, *Sweet Nothings: Notes and Texts*, ed. Mariska van den Berg (Amsterdam: Marlene Dumas and Galerie Paul Andriesse, Uitgeverij De Balie, 1998), 89.

14. According to Dumas, Documenta VII curator Rudi Fuchs was interested in "the rediscovering of a broader Europe, not in the younger American painters. I was attracted to a certain rough BANALITY in American art; Italians like Clemente were seductive, but too much mythology or fairytales. Certain other European artists were too soft or elegant for my liking." Though paired with European male counterparts, Dumas remembered being attracted to the work of Jenny Holzer, Barbara Kruger, and Cindy Sherman. Dumas, email to the author, 12 December 2007.

15. Dumas, "Love Letters," in *Marlene Dumas: Intimate Relations*, exh. cat. (Amsterdam: Roma Publications; and Johannesburg: Jacana Media, 2007), 56.

16. Though the artist acknowledged a socio-political reading of this painting, she also insisted, "This painting was firstly or more how I disliked myself with my fake smile than me being white," an indication again of her mistrust in the performance of gender and the role of the "girl" artist. Dumas, email to the author, 12 December 2007.

17. Ulrich Loock, "Pictures Incomprehensible But Illuminating," *Parkett*, no. 38 (December 1993): 117.

18. Ibid.

19. Dumas, "The Artwork as Misunderstanding" (1991), in *Miss Interpreted*, exh. cat. (Eindhoven, The Netherlands: Stedelijk van Abbemuseum, 1992), 28.

20. Dumas, "Waiting for Meaning" (1988), in *Miss Interpreted*, 52.

21. Ingrid Schaffner, "Snow White in the Wrong Story: Paintings and Drawings by Marlene Dumas," *Arts Magazine* (March 1991): 61. In a beautifully written article on this body of work, Schaffner had this painting in mind when she wrote, "as Dumas intimates, her truth to photography has a dark purpose. The Polaroids' grease and glare act as a scrim, behind which Dumas strips her subjects, throwing away their unique identities; she has use only for their hides."

22. bell hooks, "Feminism Inside: Toward a Black Body Politic," in *Black Male: Representations of Masculinity in Contemporary American Art*, exh. cat. (New York: Whitney Museum of American Art and Harry N. Abrams, Inc., 1994), 127–40.

23. Elisabeth Sussman, "Coming Together in Parts: Positive Power in the Art of the Nineties," in *1993 Biennial Exhibition*, exh. cat. (New York: Harry N. Abrams, Inc., and Whitney Museum of American Art, 1993), 13.

24. Schaffner, "Dial 970-MUSE: Marlene Dumas's Pornographic Mirror," *Parkett*, no. 38 (December 1993): 100.

25. Christopher Dickey, "Women of Al Qaeda," *Newsweek* (12 December 2005): 18.

26. Ibid., 20–21.

27. Edward W. Said, "Opponents, Audiences, Constituencies and Community" (1982), in *The Anti-Aesthetic: Essays on Postmodern Culture*, ed. Hal Foster (Port Townsend, Washington: Bay Press, 1983), 137.

28. Dumas, conversation with the author, 24 February 2008, Amsterdam.

29. "Goddess: What Happened on the Night that Marilyn Died?," review of Anthony Summers, *Goddess: The Secret Lives of Marilyn Monroe*, in *Vrij Nederland*, 26 October 1985 (Dutch translation by Ochrid Hogen Esch).

30. The article indicates, however, that for the viewing of the body, Monroe's makeup artist was called in to create her trademark visage, even giving her a wig and false breasts.

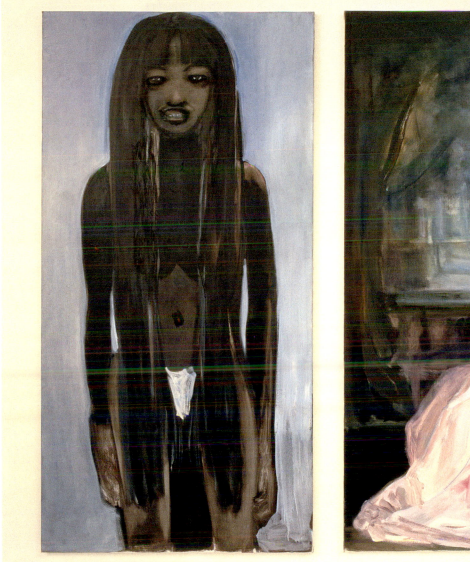

Above: *Great Britain*, 1995–97; oil on canvas;
diptych: 78 3/4 x 39 3/8 inches and 78 3/4 x 56 1/4 inches;
collection Vicki and Kent Logan, fractional and promised
gift to the San Francisco Museum of Modern Art

Right: *The Supermodel*, 1995; watercolor on paper;
26 x 19 3/4 inches; The Museum of Modern Art,
New York, gift of Jan Christiaan Braun in honor of
Marie-Josée Kravis

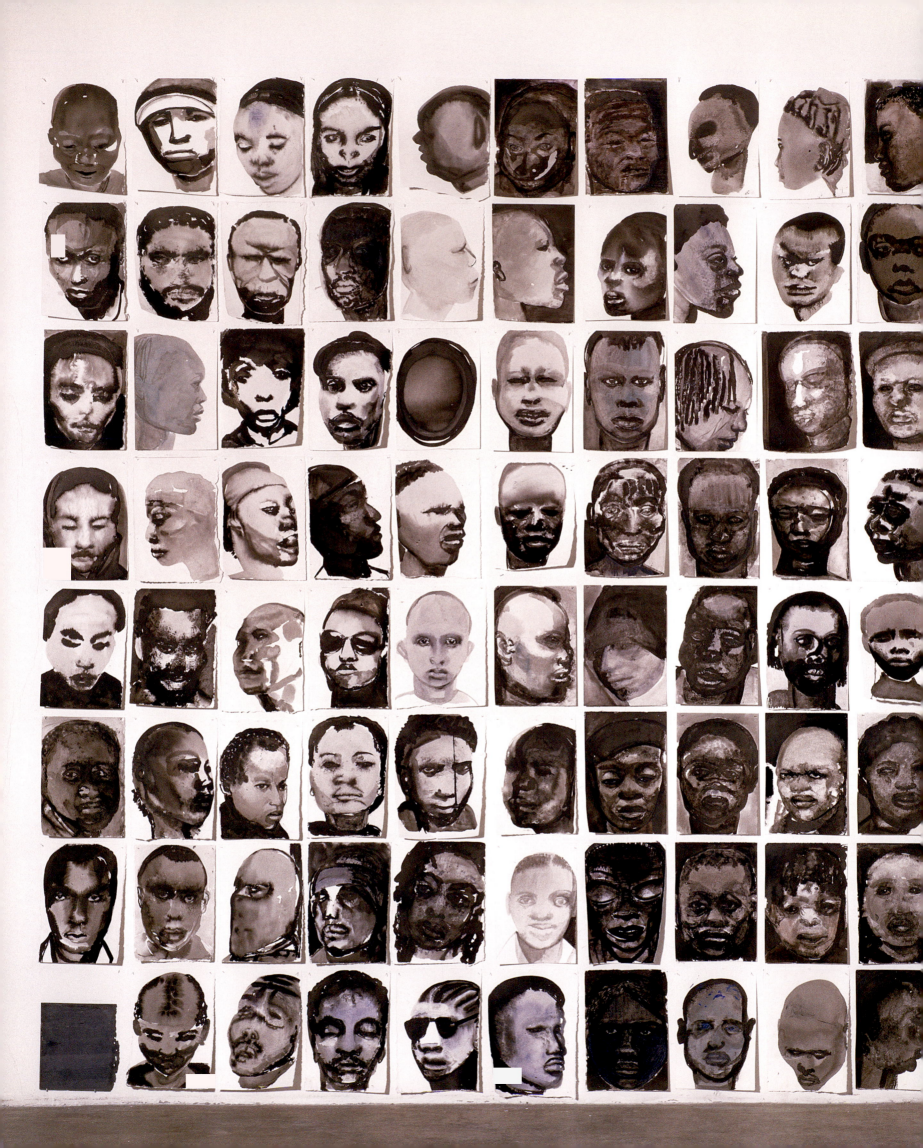

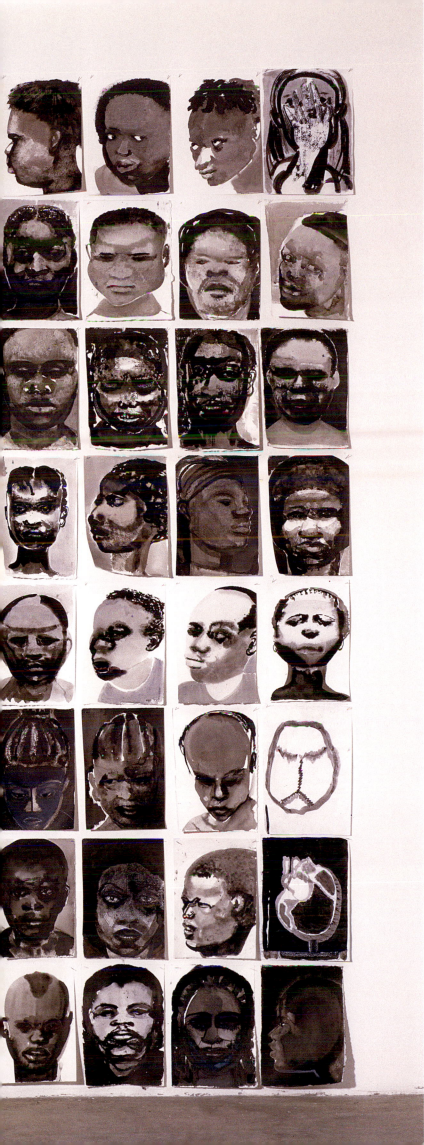

Black Drawings, 1991–92; ink and watercolor on paper and slate; 111 drawings and one slate: 9 $^{13}/_{16}$ x 6 $^{7}/_8$ inches each; De Pont Museum of Contemporary Art, Tilburg, The Netherlands

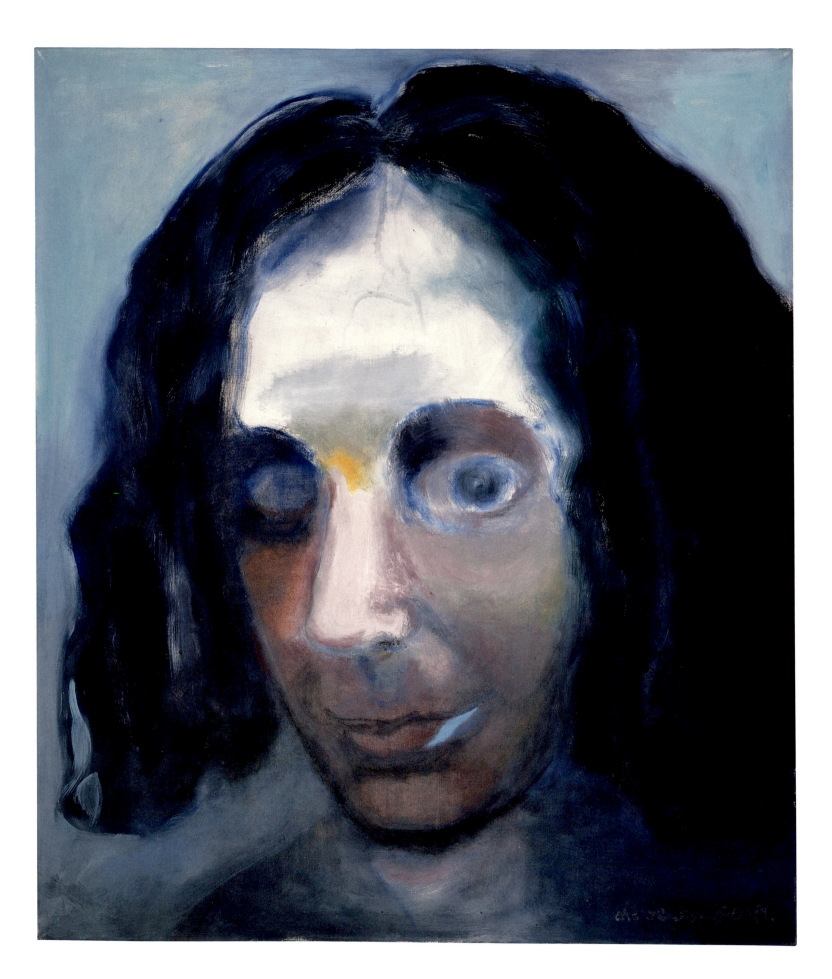

The Jewish Girl, 1986; oil on canvas; 51 3/16 x 43 5/16 inches; Centraal Museum, Utrecht

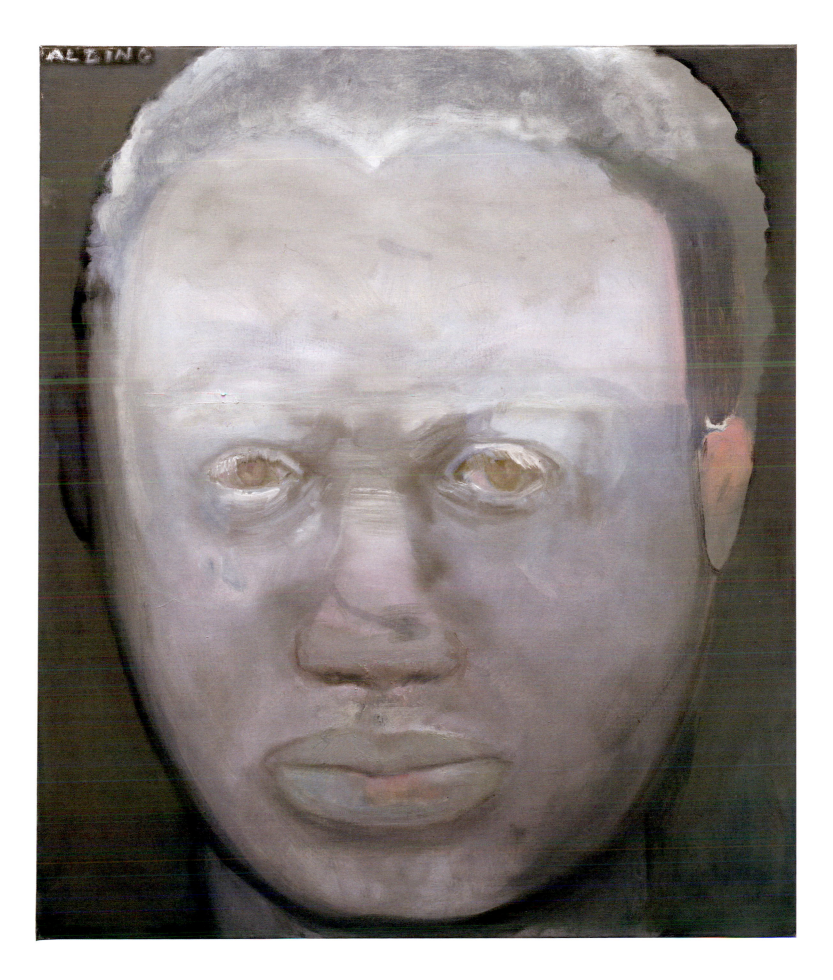

Albino, 1986; oil on canvas; 51 3/16 x 43 5/16 inches; The Art Institute of Chicago, through prior acquisitions of Mary and Leigh Block

Martha—my ouma, 1984; oil on canvas; 51 $^3/_{16}$ x 43 $^5/_{16}$ inches; private collection

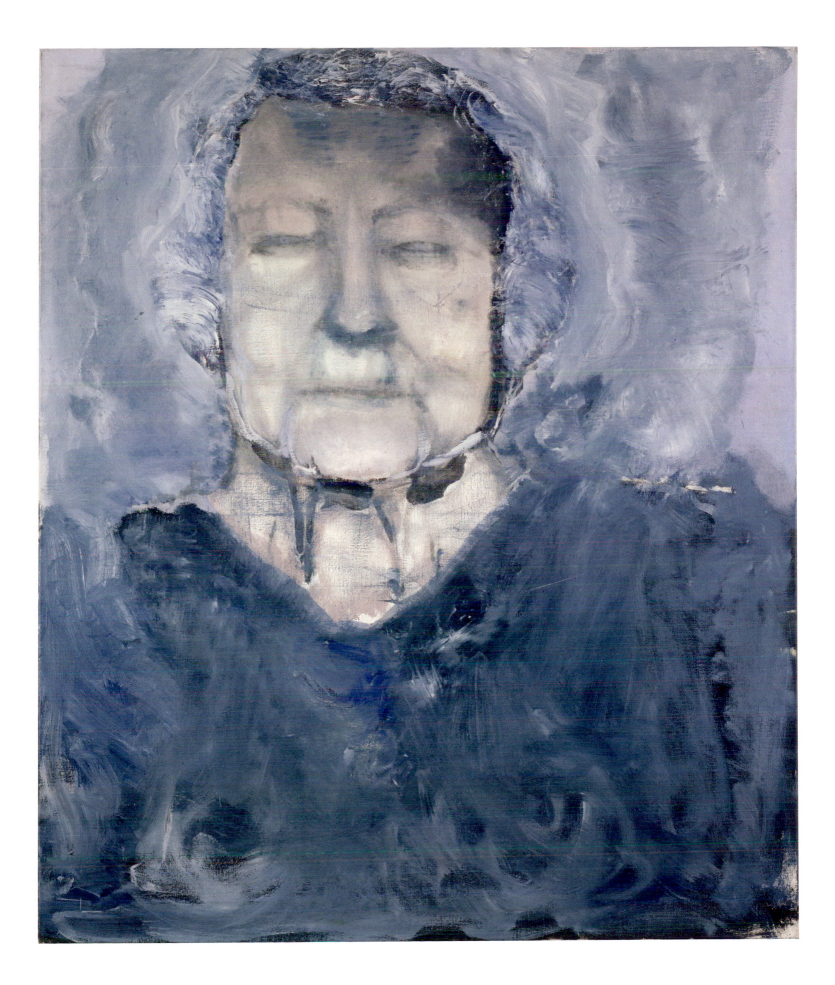

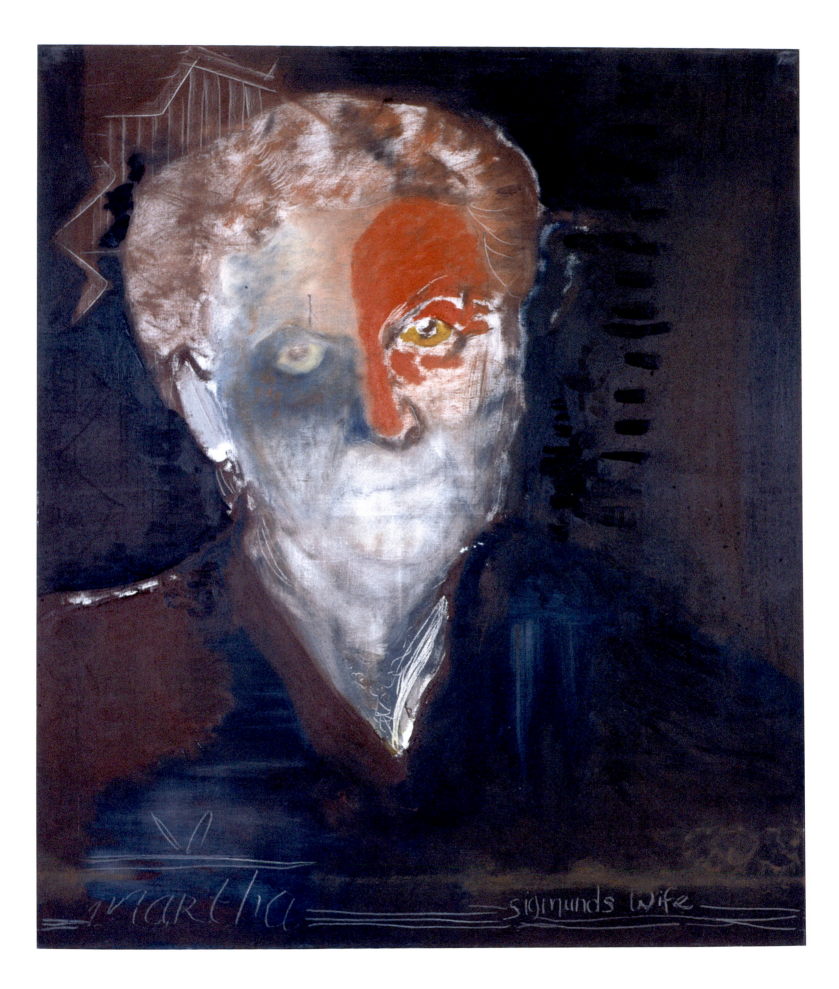

Martha—Sigmund's Wife, 1984; oil on canvas; 51 3/16 x 43 5/16 inches; Stedelijk Museum, Amsterdam

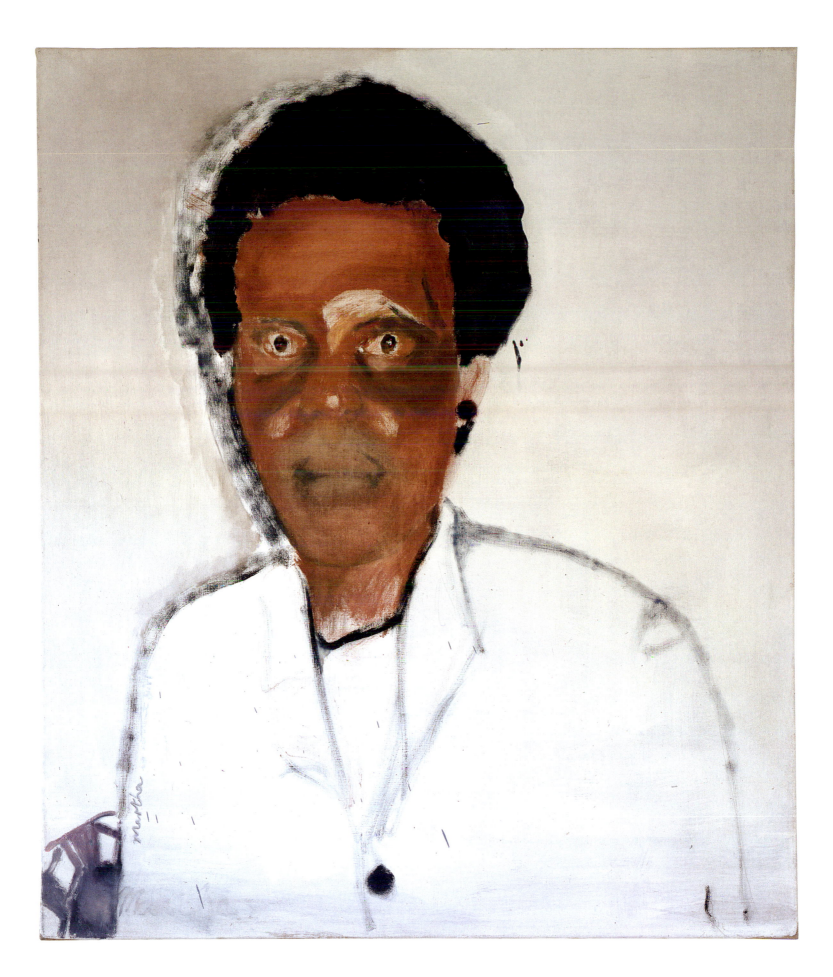

Martha—die bediende, 1984; oil on canvas; 51 $^{3}/_{16}$ x 43 $^{5}/_{16}$ inches; Marliz Frencken and Hans Liberg, on long-term loan to Centraal Museum, Utrecht

The White Disease, 1985; oil on canvas; 49 $^{3}/_{16}$ x 41 $^{5}/_{16}$ inches; private collection

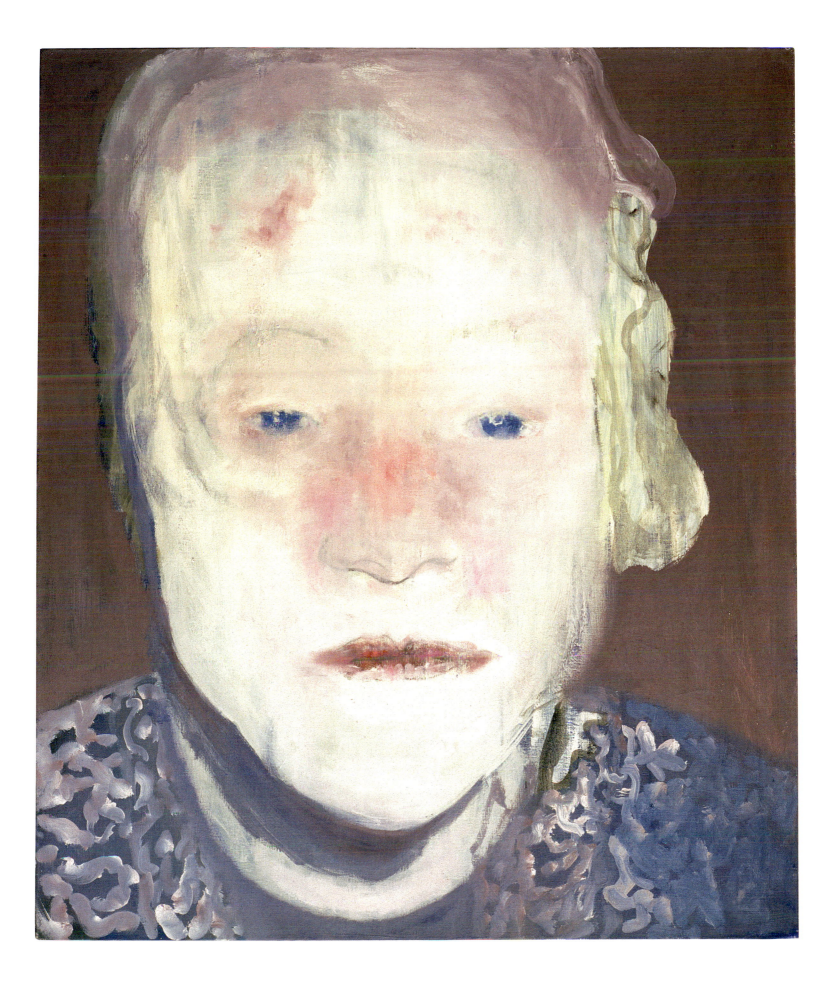

The Accident, 1986; oil on canvas; 51 $^3/_{16}$ x 43 $^5/_{16}$ inches; Bayerische Staatsgemäldesammlungen/Pinakothek der Moderne, Munich

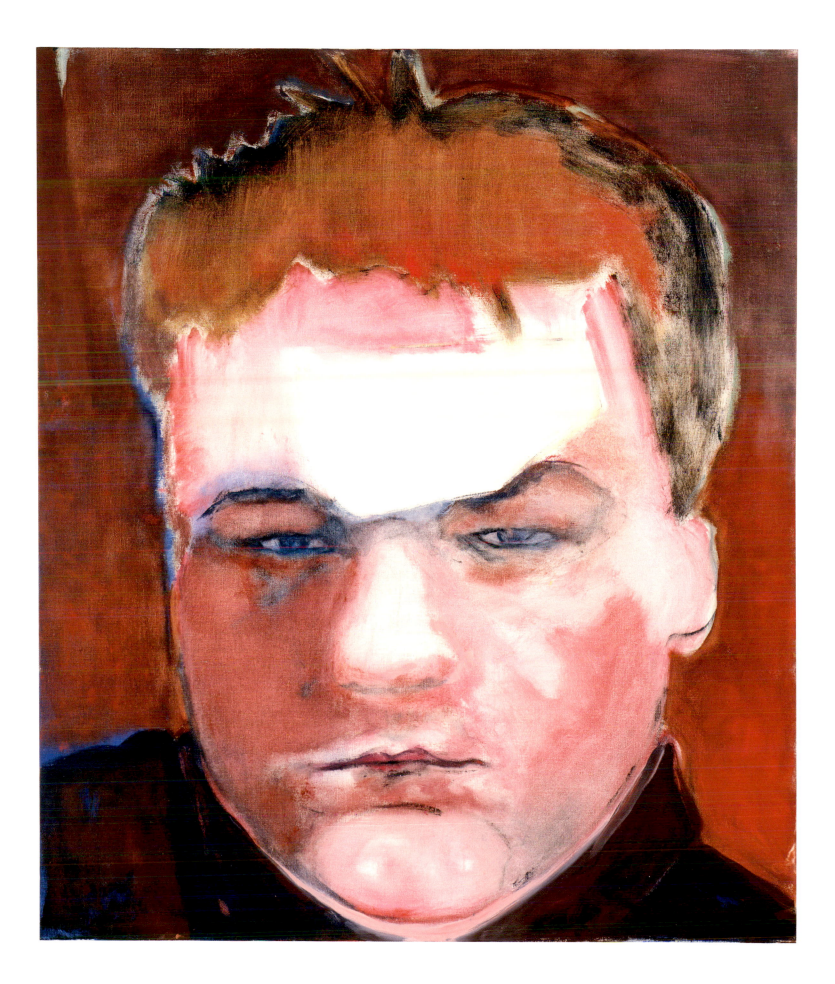

Genetiese Heimwee (Genetic Longing), 1984; oil on canvas; 51 $^3/_{16}$ x 43 $^5/_{16}$ inches; Van Abbemuseum Collection, Eindhoven

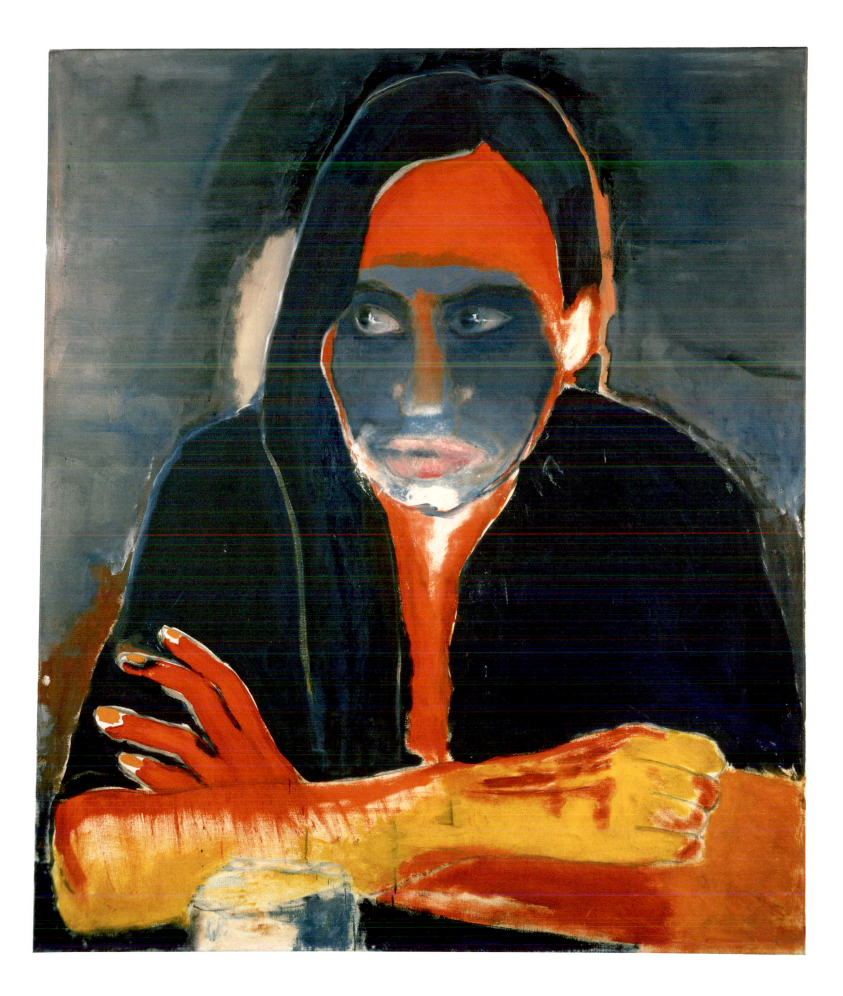

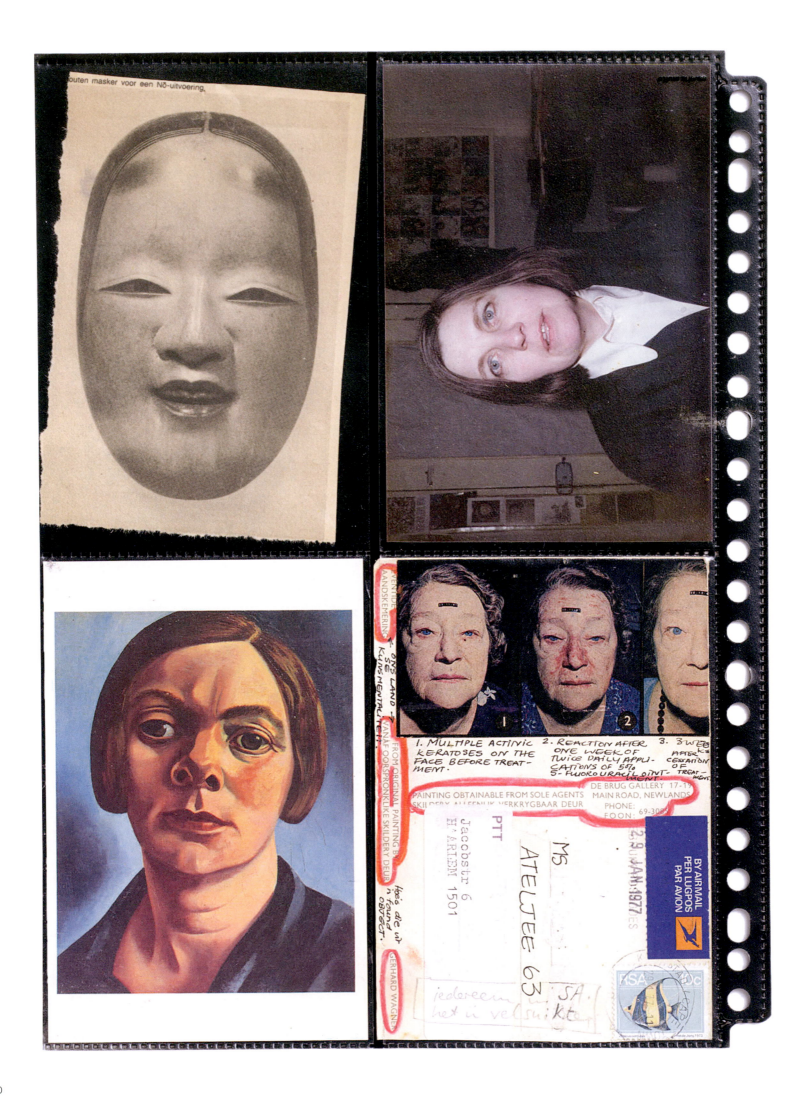

Opposite: Selections from Dumas's image bank, filed under the heading "Female Portraits." Clockwise, from top left: Japanese No theater mask, used as inspiration for *Models*, 1994; photograph of Annemarie de Kruijf, source for *De Vragende Vrouw*, 1985; collaged postcard of a patient, source for *The White Disease*, 1985; and self-portrait of Charley Toorop, used as inspiration for *Models*, 1994

Right: Polaroid photographs by Dumas, 1984–86

Homage to the Polaroid

The only camera I ever liked and ever used was the Polaroid camera.
The Polaroid, always and only, true to its own sublime distorted nature.
Fast and fickle and hands-on physical, not concerned with digital vanity.
Cheap and expensive at the same time.
No copy and no negative.

P.S. Without you, no Jewish Girl,
no Pregnant Image,
no Occult Revival, no Jule—die Vrou.

—M. D., 2008

Jule—die Vrou, 1985; oil on canvas; 49 3/16 x 41 5/16 inches; collection Barbara Lee, Cambridge, Massachusetts

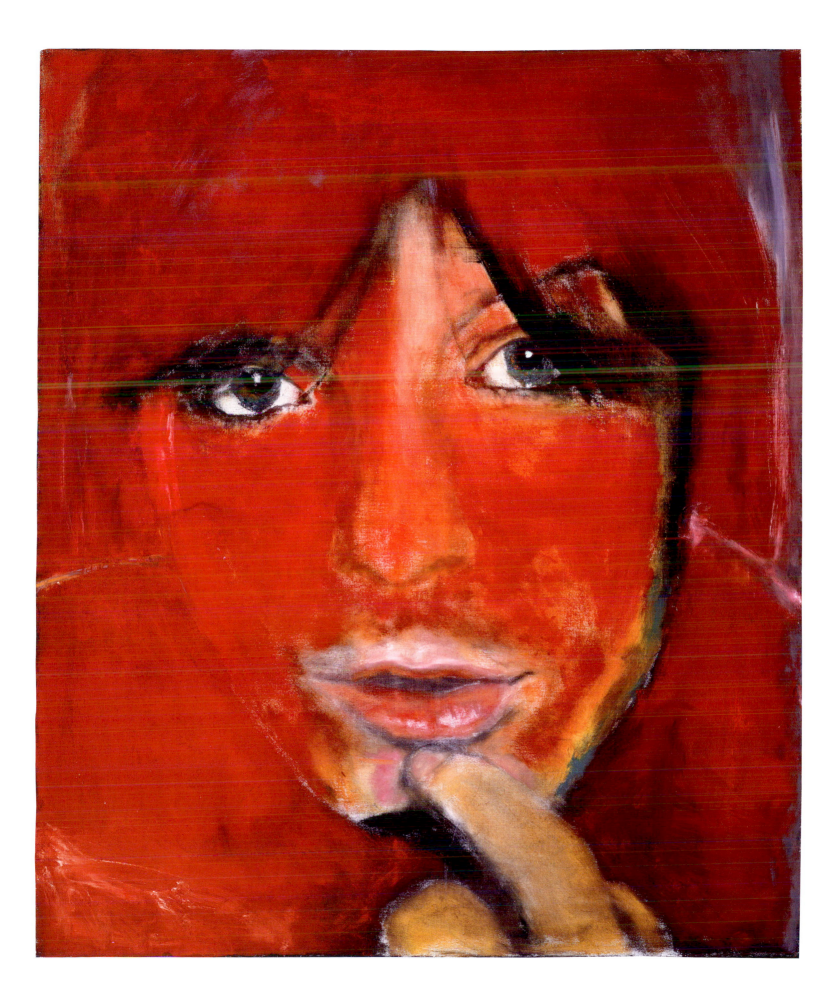

Selections from Dumas's image bank, filed under the heading "Couples"

Left: Selections from Dumas's image bank, filed under the heading "Couples." Clockwise, from top left: *Adam and Eve* and *The Fall of Man* by Tintoretto, 1518–94; Johannes at rest on the breast of Christ, Meester Heinrich te Konstanze, fourteenth century; and *Adam and Eve* by Hans Holbein, 1517

Above: Dumas (far right) and Jolie van Leeuwen (far left) installing *Female*, 1992–93, in "Das 21. Jahrhundert: Mit Paracelsus in die Zukunft," Kunsthalle, Basel, Switzerland, 1993

Below: A group of Magdalena paintings in Dumas's studio, Amsterdam, 1995

As a Couple

As a couple needs a space to warm up to,
an image needs an edge to relate to,
and a painting needs a wall to object to.

—M. D., 1995–2008

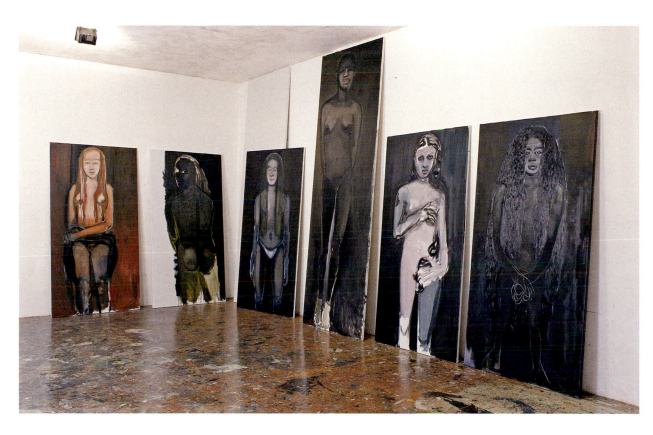

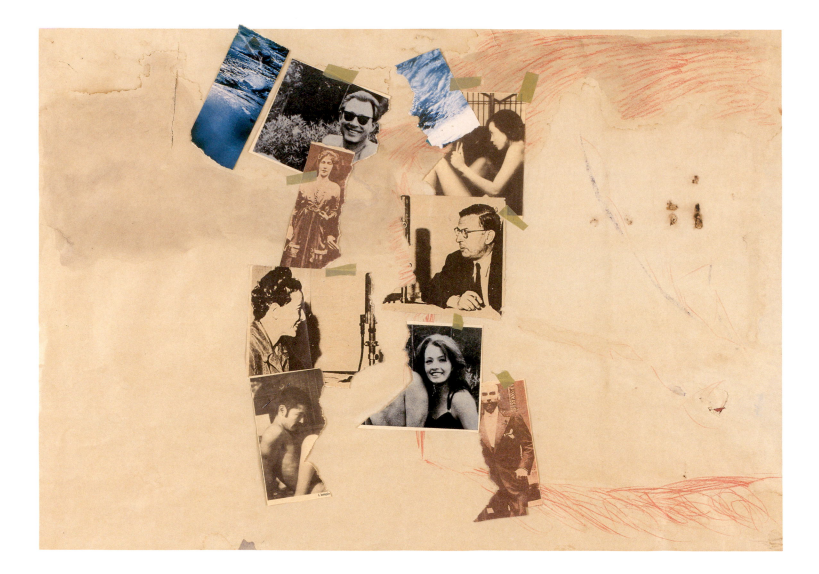

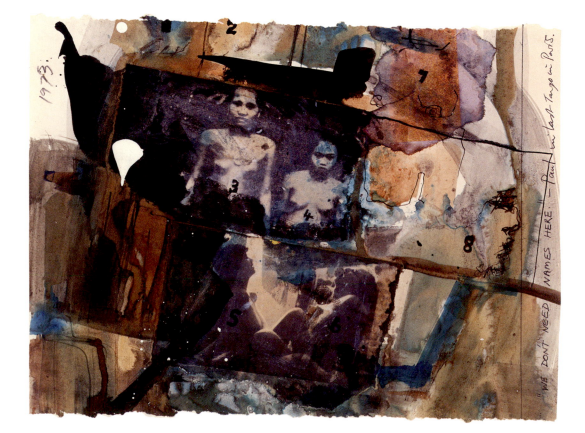

Above: *Couples*, 1978; colored pencil and collage on paper; 19 5/16 x 26 9/16 inches; The Over Holland Collection

Right: *We Don't Need Names Here*, 1973; watercolor and collage on paper; 8 9/16 x 11 1/4 inches; courtesy Paul Andriesse, Amsterdam

Don't Talk to Strangers, 1977; oil, collage, pencil, and Sellotape on canvas; 49 3/16 x 61 7/16 inches; collection De Ateliers, Amsterdam

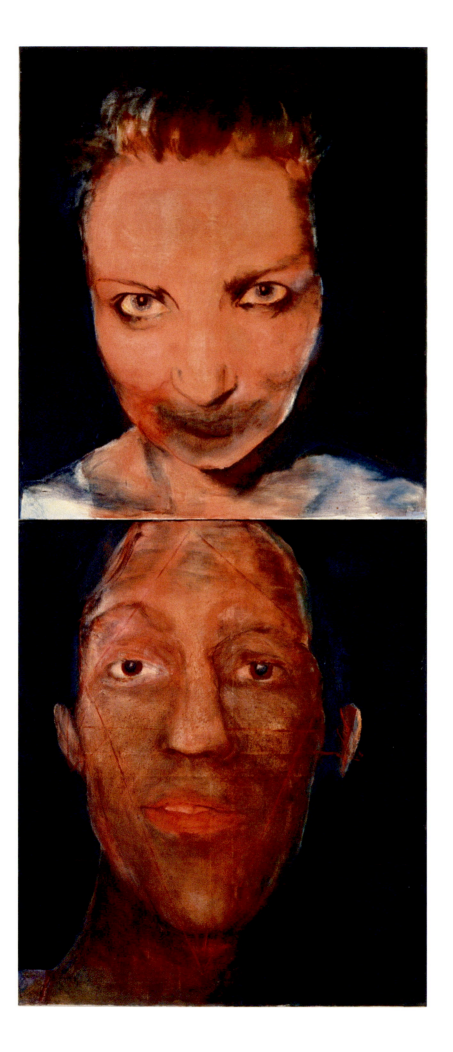

Occult Revival, 1992; oil on canvas; diptych: 51 3/16 x 43 5/16 inches each panel; Stedelijk Museum, Amsterdam

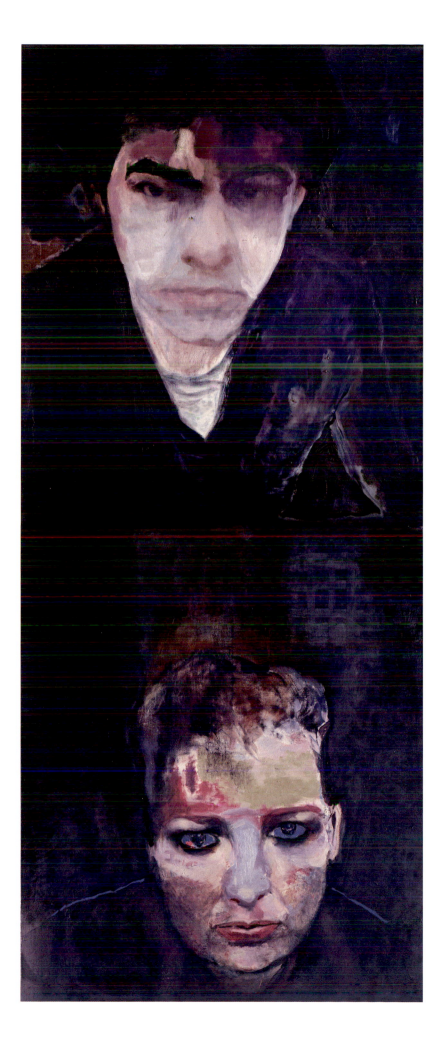

The Space Age, 1984; oil on canvas; diptych:
51 ³/₁₆ x 43 ⁵/₁₆ inches each panel; private collection, Paris

Following spread: *Chlorosis (Love sick)*, 1994; ink,
gouache, and synthetic polymer paint on paper; twenty-four
sheets: 26 x 19 ¹/₂ inches each; The Museum of Modern
Art, New York, the Herbert and Nannette Rothschild Memorial
Fund in memory of Judith Rothschild

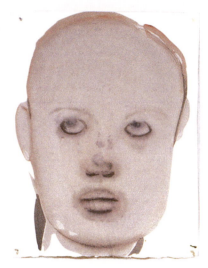 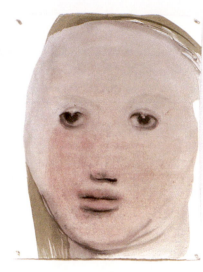 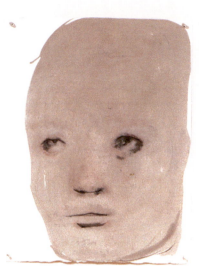 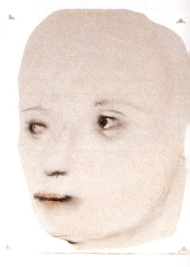

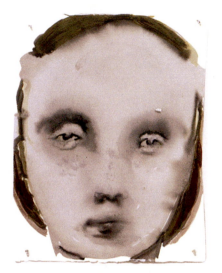 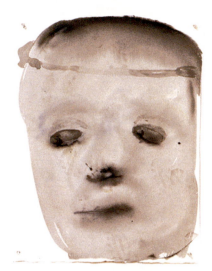 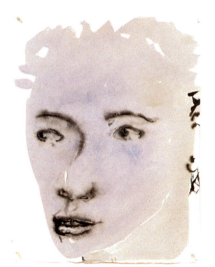 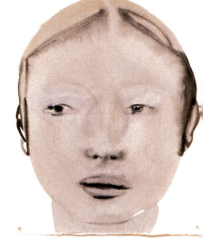

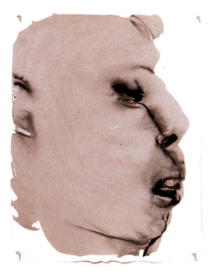 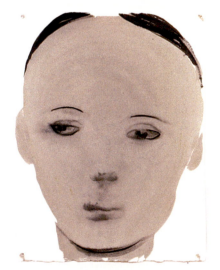 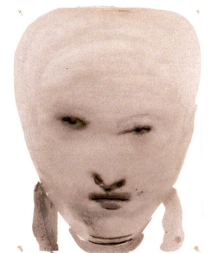 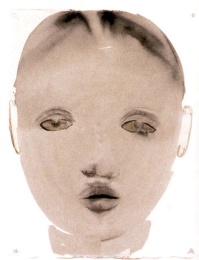

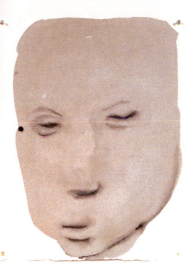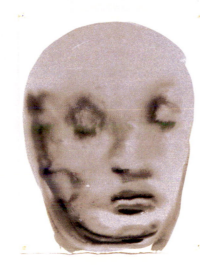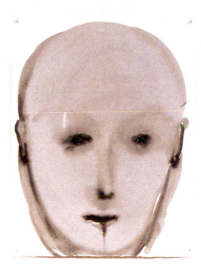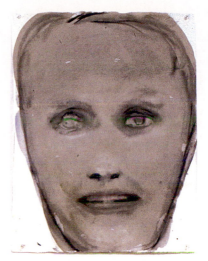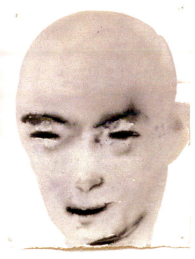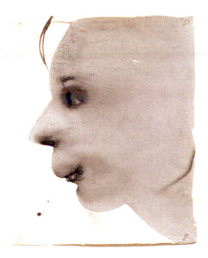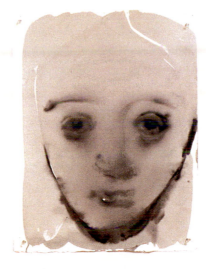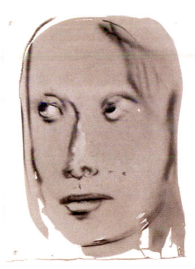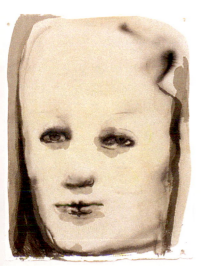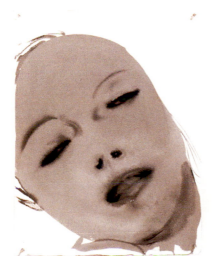

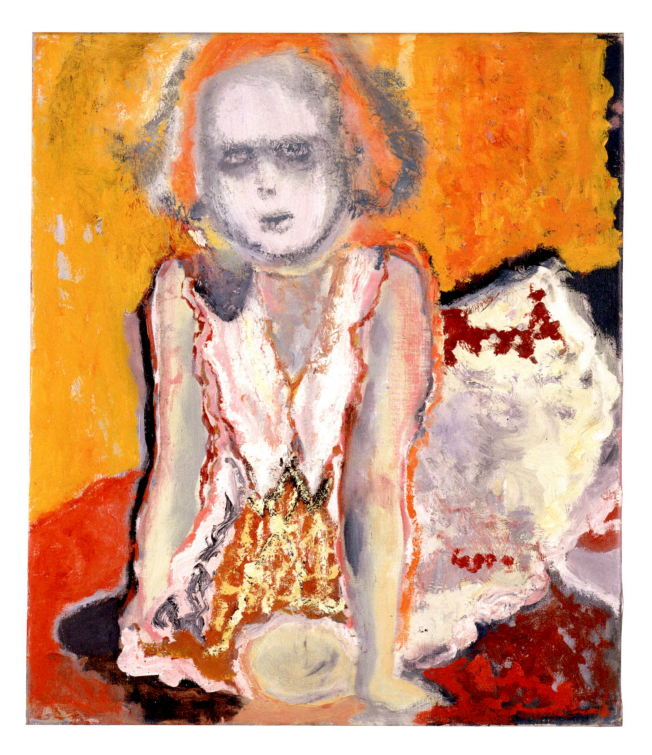

102

Het Kwaad is Banaal (Evil Is Banal), 1984; oil on canvas; 49 3/16 x 41 5/16 inches; Van Abbemuseum Collection, Eindhoven

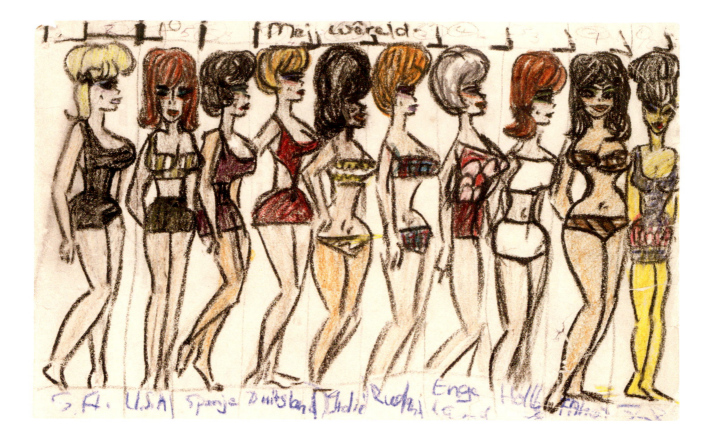

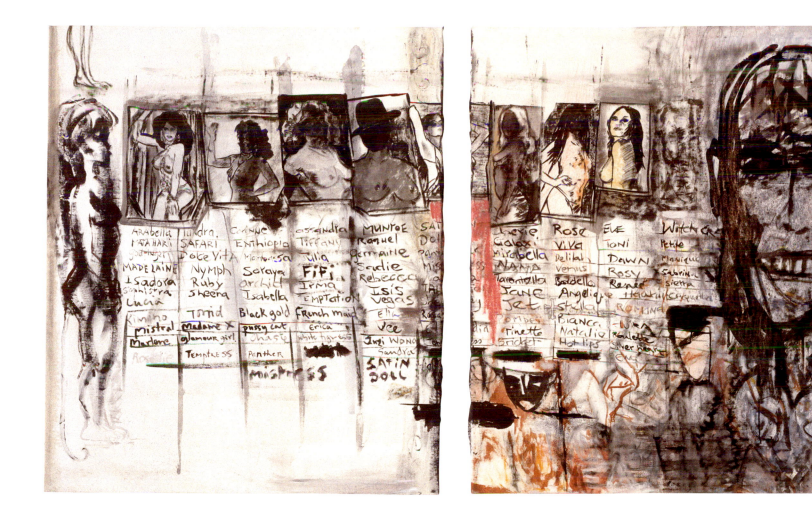

Exotic Lingerie, 1983; acrylic on canvas; diptych: 51 3/16 x 43 5/16 inches each panel; Centraal Museum, Utrecht

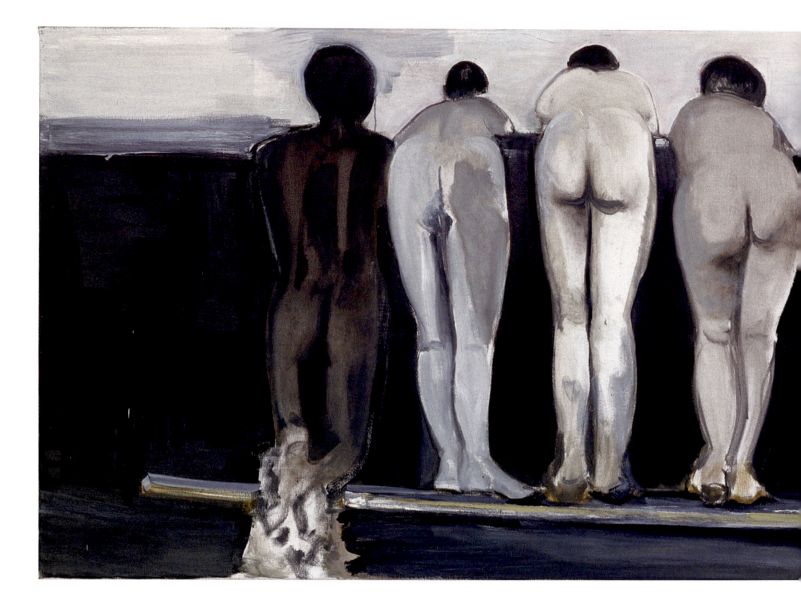

Group Show, 1993; oil on canvas; 39 ³/₈ x 118 ¹/₈ inches; Centraal Museum, Utrecht, with support of The Mondriaan Foundation

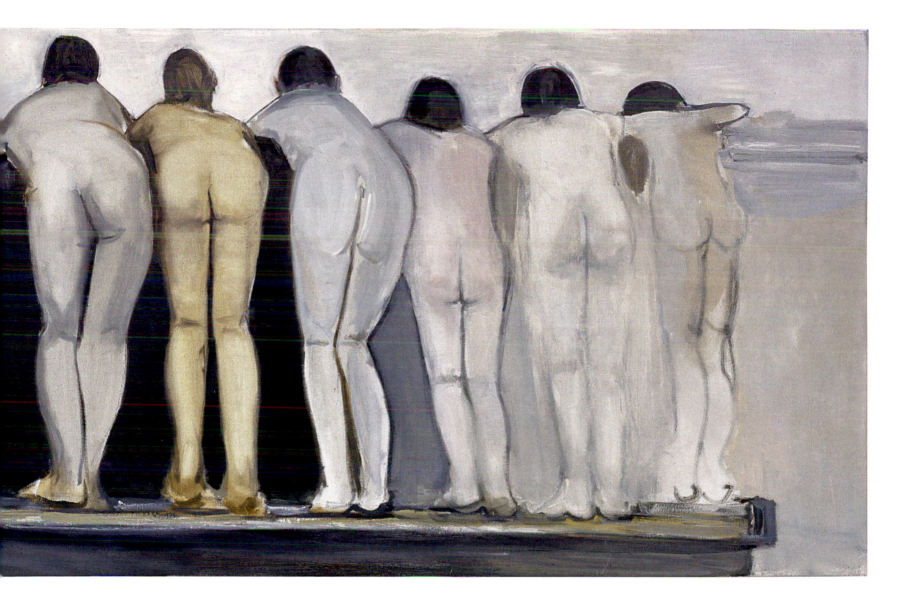

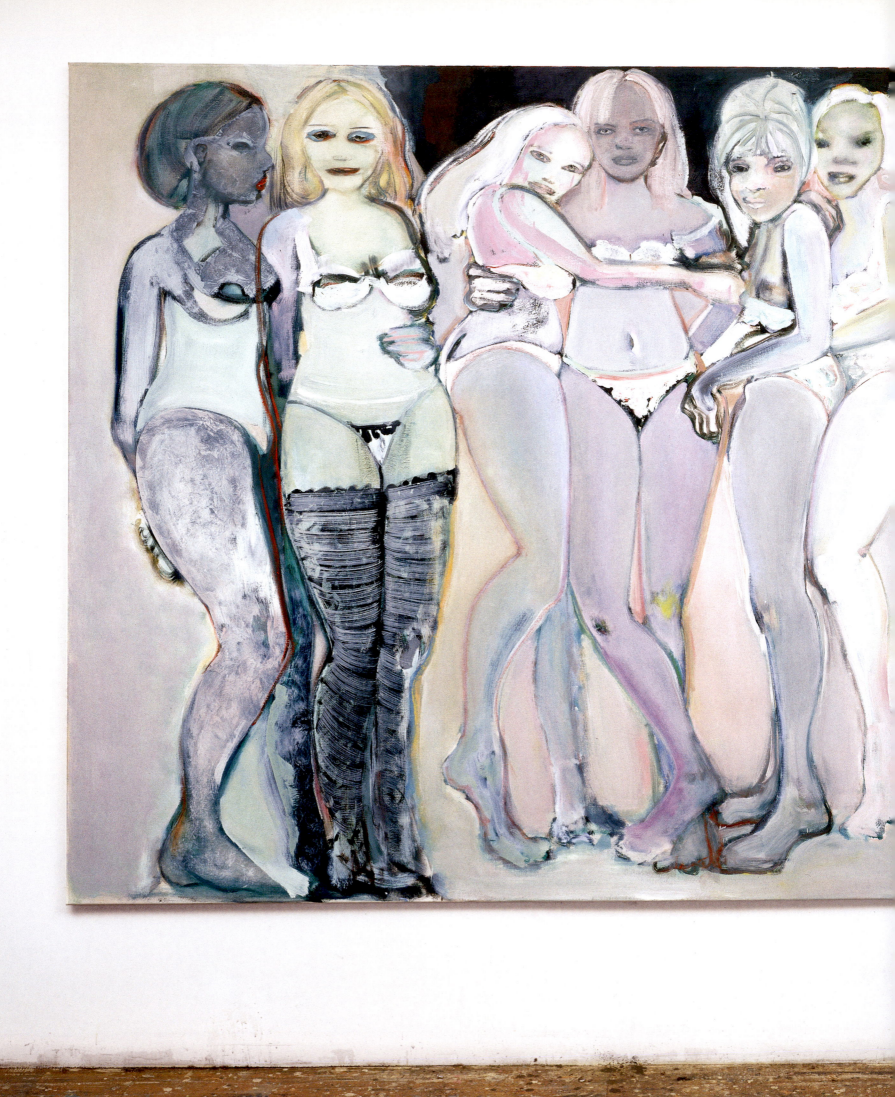

We Were All in Love with the Cyclops, 1997;
oil on canvas; 70⁷/₈ x 118¹/₈ inches; Defares
Collection, The Netherlands

Ryman's Brides, 1997; oil on canvas; 51 $^3/_{16}$ x 43 $^5/_{16}$ inches; collection Jerome L. and Ellen Stern

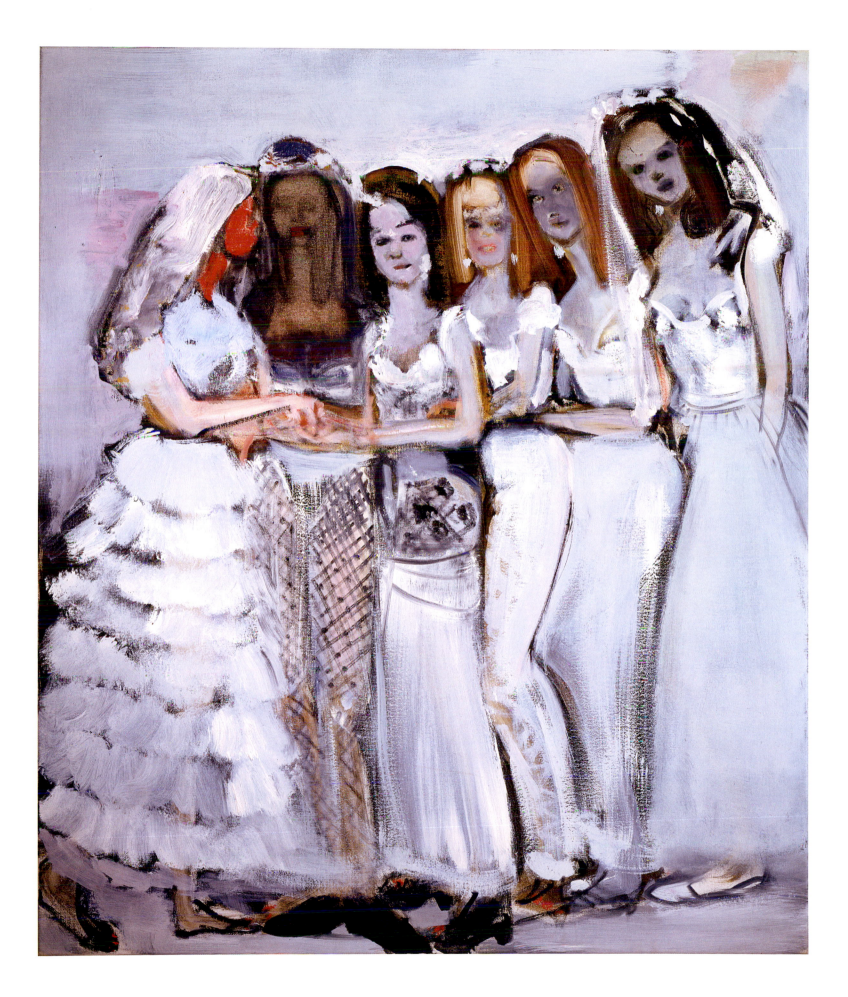

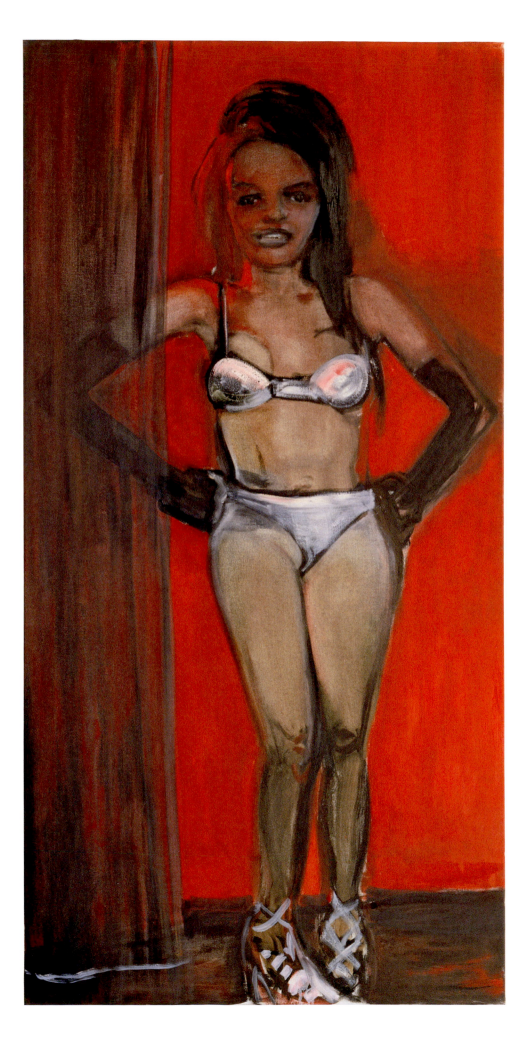

Night Nurse, 2000; oil on canvas; 78 3/4 x 39 3/8 inches; collection Anton Corbijn

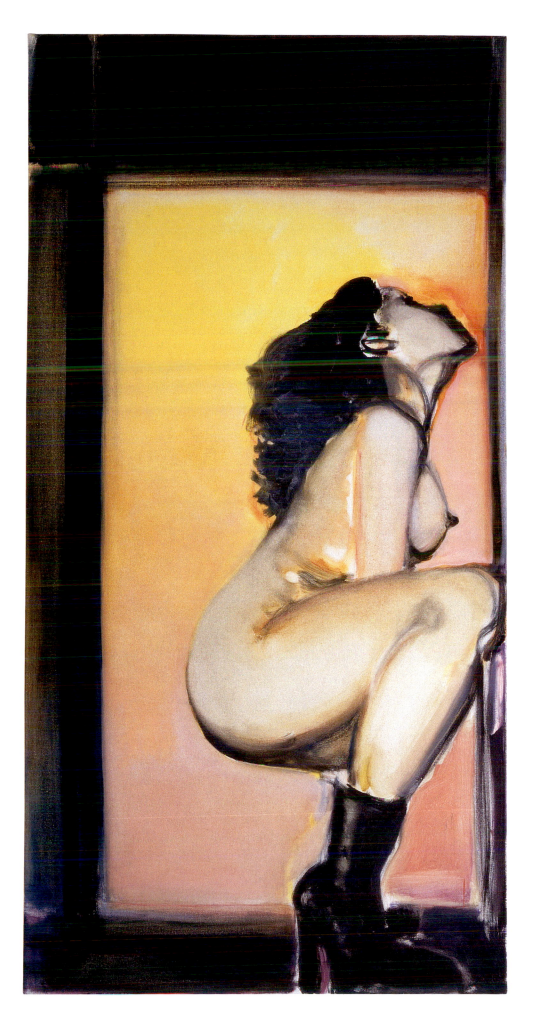

Leather Boots, 2000; oil on canvas; 78 3/4 x 39 3/8
inches; collection of the artist

Miss January, 1997; oil on canvas; 118 $^1/_8$ x 39 $^3/_8$ inches; Rubell Family Collection, Miami

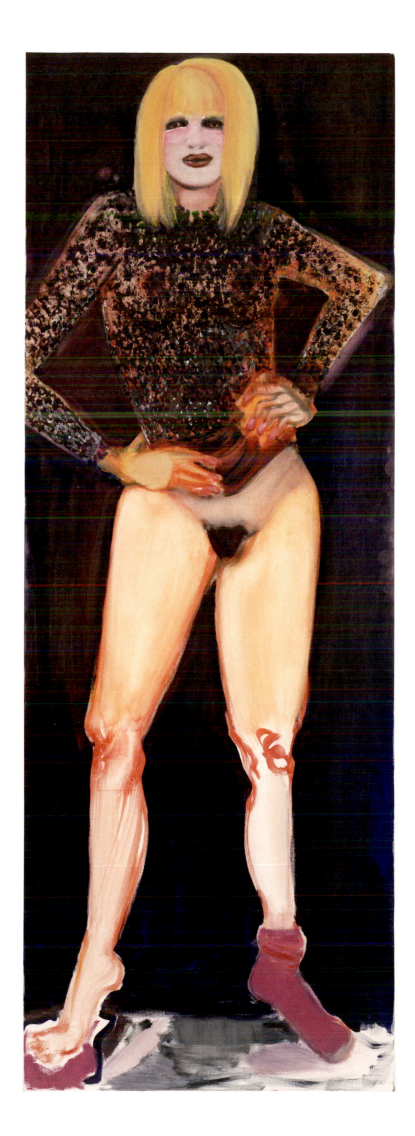

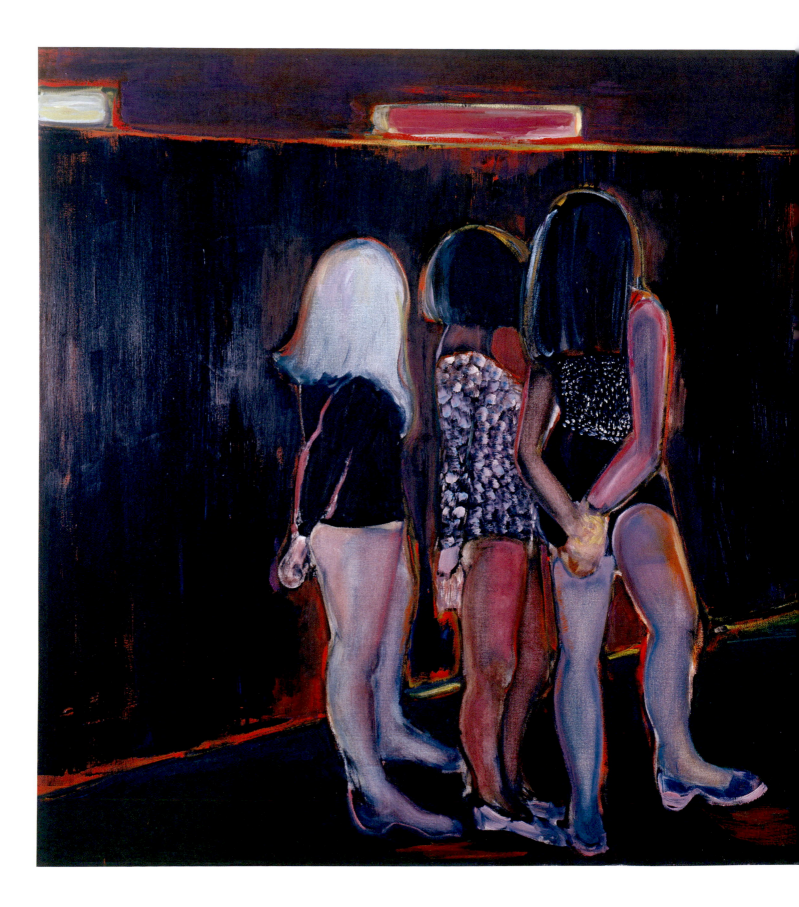

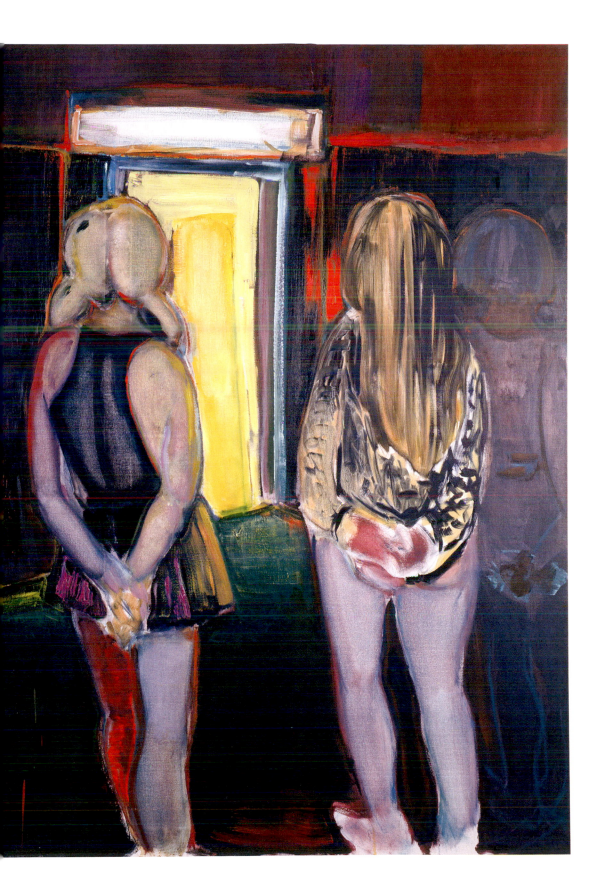

The Visitor, 1995; oil on canvas; 70 7/8 x 118 1/8 inches; private collection, on long-term loan to Lieu d'Art Contemporain, Aude, France

Colorfields, 1997; oil on canvas; 78 3/4 x 59 1/16 inches; private collection, The Netherlands

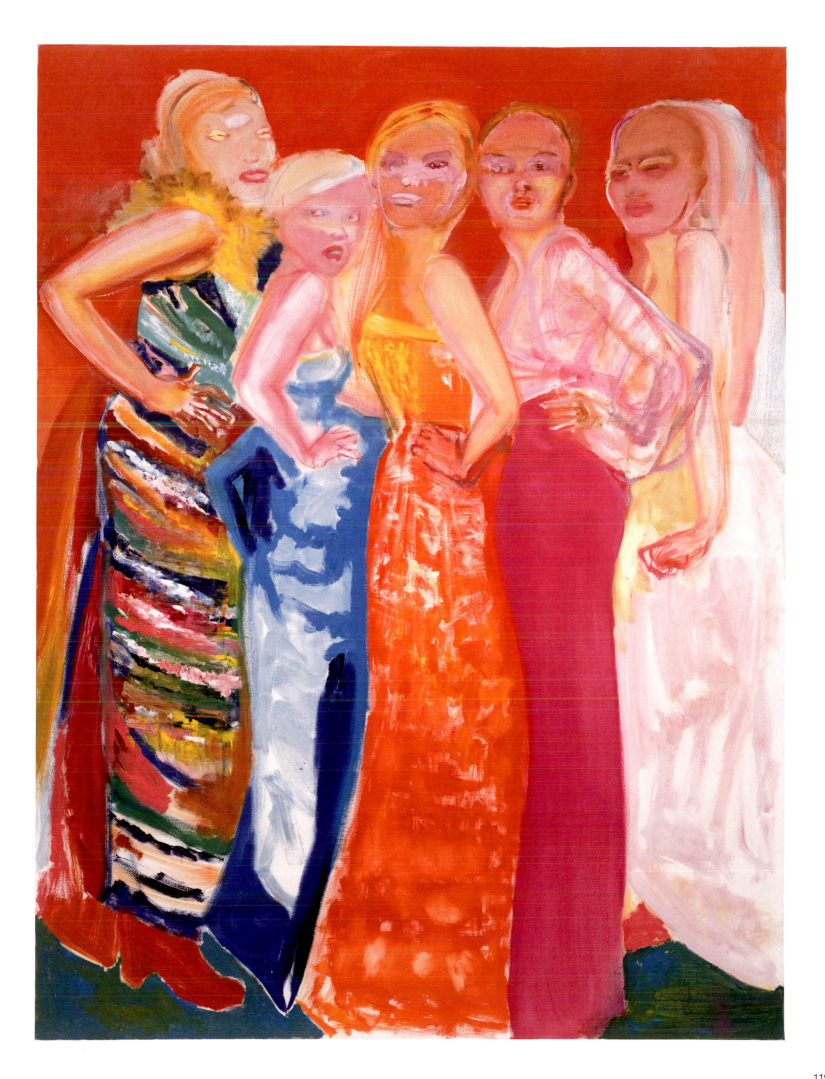

The Teacher (sub a), 1987; oil on canvas; 63 x 78³/₄ inches; private collection

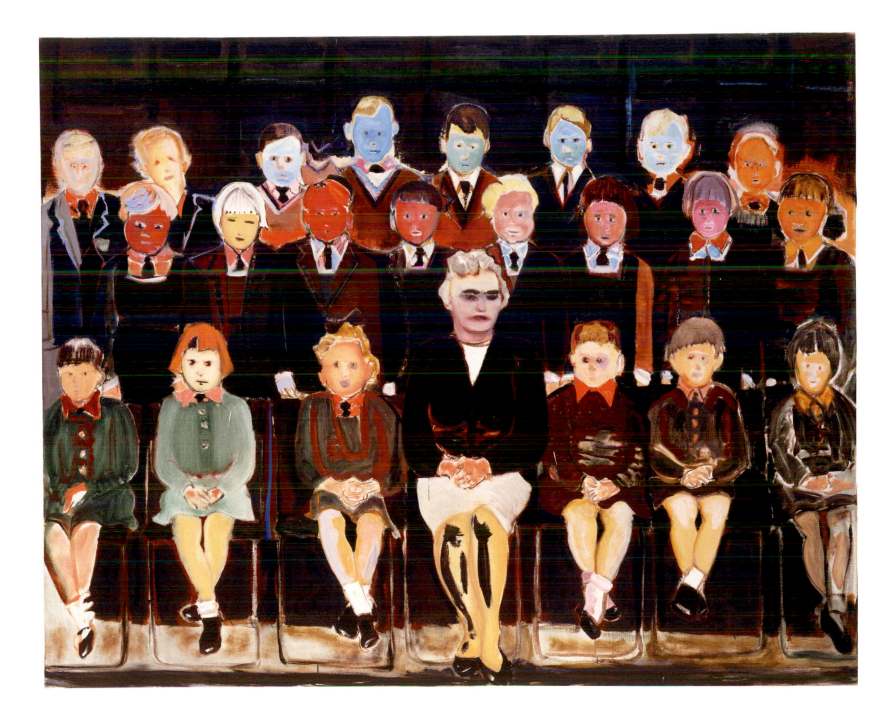

The Turkish Schoolgirls, 1987; oil on canvas; 63 x 78 $^3/_4$ inches; Stedelijk Museum, Amsterdam

Following spread: "Marlene Dumas: *Models*," installation at Portikus, Frankfurt, Germany, 1995

Pages 126–27: *Models*, 1994, details; ink and chalk on paper; one hundred sheets: 24 $^7/_{16}$ x 19 $^{11}/_{16}$ inches each; Van Abbemuseum Collection, Eindhoven

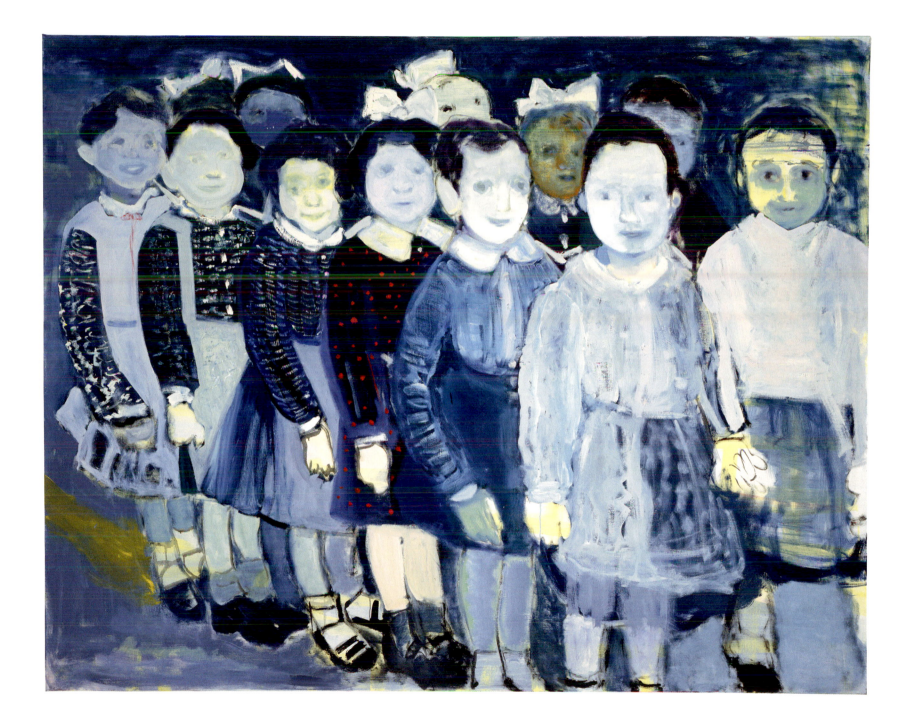

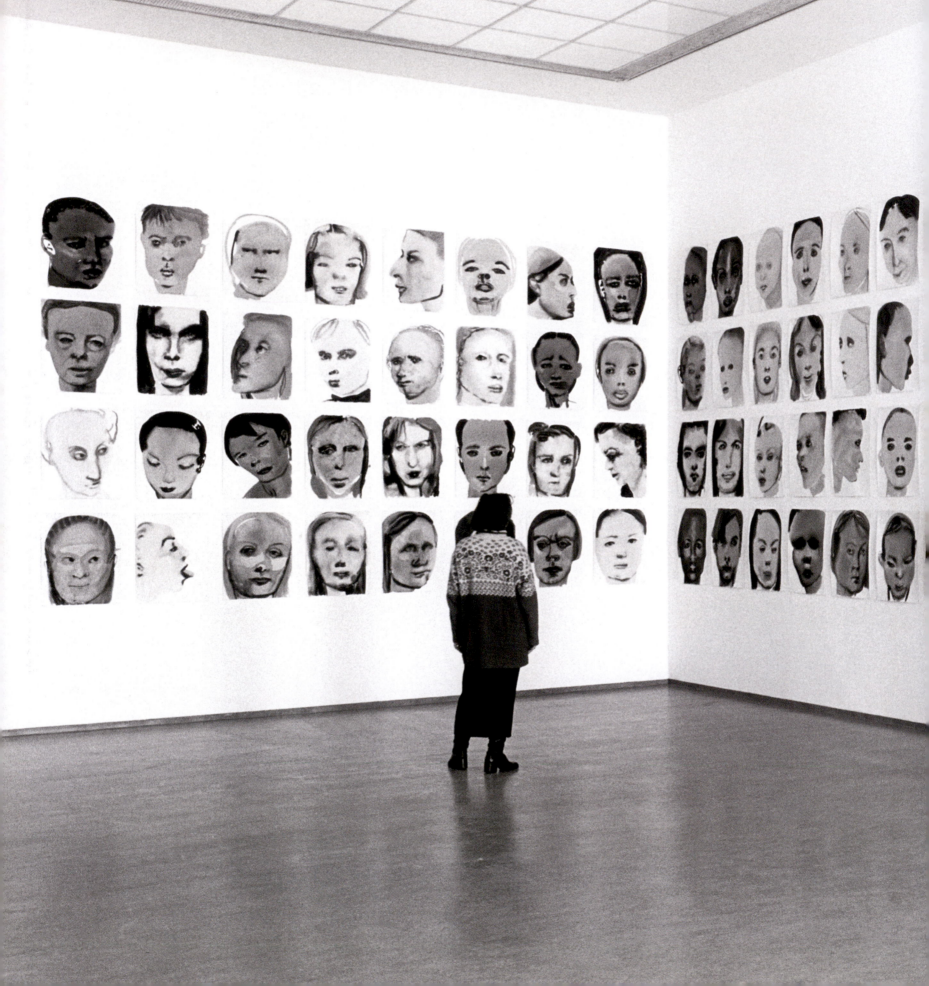

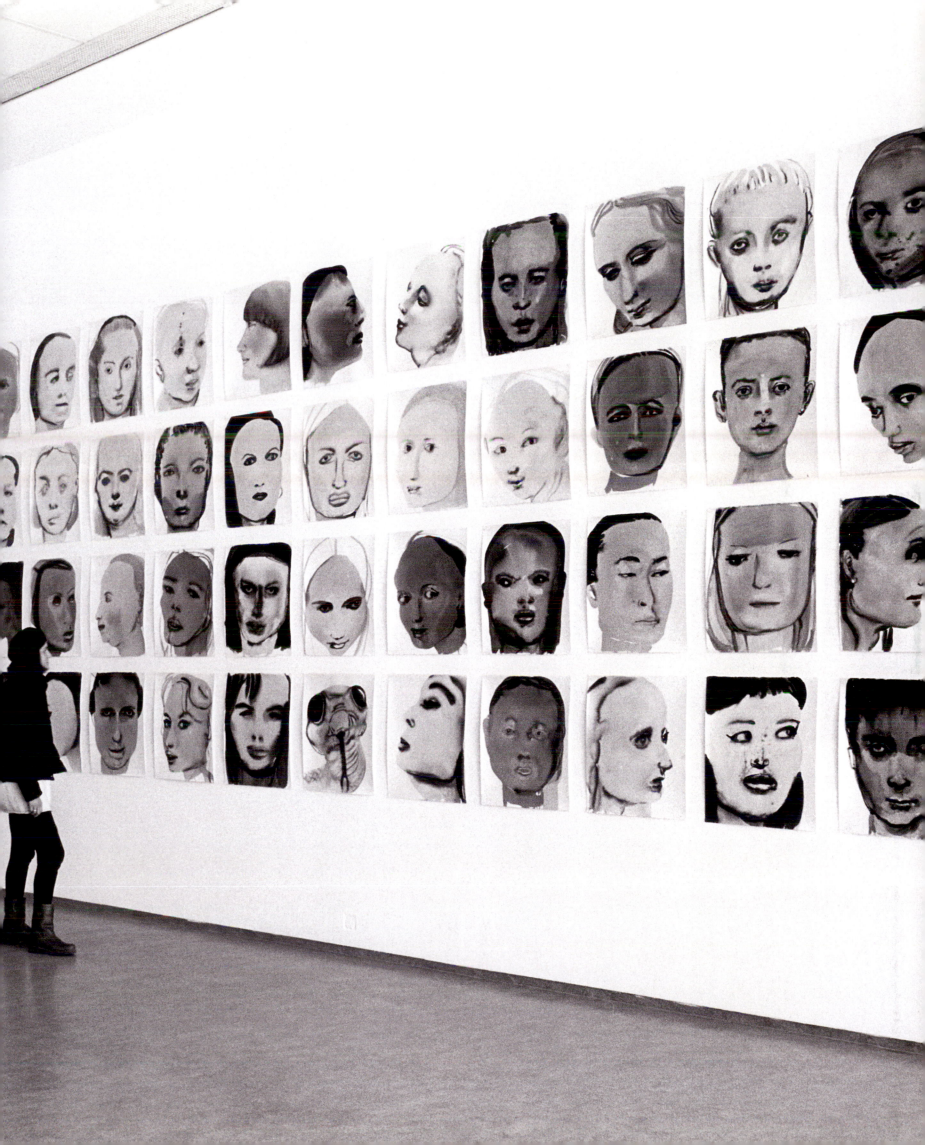

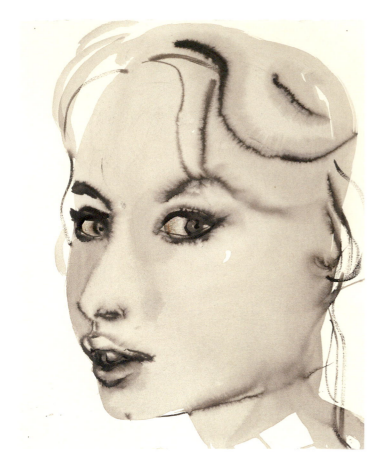
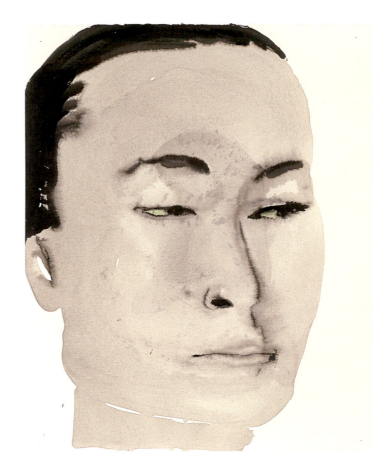
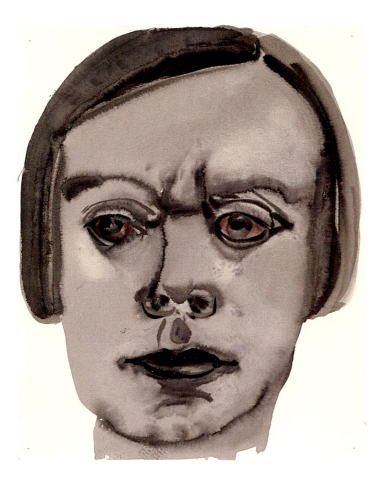
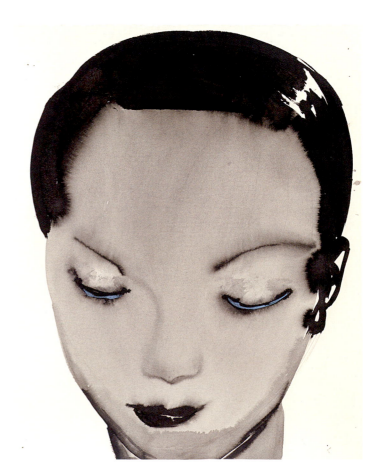

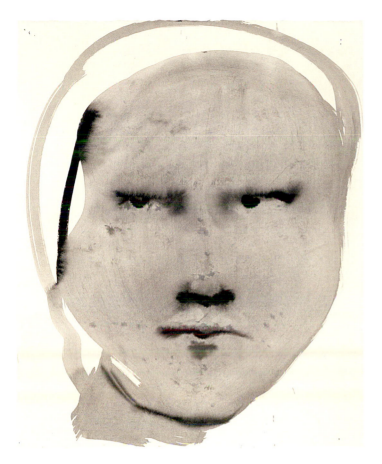
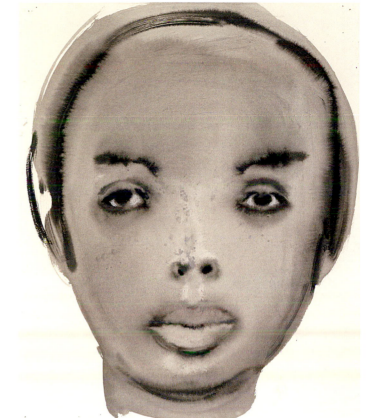
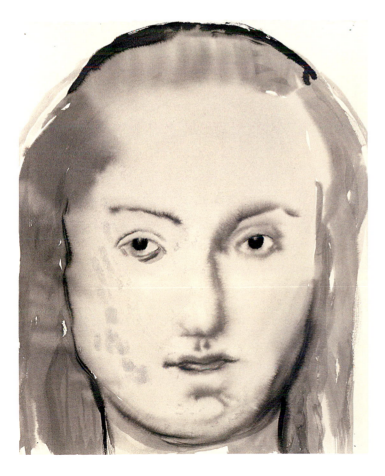
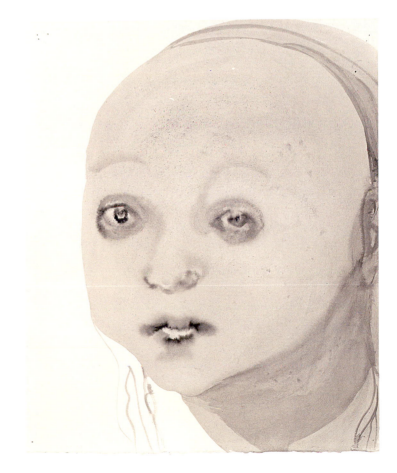

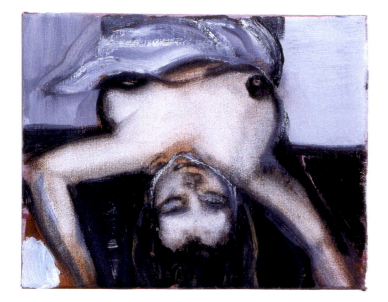 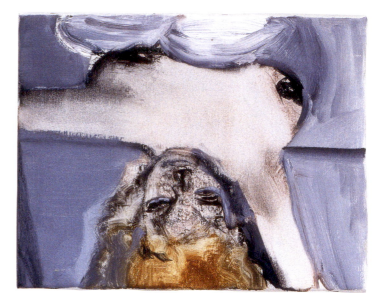

Above, across: *The Blonde, the Brunette, and the Black Woman*, 1992; oil on canvas; triptych: two panels: 9 13/16 x 11 13/16 inches each, one panel: 11 13/16 x 15 3/4 inches; Stedelijk Museum voor Aktuele Kunst, Ghent

Right: *Hierarchy*, 1992; oil on canvas; 15 3/4 x 21 5/8 inches; collection Philippe and Inez Kempeneers, Ghent

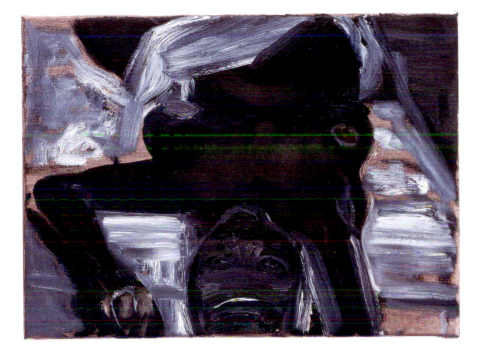

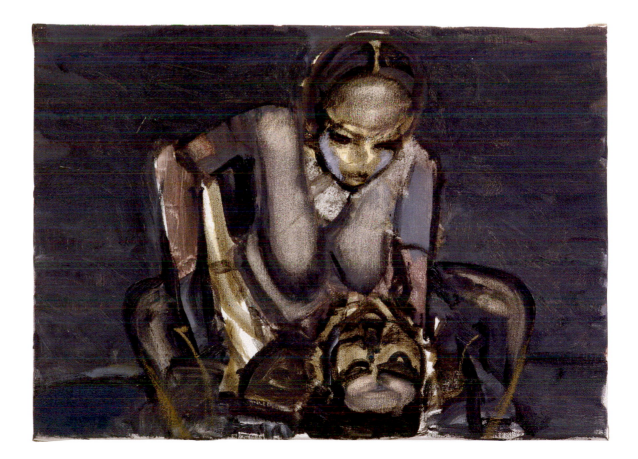

The Human Tripod, 1988; oil on canvas; 70 $^7/_8$ x 35 $^7/_{16}$ inches; Centraal Museum, Utrecht

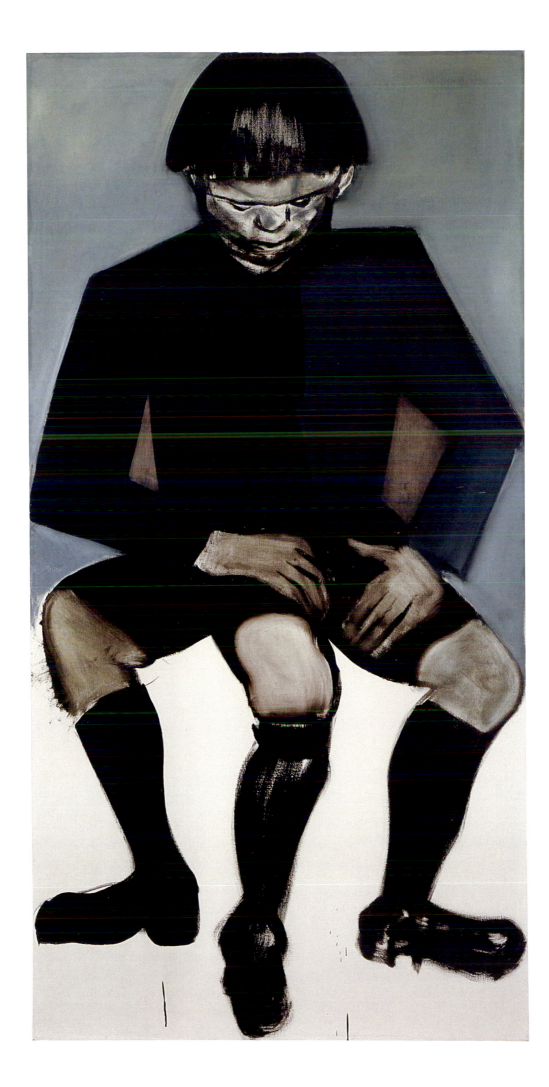

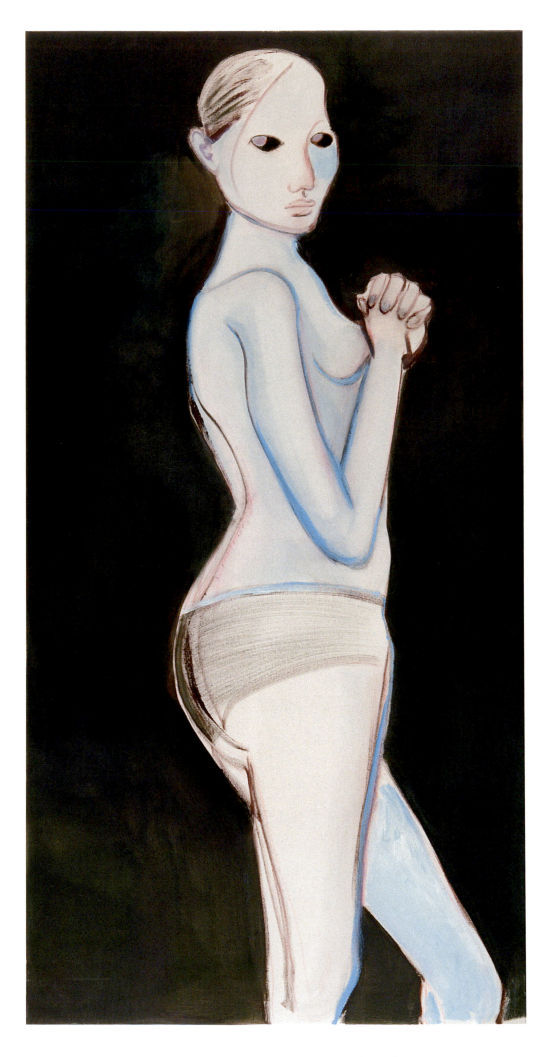

The Model, 1995; oil on canvas; 78 3/4 x 39 3/8 inches; Collection Albert H. Eenink, The Netherlands

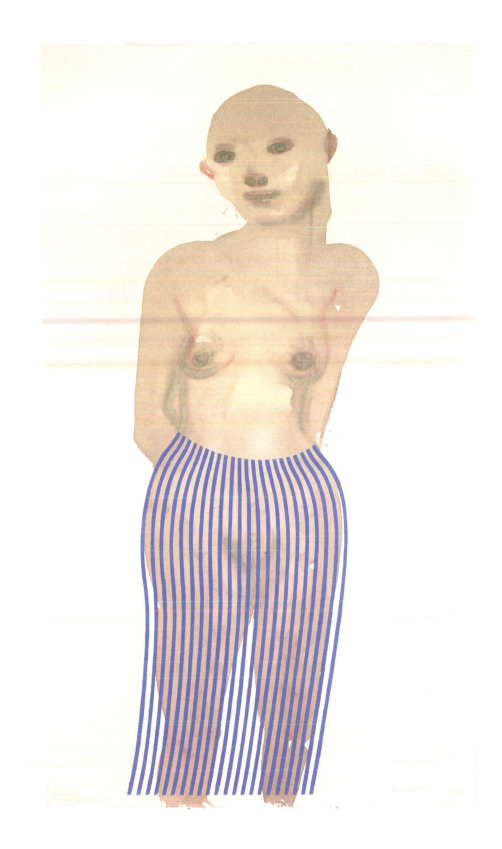

Illusion, 1998; acrylic and watercolor on paper; 49 3/16 x 27 9/16 inches; collection David Teiger

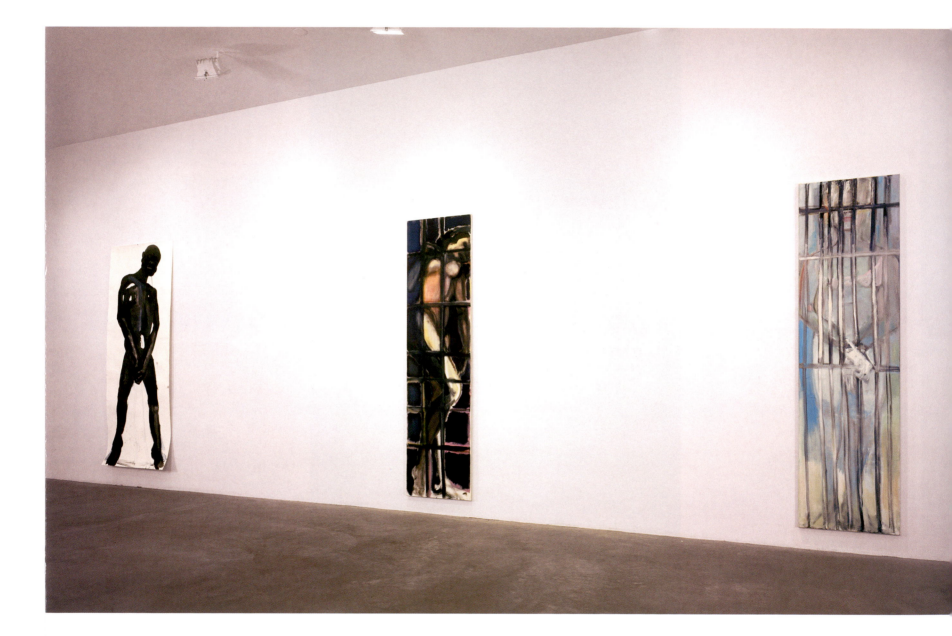

"All Is Fair in Love and War" at Jack Tilton/Anna Kustera Gallery, New York, 2001

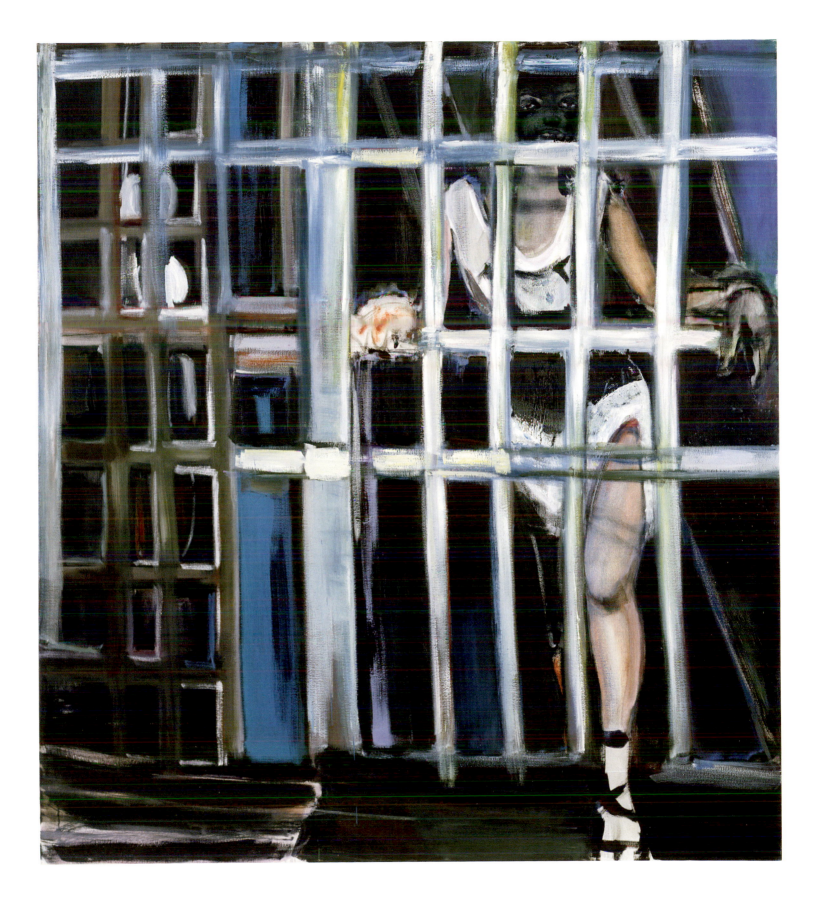

Electra, 2000; oil on canvas; 78 ³/₄ x 71 inches; Acquavella Contemporary Art

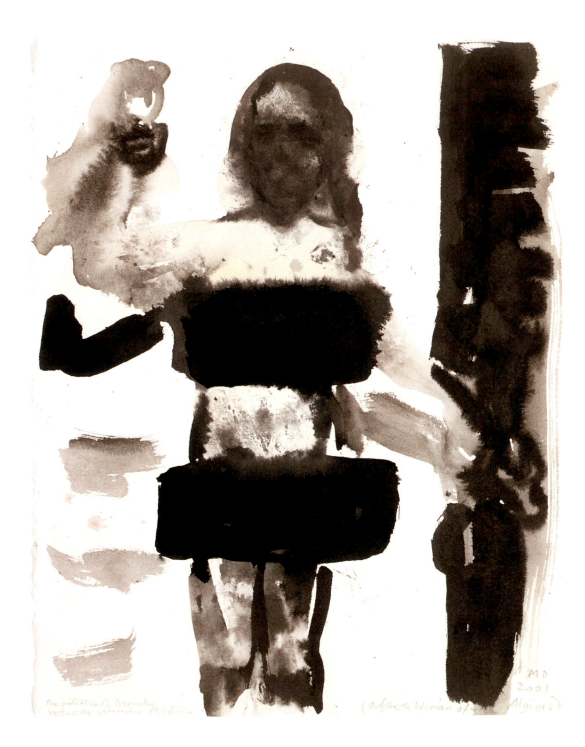

The Politics of Geometry Versus the Geography of Politics, 2001
Above: After the Woman of Algiers; opposite, clockwise from top left:
After Taboo, After Cathedral, After Aurora, and After Stella
Ink and acrylic on paper; five sheets: 17 $^{11}/_{16}$ x 13 $^{3}/_{4}$ inches each;
Fonds régional d'art contemporain de Picardie, Amiens

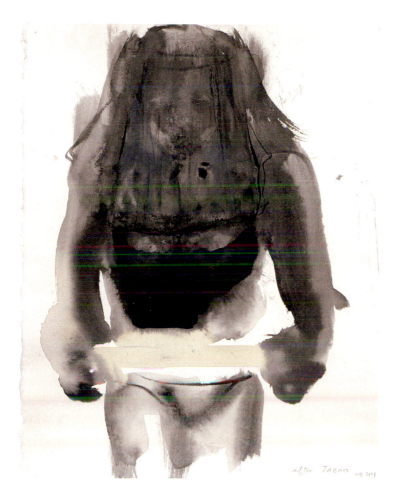

after TABOO mg 201

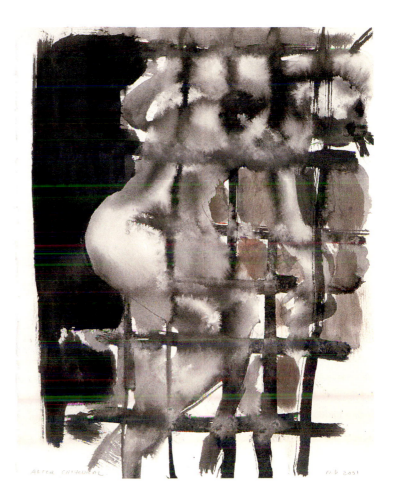

After CATHEDRAL mb 2001

After Stella 2001

After Aurora mD.2001

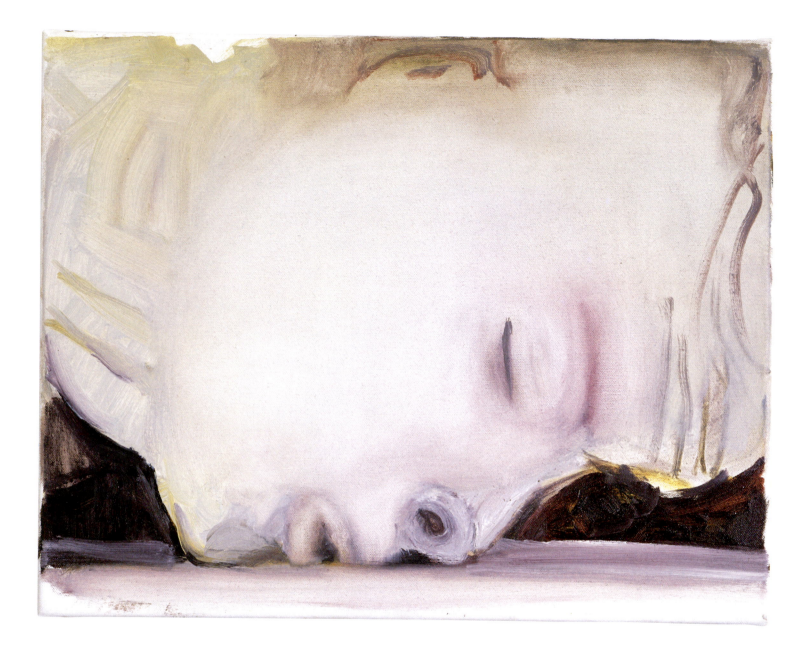

Less Dead

RICHARD SHIFF

The guilt of never knowing if one has done the "right" thing.... I see it in my own eyes.
—MARLENE DUMAS, 1974[1]

Guilty of being at too big a distance from the concreteness of life.—DUMAS, 1982[2]

Now that we know that images can mean whatever, whoever wants them to mean, we don't trust anybody anymore, especially ourselves.—DUMAS, 2003[3]

Marlene Dumas's moral dilemma is ours: try as we may, our choice of action is likely to fail us, if not now, then later. Good intentions are no guarantee that we do "the 'right' thing." This moral insecurity was already Dumas's concern during her student years. Her allusion to "the guilt of never knowing" came in an undergraduate essay in which she discussed the anxiety evident in the art of both Francisco Goya and Willem de Kooning. Even at several cultural removes, the young South African could share in this anxiety. Scare quotes marked her reference to "the 'right' thing," the equivalent, in everyday speech, of a shift in tone to acknowledge an enduring existential irony: no one knows what will prove right and to whom. To believe otherwise is to offer your mind to ideology.

Does an artist take the right meaning from her immediate situation? Whatever she perceives as the rational demands of the moment will be affected by the desires she feels. Reason and the emotions require

mutual adjustment. Does she make the right decision when she responds through an act of creation, both sensual and intellectual? At her core, a painter is a maker—this Dumas knows: "You can't TAKE a painting—you MAKE a painting."[4] By its very nature, painting is a decisive moral act. If the most transient meanings as well as the ultimate ones remain indeterminate for both artist and viewer—"images can mean whatever"—the decisions made in a painting have at least the advantage of being concrete. Just as in art, decisive acts intervene in a life, altering a person's direction. Moving this way or that, we enter into a moral void and feel the guilt of "never knowing." Yet we risk all the more guilt by refraining from action, "being at too big a distance from the concreteness of life." Although art can be an isolating enterprise— "my studio is my house, my country"[5]—Dumas is hardly a person who keeps her distance.

To the extent that photography connotes an objective uncensored vision (primarily because of its mechanical aspects), it establishes a viewer's distance from the image it presents.[6] Dumas finds her models for painting in photographs—usually press or publicity images, or just as often Polaroids that she takes of family and friends. Transforming these images, she remakes the taken. Her distinction between making (making a decision, altering the state of things) and taking (taking a meaning, accepting the given identity) plays on a common understanding reflected in colloquial language: rather than make, we "take" a conventional photographic picture. "If you take a photograph, there's always something in front of you," Dumas explained; "but with a painting there is nothing."[7] With photography, we frame a view, selecting the image from among all that reality offers, as if this view or any other needed only to be recorded by light-sensitive material. A photographer can pose a live model, compose the perspective, and perform any number of adjustments to achieve a desirable effect both before and after the image registers. Like a decision, the moment of actual registration is nevertheless unique and crucial, attesting to the living presence of the model in the captured instant.

Yet this moment of reality passes. Pondering the photographic paradox, Roland Barthes made an influential argument:

The Kiss, 2003; oil on canvas; 15 3/4 x 19 11/16 inches; courtesy the artist and Frith Street Gallery, London

By shifting this reality to the past ("this-has-been"), the photograph suggests that it [the life of the subject or model] is already dead.... In Photography, the presence of the thing (at a certain past moment) is never metaphoric; and in the case of animated beings, their life as well, except in the case of photographing corpses.[8]

Why is the "presence" of the model not metaphoric? Because a photograph represents its subject without configuring it as something else—something it is not. A corpse is the exception; photography certifies "that the corpse is alive, as *corpse*: it is the living image of a dead thing"[9]—death metaphorically transformed into preserved life. In the case of a living model, the image caught by the camera transforms only in the sense that it stills the existing presence, which survives in its photographic death as the trace of itself. If photography creates a metaphor, the metaphorical figure is stillborn, a dead metaphor, a cliché at its origin.[10]

Dumas realizes that "images can mean whatever." To this, she relates another provocative thought: "It's not that a medium dies. It's that all media have become suspect."[11] All media are unstable, unreliable, subject to manipulation and simple error, but this is not the only cause of their being suspect. The opposite also applies: a medium can be used to control and limit meaning. In any particular context, a medium will tend either to yield to or restrict meaning's free play, but the potential of each medium to turn in one direction or the other, toward either indeterminate or determined meaning, differs. Because the various media based on photography have long been the dominant suppliers of culturally coded, institutionally sanctioned imagery, painting by comparison is the less restrictive medium; it is far less likely to generate a cliché than a photograph.[12] (If this seems too bold a statement, consider a specific variant: Dumas's paintings are much less of a cliché than the photographs from which they derive.) Unlike photography, the painting process has no critical stilled moment—

despite its stock of traditional imagery, no stilled pose that it fixes into cliché.

In 2004, Dumas painted a number of images of death, including close-ups of the heads of dead individuals: Ulrike Meinhof, the subject of *Stern*; Saint Lucy as represented by Caravaggio, the subject of *Lucy*; an anonymous Chechen terrorist, the subject of *Alpha*. Not long after, she painted the head and upper torso of a young Japanese woman, *Jen* (2005). Is there a significant aesthetic (and ultimately moral) difference between the image of a dead Meinhof, Lucy, or Alpha and the image of a living Jen? This has not been Dumas's position. An image does not necessarily distinguish between the living and the dead. There is a difference, however, between photography and painting as representational media. When the subject is death, painting is more alive than photography, because it contributes its own animation. The photographic source for *Jen*, a film still reproduced as an illustration in a book, shows an unconscious drugged woman who by all appearances could be dead. She is doubly dead: dead to the world in having a dormant consciousness, and dead in having been photographed within a filmstrip. Ironically, film reanimates artificially what photography de-animates by stilling. Those who first commented on the live filming of actors and events applauded the technical achievement but recognized that the cinematic experience elicited thoughts of dead images, the cliché: "The actors perform once, and it is for the ages; their gestures have been fixed, and if they were all to die in a catastrophe, there would be no less of a continuation of the spectacle, forever identical to itself."[13] Unlike photography or even film, painting, as Dumas stated, "doesn't freeze time."[14]

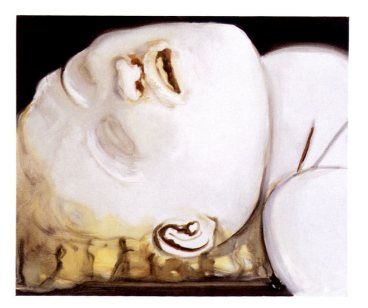

146

In a phrase, Dumas seized on the difference between *Jen* and the image of the same woman in the source photograph: by painting, as she put it, she had made "the woman less dead."[15] Was it the woman (Jen revivified) or the image of the woman (the film still retraced) that returned to the experiential world of the living? "Images don't care. Images do not discriminate between sleep and death."[16] In its many forms, Dumas plays with the distinction (the appearance of the model in life versus its representation) and the nondistinction (the similar appearance of differing physical and psychological states of being). One aspect of the source photograph that attracted the painter is far more idiosyncratic than intimations of sleep or death: Dumas noticed how the photographic perspective had set the woman's nipple extremely close to her face, and she even wondered whether the real nipple was not anatomically displaced (rather than merely appearing so). Dumas cropped the published image of the film still in order to feature this relationship in her painting— a detail that held visual curiosity and perhaps no other meaning, at least not to the artist.[17]

As a philosophical challenge to others, Dumas sometimes raises this issue—the interest to be taken in the fact of immediate appearance versus the identification of a proper category or classification. People move too quickly from the former to the latter: "Someone was interested in these smaller paintings of a naked young girl, and asked, 'What is the age of the child?' I said, 'It's not a child, it's a painting.'"[18] To appreciate Dumas's reply is to understand that the emotional life of the image belongs to the painting, not its model, and that the emotions must also belong to the artist who makes the painting as well as to the viewer who takes its meaning. The situation is further complicated because the emotional states of artist and viewer need not correspond or even be compatible. And yet, as Dumas explained,

Opposite: *Lucy*, 2004; oil on canvas; 43 5/16 x 51 3/16 inches; Tate, purchased with assistance from Foundation Dutch Artworks and Bank Giro Loterij, 2007

Above: *Death of the Author*, 2003; oil on canvas; 15 3/4 x 19 11/16 inches; collection Jolie van Leeuwen

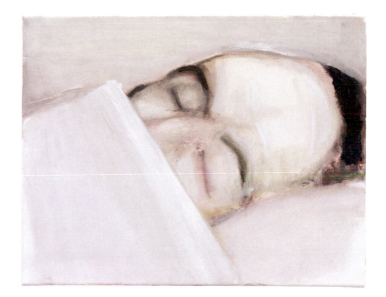

I am dealing with emotions that everyone feels. But I'm always conscious of this tension between knowing that you are making an object, a physical thing, and being aware that you are also referring to things [the emotions] that cannot actually be painted. If the painting works, that tension is in there.[19]

Painting becomes something of a Lacanian attempt to provide, if only for a moment, the missing satisfaction of every desire and the realization of its lack: "No painting can exist without the tension of what it figures and what it concretely consists of. The pleasure of what it could mean and the pain of what it's not"— for artist and viewer alike, fantasy and reality at one go.[20]

If anything, painting increases the animation and multifaceted character of its model. This is tantamount to extending the emotional range. To think across the two media of painting and photography is to understand that photography—by comparison, only by comparison—is better equipped to picture a model passively, without responding to, enhancing, or altering its existing appearance or quality. The cultural significance of photography hinges on its capacity to function as a baseline archive of fact. It stills a mobile view and represents the singular moment in all the detail available to human vision and even more, since it registers the visual beyond the physiological limitations of the eye. Beneath a surface of photographic emulsion, no traces of earlier states of the same image will be discovered, only the trace of the archival photographic moment.[21] Relative to our experience of other modes of depiction, the photographic image seems remarkably whole and

Jen, 2005; oil on canvas; 43 $^5/_{16}$ x 51 $^3/_{16}$ inches; The Museum of Modern Art, New York, fractional and promised gift of Marie-Josée and Henry R. Kravis

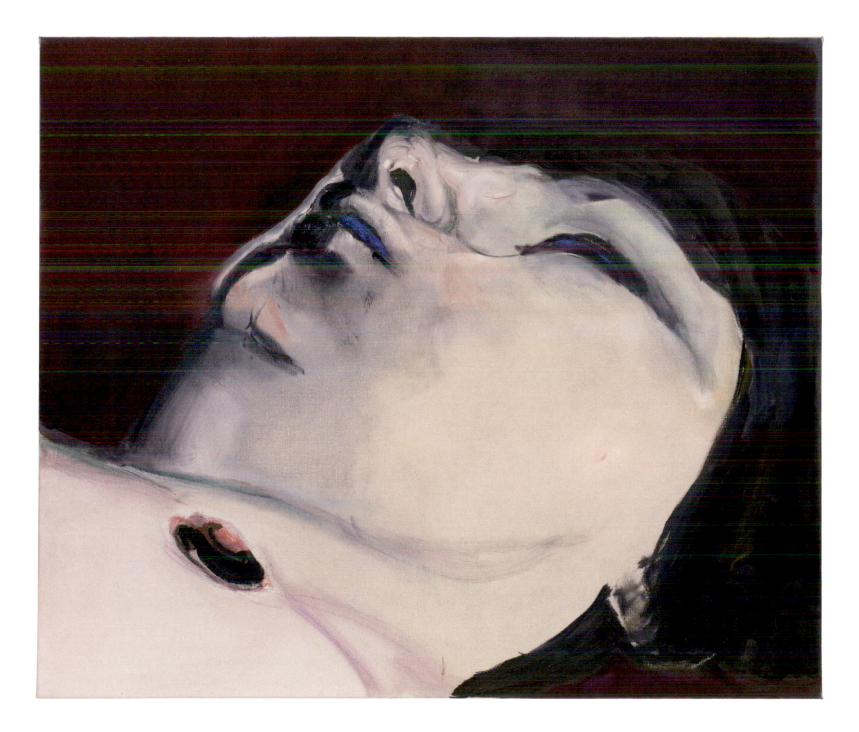

instantaneous, as if bonding a certain space to a certain time and a certain time to a certain space. Exceptions prove the rule, including early portrait daguerreotypes, which, because they required a relatively long period of exposure, failed to realize the full potential of photography to still the instant. Aware of this limitation, Walter Benjamin argued that the early subjects of photographic practice lived "not *out of* the instant, but *into* it; during the long exposure they grew, as it were, into the image."[22] The early subjects seemed to adjust their depiction, paint their own portrait—actively, not passively. Benjamin's description converts daguerreotype portraiture into an exchange of subjectivity. He suggested that the encounter between the model and the photographic apparatus was a mutual effort, with camera technology merely substituting for skills of the hand, since the speed of the picturing—even though vastly accelerated when compared to the process of drawing or painting—was not quick enough to outpace the sitter's conventional behavior and habits of perception. By living "into it," the model had time to adjust his or her performance and simultaneously adjust whatever the camera was registering.

Engaged in what is often an isolated intimate process, a painter "lives into" a painting and whatever it represents. Dumas has said as much in several different ways, including the distinction she makes between sympathy and empathy: "Sympathy suggests an agreement of temperament, and an emotional identification with a person. Empathy doesn't necessarily demand that. The contemplation of the work (when it 'works') gives a physical sensation similar to that suggested by the work."[23] Put simply, empathy is the more direct and also more dynamic relationship, established through an experiential bond of sensation. It is never as stable and abstract as a person's sympathetic identification with a personality type or a cultural orientation. Empathy, Dumas indicates, can be felt in relation to a mere scribble.[24] Representational painting becomes a matter of feeling the individual marks and tracings as well as the more general image they constitute. The surface of *Jen* makes this evident. It presents a

catalogue of sensations from one detail of facture to another: wet and dry, matte and reflective, thin and thick, neutral tones and strong chromatics—accents of blue for the eyes and mouth, green at the neck, a rose nipple, rich tones of violet and magenta surrounding the foreshortened face. Each element plays its part in creating the whole but remains relatively distinct. Looking at a painting or drawing by Dumas, you feel that you can count the separate marks that made it. The individual strokes of *Jen* feel their way around contours of the lost profile, the plaits of hair, and even the nostril. Dumas keeps the strokes visible as fluid gestures, disdaining any degree of correction that might refine them into fussiness. "For me, painting has to show its method, how it becomes what it is; [it should] move back and forth from the 'illusion' to the 'gesture.'"[25]

Dumas is a mimetic painter, coordinating her process with the model it both presents and represents; it is as if her touch were touching the model, forming it while sensing it. The three axes of the equation—artist, model, and painting—come to resemble each other through the mimetic process. They also alter each other. My description above licensed Dumas's strokes to "feel their way around"; this is to attribute a certain subjectivity and even sentience to the material and physical components of representation, as if they were leading the painter's brush as well as following it. (I will have more to say about this transfer of subjectivity.) The direction of Dumas's brush, its vector, matters. With flowing strokes that reveal their material origin, she represents a model by imitating the feel of its form as much as the look. Her graphic markings attend to the volumetric nature of the body and the functional movements of its parts. When she represents a full-length figure, as in *After Photography* (2003), she articulates the different parts of the body according to an intuitive sense of their physicality: she renders a head with a rotating stroke, a torso with a repeating arching stroke, legs and arms with long contour strokes.[26] Dumas can establish the contoured edge of a form either by tracing a line in a conventional way or by lifting the sheet of

paper and guiding the rapid flow of liquid pigment as gravity makes the edge. Sometimes a stray line or band extends out from an articulated body—a runoff of excess liquid. For large wash drawings on paper, she often uses metallic acrylic as well as ink. Its color (yellow or gold in the case of *After Photography*), coupled with the blacks and grays of the ink, aids in giving the rendered volumes the sense of a third dimension. But this type of acrylic also has a contrary effect, similar to that of the visible runoffs of color. Its glitter increases the specific material presence of the drawing surface. Although the effect is restrained, metallic acrylic catches the light, bringing extra attention to accidental spots of color that may lie outside the contours of the image proper (in *After Photography*, this chance element adds character to the otherwise blank area below the legs). The spots mean nothing—or mean "whatever." In any event, they cannot but be seen.

In 1997, Dumas provided a procedural description for her works on paper: "Paper used on the floor. Watery ink thrown onto paper like a big blob. Work with Japanese and Chinese brushes very quickly while still wet. Hold paper up to let water run down or from left to right, to create skin-like texture.... The fluid quality is important."[27] She works physically close to her sheet of paper, either squatting or resting on her knees in front of it, in position to lift it quickly to catch the potential of a flow of pigment. The paper is often human size and its manipulation requires a deft hand. "Painting is about the trace of the human touch," she stated; "It is about the skin of a surface. A painting is not a postcard. The content of a painting cannot be separated from the feel of its surface."[28] Here, Dumas inserted what might seem to be an irrelevant aside (her mind tends to race)—a painting, she said, is not a "postcard." Her remark implies that painting—good painting, guilty painting—cannot be reduced to pure message, to an image as explicit as a postcard view, so explicit that its title must read redundantly. The stock imagery of a postcard limits both visual and verbal imagination to cliché. In contrast, the message of a

painted image, with its "trace of the human touch" and "feel of its surface," moves beyond the nominal identity of its model. Even the most representational of images becomes complicated by having been drawn or painted, complicated by feelings experienced as the image was being made (not taken). So Dumas concluded: "Therefore, in spite of everything, Cézanne is more than vegetation and Picasso is more than an anus and Matisse is not a pimp."[29] To put it less colorfully, the art of Paul Cézanne, Pablo Picasso, and Henri Matisse will never be interpreted adequately by those who attend to the stock associations of its subject matter alone. Cézanne's view of a forest, Matisse's display of his coy and brazen models, Picasso's exposure of an anus no matter what the anatomical perspective—none of these characteristic features conveys the specific feel of the work. The thematic material amounts to what Dumas might call the nudity factor, the generalization, the predictable cliché in Cézanne, Matisse, and Picasso. The antidote to nudity is nakedness, as Dumas implies in a different context, considering *The Particularity of Nakedness* (1987): "It was not the nude I was looking for, nor the posing figure, but the erotic conditions of life that I was after. Two 'subjects' confronting each other."[30] Nudity is repetitive impersonal cliché. Nakedness lives in the sensual exchange of the moment.

Dumas has been particularly sensitive to the factor of exchange in both art and life. "Painting," she stated, "is about the trace of the human touch"[31]—a moving trace, passing through the experience of time and space. Having selected a photograph, she reproduces its general configuration, often tracing it with the aid of an opaque projector. She renders the taken image less dead, converting its formulaic nudity into the specificity and immediacy of nakedness.[32] Touch is the vehicle, a medium in itself. It is reciprocal, a matter of touching and being touched: "two 'subjects' confronting each other." The hand feels the set of sensations produced by its own actions. Dumas associates the painter's touch with an erotically charged human relationship. The situation of the painter is analogous to what once occurred when the subject of portraiture encountered

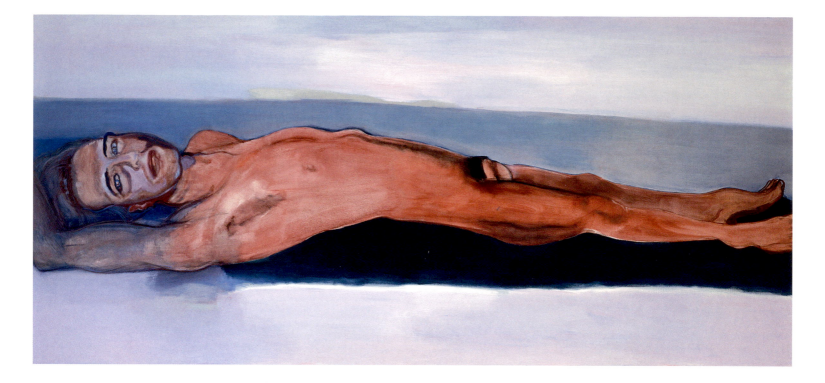

the daguerreotype medium during photography's evolutionary infancy. The daguerreotype itself became a subject of representation, changing according to, and therefore depicted by, the portrait it "took." Instantaneous photography abandoned this exchange, this erotic love affair between, on the one hand, the photographer and the equipment and, on the other hand, the equipment and the model: "With photographic activities," Dumas wrote, "it is possible that they who take the picture leave no traces of their presence, and are absent from the pictures."[33] Even the model may be absent: dead. Dumas turns to her own advantage the authorial anonymity of the press photographs she tends to favor, stating that the use of such sources eliminates the "mannerisms" that would enter her painting were she to work exclusively from her imagination.[34] She explained, "I don't want to worship my own handwriting."[35] Her personality and fantasy life are present in her art but her procedural decisions ensure that the "Dumas" in Dumas is not all that exists there. She is not her own cliché.

As one person responds to another (or to the Other in oneself), each party becomes the expressive medium for the other's self-understanding. The central meaning of Dumas's art is the fluidity of such relationships—in love, in politics, in art itself. Recounting her decision to move from her native Cape Town to Amsterdam in 1976, a development made possible by a scholarship grant, she acknowledged (with irony) the parallel significance of the three categories of experience to which she had committed herself. One: "My whole love life was mixed up"—she was dividing her love between two men. Two: "My politics were mixed up"—she was resisting the divisions of apartheid, which put her at odds with her own society. Three: "My concept of art was mixed up"—as both a "so-called painterly person" and an "anti-painter," she was aesthetically divided against herself.[36] Her conclusion: "It was a good time to leave."[37] Dumas's love of a second man is the easiest of her problems to grasp in terms of its existential dilemma. Already in love with the first man, she began to love the second because she allowed experience (the unforeseen development of an emotional attachment) to interfere with the cultural law (love only one) that would have prevented her from recognizing her emotions in their full immediacy. Yet the spontaneity of an emotional experience does not guarantee that it is "the 'right' thing," and Dumas could not help but be troubled by her situation.

When Dumas paints from a source or model in photographic form, photography and painting, as well as the real-life model, become subjects to be experienced; photography and painting confront each other in Dumas's understanding. Whatever the status of the

The Particularity of Nakedness, 1987; oil on canvas; 55 1/8 x 118 1/8 inches; Van Abbemuseum Collection, Eindhoven

source image, she actively changes it in painting it, accepting her responsibility beyond the taking for several aspects of making—or remaking. The making may be more of a remaking because the relationship between taking and making is fluid. If it were more stable, Dumas would have little to worry over, less guilt to fear. Even during the nineteenth century, theorists understood photography as making as well as taking or finding. Against the concern that the new medium would "substitut[e] mere mechanical labor in lieu of talent and experience," William Henry Fox Talbot, inventor of the paper-print process, noted that the new photographic medium left "ample room for the exercise of skill and judgment."[38] According to Francis Wey in 1851, the soft-focus paper print, as opposed to the crisp daguerreotype plate, effectively "animated" the camera image, affording not only "the reproduction of planes and lines" but also "the expression of feeling"—feeling to be identified with the photographic image as well as with the object of representation and the emotional state of the photographer-artist who chose to arrange the picture.[39] The early critics and theorists were free to stress the photographic moment of stillness as a pictorial advantage; or, to the contrary, they could focus on all the allusions to movement and duration that such a finely descriptive image might still retain.[40] The photographic medium was there to be used. Which way might be the right way, the best way, was logically indeterminable and subject to being declared according to the politics of the moment.

Whatever: From Guilt to Grief

Perhaps images mean what they will: you make them, but they act too, by virtue of their material properties and emotional potential. They act on you, their viewer-creator—on your psychic state—just as they act on others. Dumas has referred to the demise of "the so-called passive spectator"; artists, she says, are now "stuck with (over)active collaborators, finishing off the artworks."[41] Does it matter what the interpreters say?

Whatever. In 2003, Dumas uttered this word in all its irony: "Now that we know that images can mean whatever." In today's colloquial English, "whatever" connotes critical resignation, an indeterminateness more comedic than tragic. "Whatever" intones with a shrug. It also expresses suspicion and can even be accusatory when coming as the sarcastic response to someone else's statement. Dumas, a master of the tragic-comic, gives the word a humorous edge, yet embeds it in sober reflection. She knows that the viewer of an image brings his or her cultural indoctrination and personal history to bear on the perception of meaning, that differing cultures and histories generate a conflict of interpretations, that competing ideological structures lead individuals deep into moral confusion. "When I paint a 'terrorist' or 'freedom fighter' (the description depends on your point of view)…my painting does not clarify politics or explain a cause. I paint my anxiety."[42] She sees this doubt in her own eyes, and we see it in ours. "Whatever" (as a qualification) leaves morality open.

Dumas embodies cultural division: South African by birth and upbringing; privileged as white; disempowered as female; Afrikaans-speaking; speaking against the policy of apartheid that would maintain her white Afrikaner privilege; living in Amsterdam while maintaining emotional ties to Cape Town; nevertheless, by choice, more international than either Dutch or South African; a painter of the backsides of porn stars (*Mandy*, 1998) and of infants (*The Secret*, 1994); confronting fantasy (*Snow White in the Wrong Story*, 1988), fact (*Blindfolded*, 2002), and a theory of both (*Death of the Author*, 2003).[43] (What is theory?—a generalizing fantasy about particular facts.) For a Paris show in 1994, she wrote, "My fatherland is South Africa, my mother tongue is Afrikaans, my surname is French. I don't speak French."[44] And for a New York show the same year: "I am NOT a New Yorker. I am NOT Dutch. I am NO longer living in South Africa. I am always 'not from here.'"[45] With a mobile identity, Dumas makes no excuses for who she is not. She is too many people to be typecast as one.

Coming of artistic age during the 1970s and 80s as a skilled painter, Dumas was "not from here" in an art-historical sense—out of sync with the prevailing view as to where artistic practice should be heading. Painting and its existentialist anxieties were supposed to have died a formalist death. During her early years in Europe, from 1976 to about 1983, this "born painter" (as one teacher called her[46]) yielded to peer pressure, channeling much of her creativity into collage and other forms of construction with materials gleaned from features of the common culture. She often included language as an internal guide to her multivalent meaning (*Don't Talk to Strangers*, 1977) and sometimes arranged found images according to a structural principle (*Couples*, 1978).[47] Some might classify this body of work as a variation on Conceptual art, informed by psychology, anthropology, and the other human sciences; others might regard it as a type of structural abstraction, as formal an exercise as the painting that this type of work supplanted. Whatever the verdict, Dumas returned full time to her first love and recommitted herself to painting the human figure.[48] This took courage, for she had observed within her local community that "all the smart artists were doing other kinds of work"[49]—almost anything but painting, especially the representational type.

To complicate matters, Dumas was choosing to concentrate on a medium traditionally identified with men—or, what may have been worse, dead men, those "authors" whose authority was rapidly passing from history, or at least from fashion.[50] Painting, "a medium declared dead…It is an anachronism. It is outdated."[51] "The idea was that, apart from the fact that painting is dead, it's also for dead males," Dumas recalled.[52] To the extent that painting had been associated with a lineage of great male "geniuses," the political meaning of the death of painting was the demise of patriarchy, the end of gendering social and cultural authority as male. "Why not turn it around?" Dumas asked herself: "So I decided that instead of saying that in spite of the fact I'm a woman, I also like to paint, I'd say I paint *because* I'm a woman, I paint *because* I'm a blonde."[53] Dumas wears her artificial blondness as a sign of her power to choose and to create according to her will.[54] "I paint because I like to be bought and sold," she said, alluding ironically to her success in the art market (traditionally enjoyed by men far more than women) and with a nod to the history of women who have been led to sell their bodies in lieu of their creativity and imagination.[55] She is contradictory. She resembles a gestural artist like Willem de Kooning in the broad flow of her brush technique, but usually remains quite faithful to her base in photographic representation. Her images shock viewers out of the customary intellectual and emotional abstractions that would shield them from the problematic features of ordinary life, its sexuality, social contracts, and political conflict. She reveals the alien nature of babies (*Warhol's Child*, 1989–91); lends her personal touch to pornographic poses that offer predictable obscenities (*D-rection*, 1999); introduces the more disturbing obscenity of violence and torture, which should never be expected (*The Blindfolded Man*, 2007); and pictures the death that occurs against nature, by murder or suicide (*Stern*).

Don't Talk to Strangers, 1977, detail; oil, collage, pencil, and Sellotape on canvas; 49 3/16 x 61 7/16 inches; collection De Ateliers, Amsterdam

Opposite: Gerhard Richter, *Tote* from *18. Oktober 1977*, 1988; oil on canvas; 24 1/2 x 28 3/4 inches; The Museum of Modern Art, New York, the Sidney and Harriet Janis Collection, gift of Philip Johnson, and acquired through the Lillie P. Bliss Bequest (all by exchange); Enid A. Haupt Fund; Nina and Gordon Bunshaft Bequest Fund; and gift of Emily Rauh Pulitzer

The figure shown in *Stern*, the political radical Meinhof, was dead when photographed. In Dumas's painting, this image survives a double death, like the figure in *Jen*. Meinhof's picture appeared in the German news magazine *Stern* (hence Dumas's title), and the painter took it—"took" with a particular irony, for her actual source was already once or twice removed from its origin. The original image was a police photograph, which *Stern* then published. Gerhard Richter took the image from *Stern* for his archive and in 1988 painted it three times. Documenting these works, the catalogue of an exhibition at the Museum of Modern Art, New York, reproduced it once more, ultimately becoming Dumas's proximate source.[56] Richter had appropriated the image and similar photographs for his cycle of paintings *18. Oktober 1977* (1988), representing the deaths of several members of Meinhof's group, the Rote Armee Fraktion. Because Dumas chose to paint a photograph that had already been painted by an artist senior to her, her work became a commentary not only on the photograph and its subject matter but also on Richter, a ranking figure in a new European order of art. She commented playfully: "I also wanted to see with *Stern*, if I could take Richter's source out of its blur."[57]

Richter blurred his images, mimicking a type of photographic filmic look: a distancing quality, an emotional fade. In contrast, Dumas's version is more graphic, more immediate; she made the image of death less dead. Her relatively crisp rendering of the rope burn and shadow on Meinhof's neck gives it the potential to be seen as a necklace or decorative ribbon (ironically, known in English as a "choker"). Perhaps we learn from the ambiguity in Dumas's rendering of Meinhof that we should be wary of judging moral character from appearances. "It's not that *I* make things so ambiguous," Dumas insisted; "they *are* ambiguous."[58] But Richter, too, altered and ambiguated the image: "The photograph provokes horror, and [my] painting—with the same motif—something more like grief." Asked toward what his grief was directed, he replied: "That it is the way it is." He was grieving over human nature: "Grief is not tied to any [political] 'cause.'"[59] We grieve because we become aware that circumstances force individuals into ideological molds, models of one kind or another for a social order. When the social order fails, it takes the individuals with it. We grieve because we cannot prevent the tragedies that result from our beliefs, ideas, and causes. Richter's point was much the same as Dumas's—his grief was her guilt over realizing that we act in ignorance of the right course. What dies with the "death of painting," with the death of any medium, is its insight into intellectual and emotional life—its potential to make an indoctrinated person, any individual, less fixed in the social order, less dead. "Acknowledging and embracing ambiguity does not place one above suspicion," Dumas explained.[60] But painting is worth doing for the sake of extending the possibilities of moral choice.

Stern, 2004; oil on canvas; 43 $^5/_{16}$ x 51 $^3/_{16}$ inches; Tate, purchased with assistance from Foundation Dutch Artworks and Bank Giro Loterij, 2007

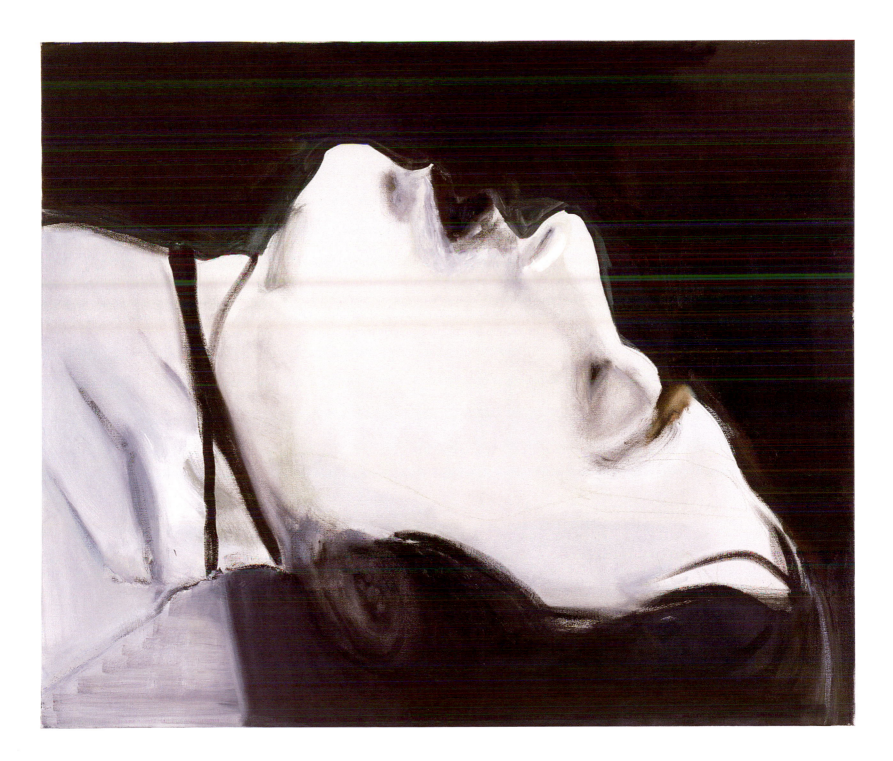

Now

"Now that we know that images can mean whatever": Dumas expressed the irony accompanying not only her "whatever" but also her "now." "Now," she said, now that we know that anything can mean anything, we have all the more need to be suspicious of the unacknowledged motivations that would lead meaning this way or that; we need to accept responsibility for our decisive actions. She seems to express the sensitivities of an existentialist, a type hardly belonging to "now." "All choices lead to ethics," she told her friend, artist Barbara Bloom; "Too many alternatives, combined with a lively imagination, lead you into an existential anxiety, where you are in continuous confusion and darkness."[61] Her early references to guilt relate to her reading works by major figures of postwar European intellectual life, such as theologian Paul Tillich and perceptual psychologist Maurice Merleau-Ponty. In her undergraduate essay of 1974, she quoted from both (for example, this from Tillich: "The courage to be is rooted in the God who appears when God has disappeared in the anxiety of doubt"[62]). "Now"—with several decades of poststructuralist speculation leading us to accept the evasiveness of meaning as a quotidian fact—we may have become inured to living in a state of moral confusion. The confusion that extends beyond doubt no longer causes deep personal anxiety. Neglecting to accept responsibility for individual action in a conflicted society, we are likely to blame the evils of the world on conceptual abstractions rather than on our existential selves: the fault will lie in ideology, essentialism, and hierarchy, as well as in a certain "whatever" factor, the unavoidable play of structural difference.

Within the play of difference, anything can mean or refer to anything else—arbitrarily. When we live within this play of meaning, experiencing it, we feel liberated; but when we theorize this play, we risk stilling it. Dumas once quoted some relevant words of painter-critic Fairfield Porter: "Art is concerned with the particular and it reconciles us to the arbitrary. There can be no 'logical' communication at all, for the arbitrariness of the original experience will not survive a generalization that is necessary for logical communication."[63] Wary that her contemporaries were replacing experience with a structural logic (playful or not), Dumas stated in 1998: "There is too much emphasis on the body these days, not *our* bodies but *the* body."[64] The body had become a conceptual abstraction, a photographic type, a pose: the female body, the male body, the black body, the white body—whatever. In a racist society, any marked perceptible difference in the body has the potential to inject race or ethnicity into a discourse, assigning to the terms of the difference a relative value. "There's black and white as races," Dumas noted, "and there's black and white as colors."[65] The former distinction (color as sign) holds meaning conceptually; the latter distinction (color as matter or mark) holds meaning experientially. Our existential doubt stems from our need for meaning, that is, the need to convert the mark into a sign. In matters of race, our culture suffers from having acquired the distinctions in meaning that it demands. In pictures, however, a white person can be colored black, and a black person can be colored white. Black and white, brown and pink, are mere colors. Dumas's explicit style of rendering—taking "Richter's source out of its blur"—provocatively blurs this other field of difference.[66]

A large number of Dumas's paintings and drawings might be cited in this regard. *The Conspiracy* (1994) shows two young girls, one black with dyed blond hair (a Dumas alter ego?), the other white with dark hair. Is it a conspiracy of two races, threatening to combine what ought to remain separate? Or a conspiracy of two children, for two of any kind constitutes a conspiracy, an illicit like-mindedness? To know Dumas's source is to think differently, for the "black" girl is based on a family Polaroid of her daughter Helena looking quite dark and tanned in relation to a pale friend. The painter has merely extended the difference, not a matter of race but of color. For *Thumbsucker* (1994), Dumas rendered a white boy mostly black (but partly white and also blue and orange). The coloration is specific to the painting, not a cultural generality—color as an arbitrary mark that resists becoming a sign.[67] Among Dumas's models for the Magdalenas are both white ones like *Magdalena*

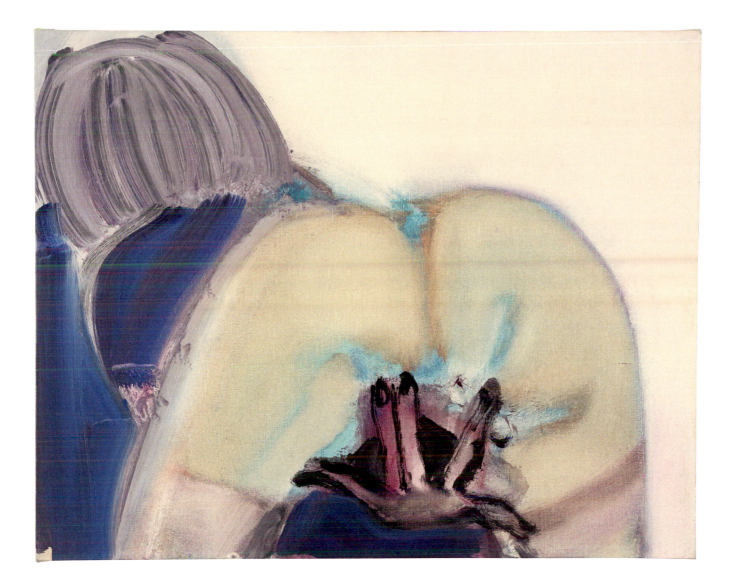

Fingers, 1999; oil on canvas; 15 3/4 x 19 11/16 inches; collection Jan Andriesse

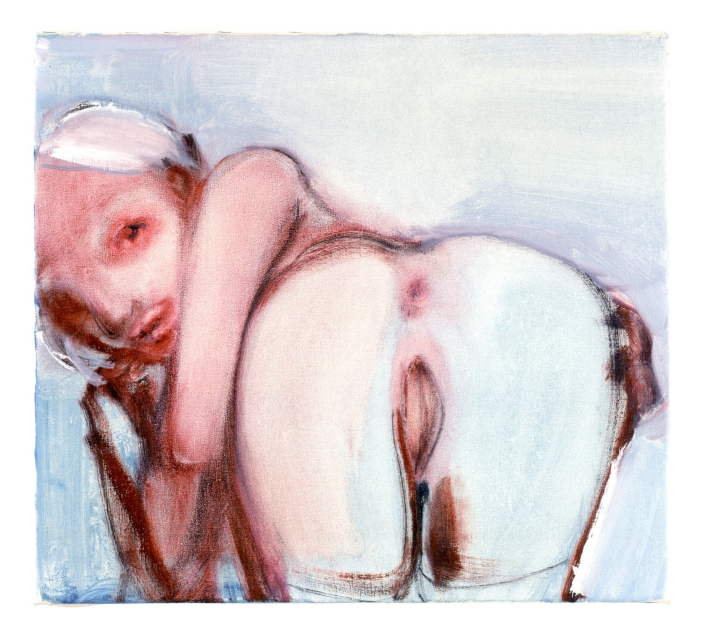

Miss Pompadour, 1999; oil on canvas; 18 ¹/₈ x 19 ¹¹/₁₆ inches; collection Dominic van den Boogerd, Amsterdam

(Newman's Zip) and black ones like *Magdalena (Manet's Queen)* (both 1995); but there are still others that seem to perform a coloristic transformation. An example is *Magdalena* (1995), a white, even blonde, woman who appears dark, even black. To complicate matters, areas that at first may appear as deep grays or blacks within this figure prove to consist of modulated reds, blues, and yellows. In the end, we are likely to perceive this figure as "white." But does not "black" skin also consist of reds, blues, and yellows?

Those desperate for meaning will convert color-marks into color-signs. And signs into other signs: "I get irritated when I draw a 'wortel' [carrot] and it is suggested that I want to draw a penis. If I want to draw a penis," Dumas stated, "I'll draw one."[68] We conveniently forget that the whatever factor in interpretation reflects on the interpreter first and only secondarily on the artist, if at all. If we are affected one way or another by sexual imagery, our response accords with our own sexuality, our desires for and fetishizing of bodies and objects. Each of us probably resists the notion that our own sexuality may not be private but instead fully shared with a class of people similarly indoctrinated by the general culture. However we think of this, we cannot assume that the situation has affected the artist in the same way. She, too, locates her sexuality in the particularity of her nakedness, not her nudity. In any event, the potential for meaning becomes all the stronger to the extent that painting remains open and ambiguous, resisting the photographic fixations of culture. This is its value, relative to photography. Culture is the objectifying fetishist, served by photographic imagery. Painting is the lover.

Closeness

In this brief passage of my lips toward her
cheek it was ten Albertines that I saw....
At the actual contact between flesh and flesh,
the lips...are alone; the sense of sight [has]
long since deserted them.
—MARCEL PROUST, 1920–21[69]

When you're dead, you're dead for a long,
long time.—WILLEM DE KOONING, c. 1970[70]

The closeness and contact characteristic of painting leads not to stillness and the death of the image but to increased animation. Dumas has produced at least one oil-on-canvas painting (there may be others) that brings images of death and kissing into generative ambiguity: *The Kiss* (2003). Her source photograph for this relatively small painting is a still from Alfred Hitchcock's black-and-white movie *Psycho* (1960), reproduced in a book illustrating the film's celebrated murder scene, which occurs as the female lead, Janet Leigh, showers. Stabbed multiple times, the character bleeds to death in the flow of water. The camera records her face-down on a cold porcelain-white floor—dead—yet seemingly returning the photographic look with an open-eyed stare. Rendering *The Kiss*, Dumas decided to close the woman's eye: "I couldn't get the 'open eye' to work in a painterly plausible way."[71] She also gave the figure more of a true profile view, altering her relationship to the ground beneath. This slight change in perspective was not necessarily a deliberate strategy; it may have resulted from the rapid application of paint, as if the dead woman's orientation were a material as much as a figural intuition, a change occurring within the "mind" of the painting as much as in that of the artist. "If the painting does not want to go in the direction where I thought it was going when I started, then I let it go its own way to some extent. I love chance.... Without surprise, no drawing."[72] Dumas has also spoken of the chance perspectives introduced by the opaque projector she uses as an aid for large compositions: "It is not very 'accurate' and also does not care to be so. 'Strange' angles of perspective can be due to whatever type of chair I put the [projector] on."[73] Her language is significant: the painting will not go where it "does not want to go"; accurate is something the projector "does not care to be." I will return to this very familiar yet "strange" attribution of an alien volition.

Even in death—but it has become less dead—the figural pose of *The Kiss* is ambiguous. It is an open question whether the cause of the ambiguity is Dumas's will or the painting's will. The Janet Leigh figure could just as well be kissing the ground as having fallen dead.

Dumas set the head tightly into the rectangular space of the canvas, hitting its four edges with four different elements present in her source: "two subjects confronting each other," as she might say, Hitchcock's film still and her rectangle. At the left, a ridged neck; at the right, ridges of the brow; at the top, an ear (not visible in the still); and at the bottom, lips against a horizontal slab, conceivably kissing. With a rational application of fantasy, Dumas imagines that the figure could be kissing another painting.[74] If so, *The Kiss* would be a painting on the theme of painting, not the themes of death and stillness. A painting can feature its play of mark (sensuality) as opposed to its play of sign (meaning). In this respect, *The Kiss* resembles *Immaculate* (2003), a torso fit snugly into its rectangle, as if kissing the framing edges (in the sense that two billiard balls are said to "kiss"). "An image needs edges to belong to," Dumas wrote; and here we imagine a representational painting in love with its abstract frame.[75] As in composing *The Kiss*, Dumas rotated the source image slightly, causing the subject's nipples to fit in near symmetry into the two upper corners of the small vertical canvas (two spots, like tacks on a studio wall).[76] The delicately brushed areas of this painting can cause a viewer to forget that it presents a full-frontal vulvic view—a description that evokes the pornographic character of its source. But this work is too personal, too touched, to function as porn.[77] It can be no more than the sign of pornography. Its specific materiality, its painterly mark, interferes with the viewer's fixation on the clichéd porno pose of genital exposure. *Immaculate* is less dead than its source, more naked than nude. Without passing judgment on this body, Dumas takes it, remakes it with "the freedom of the amoral touch,"[78] and regards it only for what it is. She redeems *Immaculate*, buying back from society a body that had sold itself too cheaply.

Perhaps the main reason that an image of death became *The Kiss* is that Dumas closed its open eye. A few years prior, she had rendered the Proustian act of *Kissing with Your Eyes Closed* (1998) as a small work on paper. Proust famously elaborated on the closeness of kissing, its negation of the distance that vision needs for its effective operation. Dumas similarly noted that an artist is handicapped in attempting to show how kissing feels, for the act cannot be coherently repre-

sented from the position in which it occurs; to represent the kiss is to admit one's distance from the actual sensation.[79] The closeness of kissing also eliminates the distance of gender (male and female lips are functionally the same, marked as different only by a culture of cosmetics). Dumas has commented on the irrelevance of sexual difference when applied to this type of human relationship: her image could be of two women, two men, or the more standard combination—"it doesn't matter at all what the sex is."[80] The eyes in *Kissing with Your Eyes Closed* are shut by the darkness of dark pigment. The rendering of the lips depends for its articulation on a narrow reserve of white between the two faces. The prominent hands, one dark and firmly drawn and the other somewhat tentative and faint, represent an exchange of the figures' caress. Their linearity also lies flat and broad against the paper, evoking the touch and presence of the artist, who goes only so far in adjusting her handling of materials to the implicit demands of illustrative refinement. Her comment on *Kissing with Your Eyes Closed* moves from the general to the specific: "Certain (intimate) activities make people close their eyes, although not all of the people all of the time. Picasso is more the type that says a painter can be blinded...while others emphasize the actual seeing and optical effects more. I am more the Picasso type, in art, not necessarily in life, when it comes to kissing."[81]

In Dumas's experience, making art about bodily sensations is very much a tactile matter—articulated by following one's hand, often rather blindly, instead of comprehending by eye the fixed image of a codified expression. By this standard, de Kooning, too, was "more the Picasso type." Dumas's interest in his art is long-standing, as her undergraduate essay demonstrates, although for many years she knew his work only through reproductions.[82] The two painters have much in

common, beyond their connection to the culture of the Netherlands. In Dumas's sense, both are empathic types, releasing their feelings from the restrictions set by concepts. Like Dumas, de Kooning, who had worked as a commercial artist, was acutely conscious of fashion, the world of advertising, and the power of established photographic icons. He treated some of the vast store of modern popular imagery with reverence, but most of it with irony. His titles came after the fact and were also ironic, occasionally referring to specific individuals such as Mae West or Marilyn Monroe. His *Mae West* (1964) assumes a Dumas-like vulvic pose, as if the star were displaying her body before an adults-only audience.[83]

De Kooning's *Marilyn Monroe* (1954) has the more iconic tempered sexuality of a smiling pin-up girl. "She" does not depict the real Marilyn Monroe but a Marilyn Monroe type, determined by the resemblance that de Kooning and his friends perceived once the painting had been completed.[84] A film shot in 1959 shows de Kooning turning his attention to a pin-up calendar in his studio, with a photograph modeled after well-known images of the Hollywood star. In a deadpan but bemused manner, he remarked: "I like the type more than the original."[85] If only because of Monroe's preeminence, her appearance having been converted by publicity photos into gendered cliché, de Kooning's preference for the derivative type over the original model must have been an odd position to hold. Why would he have chosen the secondary image over the primary, the look-alike rather than the look? Perhaps he intuited that the type offered him a choice: although he could have focused on the regularity of the pose, he was also free to perceive the variation, the degrees of color in the type, as it shifted, so to speak, from black to white, white to black. The generic anonymity of the pin-up— this general and yet specific image—demonstrates that it is as much in the nature of the type to change as to remain fixed in its representation of the authoritative original. Like de Kooning's *Marilyn Monroe*, each of Dumas's models, whether the "white" *Magdalena (Newman's Zip)* or the "black" *Magdalena (Manet's Queen)*, raises its dead cliché to a higher form of life.

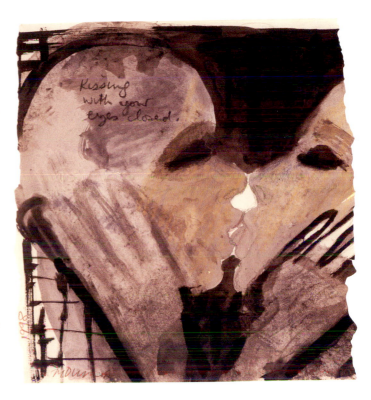

De Kooning imitated the postures of the models he actually drew from life as an attempt to assimilate the internal feel of another's body; this allowed him to draw the body with conviction. Like Dumas, he enacted a physical closeness to his art, stressing the substitution of hand for eye as a way of making the configured view intimate. He went so far as to practice drawing with his eyes closed, feeling his way around the confines of the paper, separating his sense of handling from ordinary vision, giving the paper a Proustian "kiss." He also drew in an intentionally casual distracted state, often taking his sources from the transient imagery of the television screen.[86] A drawing he did sometime during the late 1960s or 70s, one of many of the type, shows a female figure again in a Dumas-esque vulvic pose, recalling his image of Mae West. He created this drawing either blindly or extraordinarily quickly, with the result that insufficient space remained at the top of the small sheet to establish a properly proportioned head. The eyes lie atop a flattened head; the hair hanging off to the left side is composed of two or three fluid strokes. De Kooning produced great numbers of these rapid office-pad sketches. They are alive in the extreme, a distraction from any thoughts of being "dead for a long, long time."

Dumas has a deftness analogous to de Kooning's. She often challenges her talent, as he did his, by setting obstacles to its execution. Painting images of female and male exhibitionism from the pages of pornography, she focuses on the cultural (not moral) affront of genital

Opposite: Dumas holding *Immaculate*, 2003; oil on canvas; 9 7/16 x 7 1/16 inches; collection of the artist

Above: *Kissing with Your Eyes Closed*, 1998; mixed media on paper; 13 x 14 inches; collection Jerome L. and Ellen Stern

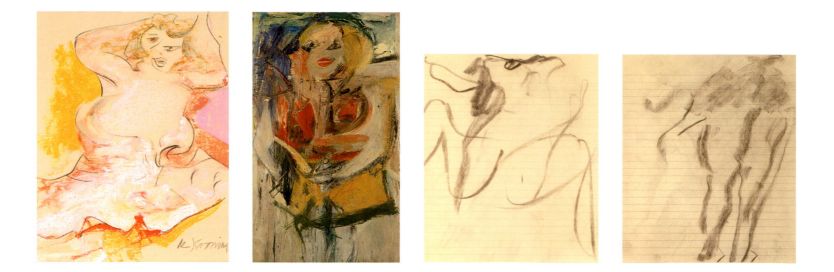

and anal exposure.[87] She often highlights the nominally offensive features of the imagery as a homeopathic strategy to return them to the body in its psychological wholeness, its nakedness. She reintroduces ambiguity to these images of formulaic ritual, making the poses less dead by mimicking them within the range of gestures that can be scaled to her hand moving within the range of canvas or paper. The watercolor *Head Rest* (2001) shows a female figure bent over and around herself so that her underside is on top and her top, her head, rests at the bottom. The anatomical orientation, in relation to the pictorial frame, has been inverted. Like de Kooning's spread-leg vulvic figure set into the unyielding boundaries of his paper, Dumas's *Head Rest* seems to have been generated by a felt miscalculation. As if having run out of pictorial space as she followed the bend of the figure, she resorted to compressing its dark head into the lower right corner of the vertical rectangle. The rest of the figure, quite pink, tilts upward toward the left, crowned by a splayed hand that suggests a narcissistic caress and perhaps masturbation. The woman touches herself. Yet each of us has hands, and any person, male or female, can imagine his or her hand being substituted for the one Dumas has indicated— just as Dumas's own hand, while drawing, must have been fondling the figure's hand and every other form in the artwork, including the flat plane of the paper. Like attracts like; a mimetic process imitates at every oppor- tunity. Pornography, however, is not mimetic: generic in nature—nude rather than naked—it is already like other pornography.[88] As pornography, *Head Rest* seems to call out like a generic template: any hand, *your* hand here (imagine it where the figure's hand is). But the placement of the image within the rectangle is another matter entirely, with an emotional valence of a different sort.

The formulaic gesture of hand fondling backside also characterizes the pose in *Fingers* (1999). Here, too, Dumas distinguishes her work by setting the figure into the rectangle in a challenging manner, with the head as far to the upper left as possible. The splay of the figure's hand corresponds to the splaying of her legs, while variations in hue—bluish, pinkish violet, and yellowish tones—fan out across the buttocks, as if extending the implied touch and movement of the hand. This hand belongs not only to the figure but also to the artist and, by empathic contact, the viewer. Apparently, Dumas followed *Fingers* with the rapidly executed brush-and-ink drawing *After Fingers* (1999). Its hand is all fingers, no thumb, as it spreads over the vulva, touching but not grasping. My guess is that this way of rendering the hand is Dumas's erotic intuition; it feels "right," this "amoral touch," which involves nothing so aggressive as grasping (hence, no thumb). The pornographic image, as Dumas remakes it, suggests an exploratory, potentially masturbatory touch that is neither more nor less erotic than Dumas's own flowing exploratory line. The line moves so engagingly that you imagine *your* hand here, drawing.

Stretch: From I to Me

When Dumas draws a line, the line says "I am aware and conscious." —JAN ANDRIESSE, 2003[89]

At two points in this essay, I implied a need to return to a constellation of related issues: the play of chance in Dumas's art, the importance of relationships of exchange, and the transfer of will from artist to work of art. Speaking to this set of concerns, her partner, painter Jan Andriesse, attributes consciousness to lines that exist only because Dumas drew them. I take his remark quite literally.

At the beginning of the twentieth century, it was not uncommon for philosophers to speculate that consciousness extended down from the higher forms of animal life to the lower ones and, even beyond this, to forms of inanimate being. During the late 1960s, this idea of a universality of sentience was revived by Gilles Deleuze in his studies of Henri Bergson. The notion was that all forms of life are composed of physical matter, and the degree of concentration of matter yields consciousness. We have to imagine that highly conscious beings like ourselves are somehow dense with matter—matter that converts to mind—whereas the barely conscious rocks are rather loosely put together. Deleuze would say that each of us is physically "contracted" and therefore tense with energy, whereas a rock is physically "expanded" and therefore lax, or relaxed, so relaxed that it is unlikely to have a serious thought.[90] Rocks incline to the cliché; they resist change.

Charles Sanders Peirce, who was Bergson's somewhat older contemporary, expressed the same notion by stating that physical "matter is effete mind."[91] He meant that all the stuff we regard as mere stuff does have a mentality, but its consciousness has grown inactive because of habit and regularity. The problem with mere matter is that it follows the laws of nature too predictably. Even in some humans, the pattern of thought can become so rigid that we feel that the person's brain must be composed of stone. "Thought is not necessarily connected with a brain," Peirce noted; "it appears in the work of bees, of crystals, and throughout the purely physical world."[92] Peirce and Bergson, and then later

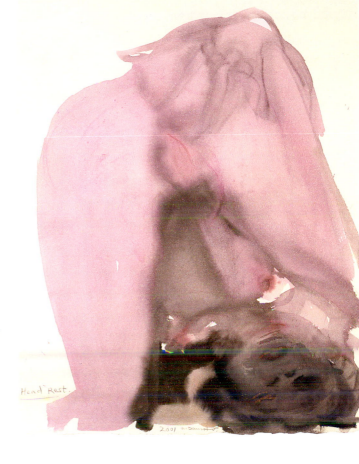

Deleuze, escaped the strict dualism of mind and matter, believing that materials can become energized like living bodies, and that matter has the potential to respond to every stimulus and stress with feelings of its own.

When we think this way, we may find ourselves imagining that a piece of matter—a spread of colored canvas, for example—must be thinking too. But our habit is to resist this explicit conclusion. We reason instead that we project our thoughts onto matter as an indirect way of representing and objectifying them. Why would we do this? Perhaps to be able to think about our thoughts, to be self-reflective. But what can it mean to "project" thoughts? Is it like film projection—an image that can alight onto any surface without leaving a material trace? Rather than conceiving of projection as a dematerialized phenomenon, the Peirce-Bergson-Deleuze position implies that the material stuff we use to express our thoughts and feelings is capable of absorbing this psychic energy; as a result, the material stuff itself receives a boost in sentience. Otherwise, why would we feel that virtually any material thing is capable of responding to us and even capable of initiating the exchange, of "speaking" to us? We find it natural to use this metaphor about mere material things. Among such things, works of art "speak" the most clearly, as if they achieved the highest degree of sentience, becoming our equals—

Head Rest, 2001; watercolor on paper; 26 x 19 ¹/₂ inches; private collection

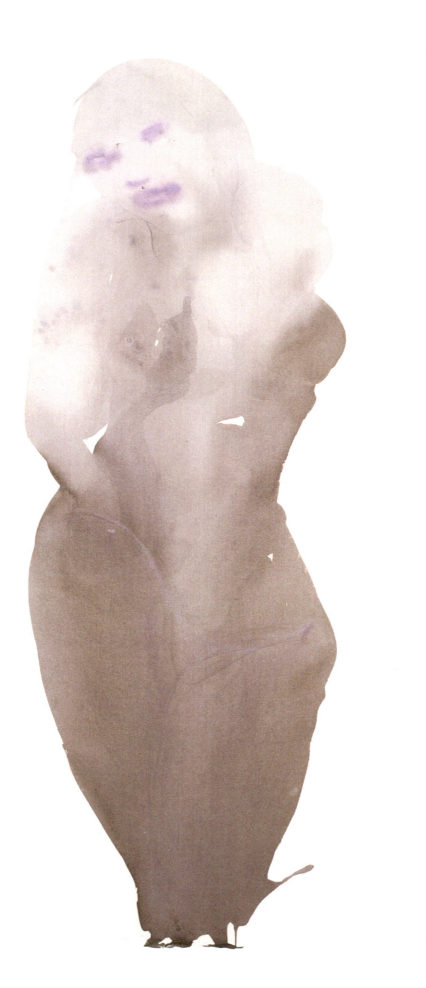

West, 1997; ink and watercolor on paper; 49$\frac{1}{4}$ x 27$\frac{1}{2}$ inches; collection Donald L. Bryant

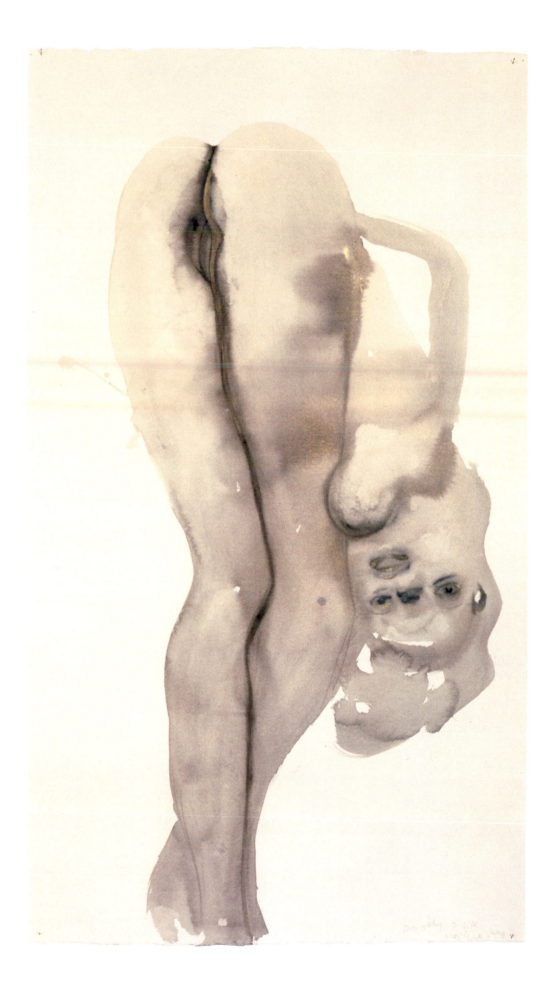

Dorothy D-lite, 1998; ink and acrylic on paper; 49 3/16 x 27 9/16 inches; collection of the artist,
on long-term loan to the De Pont Museum of Contemporary Art, Tilburg, The Netherlands, 2002

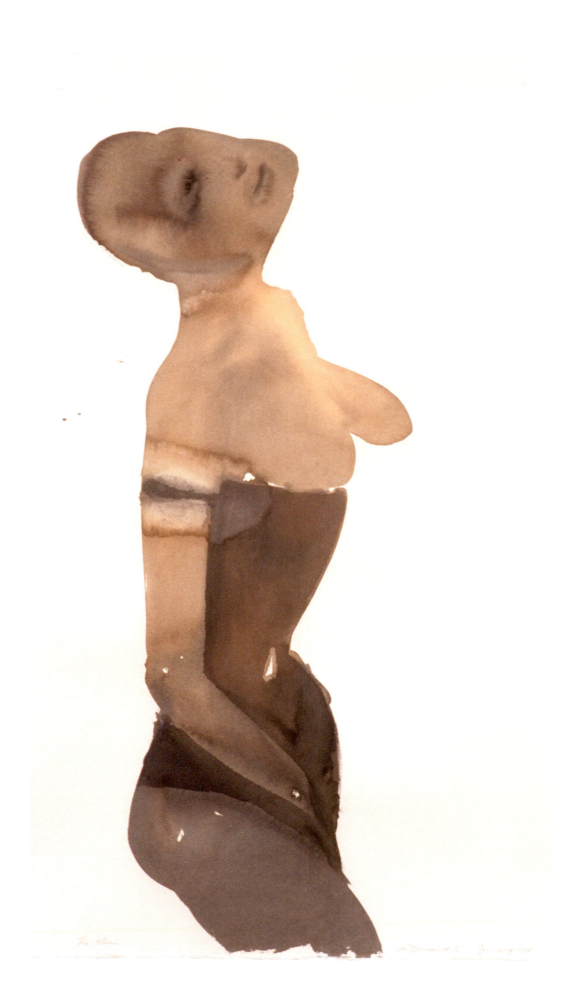

The Alien, 1998; watercolor on paper; 49 3/16 x 27 9/16 inches; Museum für Moderne Kunst, Frankfurt am Main

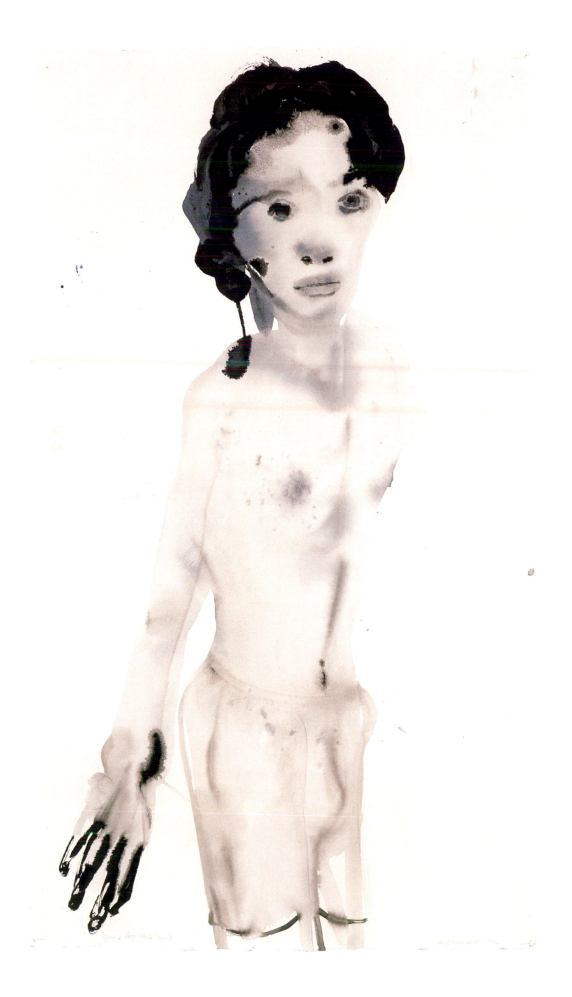

Young Boy (Pale Skin), 1997; ink and watercolor on paper; 49³/₁₆ x 27⁹/₁₆ inches; private collection

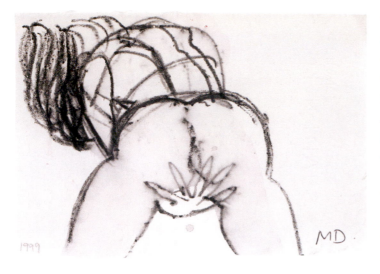

or maybe better. Given Dumas's opinions and practices, we would surmise that her painting speaks more forcefully than the photography she uses as its source. But it also speaks ambiguously and in riddles.

When we attend to a Dumas painting—or when Dumas attends to a Dumas painting—it is as if human will were acknowledging a certain necessity: it must yield to human sensation as well as to the sentience of other bodies, including other material things. This is the meaning of a line that says, "I am aware and conscious." We learn this lesson from the flow of lines in *After Fingers*, and it might also be gathered from a remarkable statement by Barnett Newman, who, like de Kooning, always occupied a place on Dumas's horizon of historical reference.[93] When asked about the meaning of *Uriel* (1955), a painting eighteen feet wide, Newman offered a witty deflection, yet a statement more serious than it might appear (his humor is not unlike Dumas's own). Referring to the great expanse of greenish blue that occupies about three quarters of the width of *Uriel*, he explained: "I wanted to see how far I could stretch it before it broke."[94]

Newman's statement exemplifies a grammatical switch that all of us tend to make, Dumas included. We pass from a transitive mode to an intransitive mode, taking responsibility for the initial action but not for the entirety of the consequence. The situation proves how limited our control is, but also relieves some of the anxiety: we have "things" with which to share the blame. Newman did not say, "I wanted to see how far I could stretch it before I broke it." Instead, he ended his sentence on an intransitive note, as if his action were stepping into an unknowable void. He seems to ascribe consciousness to the color of *Uriel*, which would break

when it wanted or needed to. This was not a situation that the painter could control but rather one of equal exchange—not a matter of surrender but of risk and indeterminacy. The painter and the paint were engaged in active existential dialogue, "two 'subjects' confronting each other." Newman's side of the exchange had no known law to guide it; he had to act without conscious regulation, "never knowing." Forcing his art beyond what he understood would succeed, he extended his hand to feel how it felt. It was the color that stretched and became energized, and Newman borrowed the sensation back from the condition of the material. In Dumas's case, energy returns to her from the form of the drawn hand as it quickly emerges in works like *Fingers* and *After Fingers*.

The language of Newman's explanation came only as an afterthought. He recognized the desire expressed in his word *want*—"I wanted to see how far I could stretch it"—only after he had exercised his pictorial judgment, which had no fixed purpose to guide it. Art must be experiential, a learning process more than either the application of knowledge or the satisfaction of selfish desire. The moral point in Newman's case was not so much to acknowledge the independent consciousness of the colored paint but to perceive the human value of stretching to the point of breaking— that is, the value of acting in whatever capacity one can, when one cannot predict the consequences.

Some of Dumas's images are stretched to the breaking point. I think of *Dorothy D-lite* (1998), a representation of a porn star with a remarkable capacity to bend her body in two—another vulva-and-anus view. In this instance, Dumas severely reduced the presence of a self-caressing hand prominent in the source photograph. Why? Perhaps because she wanted to emphasize the length and character of the line running up from the ankles to the anus (or down from anus to ankles). The line is not necessarily a continuous stroke, but it has a compelling character as an integrated sensation. As it took its form, it may have changed the artist's direction in relation to her own composition. The line went as far as it could, just like its living model, but liberated from her pose and its cliché. There is something of

After Fingers, 1999; ink on paper; 5 7/8 x 8 1/4 inches; collection David Teiger

Newman's risk in *Dorothy D-lite* and, also, a bit obscurely, something of de Kooning. He, too, could find aesthetic interest in a long and varied leg line. A woman seen from the rear, probably bending over, is the subject of one of his series of rapid-fire sketches.

When Dumas spoke of her interest in two subjects confronting each other—she and de Kooning, she and Newman, she and a lover, she and a line—she may have associated the status of "subject" with the capacity to use the pronoun "I." This would be natural: if you have a serious encounter with a line, you may feel that "the line says 'I am aware and conscious.'" It is an I; you are an I. Because the association of the I with subjectivity is so natural, it is also, as Dumas might say, "suspect" (for the very reason that, like the accepted use of a medium, anything declared natural drifts into ideological cliché).[95] When involved in an exchange with a person or a thing, even just a line, you are not only an I but also a Me. Things happen—to you, to me. The problem with speaking from the position of the I lies in its distance from the Me; the I, isolated and untouchable, creates a fixed self-image, like a photographic pose. It repeats itself, becoming unreceptive to changing conditions, insisting on acting in character. The Me is less like an image (dead), more like a mark (less dead). It has its own character but is forever affected by the marks surrounding it. It can move and change, responding to contingencies.

If there are two kinds of artists (but, of course, there are many), then Marlene Dumas is a Me more than she is an I. "If the painting does not want to go in the direction where I thought it was going when I started," she said, using the I (as we all must), "then I let it go its own way to some extent." This statement has already been cited. I repeat it for its manifestation of exchange in action, Dumas as an I becoming a Me. If only "to some extent," she lets the painting "go its own way." She followed with this: "I love chance."[96] She is entirely open to chance, which belongs to no one but targets the Me. Chance accepted, rather than directed, bears no guilt.

Barnett Newman, *Uriel*, 1955; oil on canvas; 96 x 216 inches;
Reinhard Onnasch, Berlin

62. Quoted in Dumas, "A Comparison Between Goya's *Saturn Devouring One of His Sons* and de Kooning's *Woman I*," n.p.; from Paul Tillich, *The Courage to Be* (New Haven, Connecticut: Yale University Press, 1952), 190.

63. Fairfield Porter, as quoted by Dumas, "The Private Versus the Public," in *Miss Interpreted*, 42. The statement is from Porter's essay of 1969, "Art and Scientific Method," referring to the advantage of open suggestive description of works of art— in effect, an avoidance of ideological implications. Dumas's quotation conflates two different sentences but captures the sense: see his "Art and Scientific Method," in Porter, *Art in Its Own Terms: Selected Criticism 1935–1975* (New York: Taplinger, 1979), 267–68. If one theorizes Porter's position itself, one finds it expressed by others in many different ways. For example: theory "get[s] us to recognize similarities between things that, so long as we continue to think about them in the fullness of their empirical detail, will always seem very different." Richard Wollheim, "Response to James I. Porter," in Shadi Bartsch and Thomas Bartscherer, eds., *Erotikon: Essays on Eros, Ancient and Modern* (Chicago: The University of Chicago Press, 2005), 143.

64. Dumas, in "Barbara Bloom in conversation with Marlene Dumas," 28.

65. Dumas, "Blackbirds and Young Boys" (1994), in *Sweet Nothings*, 85. On Dumas's use of black and white, sometimes to signify race, sometimes as a play on color in drawing or painting, see also her discussion in Jantjes, "Interview with Marlene Dumas," 59.

66. "There is a dark figure lying on a white sheet in *Waiting (For Meaning)* (1988). It is NOT that there is an Afro-American lying in a (hospital) bed"; Dumas, statement to the author, 21 October 2007 (original emphasis).

67. Dumas wrote of her painting *Reinhardt's Daughter* (1994), one of two pictures, similar but for the color, of her daughter Helena: "You change the color of something and everything changes (especially if you're a painter)." Dumas, "Reinhardt's Daughter" (1994), in *Sweet Nothings*, 86.

68. Dumas, in Jantjes, "Interview with Marlene Dumas," 56. See also Dumas, "Why Do I Write (About Art)" (1998), 91; and Dumas, in Enright, "The Fearless Body," 34.

69. Marcel Proust, *The Guermantes Way* (third book of *Remembrance of Things Past*), trans. C. K. Scott Moncrieff (New York: Random House, 1970 [1920–21]), 262–63 (sentence order reversed).

70. Willem de Kooning, quoted by John McMahon, the artist's studio assistant during the 1960s and early 70s, in conversation with the author, April 2001.

71. Dumas, statement to the author, 27 December 2007. For Dumas's source image, see Mark Cousins, *Scene by Scene: Film Actors and Directors Discuss their Work* (London: Laurence King, 2002), 64.

72. Dumas, in Yuko Hasegawa, "Interview with Marlene Dumas" (2 and 7 December 2006), in *Marlene Dumas: Broken White* (Tokyo: Museum of Contemporary Art, 2007), 150; and statement to the author, 7 October 2007.

73. Dumas, statement to the author, 29 November 2007.

74. Dumas, statement to the author, 27 December 2007.

75. Dumas, "Immaculate," in *Marlene Dumas* (2004), n.p. Ironies accompany the term "immaculate" because it refers to being without spots or marks of any kind. A painting cannot be "immaculate" in the strictest sense; this degree of virginity would constitute a "death of painting" in blankness.

76. For the source image, see Mark Rotenberg and Laura Mirsky, *Forbidden Erotica: The Rotenberg Collection* (Cologne, Germany: Taschen, 2000), 387.

77. "I don't think that painting actually works very well at the level of turning people on. If I really want to get aroused quickly, I wouldn't go to paintings." Dumas, in Enright, "The Fearless Body," 28–29.

78. Dumas, "Amoral Touch," statement (February 2000), in Christianne van Lomm, ed., *Anton Corbijn/Marlene Dumas: Strippinggirls*, exh. cat. (Amsterdam: Stichting Actuele Kunstdocumentatie, 2000), n.p.

79. Dumas, statement to the author, 28 June 2007.

80. Dumas, statement to the author, 21 October 2007.

81. Dumas, statement to the author, 7 October 2007.

82. Dumas, statement to the author, 17 December 2007. Dumas recalled that certain of her early paintings and drawings had features inspired by what she knew of de Kooning and other members of the New York School. See the works of the early 1970s reproduced in Dumas, "The Michaelis School of Fine Art (1970s)," 16–18.

83. Titles for de Kooning's works were often generated by playful conversations among the artist, his wife Elaine de Kooning, and a circle of friends and associates including critic Harold Rosenberg, as well as various studio assistants and dealers. When Dumas discovered that de Kooning had named a painting *Mae West*, a reference she herself had made in *West* (1997), she took this as confirmation of the two painters' subtle affinity. She was struck in addition by de Kooning's *Lobster Woman* (1965), for it reminded her of her own *The Shrimp* (1998) (Dumas, conversation with the author, 30 June 2007). In both of these oddly titled works, Dumas's watercolor and de Kooning's tracing in oil, an exploratory painting process generated shapes and markings suggestive of crustacean bodies within the context of rendering a female figure.

84. On the fortuitous resemblance of this image to Marilyn Monroe, see Selden Rodman, *Conversations with Artists* (New York: Capricorn, 1961), 104; and Thomas B. Hess, *Willem de Kooning Drawings* (Greenwich, Connecticut: New York Graphic Society, 1972), 41. During 1954, the year of her marriage to Joe DiMaggio and subsequent divorce, Monroe was an especially newsworthy character and a common cultural reference; nearly any image of a woman with blond hair and red lips was likely to evoke her. According to Edvard Lieber (representing Willem and Elaine de Kooning, letter to Teresa Spillane, 3 February 1988, De Kooning Foundation, New York), "neither Mr. nor Mrs. de Kooning recall an instance when he titled a work *before* painting it" (original emphasis).

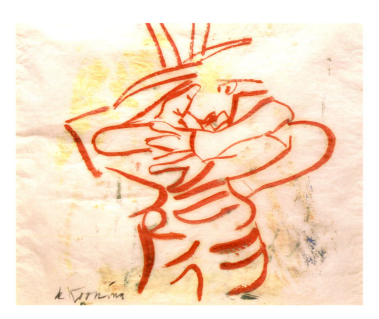

85. De Kooning, statement from the printed script for a film by Robert Snyder, *Sketchbook No. 1: Three Americans, Willem de Kooning, Buckminster Fuller, Igor Stravinsky* (written by Michael C. Sonnabend, distributed by Time Inc., 1960). The complete audiotape passage from the film itself is as follows (de Kooning referring to the calendar nude on his studio wall): "Not the same as Marilyn Monroe. Maybe I like this one more than Marilyn Monroe. In other words, I like the type more as the original version." With his linguistic quirkiness, de Kooning substituted "as" for "than."

86. On de Kooning's various methods, see my "'With Closed Eyes': De Kooning's Twist," *Master Drawings* 40, no. 1 (2002): 73–88.

87. "Showing a naked backside is different from showing an anus. The anus being a bigger taboo than any other, still." Dumas, quoted in Storsve, "Good Lady, You That Have Your Pleasure in Exile," 26.

88. There is comedy to be perceived in Dumas's arrangement of three similar splayed-leg poses of 1999, hung along a single wall: *(Male) Stripper*, *On Stage*, and *Spread*. It is as if she were conducting a structural analysis of pornographic practice: the first pose, male and frontal; the second pose, female and rear; the third pose, female and frontal. Abstractly, from a visual distance, the form of all three poses is the same.

89. Jan Andriesse, "Paint Is Matter and Paint Matters (On How She Does It)," in *Marlene Dumas: Suspect*, 33.

90. Gilles Deleuze, *Bergsonism*, trans. Hugh Tomlinson and Barbara Habberjam (New York: Zone Books, 1988 [1966]), 74,

103. "Consciousness and matter, body and soul...meet each other in perception.... We may without scruple attribute to perception something of the extensity of matter." Henri Bergson, *Matter and Memory*, trans. Nancy Margaret Paul and W. Scott Palmer (London: George Allen and Unwin, 1911 [1896]), 292–93.

91. Charles Sanders Peirce, "Scientific Metaphysics: The Architecture of Theories" (1891), in *Collected Papers*, ed. Charles Hartshorne, Paul Weiss, and Arthur W. Burks, 8 vols. (Cambridge, Massachusetts: Harvard University Press, 1958–60), 6:20.

92. Peirce, "Apology for Pragmaticism" (1906), in *Collected Papers*, 4:438.

93. For Dumas's commentary on her *Magdalena (Newman's Zip)*, see Silvia Eiblmayr, ed., *Marlene Dumas: Models* (Stuttgart, Germany: Oktagon, 1995), 28.

94. Barnett Newman, quoted by Harold Cohen, introduction to "Barnett Newman Talks to David Sylvester," BBC radio broadcast, 17 November 1965, typescript, Barnett Newman Foundation, New York. The context may be significant. Newman was speaking to painter Harold Cohen, who had restretched *Uriel* when Newman delivered it to a collector in London. Cohen may have understood a friendly pun at his own expense: he was good at stretching canvas, but Newman was good at stretching color.

95. Dumas, "Suspect," 35.

96. Dumas, in Hasegawa, "Interview with Marlene Dumas," 150.

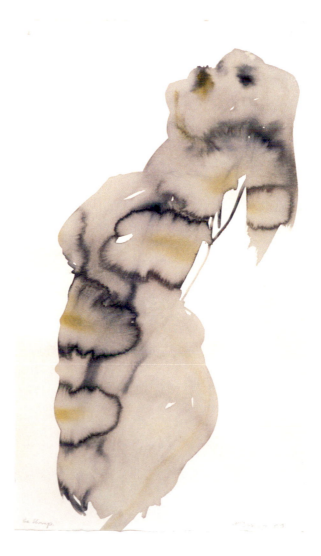

Opposite: Willem de Kooning, *Lobster Woman*, 1965; oil on tracing paper; 18 7/8 x 23 7/8 inches; Hirshhorn Museum and Sculpture Garden, Smithsonian Institution, The Joseph H. Hirshhorn Bequest, 1981

Right: *The Shrimp*, 1998; watercolor on paper; 49 3/16 x 27 9/16 inches; Museum für Moderne Kunst, Frankfurt am Main

Right: Selection from Dumas's image bank and source for *Jen*, 2005

Below: "MD—Light," installation at Frith Street Gallery, London, 1999

Opposite: Installers hanging *The Swan*, 2005, and *Broken White*, 2006, in "Marlene Dumas: Broken White" at Museum of Contemporary Art, Tokyo, 2007

situatie, opgebouwd uit executies, catatrofes, ongemakken, ongelukken en koppige heldendaden van belachelijke durf, op magische wize gecompileerd uit oerwoudfilms, kalenderillustraties, aanloopstroken, cowboyfilms, cartoons, documentaires en nieuwsfilmpjes. Niets van dit materiaal is origineel, en niets wordt voor zijn oorspronkelijk doel gebruikt. Wat aanvankelijk amusant en verwarrend lijkt, blijkt allengs een zwarte maatschappijvisie te zijn, die ons op een onderbewust niveau diep verstoort.
Bijzonder belangrijk zijn de documentaire beelden van de dood; de één seconde lang documentair verminkte lichamen van Mussolini en zijn minnares, aan hun voeten opgehangen; het neerstorten van een watervliegtuig, waarvan de piloot in een kort, verschrikkelijk moment tegen de romp slaat; een fragment van een executie, 'onthuld' als een vies geheimpje en even snel weer teruggetrokken; het einde van een brug (die even wild heen en weer zwaait en dan neerstort), onmiddellijk gevolgd door een optimistische toespraak van Teddy Roosevelt. De hele film is een ode aan de creatieve montage.

▲ Een onheilspellende en bedriegljke instelling: het meisje is zwaar verdoofd, niet dood, maar de aanwezigheid van vliegen die zich bedrijvig over al haar lichaamsdelen bewegen, veroorzaakt een onvermijdelijke keten van morbide associaties. De korreligheid van het beeld verhoogt deze indruk nog. Het is alsof het lichaam al in ontbinding verkeert (Yoko Ono, 'Fly', Groot-Brittanniä, 1970, zie blz. 208).
▲ Een beschouwing van de dood. In een episode van Pasolini's persoonlijkste en meest controversiële film speelt Clementi een wilde in de middeleeuwen, die in een verlaten, mogelijk door

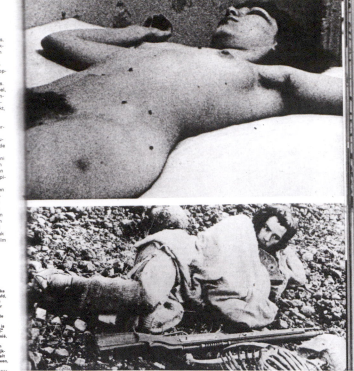

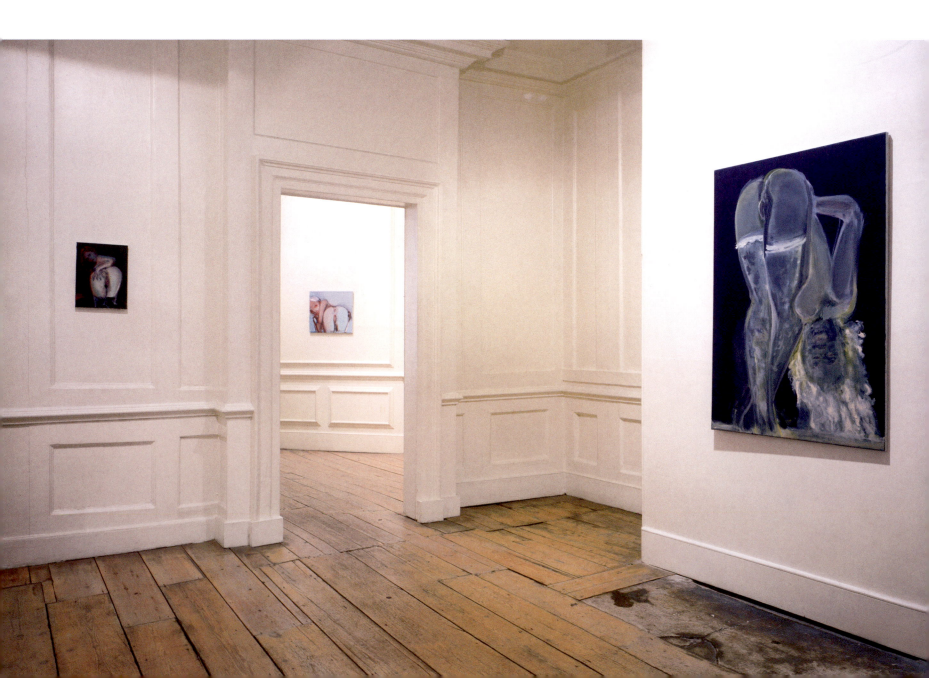

North Africa

Home of the striptease.
Home of the dance of the seven veils.
Home of the ancestors of Abraham,
forefather of the Jews, Muslims, and Christians.
Home of a God that does not want to be reproduced.
About Algiers, Nelson Mandela had military training there,
learned lessons of guerilla tactics from their liberation war.
Delacroix made a painting called *The Women of Algiers* (1834).
Women relaxing in a peaceful female harem.
In 1954, Picasso made (one of many) sensuous paintings
inspired by this French-African source.
Little did he know where this orientalism would later go.
In 2000 I saw a photograph of a young girl standing naked
held by, "exhibited" between, two posing French soldiers.
It was taken in 1960 in Algiers.
I painted my *Woman of Algiers* in 2001.

—M. D., Amsterdam, 2008

Japan

Home of one of my favorite erotic artworks,
Hokusai's *The Dream of the Fisherman's Wife*
(Girl Diver and Octopuses) (1814).
I have always been fascinated by the relationship between sex, violence, beauty, and
the artificial.
Traditional African and Japanese art are the "models" that attract me most.

—M. D., Japan, 1998

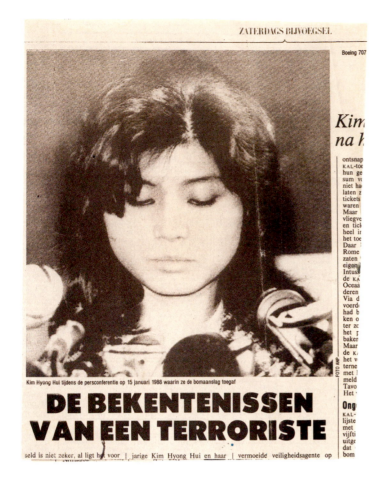

Boeing 707

Kim
na h

ontsnap
KAL-toe
hun ge
sum vo
niet ha
laten z
tickets
waren
Maar
vliegve
en tick
heel in
het toe
Daar
Rome
zaten
eigen
Intuss
de KA
Ocea
deren
Via d
voerd
had b
ken o
ter z
het p
baker
Maar
de K
tern
met t
meld
Tavo
Het

Ong

KAL-
lijste
met
vijfti
uitge
dat

Kim Hyŏng Hui tijdens de persconferentie op 15 januari 1988 waarin ze de bomaanslag toegaf

DE BEKENTENISSEN
VAN EEN TERRORISTE

seld is niet zeker, al ligt het voor | jarige Kim Hyong Hui en haar | vermoeide veiligheidsagente op
bom

Céline op zijn doodsbed (foto Pierre Duverger)

LEVEN EN DOOD
VAN EEN DOLLE HOND

DE BIOGRAFIE VAN LOUIS-FERDINAND CÉLINE

Volkenbond, lange dienstreizen haar onder andere Amerika en Afrika, een medische praktijk in verschillende Parijse buitenwijken en anderhalf jaar gevangenschap in Denemarken, waarheen hij in 1945 via Duitsland voor de bevrijders was gevlucht). Zelfs als hij *Voyage au bout de la nuit*, *Mort à crédit* en de trilogie over het einde van de laatste oorlog niet had geschreven, zou hij voor een lezer met historische en psychologische

biograaf, zeker zijn object als 'crimineel' bekend staat. Gibaults stijl is goddank niet in de geringste mate Celiniaans — hoe funest Célines invloed alleen al verbaal kon zijn, bewijzen enkele door de biograaf aangehaalde, deerniswekkend geschreven brieffragmenten van sommige van Célines vrienden en vriendinnen. Het Frans in de biografie is gemakkelijk te lezen, klassiek helder en verzorgd. Het enige storende dat ik erin heb gevonden

Onlangs verscheen het derde deel van François Gibaults biografie over Louis-Ferdinand Céline. Tegelijkertijd voltooide Frans van Woerden met 'Rigodon' de vertaling van Célines trilogie. Kees Verheul las ze allemaal, vergeleek de biografie met Célines laatste boek en schetst het leven, de kunst en de dood van de omstreden schrijver, die zich zelf de 'dolle hond van de Franse literatuur' heeft genoemd.

Topboeken

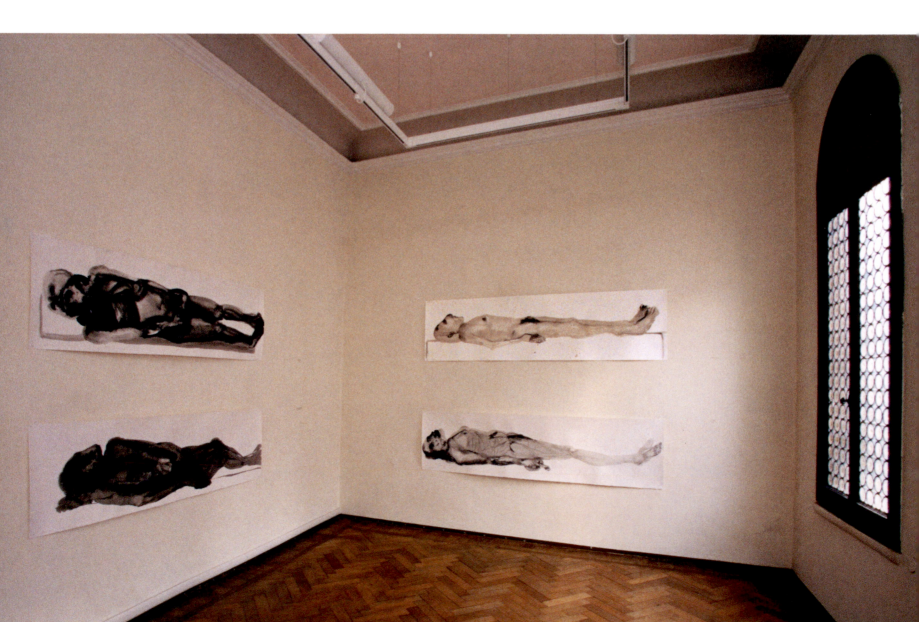

Southern Comfort

There's always been a lot of water in the sea.
Now there's too many Chinese in Africa, maybe.
And what about the Americans in the Congo
who were undercover, without telling me?

Left the white beaches of South Africa
for the dark continent of Europe and now
the United States of America.

Never knew that Columbus went the wrong way
looking for a shortcut to get to the East, to China.
Instead he stumbled upon America
and, realizing that it was somewhere else,
he thought, this must be India!
So that's why he called the natives Indians.

In 1620, the Mayflower brought the first group
of pale-faced pilgrims to America.
In 1619, a Dutchman brought the first group
of African slaves to America.

Centuries later, in the late 1960s, I was sitting in Africa
reading *Time* magazines, listening to Janis Joplin singing
Big Mama Thornton's song "Ball and Chain."

—M. D., Amsterdam, 2008

Expiration Dates

There are as many important dates
as there are different wars and love stories.
Take 9/11:

11 September 1922: The British government promised the European Zionists a homeland
for Jews in Palestine.
11 September 2001: Hijacked jetliners hit the World Trade Center in New York,
destroying the Twin Towers.

12 September 1977: Steve Biko died in South African police custody.
12 September 2007: My mother died after noon.

—M. D., Amsterdam, 2008

Opposite, top: Selections from
Dumas's image bank filed under
the heading "War" and sources
for *Kim*, 2004 (left), and *Death of
the Author*, 2003 (right)

Bottom: "Marlene Dumas: Suspect,"
installation at Fondazione Bevilacqua
La Masa, Palazzetto Tito, Venice,
Italy, 2003

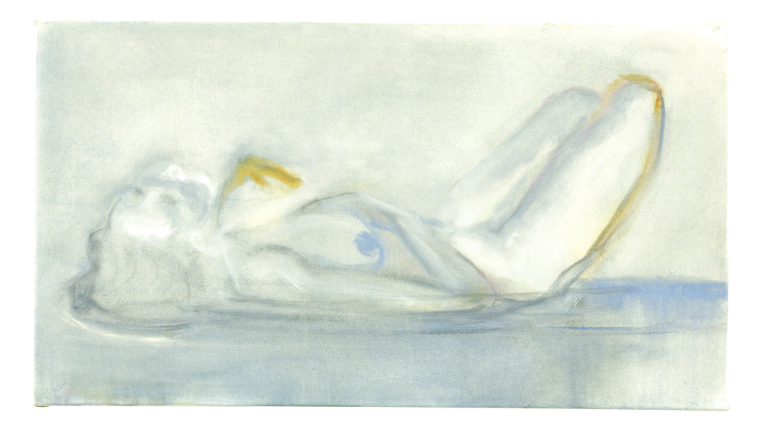

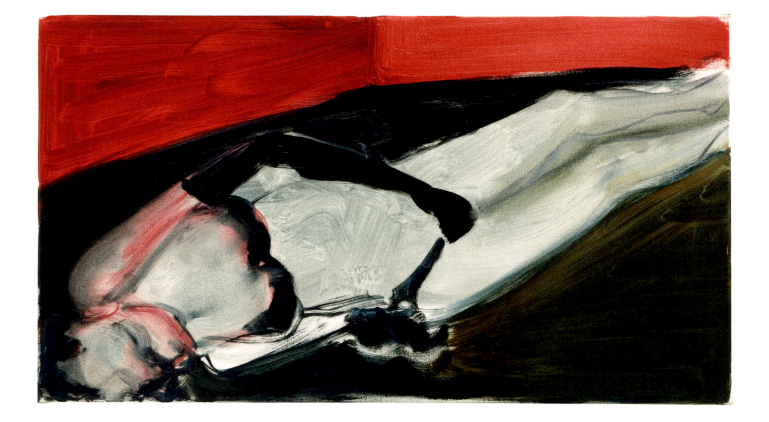

Mist, 2000; oil on canvas; 22 1/16 x 39 3/8 inches; private collection, courtesy Zeno X Gallery, Antwerp

Suspect, 1999; oil on canvas; 22 1/16 x 39 3/8 inches; collection Åke and Caisa Skeppner, Belgium

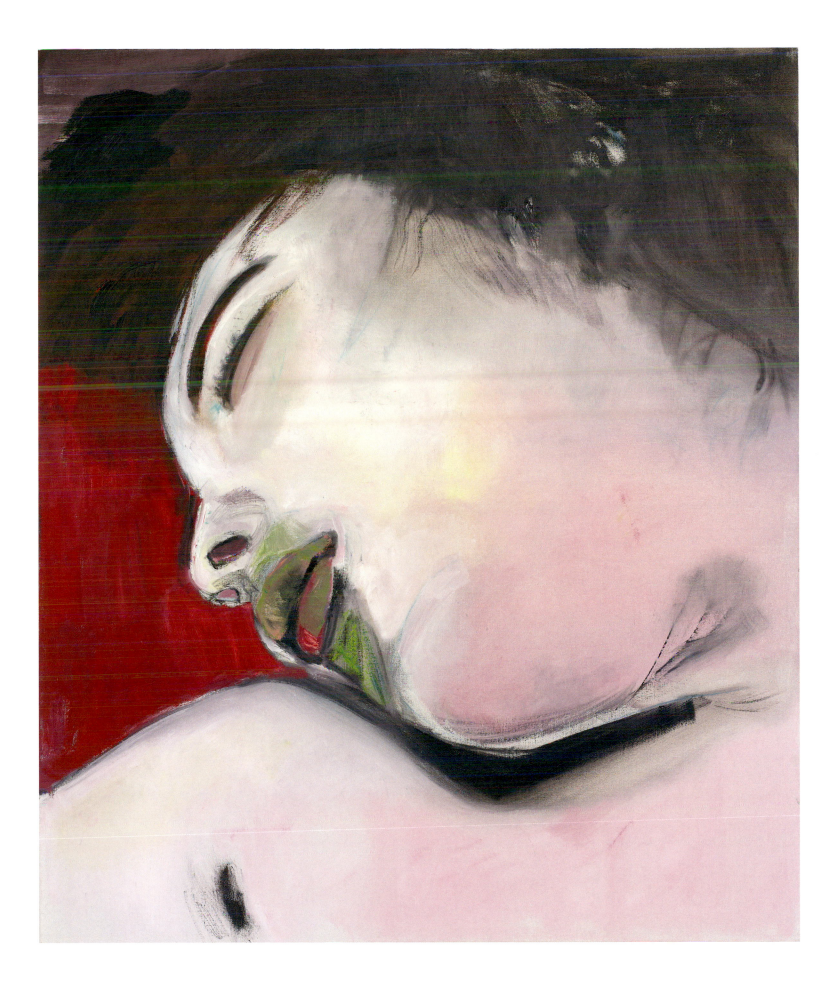

Broken White, 2006; oil on canvas; 51 $^{3}/_{16}$ x 43 $^{5}/_{16}$ inches; courtesy Gallery Koyanagi, Tokyo

Kim, 2004; oil on canvas; 51 3/16 x 43 5/16 inches; private collection, Madrid

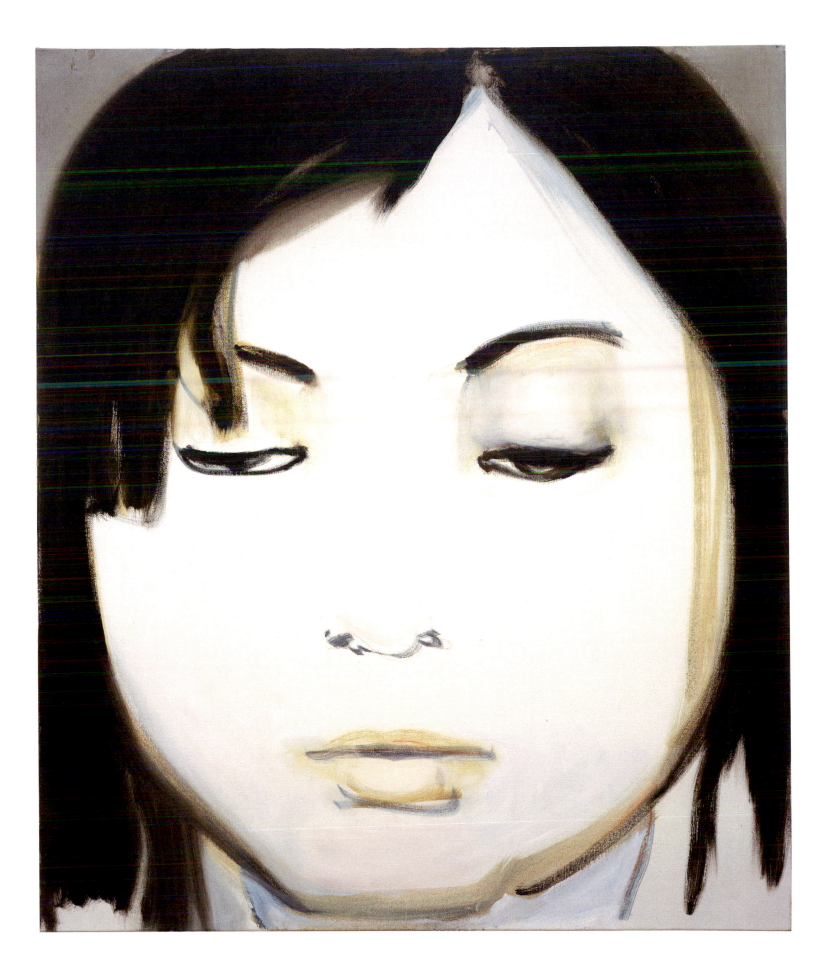

Dead Girl, 2002; oil on canvas; 51^{3}/$_{16}$ x 43^{5}/$_{16}$ inches; Los Angeles County Museum of Art, purchased with funds provided by the Buddy Taub Foundation, Jill and Dennis Roach, Directors

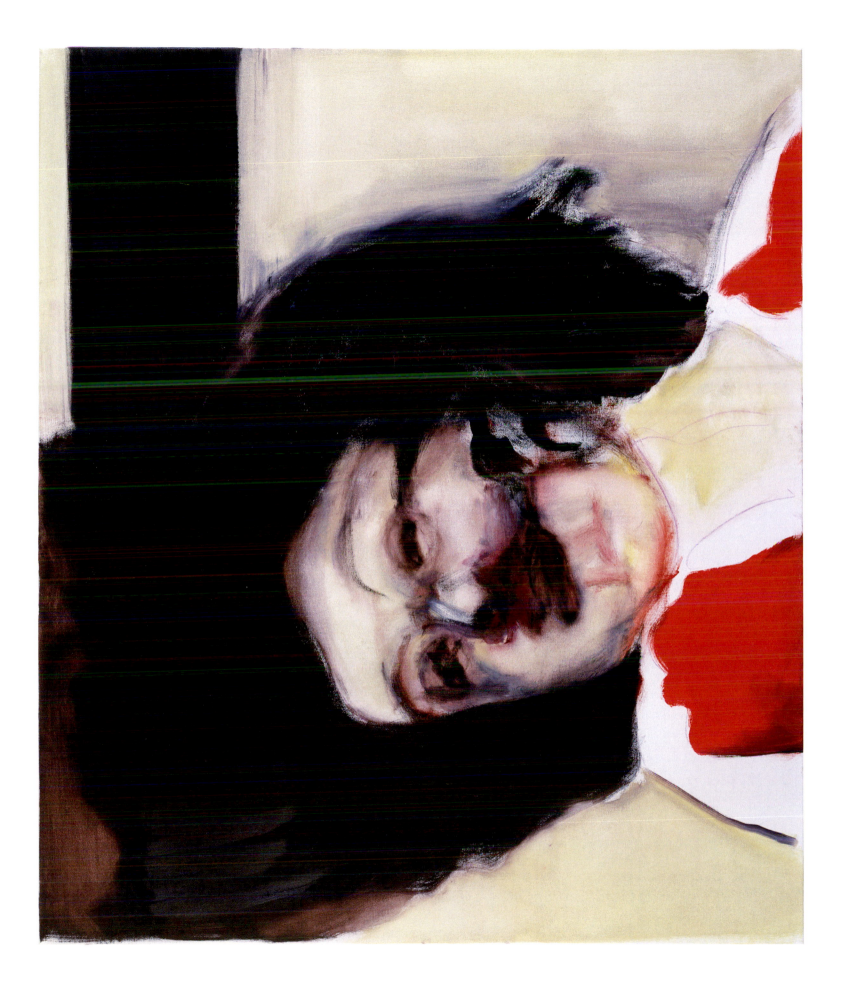

185

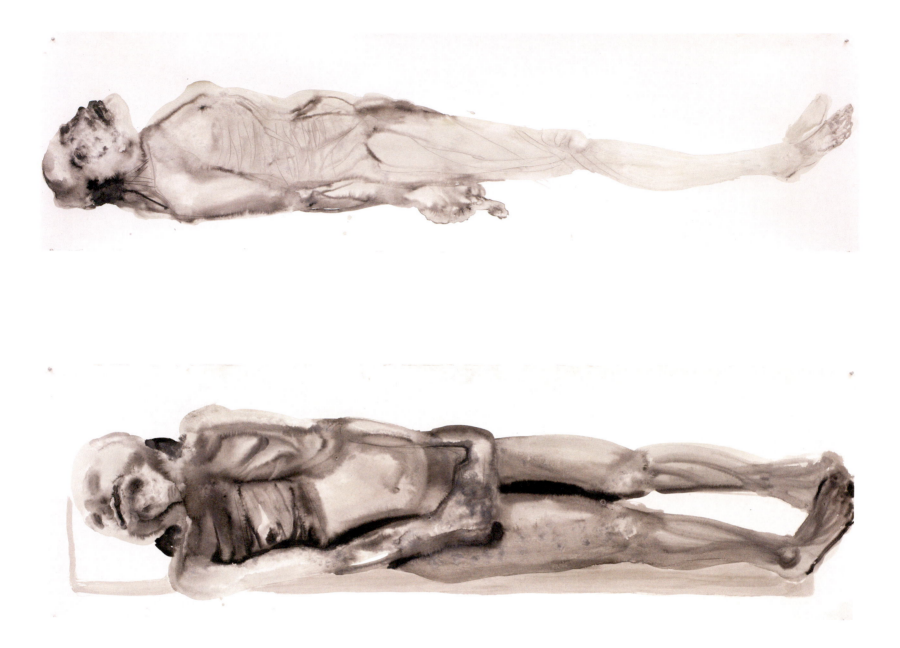

After Painting, 2003; ink, acrylic, and watercolor on paper; 24 5/8 x 90 9/16 inches; collection Craig Robins, Miami, Florida

After Stone, 2003; ink, acrylic, and watercolor on paper; 24 5/8 x 78 3/4 inches; collection Craig Robins, Miami, Florida

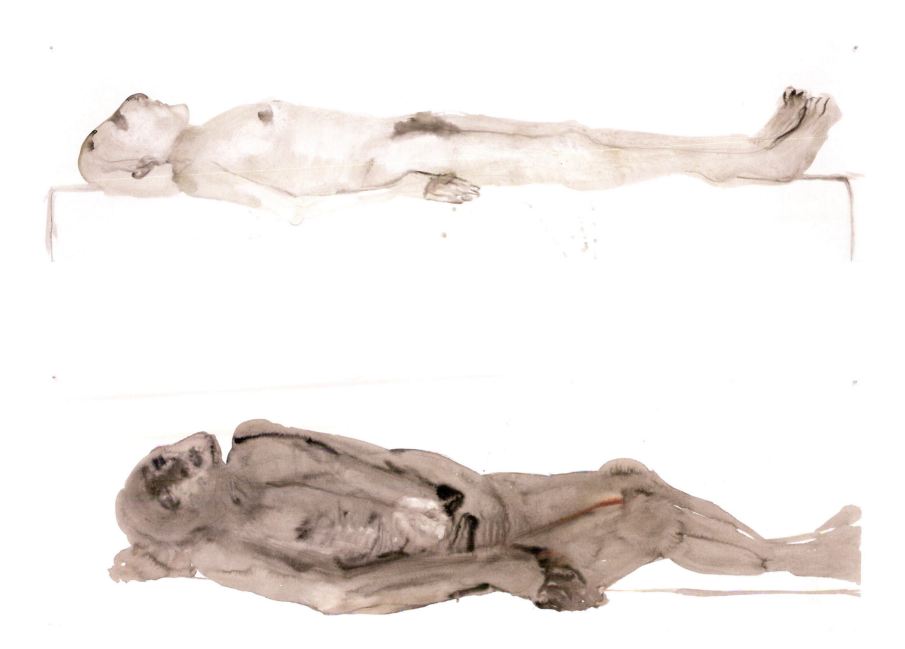

After Photography, 2003; ink, acrylic, and watercolor on paper; 24 5/8 x 90 9/16 inches;
The Art Institute of Chicago, gift of the Neisser Family

After All (Is Said and Done), 2003; ink, acrylic, and watercolor on paper; 24 5/8 x 78 3/4 inches; The Museum
of Modern Art, New York, The Judith Rothschild Foundation Contemporary Drawings Collection Gift

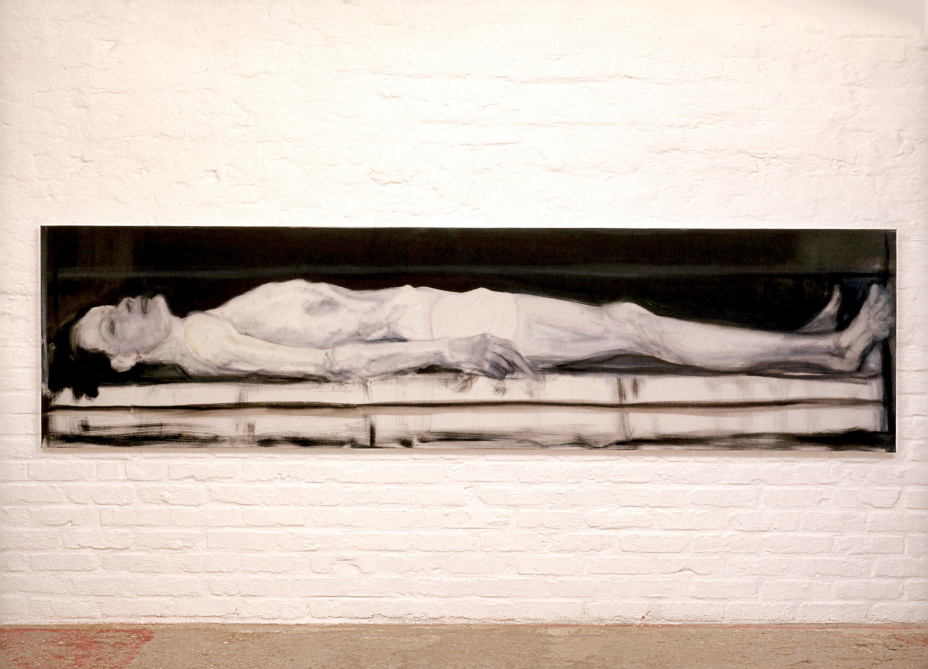

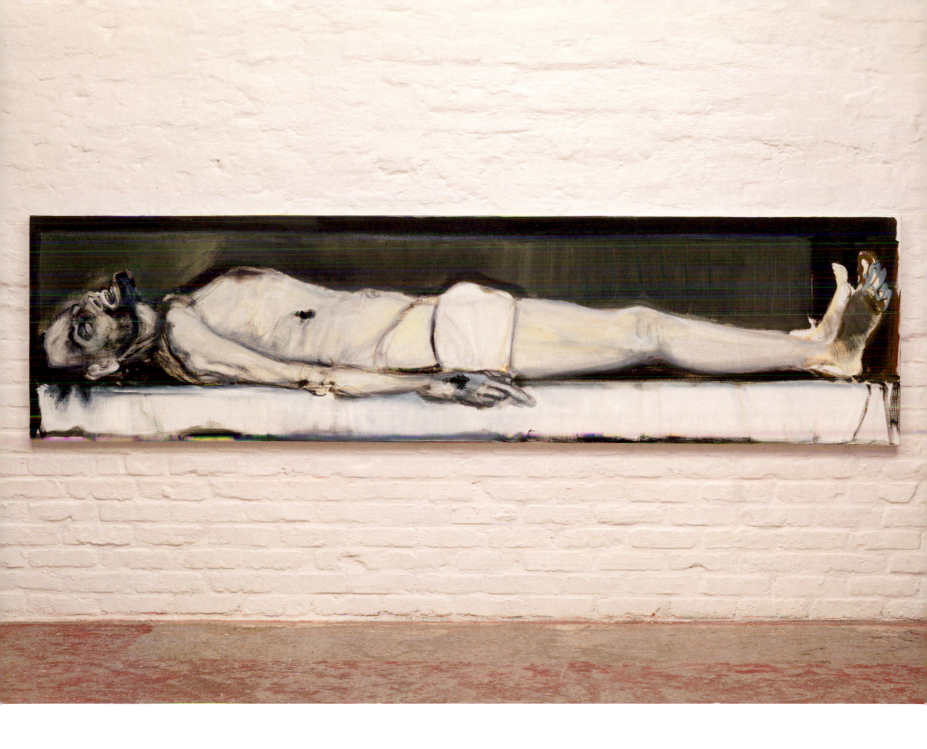

Gelijkenis 1 en 2 (Likeness 1 and 2), 2002; oil on canvas; diptych: 23 $^5/_8$ x 90 $^9/_{16}$ inches each panel; collection François Pinault

Following spread: *(In Search of) the Perfect Lover*, 1994; ink and pencil on paper and oil on canvas; sixty sheets: 11 x 9 $^5/_8$ inches each, painting: 9 $^7/_{16}$ x 7 $^1/_{16}$ inches; private collection

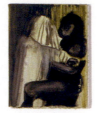
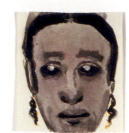
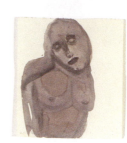
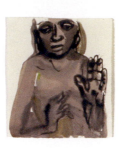
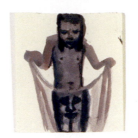

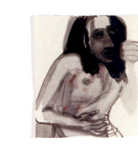

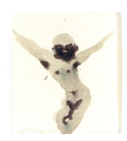
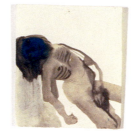

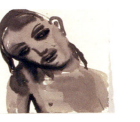
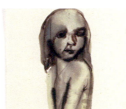

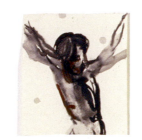
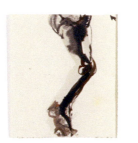
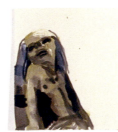
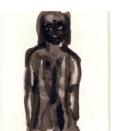
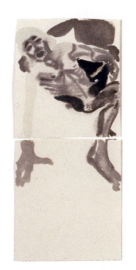
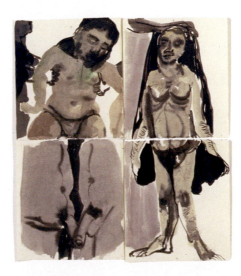

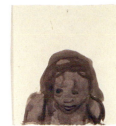
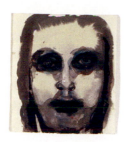
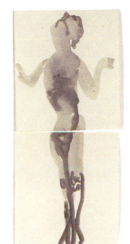

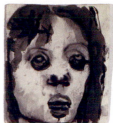

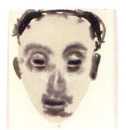
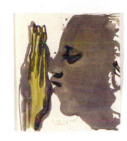
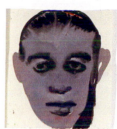

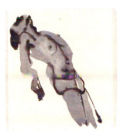
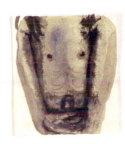

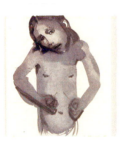
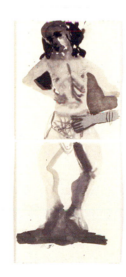
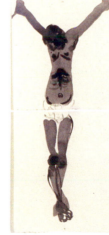

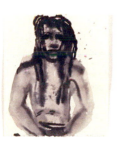

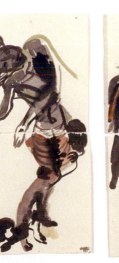
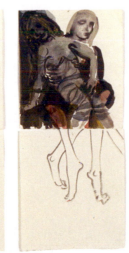
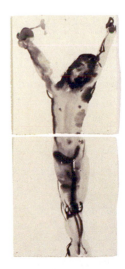

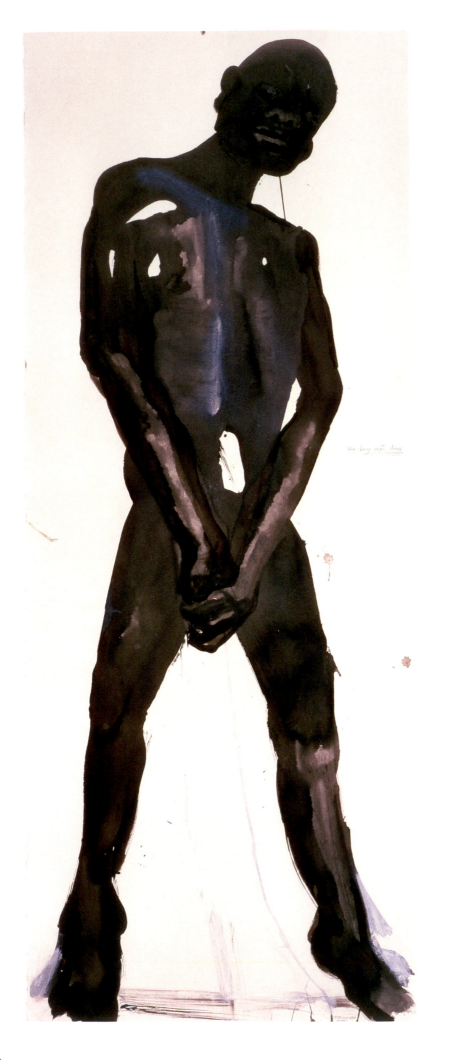

The Boy Next Door, 2001; ink, acrylic, and pencil on paper;
90 1/4 x 35 1/2 inches; collection Annie Camarda

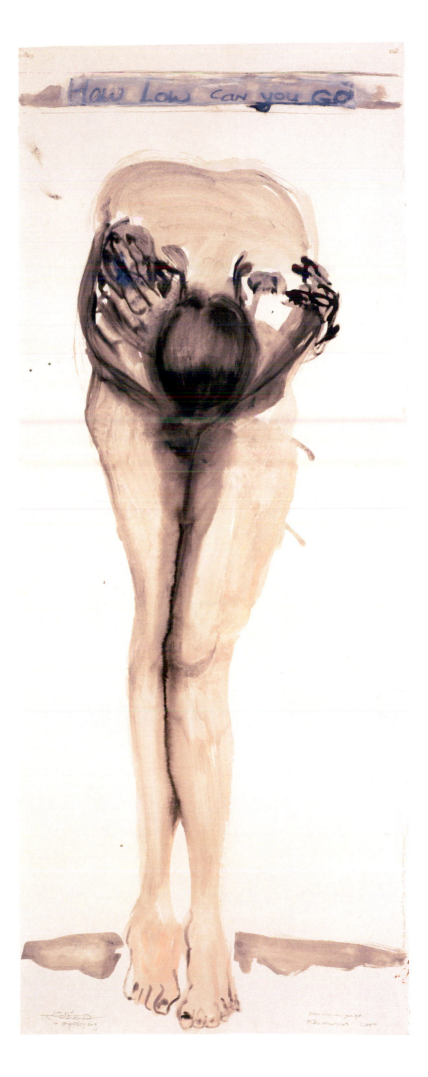

How Low Can You Go, 2000; ink and acrylic on paper;
90 ¹/₄ x 35 ¹/₂ inches; collection Susan and Leonard Feinstein

Measuring Your Own Grave

I am the woman who does not know
where she wants to be buried anymore.
When I was small, I wanted a big angel on my grave
with wings like in a Caravaggio painting.
Later I found that too pompous.
So I thought I'd rather have a cross.
Then I thought—a tree.
I am the woman who does not know
if I want to be buried anymore.
If no one goes to graveyards anymore
if you won't visit me there no more
I might as well have my ashes in a jam jar
and be more mobile.

But let's get back to my exhibition here.
I've been told that people want to know,
why such a somber title for a show?
Is it about artists and their mid-life careers,
or is it about women's after-50 fears?
No, let me make this clear:
It is the best definition I can find
for what an artist does when making art
and how a figure in a painting makes its mark.
For the type of portraitist like me
this is as wide as I can see.

—M. D., Amsterdam, 2008

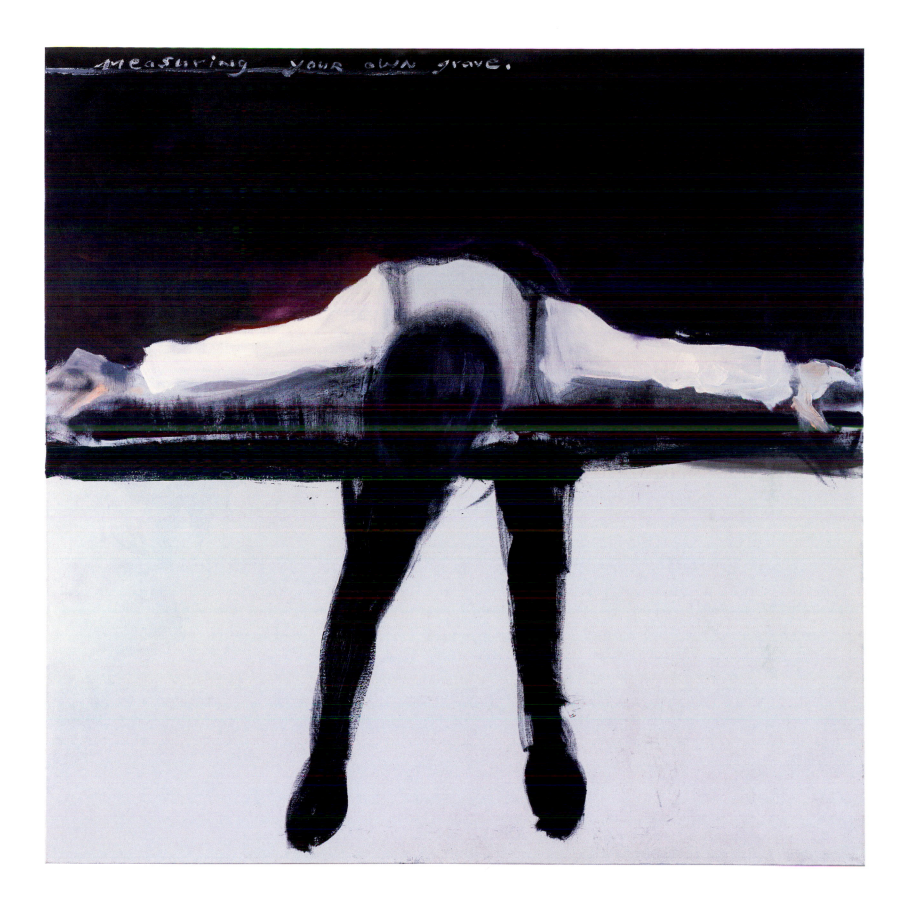

Measuring Your Own Grave, 2003; oil on canvas; 55 1/8 x 55 1/8 inches; private collection

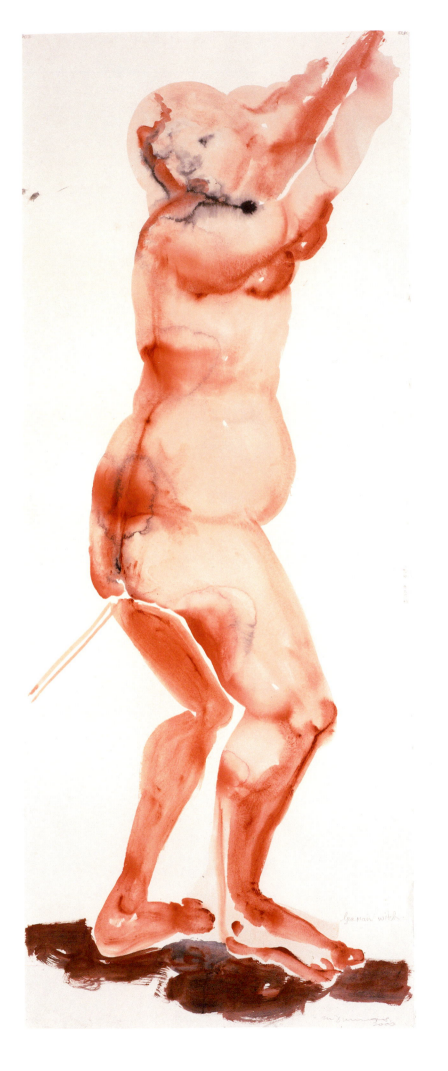

German Witch, 2000; ink and acrylic on paper; 90 $^{1}/_{4}$ x 35 $^{1}/_{2}$ inches;
The Institute of Contemporary Art, Boston, fractional and promised
gift of Beth and Anthony Terrana

"All Is Fair in Love and War," installation at Jack Tilton/Anna Kustera Gallery, New York, 2001

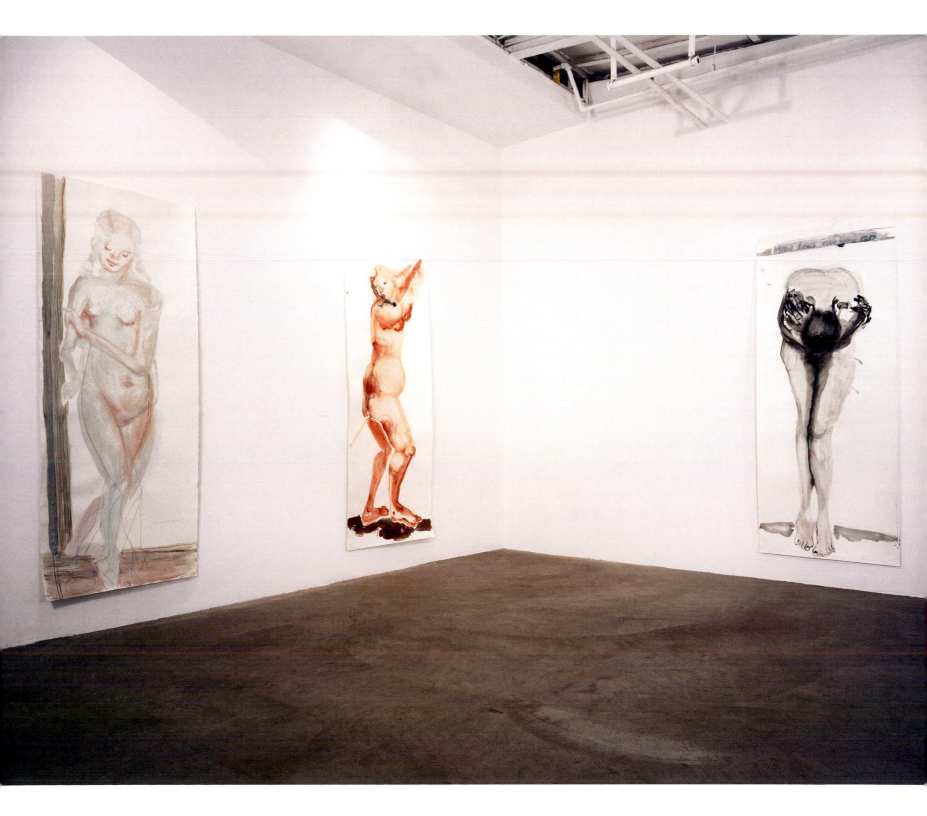

D-rection, 1999; oil on canvas; 39 $^3/_8$ x 22 $^1/_{16}$ inches; private collection

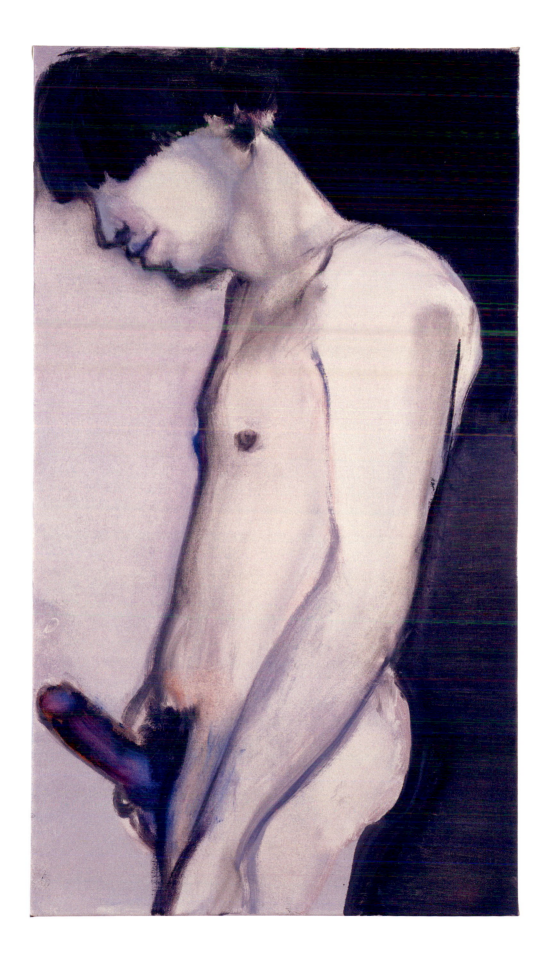

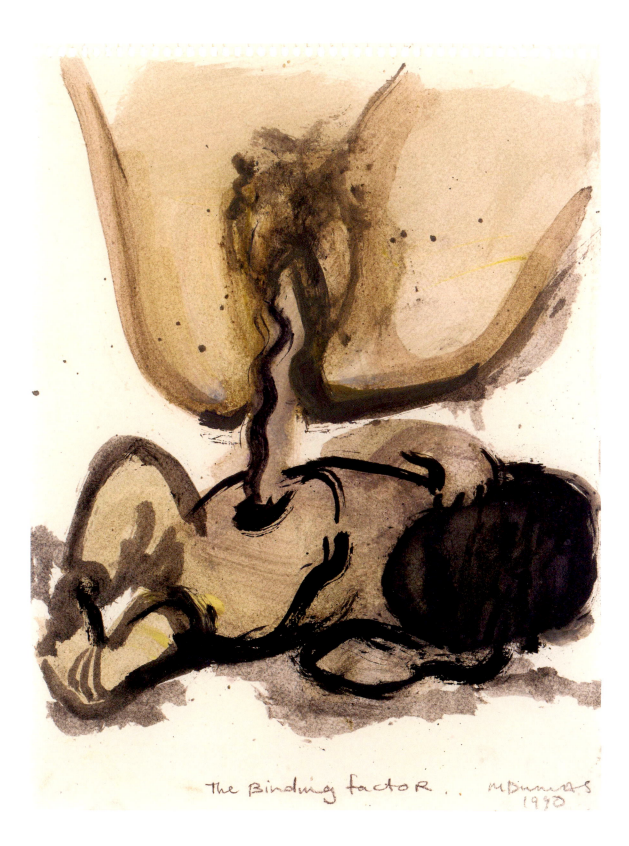

The Binding Factor, 1990; ink and crayon on paper; 12 1/2 x 9 1/2 inches; CAP Collection

The Binding Factor:
The Maternal Gaze of Marlene Dumas

LISA GABRIELLE MARK

To create an artwork
(to make an image of)
and to give birth
(to another human being)
have essentially nothing to do
with one another.
Yet this is no reason to stop loving
metaphors or avoiding the unrelated.
But the poetry that results from mixing
different kinds of language,
disappears into sloppy thinking,
when we imagine that these
differences can ever be solved
harmoniously; or even worse, when
we forget that these realities we are
mixing are of a beautiful and often
cruel indifference towards each other.

—MARLENE DUMAS[1]

My body is no longer mine, it doubles
up, suffers, bleeds, catches cold, puts its
teeth in, slobbers, coughs, is covered with
pimples, and it laughs. And yet, when its
own joy, my child's, returns, its smile washes
only my eyes. But the pain, its pain—it comes
from inside, never remains apart, other,
it inflames me at once, without a second's
respite. As if that was what I had given birth
to and, not willing to part from me, insisted
on coming back, dwelled in me permanently.
One does not give birth in pain, one gives
birth to pain: the child represents it and
henceforth it settles in, it is continuous.

—JULIA KRISTEVA[2]

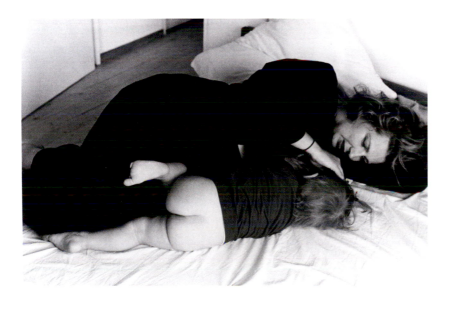

Marlene Dumas with daughter Helena, 1990 (photograph by Helena van der Kraan)

A dominant thematic strain in Marlene Dumas's work since the mid-1980s has involved the representation of pregnant women, newborn babies, and children—sometimes her own daughter. Although artists as diverse as Mary Cassatt, Otto Dix, Susan Hiller, Jorg Immendorf, Mary Kelly, Dorothea Lange, Léa Lublin, Paula Modersohn-Becker, Alice Neel, Gerhard Richter, Lara Schnitger, and Vincent van Gogh have represented various moments and aspects of motherhood, few have dedicated themselves more consistently to the subject than Dumas. Fewer still have dared to evoke the erotic flush and existential terror of motherhood, a trajectory that begins with the warmth and intimacy of sexual desire and eventually meets the cold indifference of the outside world. Dumas has said, "*I paint because I am a woman*,"[3] but her work goes beyond gendered causality to suggest the experience of inhabiting a female body, the fullness and "viscerality" of being a woman, through a painterly vocabulary that straddles form and formlessness.

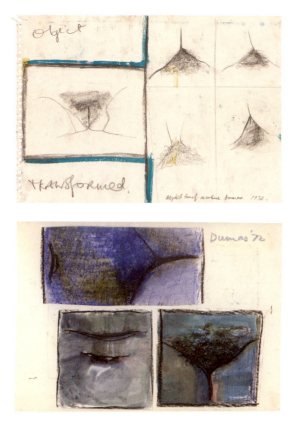

"intention" (as originated by the artist) and "interpretation" (as originated by the viewer): "Meaning and above all the ambiguity of meaning [are] coupled with the reversibility of truths. Throughout her work we find contradictory meanings: beauty is always combined with ugliness, good with bad, life with death."[5] Similarly, it is important to distinguish between the paintings and the "people" in them: a figurative painting is an object distinct from what it depicts, though there may be overlap in the language used to describe each one. One of the remarkable strengths of Dumas's work, however, is how it plays with such seeming polarities and distinctions. Switching between intention and interpretation, between what the work is and what it represents, the viewer's perceptual experience is simultaneously mental and physical, empathetic and kinesthetic.[6]

Desire/Origins

While both of this essay's epigraphs speak about representation and birth using contrasting metaphors of blending and distinction, both also hint at the profound ambivalence inherent in each form of "creation." While Dumas cautions against the sloppiness of concluding that these two "languages" could be brought together into a harmonious whole, the surfeit of meaning (i.e., "poetry") that is yielded when they are brought into dialectical relationship with one another would seem reason enough to undertake it. How else to account for the proliferation of images relating to pregnancy, birth, and early childhood within Dumas's oeuvre? In Julia Kristeva's text, the trauma associated with the physical separation of the child from the mother's body at birth compels the mother to reassume the child as pain—what the child comes to "represent" to the mother.[4] Within such a scenario, one imagines that the painterly representation of gestation, birth, or even children could never be anything but fraught—a fact to which Dumas's works consistently bear testament. Tirelessly interrogating received ideas of what it means to be a woman, a mother, a person, and a painter, she generously invites (at times to the point of seducing) the viewer to consider these respective realities through her work.

Of course, it is crucial to distinguish between an artist and her work. One is not the other and yet they are inextricably intertwined. Selma Klein Essink articulated the play of meaning in Dumas's works in terms of

Immaculate, a small oil-on-canvas painting from 2003, succinctly depicts the mysterious locus of sexual desire and evokes the beginnings of human life. Struggling to be contained within the work's diminutive proportions

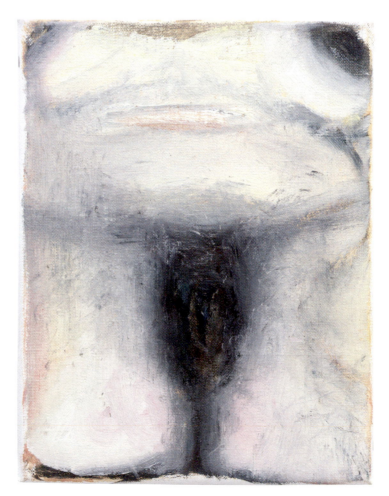

(9 7/16 by 7 1/16 inches), full-frontal flesh seems to press up against the picture plane like a photograph from Ana Mendieta's *Untitled (Glass on Body)* (1972). But there is no mistaking that the title refers to the florid slashes that serve as parentheses for the dark unknown in the lower center of the canvas. The work's unflinchingly anatomical composition makes Gustave Courbet's bushy and vulvic *L'Origin du monde* (Origin of the world, 1866) seem modest by comparison.

Immaculate would seem to relate most readily to works such as *Fingers* and *Miss Pompadour* (both 1999), oil paintings of women splaying and displaying their pudenda in poses familiar from their pornographic sources. However, its title connects it to conception at its most divine, radically rejoining the distinct art-historical subjects of Virgin and Whore, categories within which loom the antiquated specter of patriarchal oppression and male guilt. Dumas slyly reminds us that, in the relatively under-defined climate of "post-feminism," Virgin and Whore are also deployed as a kind of drag, something to inhabit consciously for the purpose of subversion, play, or just "gettin' paid"—that is, empowerment through economic benefit.

In its awesome explicitness, *Immaculate* just as easily conjures the gynecological safari of Annie Sprinkle's cervical exam performance as it does Immanuel Kant's concept of the sublime, which promoted the idea that nature (and, by extension, the "natural") is fearsome and transcendent. The painting does evoke transcendency in the sense that it connotes a pleasure that remains ineffable, only intimated through an excess of language (the poetry resulting from Dumas's notion of "mixing languages") or even silence. American poet Sharon Olds came close to expressing what is visually implied in *Immaculate*:

> Deep in my sex, the
> glittering threads are thrown outward and thrown outward
> the way the sea lifts up the whole edge of its body,
> the rim, the slit where once or twice in a lifetime
> you can look through and see the other world—

> it is this world, without us,
> this earth and our bodies
> without us watching.[7]

As Dumas said, "I situate art not in reality but in relation to desire."[8] In that context, then, *Immaculate* can be seen as a portrait of desire. However, this desire is inextricably connected to a chain of life and death, not isolated as a moment out of time, devoid of effect.

Anticipation/Idea

Pure biology posits the relationship between desire and conception as cause and effect, but it is better explained using Dumas's notion of mixing two distinct realities marked by "a beautiful but often cruel indifference towards each other." This fundamental ambivalence imbues the biological imperative with a startling mix of idealism, anticipation, urgency, attraction, repulsion, trepidation, and terror. Dumas's *Fear of Babies* (1986) comprises twelve works on paper, beginning with a panel bearing the title embedded in a web of agitated pencil strokes, much like the first frame of a comic strip. Each subsequent work features a portrait of a baby whose cartoon-like features have been exaggerated to eerie or comic effect. (One particularly sinister-looking baby wears a crown, while another's flat right cheek and graduated neck cause it to resemble a mollusk.)

Fear of Babies is based on Dick Jewell's *Cosmo/Babies* (1978), in which photographs of magazine cover girls are interspersed in a grid alongside studio portraits of babies. Jewell's work plays humorously with the two types of commercial images—equally contrived—laughably hinting that "picture day" at Sears might plant the seeds for a lucrative modeling contract down the road. While Jewell's work is ultimately engaged in

Opposite, top: *Sketchbook—"Object Transformed"*, 1972, details; mixed media on paper; 8 1/8 x 11 9/16 inches; collection of the artist

Bottom: *Immaculate*, 2003; oil on canvas; 9 7/16 x 7 1/16 inches; collection of the artist

Above: Dick Jewell, *Cosmo/Babies*, 1978; photo-litho print; 25 3/16 x 34 1/4 inches; courtesy of the artist

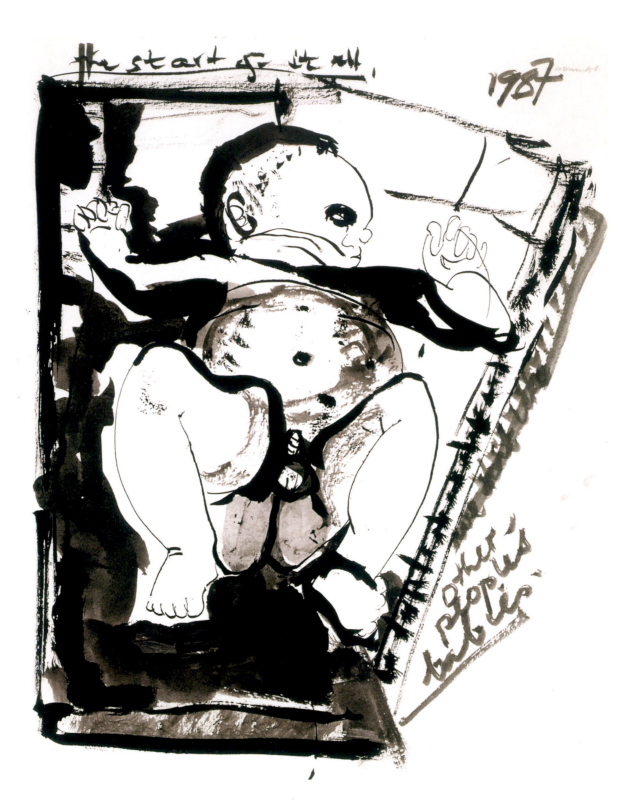

The Start of It All / Other People's Babies, 1987; watercolor and ink on paper; 11 ¹⁵/₁₆ x 9 ¹/₂ inches; The Over Holland Collection

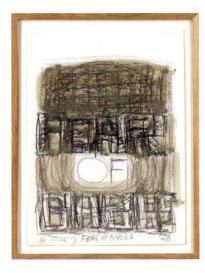 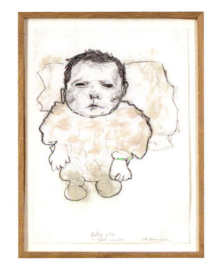 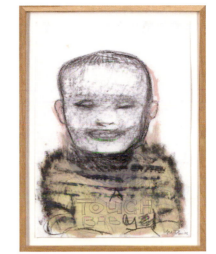 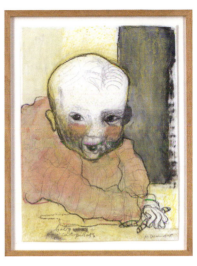

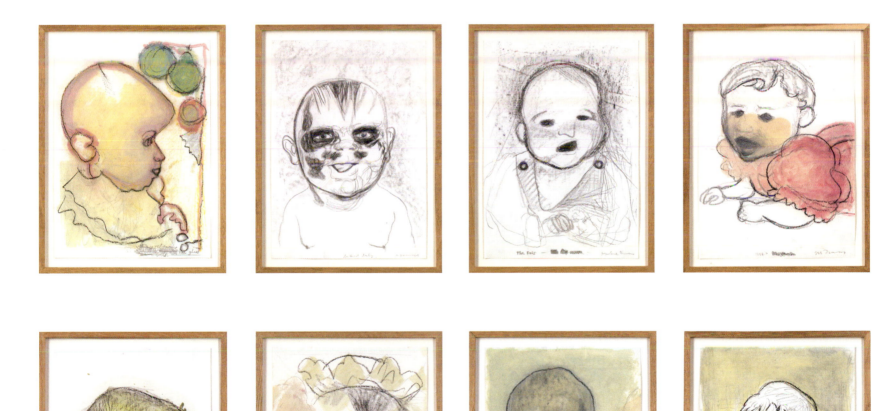

Fear of Babies, 1986; crayon, pencil, and watercolor on paper; twelve sheets: 11⁵/₈ x 8¹/₄ inches each; Gemeentemuseum, The Hague

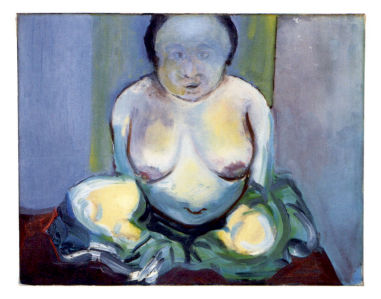

a critique of the media, Dumas's work is taken up with the expressive transformations made possible through mark-making, contrasting sinewy contour lines and jittery scribbles, flat patches of ochre and mottled washes of buff and gold.

While *Fear of Babies* registers a note of lighthearted ambivalence about the prospect of parenthood, a large oil-on-canvas work from the previous year, *Die Baba (The Baby)* (1985), strikes a more somber chord. Much has been said about the subject's self-composed expression, which surely rivals the Mona Lisa's in its inscrutability. One might presume the baby is a boy, based on the blue vest, but there are no clear indicators. Similarly, one might guess "him" to be in late infancy, if not for the uncanny facial expression. Late infancy is typically the stage at which language development begins. However, if the child in *Die Baba* seems wise beyond his years, with much to say but no means to express it, it can only be because of the viewer's ability to project upon him—and that would seem to be the point. The image is precisely about what one does *not* know about this little being, so new and yet seemingly so fully formed psychologically.

The composition of the painting is such that the child's gaze is set ever-so-slightly above the viewer's; he appears to be looking down, with an arched brow and a gentle pout. Dumas's spare palette consists predominantly of cool gray-blue and white, warmed throughout by yellow. The face is articulated using gray, black, and the subtlest stroke of red where the lips meet. The eyes are a lustrous black with white spots of reflected light.

Dumas consistently manipulates scale to underscore the emotional power of her works while retaining the human body as the measure of all things. If a painting

is small, one is aware of its being smaller *than life*, and vice versa if a work is large. *Die Baba*'s grand proportions amplify its unspoken psychological resonances while also serving as a metaphor for the monumental significance of the child to its mother. Dumas has explained her approach to scale as follows:

> I don't have any conception of how big an average head is…. I've never been interested in anatomy. In that respect I relate as children do. What is experienced as the most important is seen as the biggest, irrespective of actual or factual size.[9]

Like *Fear of Babies*, *Die Baba* suggests a sense of underlying trepidation about motherhood but also evokes the profound Otherness that lies at the heart of maternity: for the mother, the child is *of* her but *not* her; it is the source of most profound joy reassumed, in Kristeva's conception, as pain.

Pregnant Mother/Baby As One

A number of works from 1988 and 1989 depict pregnant women, exploring the interrelationship of mother and unborn child—at times to the point of conflating the two. One modestly scaled work, *Pregnant Woman as a Baby* (1989), shows a pregnant figure seated in a corner on the floor. Her distended breasts and belly occupy the center of the canvas, recalling those of the Venus of Willendorf or an Inuit sculpture, while her face—the top of which extends beyond the frame—is laid out as a hazy wash of cool lavenders and blues, all but assimilated into a background of the same tones. The hair and facial features of the mother-to-be are only broadly articulated, suggesting that her identity is of less significance than the fact that she is carrying a child; her very form is determined by this fact. The subject of *Pregnant Woman as a Baby* resembles a generalized female archetype more than any specific woman, and for good reason: she is in the throes of an existential crisis in which she is becoming irretrievably and

Pregnant Woman as a Baby, 1989; oil on canvas; 15 3/4 x 19 11/16 inches; collection T. Bignand, Paris

undeniably *woman*,[10] yet as a distinct entity/identity she is simultaneously being erased. Simone de Beauvoir famously spoke of "becoming woman" in *The Second Sex* (1949), describing pregnancy as "a drama that is acted out within the woman herself":

> She feels it as at once an enrichment and an injury; the fetus is a part of her body, and it is a parasite that feeds on it; she possesses it, and she is possessed by it; it represents the future and, carrying it, she feels herself vast as the world; but this very opulence annihilates her, she feels that she herself is no longer anything.[11]

The title *Pregnant Woman as a Baby* bids the viewer to see them as one, to mark the moment before separation. The center of the composition is occupied by one who is unseen but whose presence is everything. In contrast, several of Dumas's images of babies, including *Warhol's Child* (1989–91) and *The First People (I–IV)* (1990), feature babies whose bloated bellies resemble those of pregnant women. This visual equivalency between the rounded form of a pregnant woman and that of a baby suggests the interchangeability of subjectivity—mother as child, child as mother—before the separation that occurs at birth and increases over time. The watercolor and pencil drawing *A Child Expecting a Child* (1988) anticipates this idea. A female figure sits angled away from the picture plane, the contours of her body indicated by several loose dark brushstrokes with a single line trailing down the center of her belly. Sepia washes across her belly and breasts, while bloody blue-red flickers agitatedly over her stomach, shoulders, and head and nervous pencil strokes shade one side of her body. Though the woman depicted appears to have reached sexual maturity, the title suggests her dual role as both child and prospective parent.

The title of *Pregnant Image* (1988–90) operates both literally and metaphorically, plainly describing the picture but also alluding to the retention of meaning within. Larger than life size, the work depicts a pregnant woman (partially based on a friend of the artist) wearing

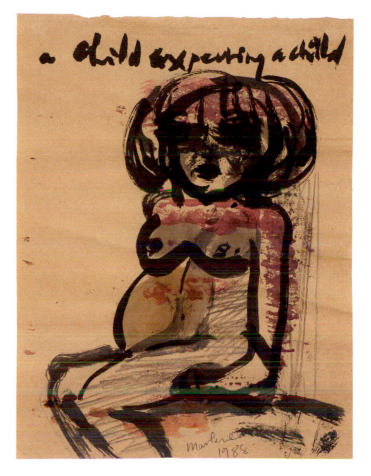

A Child Expecting a Child, 1988; watercolor and pencil on tar paper; 21 x 17 inches; collection Blake Byrne, Los Angeles

nothing but an unbuttoned blouse and kneeling on the floor. The ambiguous setting is similar to *Pregnant Woman as a Baby*, as is the fact that the top of the woman's head is cut off and her belly is positioned just above center. The figure appears within an impossibly constraining and shallow environment: the floor appears to meet a wall in the lower left of the canvas, creating the effect of a flat plane immediately behind her—but the woman's calves and feet, which extend out at an angle behind her on the other side, would actually go beyond that plane were Dumas observing classical Renaissance perspective.

Pregnant Image was begun 1988, the year Dumas became pregnant with her first (and only) child, and was finished after her daughter was born in 1989. Though the painting is of someone else, Dumas's empathy with the physical condition of her subject, who is clearly well into her third trimester, is palpable. And this empathy is transmitted to the viewer though the act of looking. The precariousness of the woman's pose, kneeling on the floor with hands behind her back, sets one innately off balance—as does the fact that the shallow pictorial space thrusts her out toward the viewer. This formal push and pull is echoed in the work's tonal contrasts, including that between her pearlescent belly and her dim lugubrious face.

207

Pregnant Image, 1988–90; oil on canvas; 70 7/8 x 35 7/16 inches; collection Jack and Connie Tilton

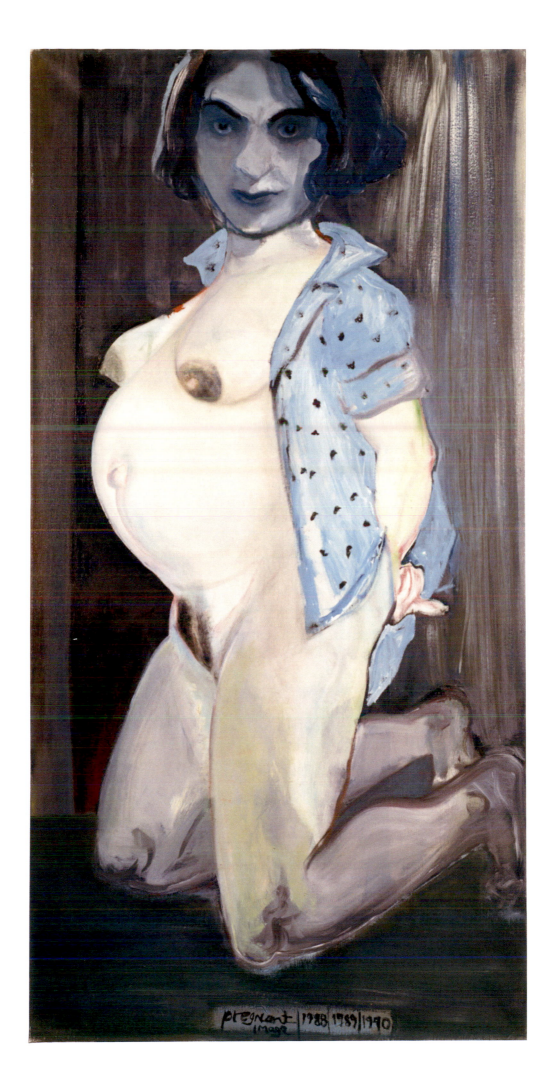

A number of works on paper from the late 1980s depict pregnancy. *(Ver) wachtende (Expectant)* (1989), a loosely executed ink-wash drawing showing a pregnant figure lying tilted so that her gaze is toward the viewer and her belly is above her head, evokes the dark amniotic world of the unseen child. The pivotal drawing *The Binding Factor* (1990) revisits the perspective presented in *Immaculate* but with a key difference: a newborn infant has just emerged from the birth canal and is still connected to the mother by the umbilical cord. This moment is so potent and primal, yet surprisingly, one is hard-pressed to think of another artist who has represented it.

Newborn/Alien

At the moment of birth, when the child is separated from the mother's body, the previously unseen becomes visible. What was subsumed is now Other, outside. But what is it exactly that one has given birth to? And where did it come from? These fundamental questions of existence can never be satisfactorily answered because, as de Beauvoir explained, "In a sense the mystery of the Incarnation repeats itself in each mother; every child born is a god who is made man." However, while "every mother entertains the idea that her child will be a hero… she is also in dread of giving birth to a defective or a monster."[12] These two fantasies—god and monster— map out two poles in a field of maternal ambivalence that, though not the same as Kristeva's joy (*jouissance*) and pain, nonetheless have a grip on the popular consciousness: the deep-seated fear of giving birth to a monster has been played out in countless science-fiction narratives, while Christ represents the paragon of the hoped-for hero-child.

Several paintings made between 1989 and 1991 continue to explore the subject of maternal ambivalence through the representation of naked infants. *Warhol's Child* and *The First People (I—IV)* depict newborn babies not as perfect pink bundles, but as fearsome beings. In both works, the composed grandeur of *Die Baba* explodes into a monumental scale that forecloses any

possibility of sentimentality (or baby lust). At nearly ten feet wide, *Warhol's Child* has been described as having both "a horrifying presence"[13] and "psychedelic skin."[14] The giant girl-child, whose torso and abdomen are proportionally elongated to allow her bloated spherical belly to occupy the center of the composition, is contained in an environment as shallow, contorting, and undetermined as those of the pregnant women. One seems to look down at her, yet she floats horizontally above a line that suggests ground level. Her head is tipped at an impossible angle from her chest, which twists the other way, and a sickly mix of black, gray, brown, and pink articulate the surface and folds of her skin.

In deference to the title, some have claimed to see a resemblance to Andy Warhol, but, rather than seeking out actual physical similarities, it may be more fruitful to imagine that it represents *another* Andy, in much the same way as Alice Neel's portrait *Andy Warhol* (1970) offers a depiction of the artist that is very different from the media's (and his own). Neel's painting presents an aging feminized Warhol, naked from the waist up, eyes closed, breasts sagging, the effects of Valerie Solanas's gunshots visible in the white stitches of his abdominal incision and corset. While Neel sympathetically imagines Warhol as a tired and tender old woman, Dumas daringly envisions the offspring of the famously celibate gay artist as a disturbing baby-blimp, as if to suggest that the creative act itself is capable of producing gods and monsters. Similarly, *The First People (I—IV)* presents four individual babies as huge hovering entities effected through the crude handling of paint and the deployment of excessive scale. Their patchy purple faces resemble those of newborns and their limbs, previously unencumbered by gravity, seem to sprout from their torsos like rhizomes. Yet even the most odd-looking newborn is received into the arms of its parents as the most beautiful of all creation. By resisting the aesthetic cliché that sees babies rendered as perfect little flesh dumplings, Dumas's work teeters on the threshold of beauty and ugliness, suspended between what is embraced and what is rejected.

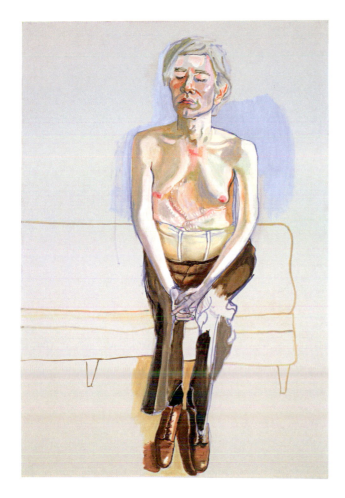

While the representation of children within Dumas's oeuvre is never innocent, not all images fall so distinctly on the side of the monstrous. *In the Beginning* (1991) is a larger-than-life-size painting featuring an infant on her hands and knees wearing a bold crimson sweater. Her left hand, reaching over a doll, holds a drawing implement with which she marks a paper lying on the "ground." (The quotation marks are necessary, as space in this work is as minimally defined and non-perspectival as in *Pregnant Woman as a Baby* and *Pregnant Image*.)

The source image for this painting is from a series of personal snapshots of Dumas and her infant daughter lying on a bed—presumably after breast-feeding, as the artist's breast is exposed in one photo. In that tender image, the child looks up at whoever is taking the picture while Dumas gazes sleepily at her. But Dumas did not choose to paint that picture; instead,

she removed herself, isolated the child,[15] and gave her an unlikely pose for an infant (stay balanced on one hand, while making a drawing with the other). This is a simple and direct example of how, in addition to bringing the full force of her materials and gestures to bear on her paintings, she also radically changes the content of source images through subtle alterations. Combined with a title whose religious connotations connect it to creation, *In the Beginning* stands as a meditation on the beginning of human life, a time during which, as the work suggests, one is alone yet under the gaze of another. Further, without knowing that the mother is present in the source image, one might easily imagine that gaze to be the mother's.

In a more general way, the concept of a maternal gaze could be said to underlie all of Dumas's works. Not based on biology but on investment with the subject, it is the implied gaze of the mother—bearing witness, weighing the implications, and committing stories and images to collective memory (which is *not* the same as the writing of history). It does not look away, nor does it look upon something purely for its own use or pleasure, furtively seizing/seeing only what it wants. The maternal gaze looks upon the ugly or the unconventional with the same sense of acceptance that it brings to the beautiful, perhaps even finding beauty where others do not.

Though Dumas herself does not demure from acknowledging the power dynamic implicit in her acts of representation ("My people were all shot by a camera, framed before I painted them. They didn't know I'd do this to them."[16]), she creates a condition of risk for herself that equals that of her subjects in being represented. As she explained:

> The aim is to "reveal" not to "display." It is the discourse of the Lover. I am intimately involved with my subject matter...I am not disengaged from the subject of my gaze. With photographic activities it is possible that they who take the picture leave no traces of their presence, and are absent from the pictures. Paintings exist as the traces of their makers and by the grace of these traces. You can't TAKE a painting—you MAKE a painting.[17]

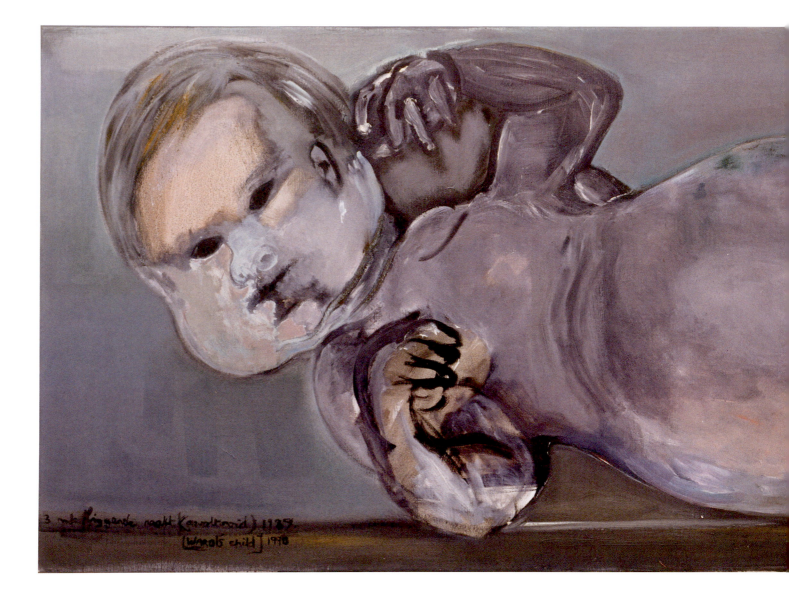

Warhol's Child, 1989–91; oil on canvas; 55 $^1/_8$ x 118 $^1/_8$ inches; Städtische Galerie Karlsruhe, Sammlung Garnatz

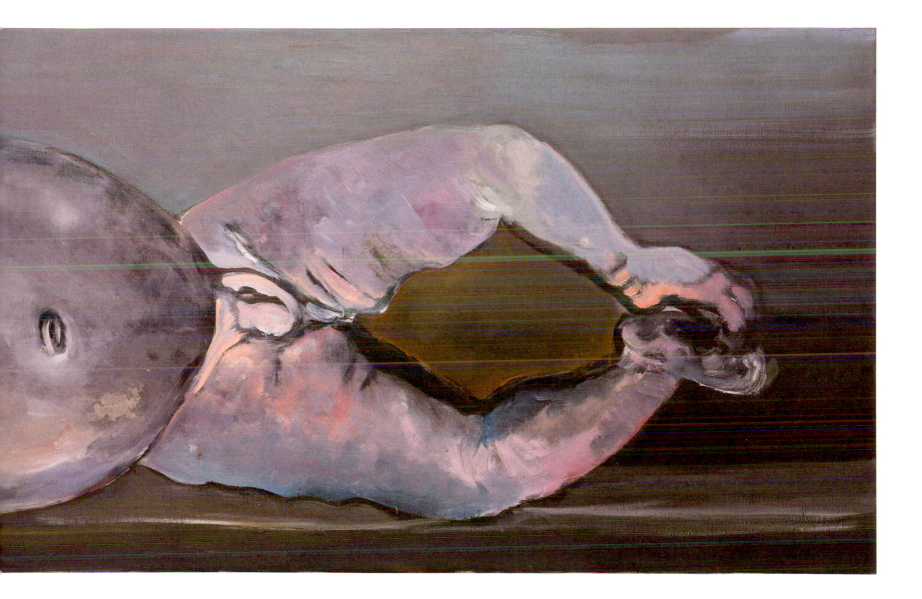

Dumas resists the voyeurism implicit in "taking" a picture, instead imbuing the work with what she refers to as "grace." This grace is extra-human, derived from the fact that the works are distinct from their maker and exempt from the emotional vicissitudes of human life. Though the paintings bear the indices of her intentions,[18] they exist and are received by a community of viewers, independent of the artist. Despite its connotations of serenity, grace does not imply that Dumas's works are placid or harmonious. One of the ways they derive power is through their insurgent materiality: the representational image has no more purchase on the viewer than the individual strokes, stains, and drips—as well as the layers of color—that constitute the works' "traces," indexical marks of the artist's own body. The artist's evident investment in her subjects combines with the gestural fluidity of the drawn and painted marks to lend the work visceral—as well as cerebral and emotional—impact. In this way, Dumas posits a viewer who is an embodied receiver of the work, rather than merely appealing to optical and intellectual faculties.

Distinction/Secrets

The Painter (1994) is a near-allegory for the primal experience of mark-making, while at the same time serving as a nuanced psychological portrait of the relationship of mother and daughter (though not, specifically, Dumas and her daughter). Startlingly large (and somewhat menacing as a result), a young child stands naked, hands caked in paint (red on the right hand, blue and red on the left). A strange sullen expression hangs low on her face, beneath her oversized cranium and the yellow-gray smudges that stand in for her hair. Again, signals are mixed: she is young but somehow old, disarming but somehow vulnerable. Her belly is rubbed in blue, as if a frigid rash of pigment was advancing up her abdomen, and a line runs from her navel to her pubic bone. The paint application is thin and sketch lines are visible, lending the work an ethereal quality.[19] She is there and not there.

Once again, the differences of the painting from its source image are telling. The snapshot on which the work is based shows a sweet little brown-haired girl (Helena) with red and blue painted designs on her tummy and legs. The grass and kiddie pool behind her suggest she had been photographed outdoors during a brief respite from finger-painting on a hot summer day. In Dumas's painting, which is devoid of the familiar quality of the source image, the temperature has changed from warm to cool. Moreover, the sense of alienation (fully embracing the word's extraterrestrial connotations) is palpable. The girl's frontal pose in the source image becomes confrontational when magnified to such a formidable scale, just as her slightly reserved expression transforms into an impenetrable glare.

As with *In the Beginning*, whose source image is also derived from the documents of Dumas's personal life, the figure in *The Painter* is isolated from its original context, lifted from familiar indicators of place, time, and identity. Though both paintings leave issues of place and time undetermined, they recast the question of identity by featuring a child in the role of artist. But is this child-as-artist, perhaps alluding in a generalized way to the idea of creative potential? Or is this artist-as-child, a more personal reflection by the creator of the works? It could be neither or both. Once again, as a viewer, one is faced with the limits of knowability (intention) and the creative possibilities that ensue (interpretation). *The Painter* goes one further by making a series of subtle reflexive links between mother and child that are possible only when considering Dumas's entire body of work. For instance, the emphasis given to the belly connects it to her paintings of pregnant women (*Pregnant Woman as a Baby* also features a blue belly) and the line running from the girl's navel to her pubic bone resembles a common stretch mark that appears during pregnancy. The potential interchangeability of identities serves to highlight certain narcissistic aspects of motherhood, the ability of mothers to project their own identities (desires, fears, aspirations, insecurities, etc.) upon their children. Yet, like most children, the subject in *The Painter* does not willingly assume the identity projected on her by the artist/mother; her own gaze is guarded, even defiant. She is clearly her own "person." (A smaller earlier work, *Helena* [1992], bears a similar expression.)

The Painter, 1994; oil on canvas; 78 3/4 x 39 3/8 inches; The Museum of Modern Art, New York, fractional and promised gift of Martin and Rebecca Eisenberg

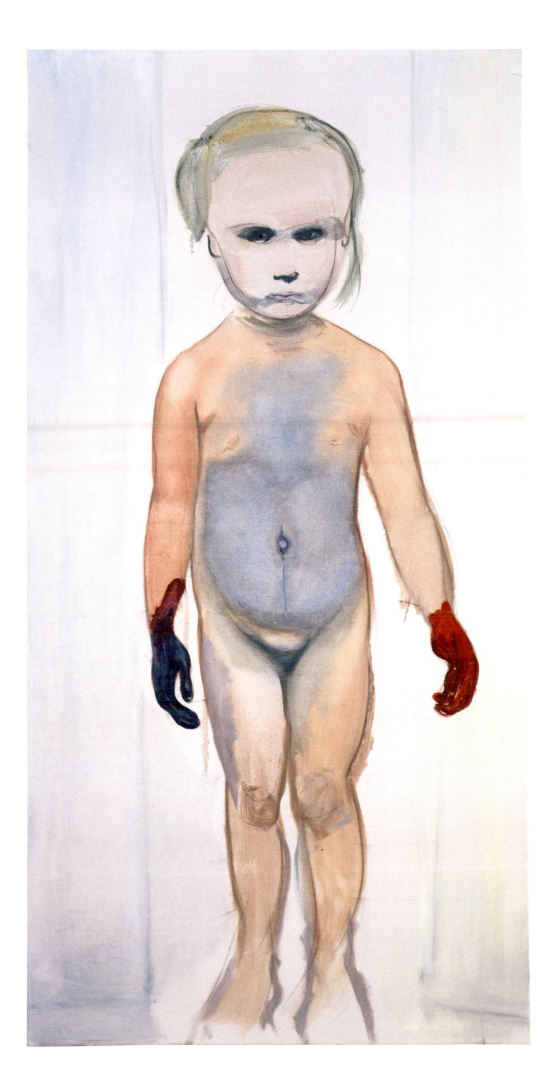

While individuation is necessary, the Oedipal crisis involved in separation from the mother can nonetheless be a source of shame and/or loss for the child, the exact dynamics of which may be affected by gender.[20] Attendant, though less fully explored, is the sense of longing and loss that may be experienced by the mother. *The Secret* (1994) plays on this duality by presenting a child with its back turned to the viewer. As with *The Painter*, the figure is large, and the surface is for the most part thinly painted. The title teases with the promise of a "secret," but it does not say what the secret is or to whom it belongs. All indicators of identity have been removed (we don't even know what gender the child is), yet the interpretive possibilities multiply exponentially. Numerous markers—the turned back, arms appearing to hold something up toward the face, the darkly painted body, the dense black background—suggest that the secret belongs to the child, and yet that secret may simply be one of *difference*, marked by an unwillingness to subject oneself to the prying eyes of the mother. Of this period in a girl's development, de Beauvoir explained, "She would like to escape from her mother's authority, an authority that is exercised in a much more intimate and everyday manner than is anything the boys have to accept.... Having secrets is also one way of giving herself importance."[21] Regardless of gender, *The Secret* suggests that the intimacy of the maternal gaze may at times simply be too much to bear as the child struggles to assert her or his own independence.

Ultimately, however, the work stands as a testament to the limits of intention and interpretation versus the grace of experience. As one is confronted with what one does not know—will never know—and the reality that whatever interpretation one might generate is its own form of fiction, one is given the opportunity to reflect on one's own compulsion to make meaning. Simultaneously, one is bathed in the work's "traces," suspended in grace and free to imagine a liminal state of between-ness—a "binding factor" that connects mother and child, artist and subject, while allowing each their distinctness.

Empathy/Imagination

Dumas's work is both figural and corporeal. In the representation of one body (or bodies), another body asserts itself through the painted marks. With many forms of painting, the viewer kinesthetically senses the existence and movement of another through the indexical traces of the artist's gestures, like walking on the beach and seeing footprints in the sand. However, one need not be looking at a representational form to have this experience—in fact, Abstract Expressionism gave particular weight to this form of perception. Figurative painting is predicated on another kind of recognition, that of one body recognizing another, like looking in a mirror. This dance of form and formlessness creates a condition of empathy that, although enhanced by the representational content of the painting, does not depend on the presumption of shared emotion for its impact. As Dumas has explained:

> The aim of my work, I have come to believe, has always been to arouse in my audience (as well as myself) an experience of empathy with my subject matter (be it a scribble, a sentence, or a face...) more so than sympathy. Sympathy suggests an agreement of temperament, and an emotional identification with a person. Empathy doesn't necessarily demand that. The contemplation of the work (when it "works") gives a physical sensation similar to that suggested by the work.[22]

Because of this empathetic condition, Dumas's images of mothers and children do not depend on the shared circumstance of being a woman or a mother for their intelligibility. Instead, they posit a gaze through which one can imaginatively engage ideas of difference within a framework of intimacy.

How to Kill Your Mother, 1989; ink and colored pencil on paper; 17 1/2 x 12 3/8 inches; The Museum of Modern Art, New York, The Judith Rothschild Foundation Contemporary Drawings Collection Gift

NOTES

The author would like to thank John Alan Farmer for his sagacious editorial advice on this essay.

1. Marlene Dumas, "Birth" (1989), in Dumas, *Sweet Nothings: Notes and Texts* (Amsterdam: Galerie Paul Andriesse and Uitgeverij De Balie, 1998), 49.

2. Julia Kristeva, "Stabat Mater" (1976), in *Tales of Love*, trans. Leon S. Roudiez (New York: Columbia University Press, 1987), 240−41.

3. Dumas, in "Cherchez la femme peintre," *Parkett*, no. 37 (September 1993): 140. Dumas's contribution to the inquiry was a seven-point essay on the subject of "Woman and Painting," whose first point uses a logical fallacy to convey a poetic truth:

 > 1. *I paint because I am a woman.*
 > (It's a logical necessity.)
 > If painting is female and insanity is a female malady, then all women painters are mad and all male painters are women.

4. This holds interesting implications for the entire field of "representation," but that is outside the scope of this text.

5. Selma Klein Essink, introduction to *Marlene Dumas: Miss Interpreted*, exh. cat. (Eindhoven, The Netherlands: Van Abbemuseum, 1992), 16.

6. Kinesthesia is a physical sense that produces empathy. One senses a decidely corporeal dimension to Dumas's empathy for the subjects who appear in the photographs she has used, whether they are pregnant women or political prisoners; in turn, her painterly gestures produce a physical sensation in the viewer that is as real as smell or taste.

7. Sharon Olds, "A Woman in Heat Wiping Herself," in *The Gold Cell* (New York: Alfred A. Knopf, 1992), 59.

8. Dumas, "Love Notes (The Lava-Edge)" (1983), in *Sweet Nothings*, 21.

9. Dumas, "Miss Interpreted (extract)" (1992), in *Marlene Dumas* (London: Phaidon Press, 1999), 116.

10. Dumas has written of her own pregnancy, "Now I'm not one of the boys anymore." Dumas, "The Origin of the Species," in *Marlene Dumas: Miss Interpreted*, 58.

11. Simone de Beauvoir, *The Second Sex* (1949) (New York: Vintage Books, 1974), 553. I refer to her stage-by-stage account of a modern woman's life and development as it pertains to an evolving awareness of the female subject because it has yet to be equaled in the nuance and sensitivity with which it recounts the passages of being a woman; yet it is important to note that this translation, done by H. M. Parshley, has been criticized by feminist and existentialist writers including Toril Moi. As the publisher has refused to authorize a new translation, I quote from it provisionally.

12. Ibid., 555.

13. Dominic van den Boogerd, "Hang-ups and Hangovers in the Work of Marlene Dumas," *Marlene Dumas* (1999), 60. Describing *Warhol's Child*, he stated, "the king-sized youngster has a horrifying presence."

14. Ingrid Schaffner, "Erotic Displays of Mental Confusions: Marlene Dumas at the Van Abbemuseum," *Kunst & Museumjournaal* 3, no. 6 (1992): 27. This puzzling text describes the work as "the popular baby with the psychedelic skin and a Warholean head of hair." (While there are strokes of gray and white on the head that might indicate wisps of hair, calling it Warholean seems a bit of a stretch.)

15. Dumas on the isolation of the figure: "As the isolation of a recognizable figure increases and the narrative character decreases (contrary to what one might initially assume that this lack of illustrative information would bring about), the

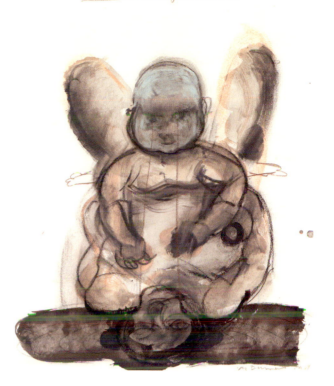

How to kill your mother.

interpretive effects are inflamed." "Miss Interpreted (extract)," 116−20.

16. Dumas, in *The Eyes of the Night Creatures* (Amsterdam: Galerie Paul Andriesse, 1985), n.p. Cited in Shaffner, "Erotic Displays of Mental Confusions," 28.

17. Dumas, *Marlene Dumas: Miss Interpreted*, 43.

18. On the issue of intentionality, Dumas cites Paul Cézanne: "We cannot really know how personally expressive any work of art is, for such a proposition implies full knowledge of its maker's expressive intention. While works of art by definition separate themselves from works of natural beauty (or ugliness) by being embodiments of intention, we cannot judge them according to their intentions, for we only know their intentions from the works themselves." Cézanne, quoted in John Elderfield, "The Lesson of the Master," *Art in America* (June 1985), cited in *Marlene Dumas: Miss Interpreted*, 76.

19. Comparing her approach to that of Lucian Freud, Dumas has said, "My daughter looks as if she comes from Mars, she looks less than human, like a total alien." Dumas, interview with Robert Enright, "The Fearless Body," *Border Crossings* 23, no. 3 (August 2004): 32.

20. Susan C. Greenfield articulates two distinct schools of thought regarding the Oedipal relationship of mothers and daughters. One argues that the daughter never fully relinquishes her connection to the mother, based on D. W. Winnicott's Object Relations Theory that was further developed by Nancy Chodorow in *The Reproduction of Mothering* (1978). The other takes the Lacanian view that individuation is experienced as loss, articulated in the work of French feminist writers Hélène Cixous, Luce Irigaray, and Julia Kristeva. See Greenfield, *Mothering Daughters: Novels and the Politics of Family Romance, Frances Burney to Jane Austen* (Detroit: Wayne State University Press, 2002), 21−22.

21. De Beauvoir, *The Second Sex*, 331−32.

22. Dumas, "The Eyes of the Night Creatures" (1985), in *Sweet Nothings*, 25.

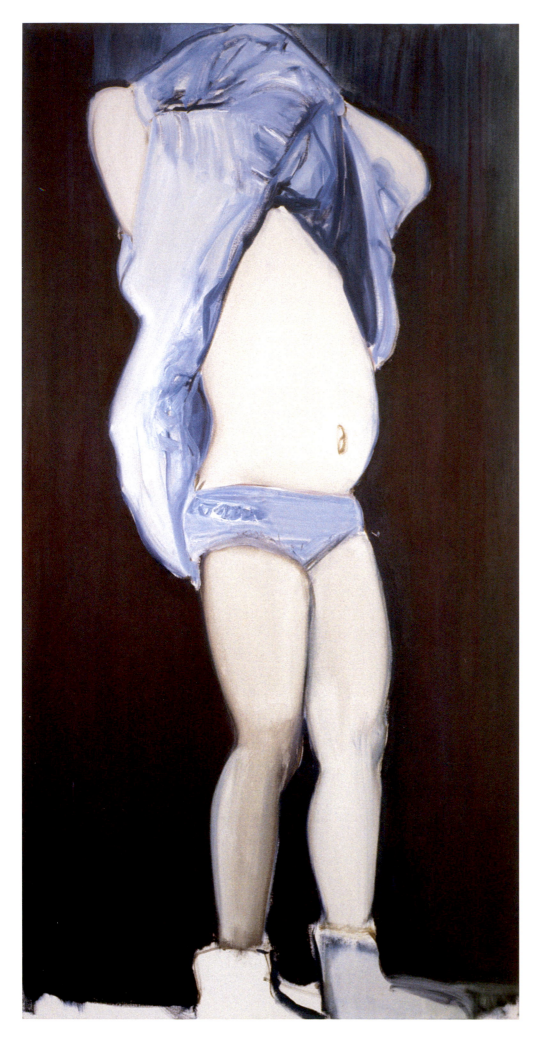

The Cover-up, 1994; oil on canvas; 78 3/4 x 39 3/8 inches; Scheringa Museum of Realist Art, Spanbroek, The Netherlands

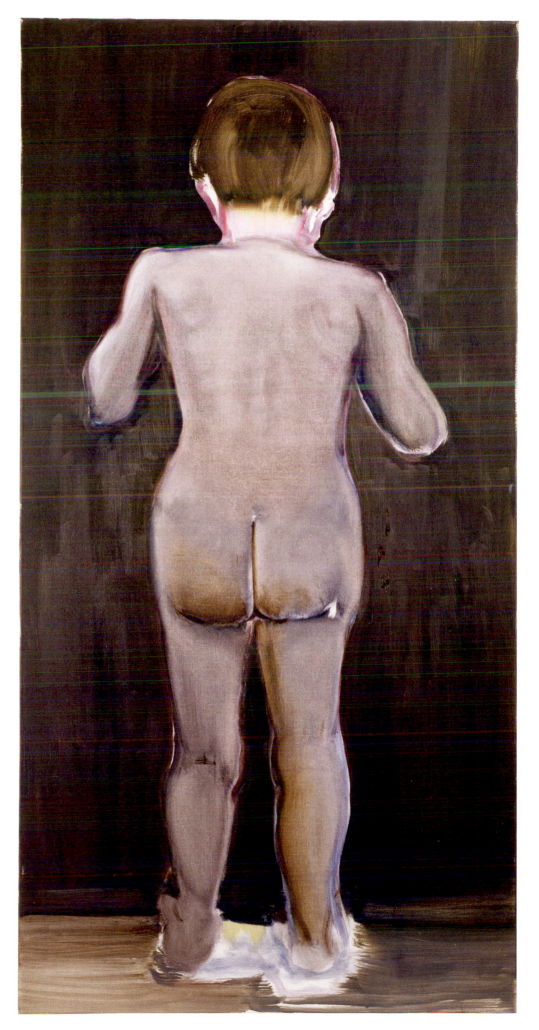

The Secret, 1994; oil on canvas; 78 3/4 x 39 1/4 inches;
The Carol and Arthur Goldberg Collection

In the Beginning, 1991; oil on canvas; 57 $^{1}/_{16}$ x 78 $^{3}/_{4}$ inches; private collection

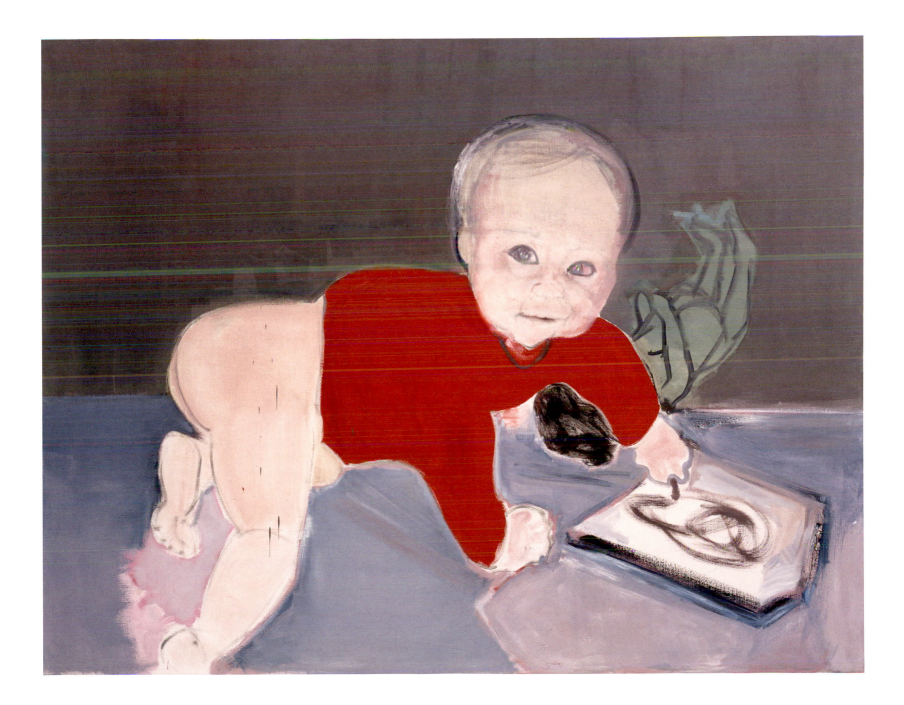

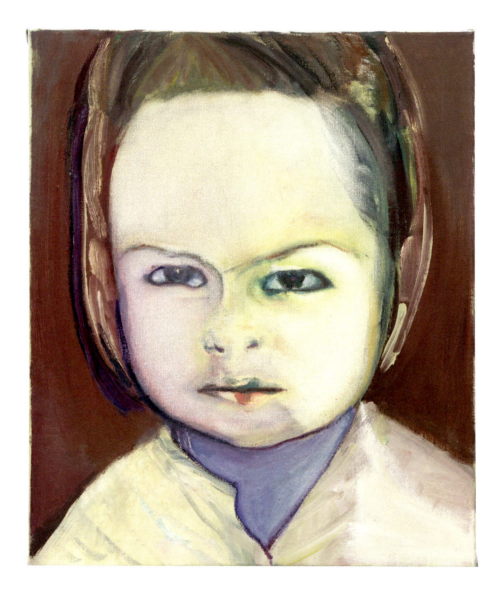

Helena, 1992; oil on canvas; 23 5/8 x 19 11/16 inches; collection Helena Dumas Andriesse, Amsterdam

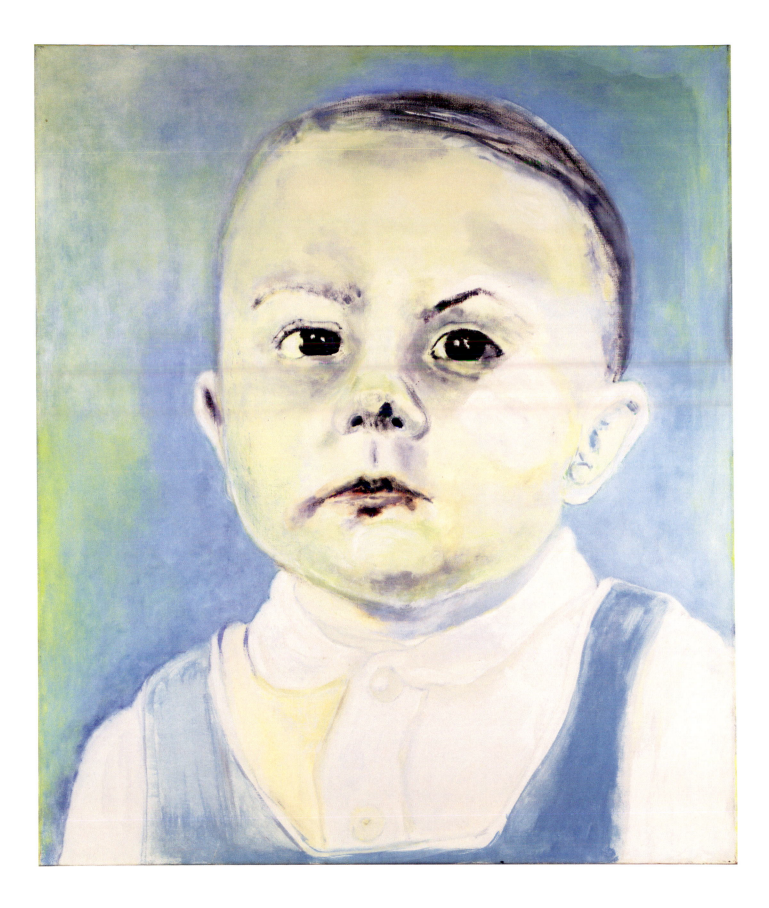

Die Baba (The Baby), 1985; oil on canvas; 51 3/16 x 43 5/16 inches; private collection, courtesy Christie's

The artist as a young girl

Opposite, clockwise from top left: Dumas as a baby, Dumas's grandmother and niece, and Dumas as a young woman, filed under the heading "Children" in Dumas's image bank

Right: Invitation card for an exhibition

Below: Jan Andriesse with daughter Helena, 1989 (left, photograph by Helena van der Kraan), and 1991 (right, photograph by Dumas)

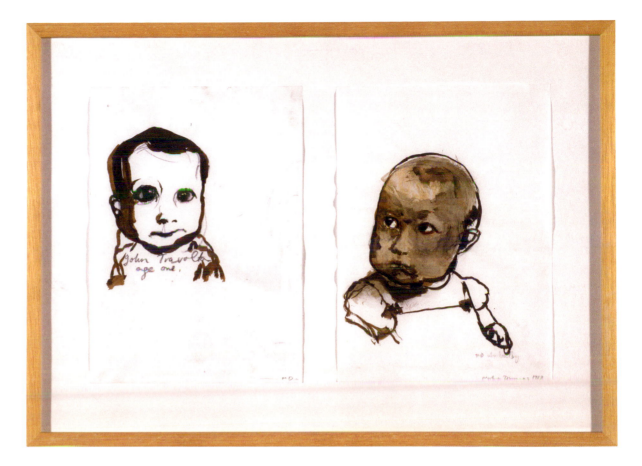

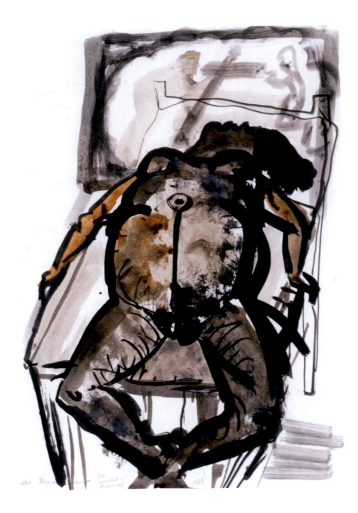

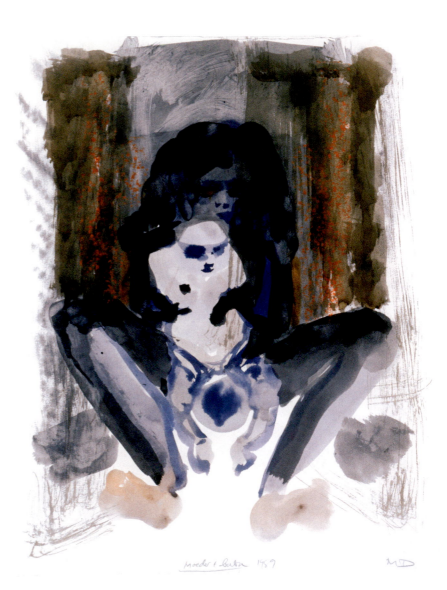

Above: *De Wacht-Kamer (The Waiting Room)*, 1988; gouache
on paper; 11⁵/₈ x 8¹/₄ inches; Städtische Galerie Karlsruhe,
Sammlung Garnatz

Right: *Moeder en Baba (Mother and Baby)*, 1989; gouache
on paper; 15¹/₂ x 12³/₈ inches; Städtische Galerie Karlsruhe,
Sammlung Garnatz

Opposite, top: *Eaten Up*, 1989; watercolor and ink on paper;
12 x 15¹⁵/₁₆ inches; private collection, courtesy Paul Andriesse,
Amsterdam

Bottom: *Wounded Man and Pregnant Women*, 1989; ink and
pastel on paper; 11⁷/₁₆ x 16¹/₈ inches; private collection,
courtesy Galerie Paul Andriesse, Amsterdam

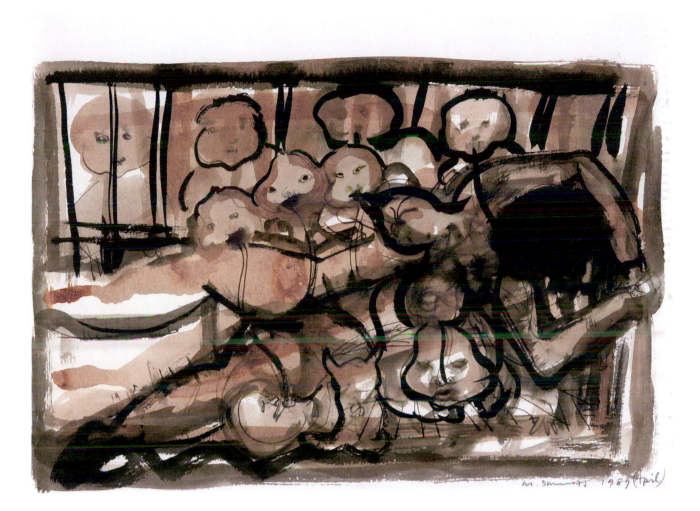

M. Dumas 1989 (April)

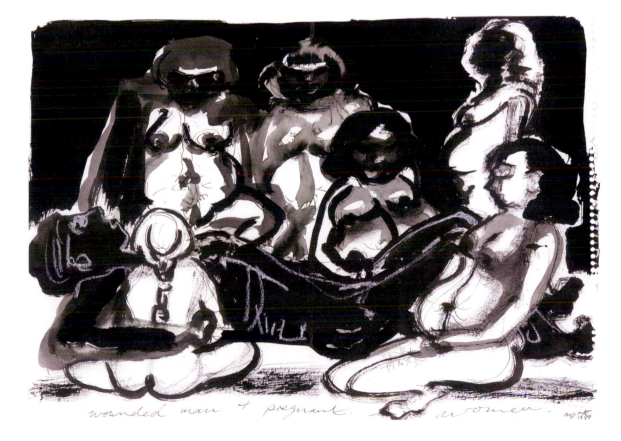

wounded man + pregnant women MD 1989

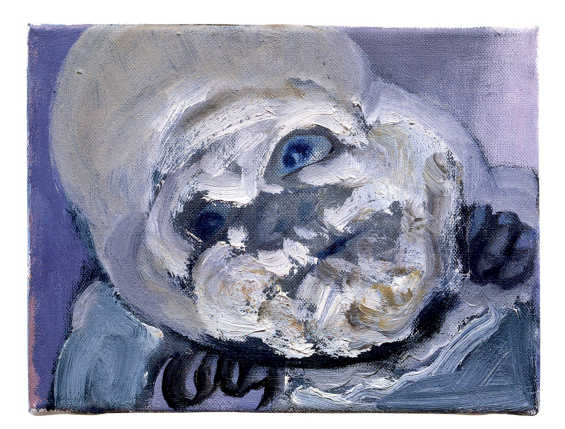

After Life, 1989; oil on canvas; 7 $^1/_{16}$ x 9 $^7/_{16}$ inches; collection Milco and Boudi Onrust, Amsterdam

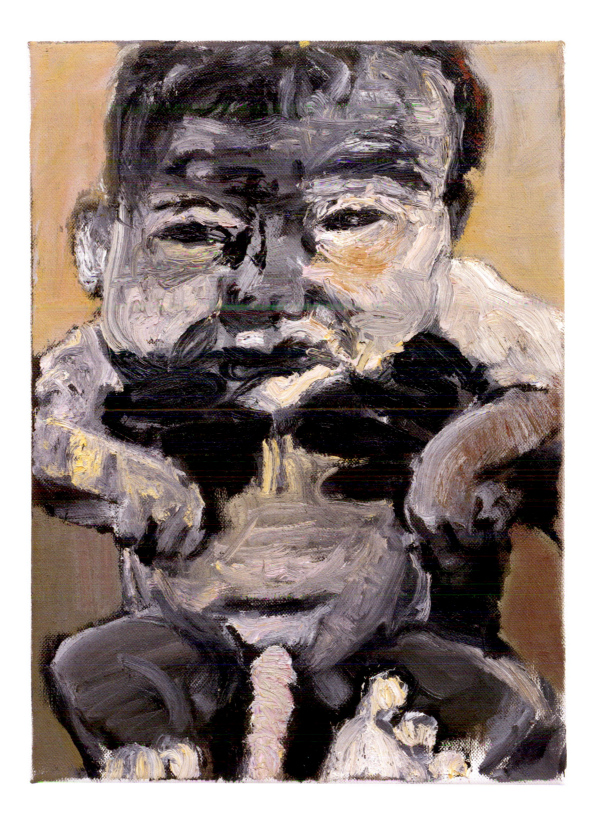

New Born, 1991; oil on canvas; 13 9/16 x 10 1/16 inches; private collection, San Francisco

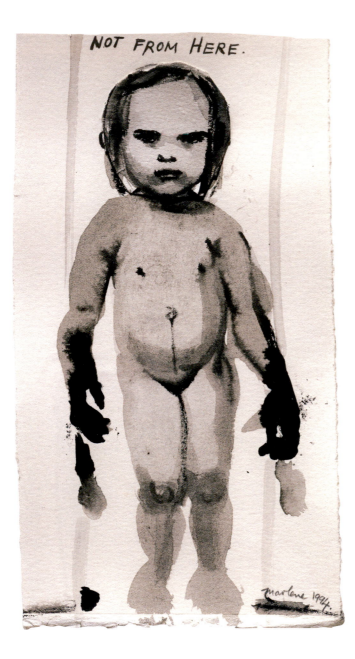

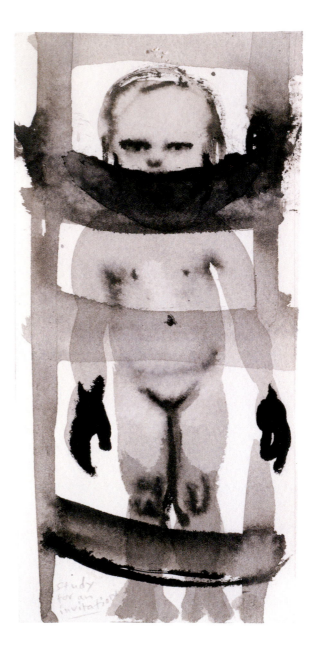

Left: *Not From Here*, 1994; ink on paper; 9 x 4 inches; collection Anita and Burton Reiner, Washington, D.C.

Right: *Study for Invitation*, 1994; ink on paper; 8 ³/₄ x 4 inches; collection Ofra and David Bloch

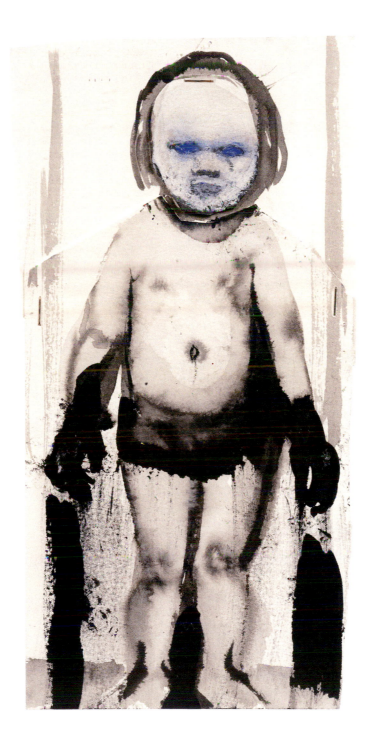

Baby with Blue Face, 1994; ink on paper; 11 x 5 inches;
collection Jack and Connie Tilton

Following spread: *The First People (I–IV)*, 1990;
oil on canvas; four panels: 70$\frac{7}{8}$ x 35$\frac{7}{16}$ inches
each; De Pont Museum of Contemporary Art,
Tilburg, The Netherlands

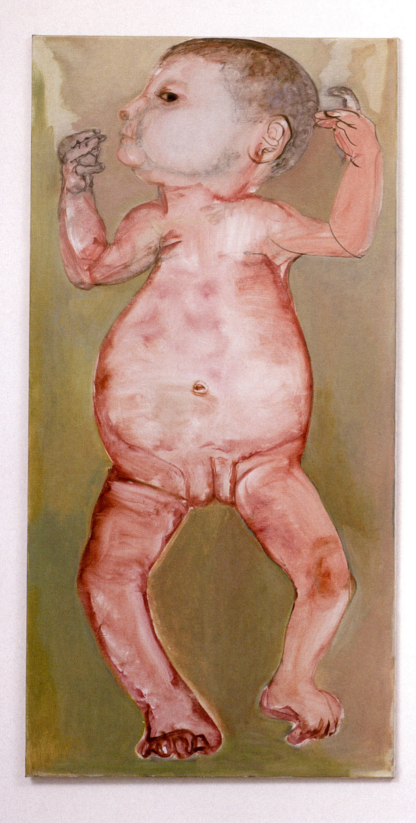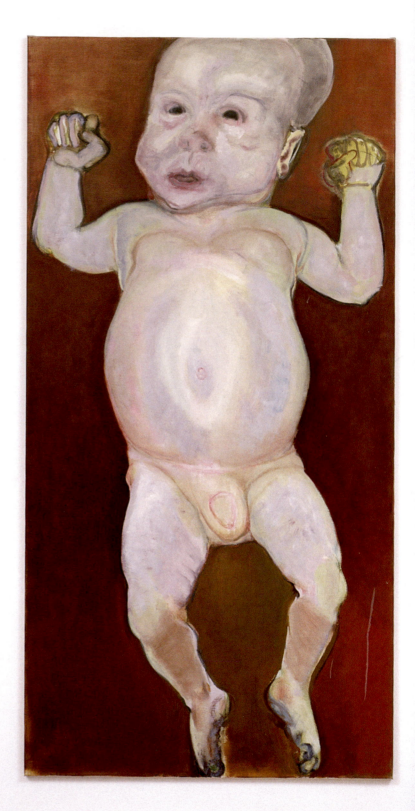

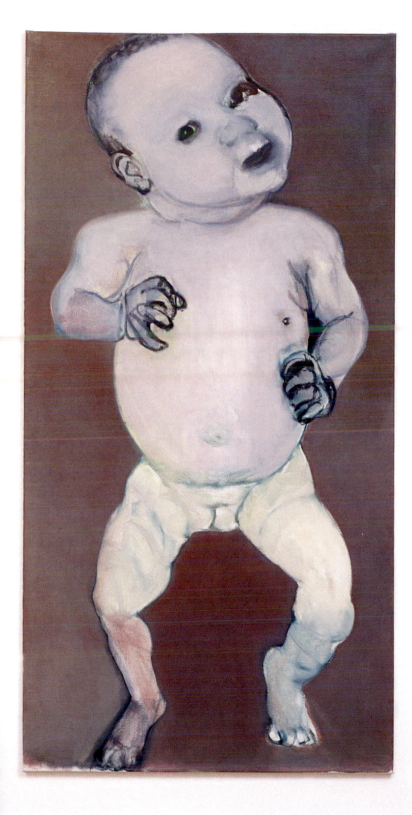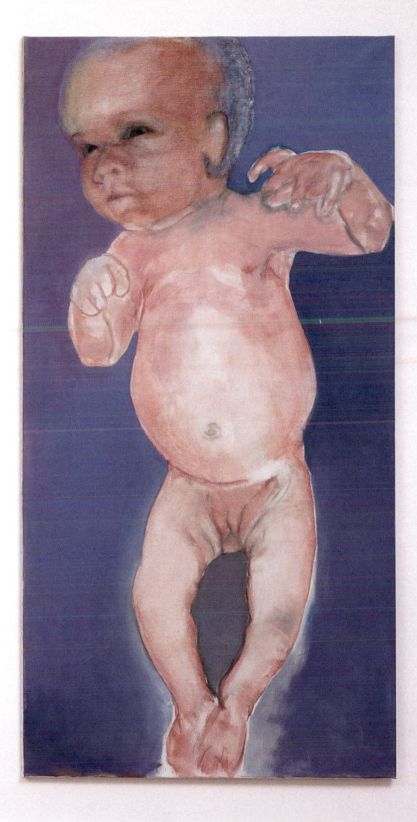

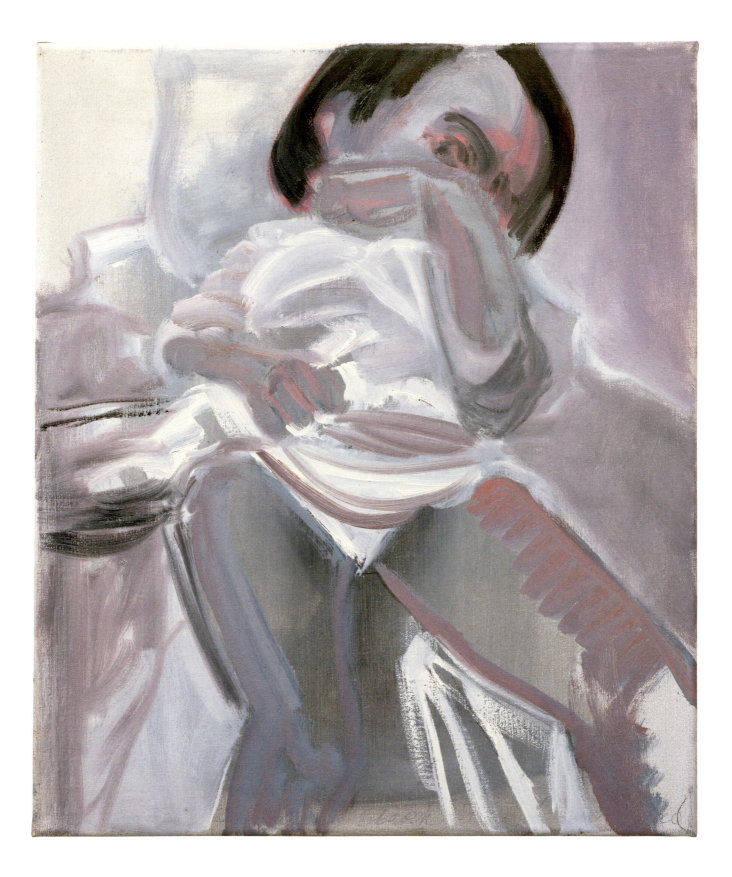

Misinterpreted, 1988; oil on canvas; 23 5/8 x 19 11/16 inches; A. Batenburg and K. De Leeuw, The Netherlands

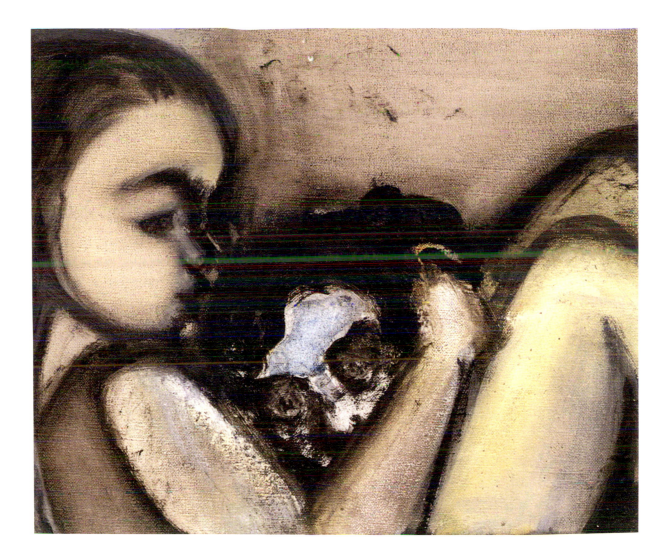

Girl with Head, 1992; oil on canvas; 9 ¹³/₁₆ x 11 ¹³/₁₆ inches; collection Mr. and Mrs. Jan Hoet, Belgium

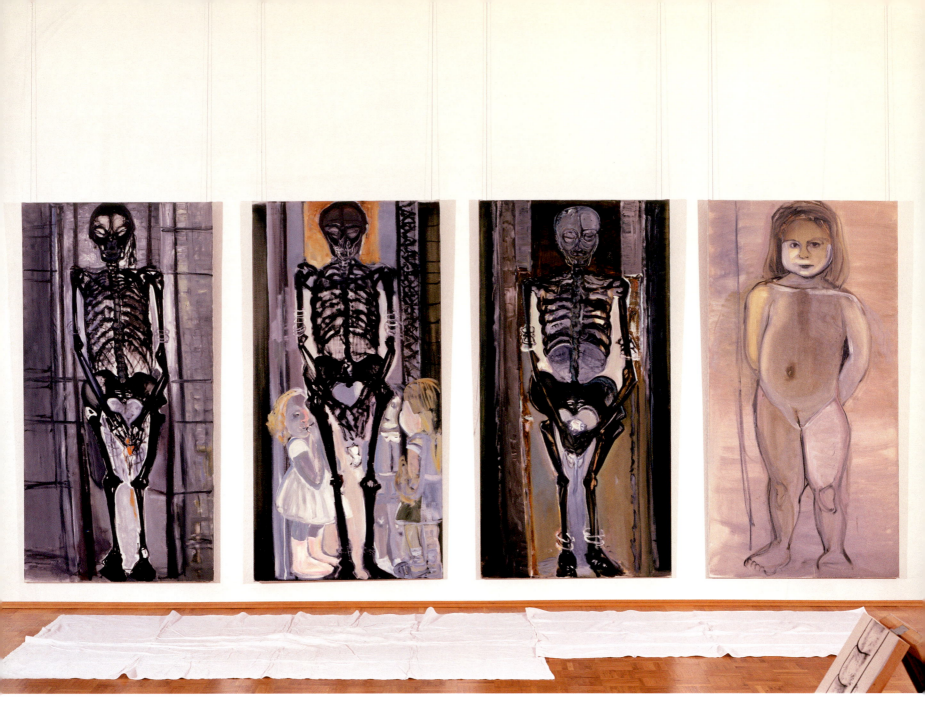

The Messengers, 1992; oil on canvas; four panels: 70 ⁷/₈ x 35 ⁷/₁₆ inches each; collection Barbara Lee, Cambridge, Massachusetts

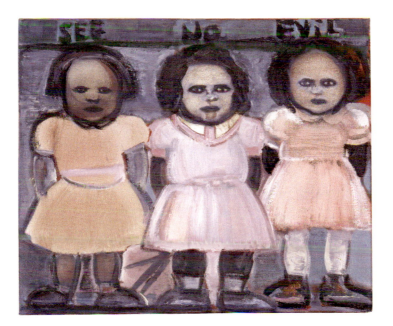

See No Evil, 1991; oil on canvas; diptych: 19 11/16 x 23 5/8 inches each panel; Städische Galerie Karlsruhe, Sammlung Garnatz

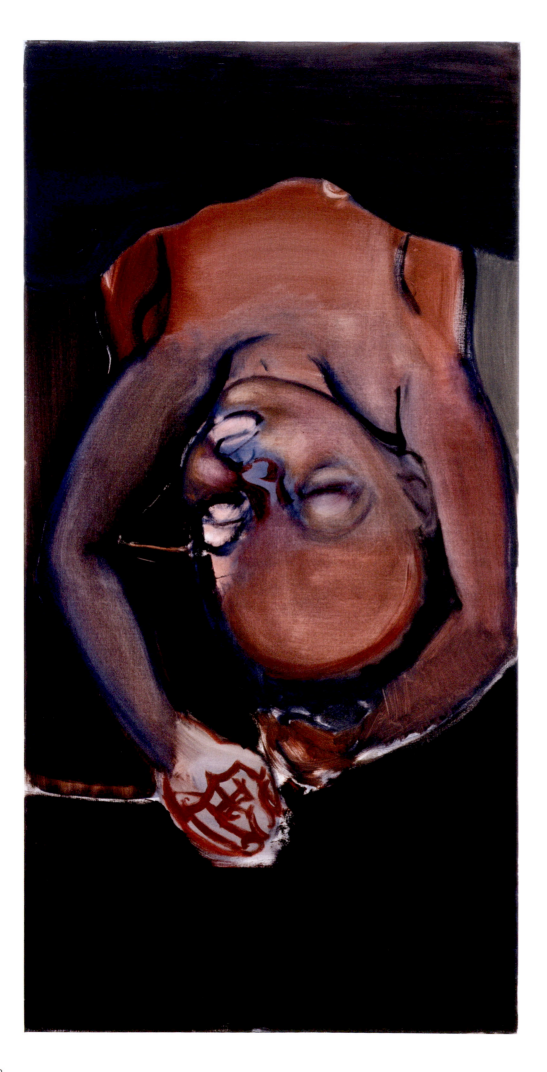

Reinhardt's Daughter, 1994; oil on canvas;
78 3/4 x 39 3/8 inches; private collection

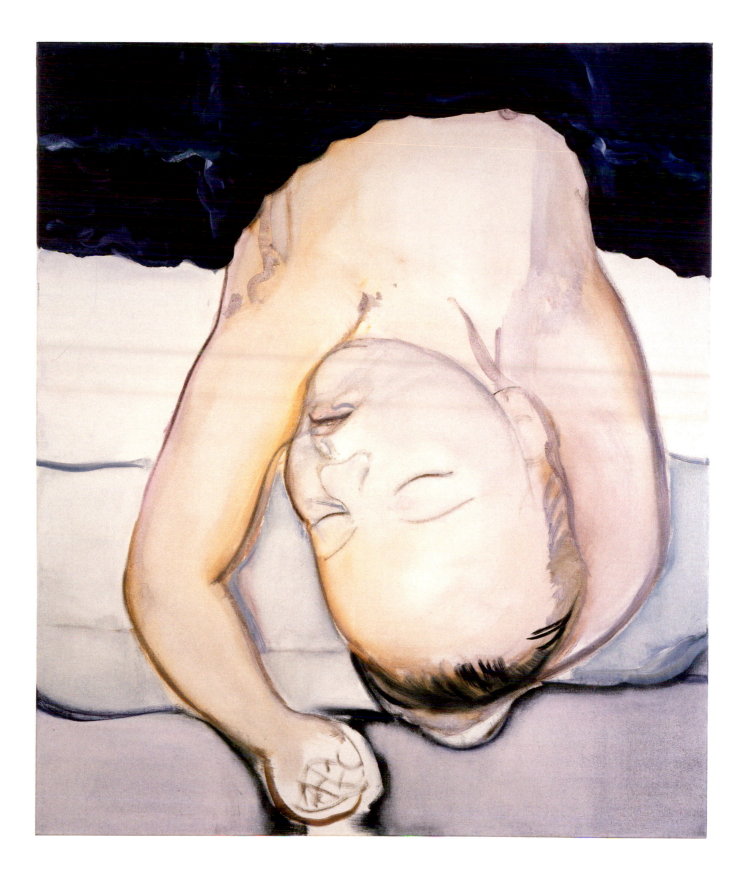

Cupid, 1994; oil on canvas; 63 x 55 1/8 inches; Pinakothek der Moderne, Munich, Michael und Eleonore Stoffel Stiftung

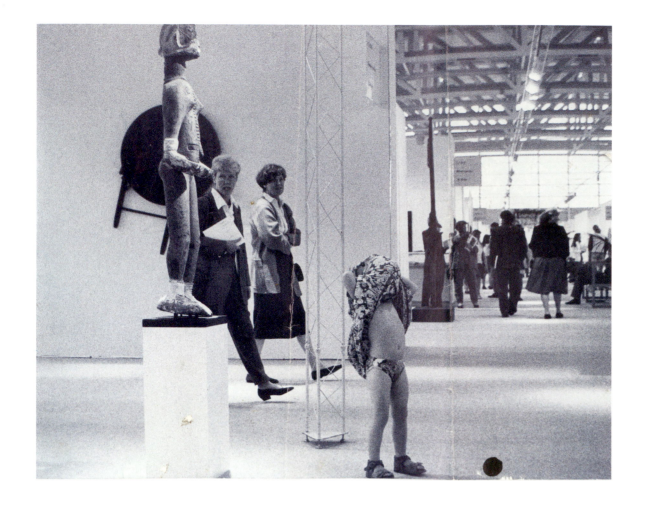

Left: A child at an art fair in Amsterdam, c. 1990, source photograph for *The Cover-up*, 1994, from Dumas's image bank, filed under the heading "Children"

Below: "The Particularity of Being Human: Marlene Dumas—Francis Bacon," installation at Castello di Rivoli, Museo d'arte contemporanea, Turin, Italy, 1995

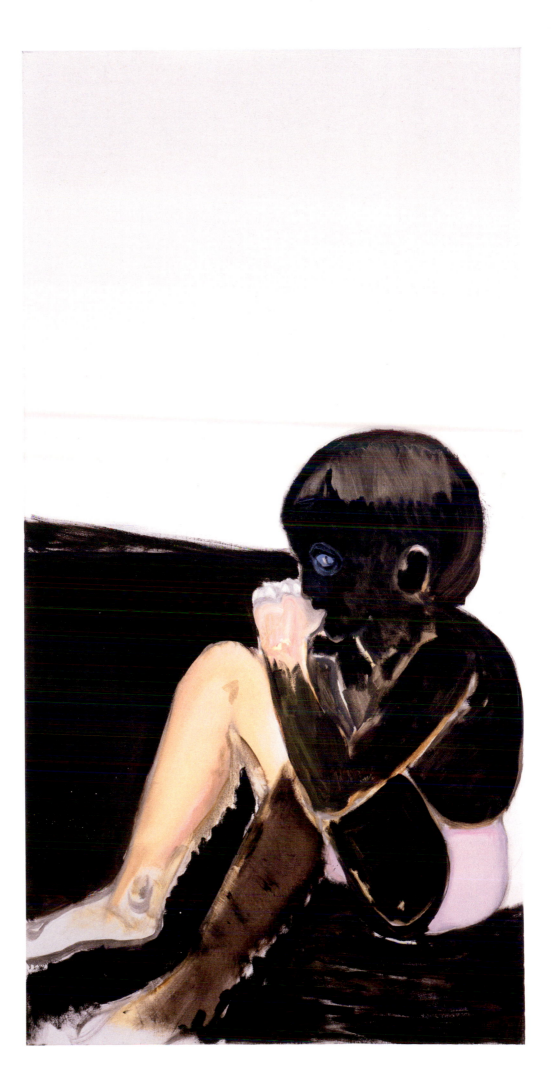

Thumbsucker, 1994; oil on canvas;
78 3/4 x 39 3/8 inches; collection
Blake Byrne, Los Angeles

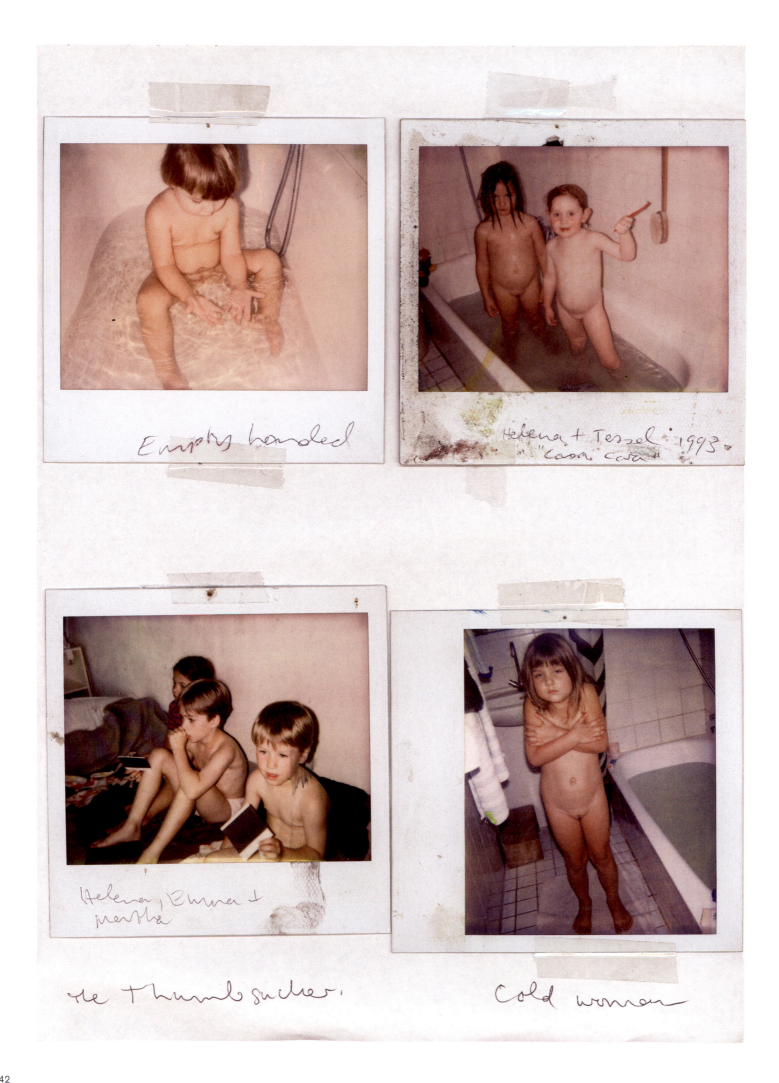

Empty handed

Helena + Tessel 1993
"Casa Cava"

Helena, Emma +
martha

the Thumbsucker.

Cold woman

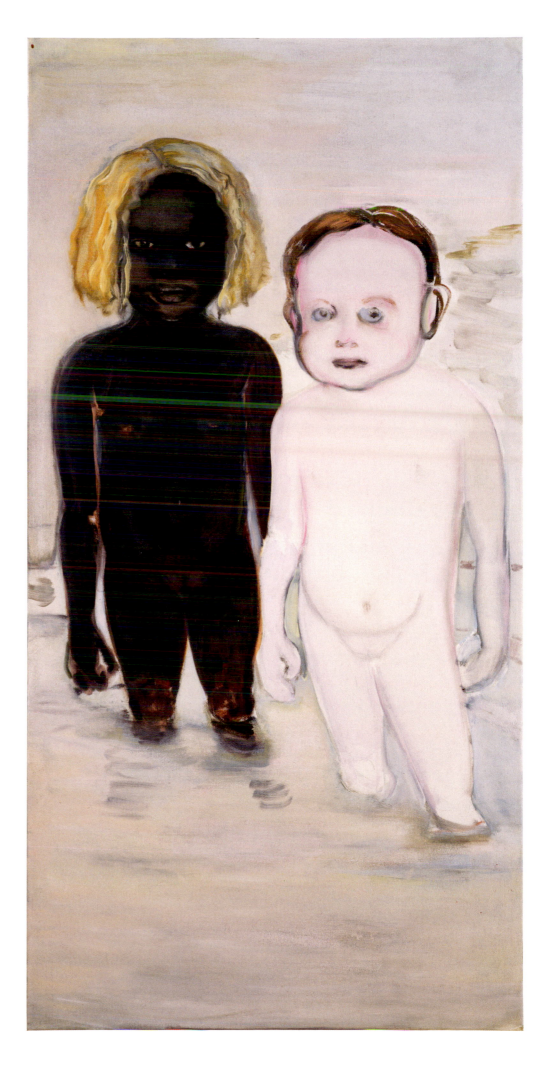

Opposite, clockwise from top left: Polaroid
photographs by Dumas of her daughter and
friends, c. 1991–93, used for *Empty Handed*,
1991; *The Conspiracy*, 1994; *Cold Woman*,
1995; and *Thumbsucker*, 1994

The Conspiracy, 1994; oil on canvas;
78 3/4 x 39 3/8 inches; collection Jack
and Connie Tilton

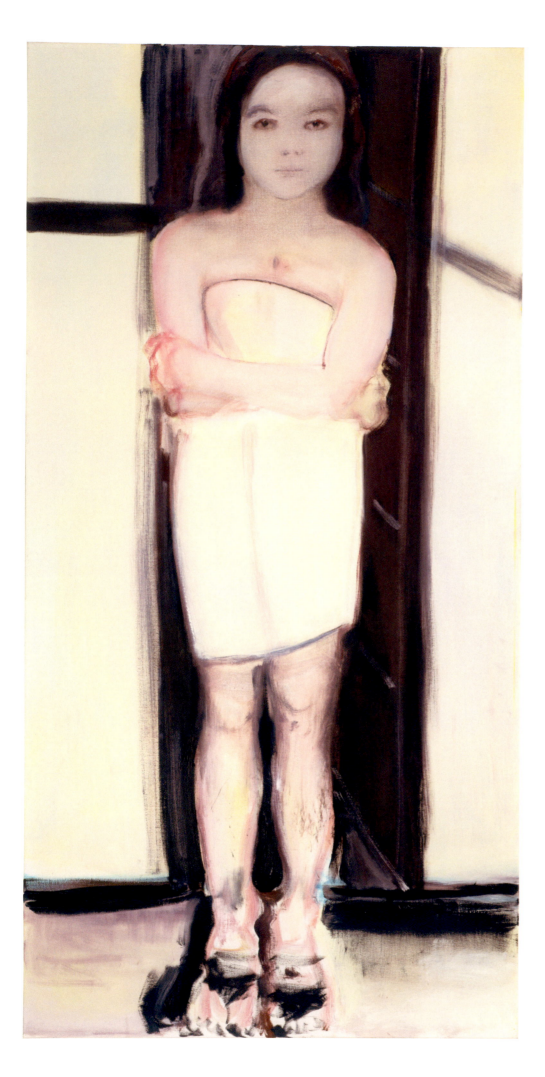

Helena 2001 nr. 3, 2002; oil on canvas;
78³/₄ x 39³/₈ inches; private collection,
courtesy Zeno X Gallery, Antwerp

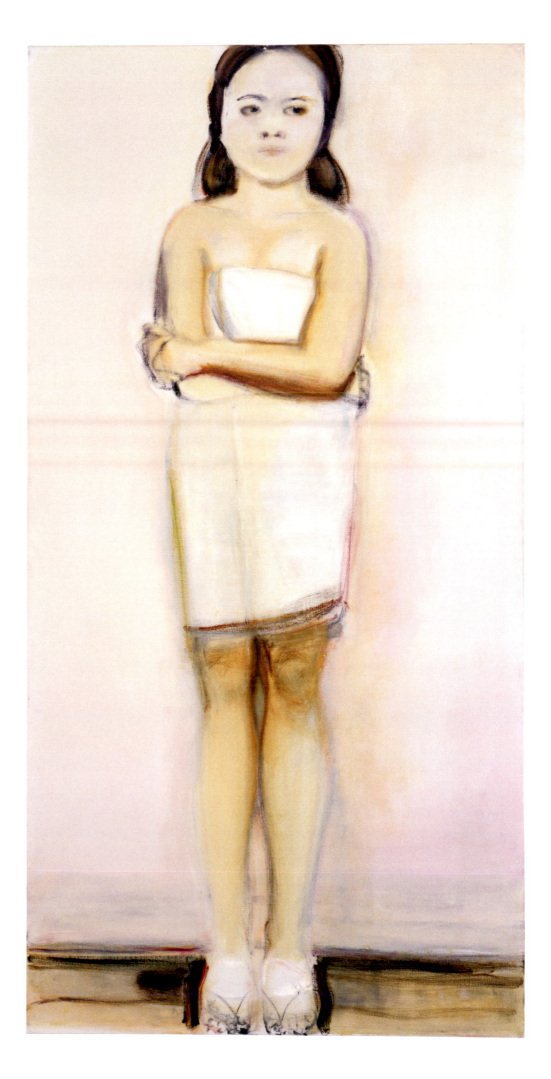

Helena 2001 nr. 2, 2001; oil on canvas;
78 3/4 x 39 3/8 inches; private collection,
courtesy Zeno X Gallery, Antwerp

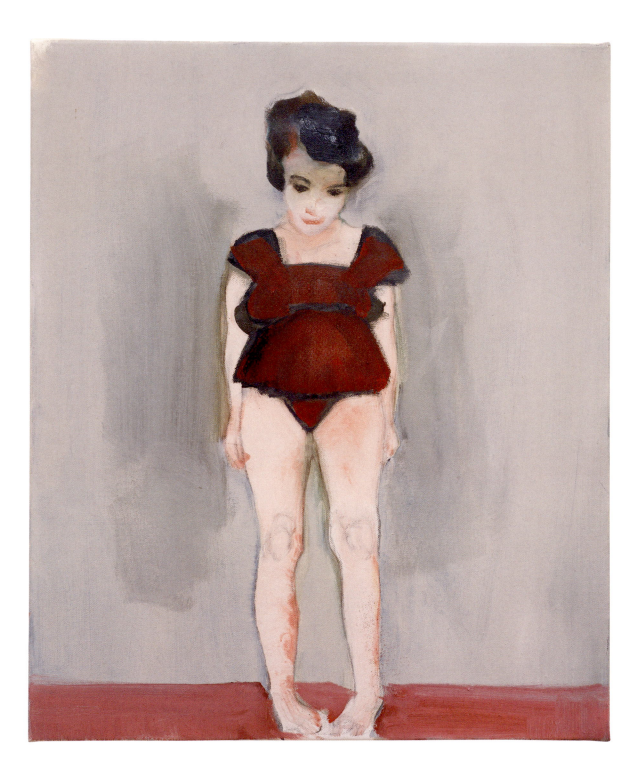

Schaammeisje (Shy Girl), 1991; oil on canvas; 23 $^5/_8$ x 19 $^{11}/_{16}$ inches; private collection, courtesy Galerie Paul Andriesse, Amsterdam

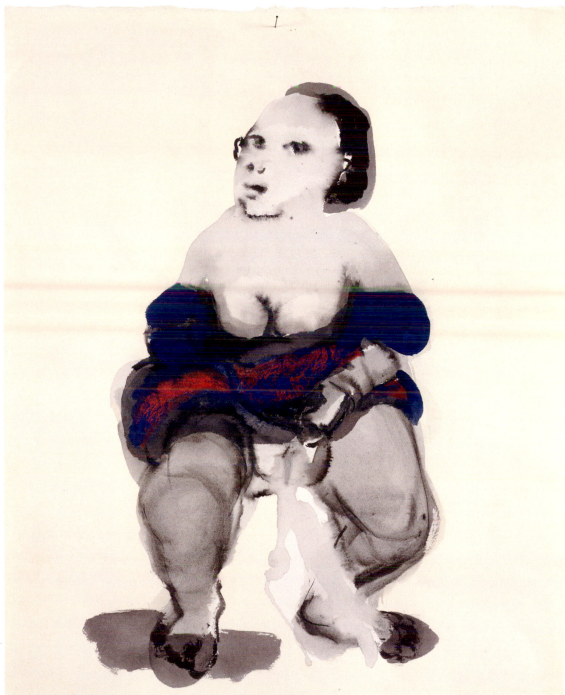

Peeing with a Blue Dress On, 1996; ink and acrylic on paper; 24 $^{7}/_{16}$ x 19 $^{11}/_{16}$ inches; Centre Pompidou, Paris,
Musée national d'art moderne/Centre de création industrielle

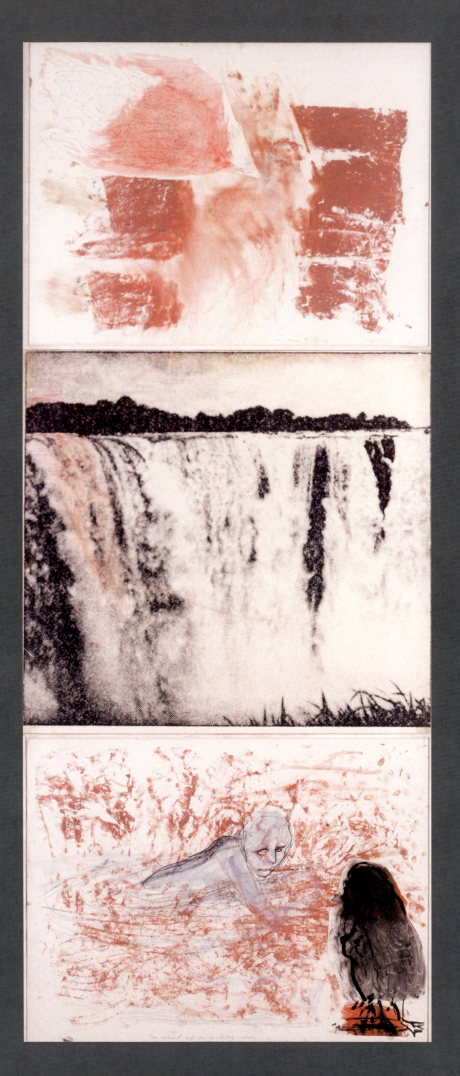

Victoria Falls, 1983; oil, crayon, and
photograph on paper; 98⁷/₁₆ x 40³/₁₆ inches;
Museum voor Moderne Kunst Arnhem/
Instituut Collectie Nederland

Victoria Falls (For M. D.)

MATTHEW MONAHAN

Trying to imagine you now, to portray you in words, I should like to begin as in the old days by dipping the quill into the well, drawing the ink into the nib, and secreting thin articulate curls across the paper. I know it will be impossible to do it by hand—my hand, especially, will press too hard, smearing as I go. A sentence doesn't stand a chance against the flow of ink as it begins to make a drawing, the image bleeding across the paper. This is how it begins, how the picture starts—your image appearing magically, only dipping now and then into the well to fetch a few shadows, the drops of indigo dispersing in the capillaries of cotton paper like blood finding its way to features. You, whoever you are, might never even appear on the page at all, but among many possible faces. Why should we proceed in straight lines? There is not a single straight line in our bodies, and, as you say, "Evil travels in straight lines."[1]

Among all these faces and bodies, I can't make out the whole image, but I think of you coming toward me in that room full of men, among paint-stained books and heavy coats by the door. Sooner to feel your face than to see it, you do not stop to arrange yourself, to prepare your greeting—the national custom of three kisses sounded on the cheeks. You disturb the formal gesture by coming at me head-on, symmetrical, kissing right on the lips, smacking "hello it's been too long, dear one!" And as if from embarrassment I follow with the American standard hug, such a coarse camaraderie of clothing after your warm skin, waxy lipstick, and rainy hair. What nationality is your kiss? Is that your ex-pat's way to shock the natives? Or maybe you just can't keep up with the composition going side to side, all that facial boogie-woogie? You and I are "not from here,"[2] but here we are again, in our old school on the canal where Piet Mondrian was a student like us, and where we now teach from time to time. On the wall by the secretary's desk is your drawing from 1977, and opposite is mine from 1995. Yours is a still life of sorts: thick pencil lines trace the wide flat leaves of a houseplant; above it you've written, "I Won't Have a Potplant."[3] I read it now like a declaration of independence and imagine you thirty years ago, a foreign student, a farm girl, "not from here" in an old European city. The scene is so familiar to every generation of art students. We've all been "doomed to rooms"[4] with pot smokers and artistic experimenters getting

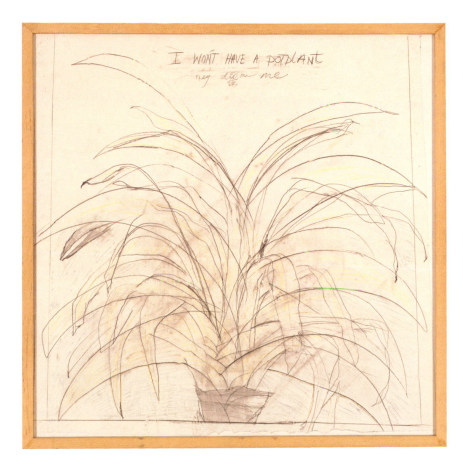

I Won't Have a Potplant, 1977; colored pencil on paper; 36 13/16 x 36 5/8 inches; collection of the artist

249

stoned, getting conceptual, optical, debating the definition of art and turning "attitudes into forms."[5]

The pot plant is dried for its crystals, and the stoner's vision crystallizes—it fragments and outlines specific bodies, it clarifies by isolation and discontinuity. Your plant is a wide-open green leafy thing, with leaves waving like big hands. You were looking for continuity: for shared bodies, not apartheid. In your journal, you were still homesick, busy with your photos and pin-up girls and lingerie ads, trying to reconfigure your body's place in the world. You didn't have a pot plant, but you had a bottle of wine—wine full of earth and sunshine like the vineyard back home. You were looking to make things flow; to unlock feelings, not thoughts—feelings that originate in the medieval humors of the blood and the dark reverie of melancholia. Pencil in hand, scribbling on photos like the monkey in *Die drie Kronen van het Expressionisme (The Three Crowns of Expressionism)*,[6] you tried to hear again the thundering waters of *Victoria Falls*,[7] "the smoke that turns to thunder," the violence of your continent, to make postcard images flow and explode into those placid concentric canals of Amsterdam. By your third painting of Victoria Falls, you hit bottom, but some figures emerged from the mist, reaching out for each other. You are safe here in the concentric circles. Things flow slowly and don't disturb your reflections: You have found "a place to rest, like a psychiatric couch on which to lay comfortable, while [your] nightmares are exposed."[8]

You step back into the room, greeting the other tutor, and then you take a moment to squint at me, to bring me into focus (or maybe to make me out of focus, as painters do). The particulars needn't overwhelm the whole. The face is what counts now; recognition and likeness, a singular luminosity naked atop a dark wash of clothing. You see me—that skinny American guy with crooked glasses, skin turned green from the long winter—and smile. The other teachers are clearing away the coffee cups and ashtrays—the fuel for a day's mentoring. We are parched from things unsaid, unsolved riddles, and the lessons that can't be taught.

These days, after teaching, the rare Tuesdays when we are all together again, we end up in the Mazzeltof, a dive near the market, a place that hasn't yet been revamped in the Euro-airport style. It has a pool table and a dartboard on the door to the pissoir. We keep saying this is going to be the last round, but before long we lose count, and after ten the students arrive and the role-playing starts to change. We are losing our age and rank in a cloud of smoke and pop songs. Because *The Saint of Drunken Men (and Women)*[9] doesn't discriminate, she swoops down, voluptuous and naked, rattling bottles of whiskey and promising touches and love. That saint of yours in the rough ink drawing could have been made right here at the bar on a beer coaster.

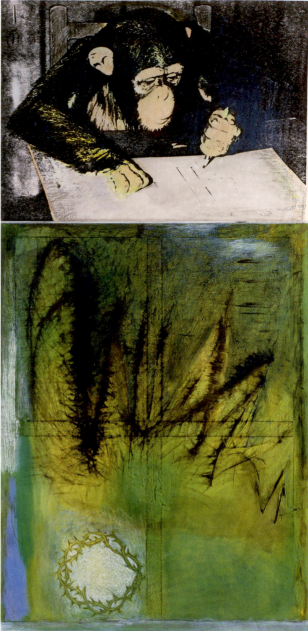

De drie Kronen van het Expressionisme (The Three Crowns of Expressionism), 1982; photograph and oil on canvas; 98 7/16 x 59 1/16 inches; private collection

You remind me she's not an "autonomous work of art," she's just a drawing, "less fraught with meaning and...more friendly," and she keeps your "circulation going in chilly spells."[10] I want to hang her over the till, illuminated by candles like a shrine. She deserves a shrine, not a museum. We've spent so many nights with her, nights fraught with meaning and not always friendly, filled with manifestos rapped to the beat of songs, words too swollen with meaning to pronounce. These words are not intended to say anything at all but to make some proof of life, to hold your ear and your gaze across from me a few more minutes.

But they always call last round, and before you know, it's time to order a cab or a coffee and start to sober up again, thinking about the work in the studio, those big paintings, the exhibition halls housing your thesis, your gender, your nationality, your crisis of representation. Yeah, maybe you are right, "maybe drawing should never have become 'art' after all."[11] *The Saint of Drunken Men (and Women)* is not becoming art, she is not going to join your holy family of

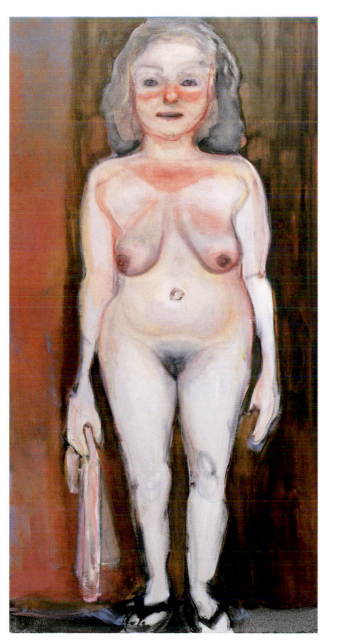

Drunk, 1997; oil on canvas; 78 3/4 x 39 3/8 inches; collection de Bruin-Heijn

Jesuses and Magdalenas. (You can't make drunkenness into a theme without spoiling the whole party.) But she is one of your spirits, and you will face her in the mirror, painting *Drunk*[12] not as a winged creature but in a particular nakedness, not shouting or dancing or flying or fucking, just standing there, already anticipating the many hues of the hangover, when the wings wither into a dull throb and you become light sensitive and languid, thin as an eggshell. In the morning it is all different; the body is fragile and bashful, the gaze is just a furtive glance. The vision can't get past the fact of the eye in the skull, the body is something put together, and not all that well. The mind is curled up behind bloodshot eyes, just an amateur puppeteer of the limbs. The clanking of silverware at the breakfast table is like a light rattle of bones.

More than once on these nights when I have mustered enough Dutch courage, I have tried to get you to admit that you really are Marlene Dumas, that your reputation precedes you and that, although you treat me like an equal, you are a famous painter, published, auctioned off, the rich and a notorious female savior of feminist figurative painting. On these occasions you go deaf to me. How can you answer for this public doppelganger, this sum of (mis)understandings that accumulate around your own name and trade you in for a symbol? How hard is it to remain specific when the world passes you around like a coin, wearing down your heads and tails? But I realize that I really just want to thank you. Perhaps important artists are those who manage to clear a certain path for themselves as well as for others. Your fame is kicking the door open for so many lonely hearts and dry brushes—for artist women and artist men, for anyone who throws their own body into the wager of the great themes: the mis-d-rection of the

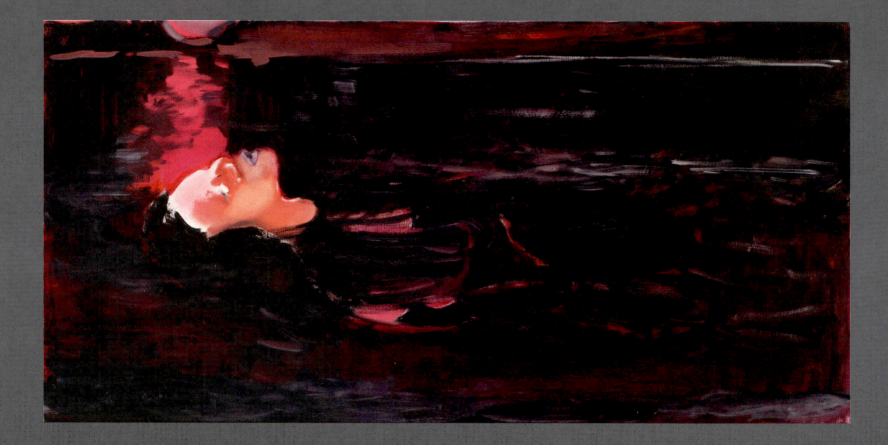

Red Moon, 2007; oil on canvas; 39³/₈ x 78³/₄ inches; courtesy Elzan Frank

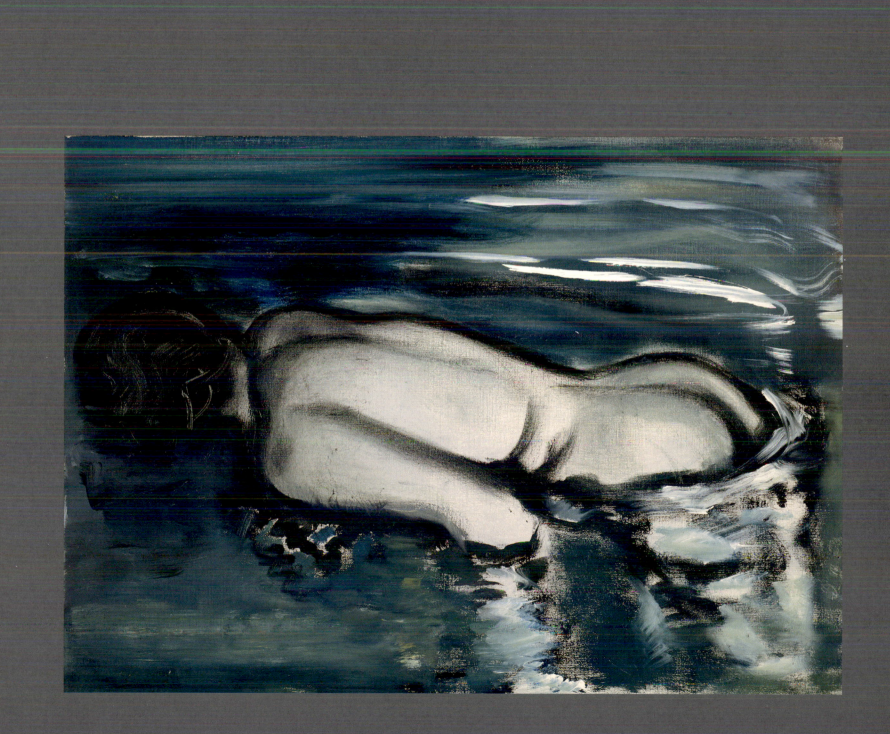

Losing (Her Meaning), 1988; oil on canvas; 19 11/$_{16}$ x 27 9/$_{16}$ inches; private collection, courtesy Galerie Paul Andriesse, Amsterdam

sex drive, the fluidity and filth of the imagination, the flaccid, the dead, or the birth and death of images from one hole to another! And I know you have fought for the space to do it; all the shows, the countless letters, the interviews, the symposia, trying to disentangle yourself from the language of the time, to embarrass yourself, just to clear a place to stand in naked, out of whack, imperfect, and human. You traded all that cool fame for hot tears and you did it in the most frigid place of all, the art world! They will end up calling it the "return of sincerity." Too many artists just playing one language off another, caught in the polarity between the expressive fallacy and image significance, but that's too brainy for you—"too...controlled for the cheaper sensational thrill of moving someone to tears."[13] You stroke the polarity and steam up the lens until I don't know who is who anymore. The image has to pass roughshod through the body of the maker, through the voice of the diva!

My ranting has attracted a few curious students, who pay admission to the table with a new round of drinks. The Heineken tastes like cow patty and it's time for whiskey. Someone got the barman to play Janis Joplin in your honor, and she comes tearing down that country road singing, "Take another little piece of my heart now baby!" The stupid words obliterated by her voice, the breath brought from the depth and grated into a real jagged pain. "What's love but a second-hand emotion"—it is the voice that transforms it into some particular shape with texture and color. You have to bring your voice and body back to the cliché, back to the photographic image: You have to confuse the "second-hand images and first-hand experiences."[14] What a strange and wonderful voice you have! Even when I don't understand what you say, your voice is a crazy song full of highs and lows; it warbles from a sweet ditty to sudden warm growls and then rolls into laughter. It's full of faces, nods, and shrugs. You whisper loud enough that the whole room can hear us conspiring, we artists of the face and figure. Your paintings, too, are loud whispers, intimate conspiracies with the audience.

On the street we are still shouting above the ringing in our ears, but there is only the white noise of the drizzling rain and the clatter of drunks unlatching their battered black bicycles. The air is like a cold drink of pure water. The city encircles us with its narrow canals, like a castle with moats of the Nord Zee. During the day, the sunlight is fickle and precious, refracting between the clouds and the sea, bouncing between the two mirrors and casting down on a man-made green horizon. It reflects off the canals into your houseboat, creating waving lines on your ceiling. It is light inseparable from water. But you are not a painter of this famous Dutch light; your light comes from long nights and gray winters and the fluorescent street lamps and the warren of cubicles in the red-light district. It comes from the wet black of bicycle tires and the blues of water on the brick streets. It comes from the canal streaked with oil by the diesel engines of the big barges on the Amstel. Your colors are mixed with the dregs of those shallow canals, the dark waters where there is every face there ever was or will

be. Ultimately, there is no outline and no correction, only flow, only the movement of water and the modulation of blackness across the paper. Blackness, not light, is the source of the imagination. Your models have just come in from the rain at the end of a long night. They leave their wet clothes in a pile by the door. The likenesses that gaze back at you come by an act of grace. Come on in and stay awhile. Trying too hard to control the destiny of the image will only lead you back to the source and leave you lying face down in that pool of blackness, looking for meaning.

There is nowhere left to go anymore. A taxi door slams behind you and I push off on my bike. The crank is bent and the rack is loose; every turn of the pedal makes a wheezing sound and a bang, while the rear wheel flicks a stream of water up my back. I race for the park, and once through the gates I lean back and coast on the flat dark paths. I am out of breath, soaked, not made of bone and muscle anymore but of rain and mud and booze and nicotine. If I could just give over to it, just collapse on the lawn and dissolve into the rain, I wouldn't mind, it wouldn't make a difference, but my body just won't stop shivering. It takes a lot to lose your meaning[15]: the body won't give up the fight and the subject can't shake off this object! Isn't that the only way to find out what the body and soul really are, to find out what is irreducible in each other? Are you like those sixteenth-century Anabaptists who ran naked through the streets of Amsterdam crying, "We are the naked truth!" Artists find out too soon that being naked is not enough to find the truth, that prostitutes give away nothing but a display of leather boots and glitter bras. You have to take away more than clothes, you have to take away function, background, history, and names, but even then we keep dressing them up in allegory and myth. We cannot shake meaning from the body; paradoxically, in some final act, to know what life is we

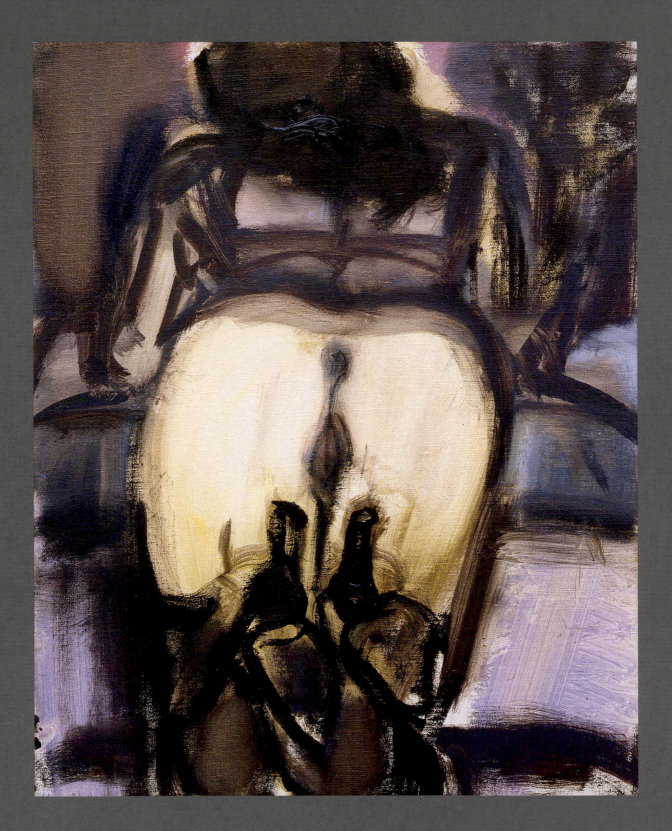

High Heeled Shoes, 2000; oil on canvas; 19 11/16 x 15 3/4 inches; private collection, courtesy Zeno X Gallery, Antwerp

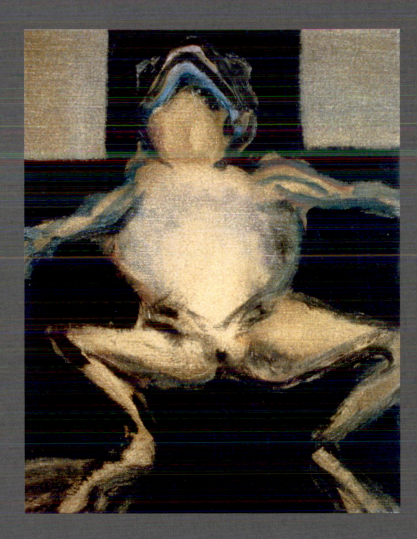

The Crucifixion, 1994; oil on canvas; 11 5/8 x 9 1/2 inches; courtesy Jack Tilton Gallery, New York

have to take away life itself. We need to see the body dead, the corpse laid out on the table, to search for the spirit in its wounds. That is what we did to Jesus. We had to kill him to drive the spirit of God out into the open. His immortality was proven by the disappearance of his body from the tomb. You don't give us that escape. Like Hans Holbein, you make us stay with the body. For a painter so skilled at evoking that flint of life, how did you let it die? In the dead, where has it gone and what was it to begin with? In painting, invoking the spirit of life is simply an illusion, an effect of light and color and composition. To die is to change your hue and misplace the highlight in your eyes. To die is to become horizontal—verticals are living, horizontals are dead. To die is to become a landscape, a chin-bone cliff, and a rolling chest of hills eroding into a thin river of legs. Strangely, your mausoleum is more expressive than your catwalk. No duty to face *The Human Tripod*[16] and the photographic *Cyclops*.[17] These models don't model. Either their arms are thrown wide open, backs bent in total abandonment, heads thrown back like Gian Lorenzo Bernini's *Ecstasy of Saint Theresa*, or they compress themselves as if bracing against the cold. There is no more saving face here, and finally the body gives itself completely. You make it beautiful to imagine, to imagine death here in the park on this cold night, becoming a landscape of red loam, finally beyond night, beyond cold, beyond body. I know it's waiting there for you and me both, but I can't stop. I keep at it, steering this old bike through the inky puddles and banging out our song as I go.

NOTES

1. Marlene Dumas, "Not from Here (II)" (1994), published in Dumas, *Sweet Nothings: Notes and Texts*, ed. Mariska van den Berg (Amsterdam: Galerie Paul Andriesse and Uitgeverij De Balie, 1998), 85.
2. "Not from Here" is the title of two 1994 texts by Dumas, published in *Sweet Nothings*, 84–85.
3. Taken from the title of a 1977 work on paper.
4. Dumas, "Doomed to Room" (1997), in *Sweet Nothings*, 112.
5. Referring to the 1969 exhibition "When Attitudes Become Form," curated by Harald Szeemann for the Kunsthalle, Bern, and featuring several of the artists who founded De Ateliers, Amsterdam.
6. Referencing a 1982 painting by Dumas.
7. Taken from the title of a 1983 work on paper.
8. Dumas, "Dutch Art?" (1994), in *Sweet Nothings*, 83.
9. Taken from the title of a 1990 work.
10. Dumas, "The Meaning of Drawing" (1986), in *Sweet Nothings*, 34.
11. Ibid., 35.
12. Taken from the title of a 1997 painting.
13. Dumas, "Goya's The Fates" (1996), in *Sweet Nothings*, 103.
14. Lyrics by Tina Turner, cited by Dumas in "Blind Dates and Drawn Curtains" (1993), in *Sweet Nothings*, 78; and Dumas, ibid.
15. Referencing Dumas's 1988 painting *Losing (Her Meaning)*.
16. Taken from the title of a 1988 painting.
17. Referencing Dumas's 1997 painting *We Were All in Love with the Cyclops*.

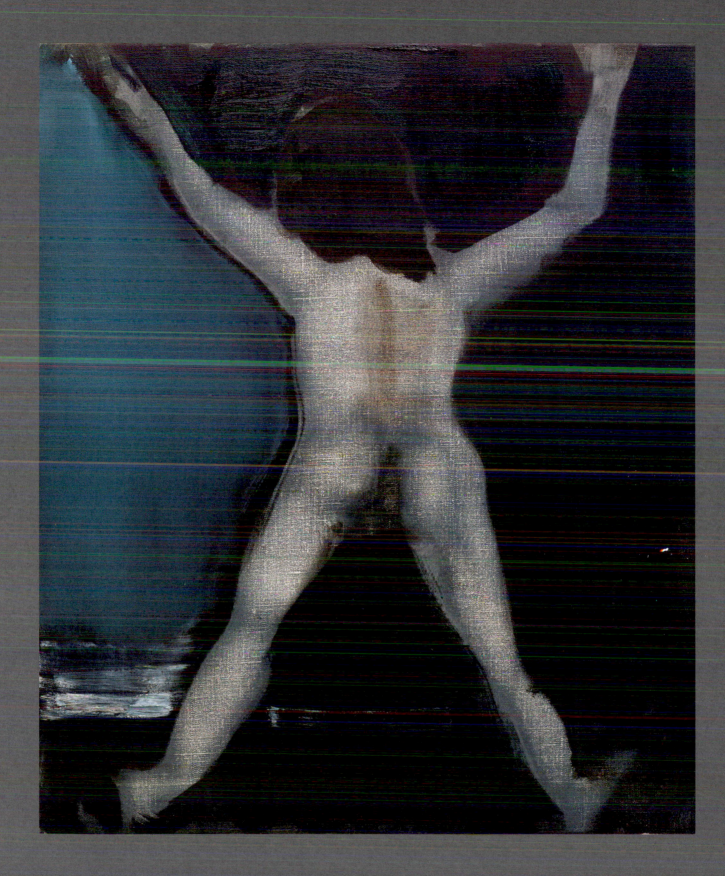

Lovesick, 1994; oil on canvas; 23 $^{5}/_{8}$ x 19 $^{11}/_{16}$ inches; private collection, London, courtesy the artist and Frith Street Gallery, London

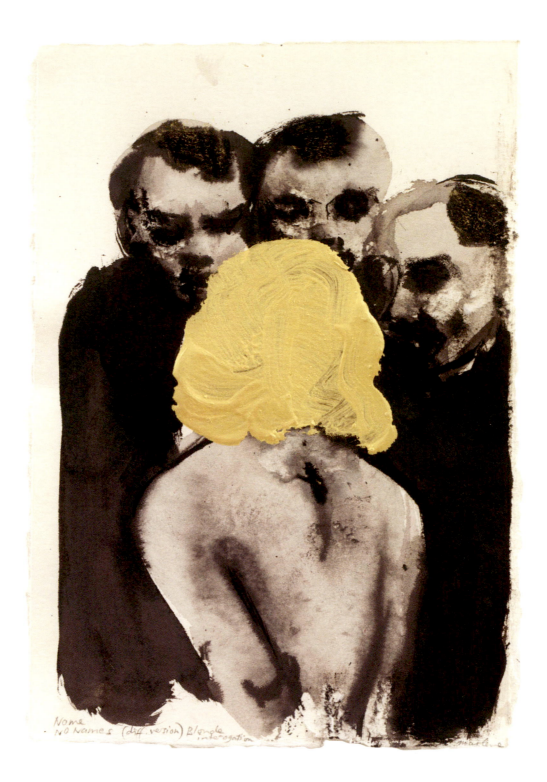

Name No Names, 2005; ink and metallic acrylic on paper; 12 3/16 x 8 7/16 inches; collection of the artist

Framing and Naming

Naming (a work) is important. Framing (a work) is crucial.

I wanted to make many beautiful new works for my U.S.A. show
but in the end, I only painted a portrait of Marilyn Monroe.
The Monroe that died.

During the McCarthy hearings (1954), Marilyn Monroe was threatened.
If she did not get Arthur Miller to frame his colleagues, she would never be heard from again.
In her last interview for *Life* magazine (1962), she said:
"*Once I was supposed to be finished—that was the end of me: When Mr. Miller was on trial
for contempt of Congress,
he was told that either he named names
and I got him to name names or I was finished.
I said, 'I'm proud of my husband's position
and I stand behind him all the way.'*"

I never wanted to paint symbols.
I also never wanted a painting to be a symbol.
Jean-Paul Sartre said it was out of cowardice
that we fell into the symbolic.
I've said, I paint because I am afraid
to be dead while still alive.

Marilyn said,
"*I never quite understood it—this sex symbol—
I always thought symbols were those things you clash together...
But if I'm going to be a symbol of something, I'd rather have it sex then some other things
they have got symbols of!*"

(b. L.A., 1926; d. L.A., 1962)

—M. D., Amsterdam, 2008

Dead Marilyn, 2008; oil on canvas; 15 ³/₄ x 19 ¹¹/₁₆ inches; courtesy the artist and Zeno X Gallery, Antwerp

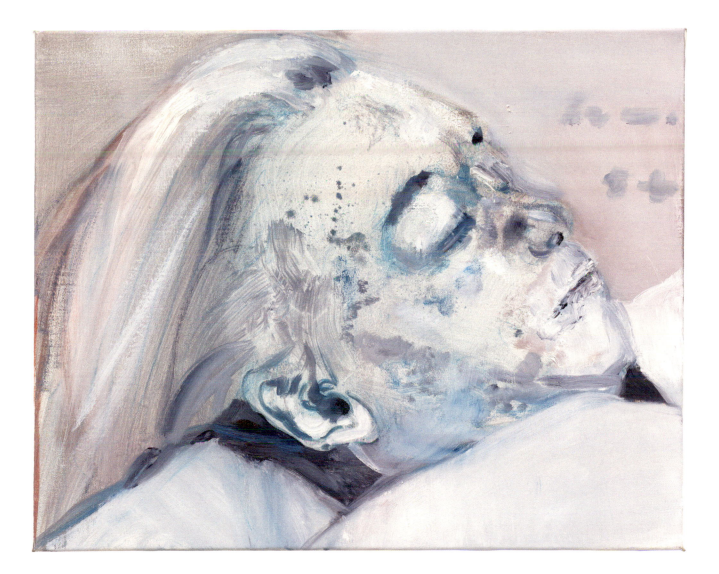

Illustrated Works by Dumas

Checklist of the Exhibition

Miss World, c. 1963
Crayon on paper
$7^{7}/_{8}$ x $12^{13}/_{16}$ inches
Collection of the artist

Sketchbook, c. 1966
Mixed media on paper
11 x 15 inches
Collection of the artist

Sketchbook—"Object Transformed",
1972
Mixed media on paper
$8^{1}/_{8}$ x $11^{9}/_{16}$ inches
Collection of the artist

Black Notebook, 1974–76
Mixed media on paper
8 x 5 inches
Collection of the artist

*Dedicated to All My Photography
Friends*, 1974
Four layers of transparent plastic on top
of one layer of black plastic on paper
$7^{1}/_{2}$ x $12^{3}/_{16}$ inches
Collection of the artist

Breakfast for Claes Oldenburg, 1975
Canvas, cotton wool, paint, and glue
on paper
$9^{7}/_{16}$ x 13 inches
Collection of the artist

Sketchbook, 1975
Mixed media on paper
11 x $14^{15}/_{16}$ inches
Collection of the artist

Untitled, 1976
Ink on paper
Twenty-two sheets: $14^{3}/_{4}$ x $9^{5}/_{8}$
inches each
Collection of the artist

Don't Talk to Strangers, 1977
Oil, collage, pencil, and Sellotape
on canvas
$49^{3}/_{16}$ x $61^{7}/_{16}$ inches
Collection De Ateliers, Amsterdam

Couples, 1978
Colored pencil and collage on paper
$19^{5}/_{16}$ x $26^{9}/_{16}$ inches
The Over Holland Collection

*Drie Vroue en ek (Three Women
and I)*, 1982
Mixed-media collage
$82^{11}/_{16}$ x $51^{3}/_{16}$ inches
Museum voor Moderne Kunst Arnhem/
Instituut Collectie Nederland

*Genetiese Heimwee (Genetic
Longing)*, 1984
Oil on canvas
$51^{3}/_{16}$ x $43^{5}/_{16}$ inches
Van Abbemuseum Collection, Eindhoven

*Het Kwaad is Banaal (Evil Is
Banal)*, 1984
Oil on canvas
$49^{3}/_{16}$ x $41^{5}/_{16}$ inches
Van Abbemuseum Collection, Eindhoven

Martha—my ouma, 1984
Oil on canvas
$51^{3}/_{16}$ x $43^{5}/_{16}$ inches
Private collection

Die Baba (The Baby), 1985
Oil on canvas
$51^{3}/_{16}$ x $43^{5}/_{16}$ inches
Private collection
Courtesy Christie's

*Die Hotnottsgod (The Praying
Mantis)*, 1985
Ink on paper
$10^{1}/_{16}$ x $8^{1}/_{4}$ inches
Collection Aloys van den Berk,
The Netherlands

The White Disease, 1985
Oil on canvas
$49^{3}/_{16}$ x $41^{5}/_{16}$ inches
Private collection

Albino, 1986
Oil on canvas
$51^{3}/_{16}$ x $43^{5}/_{16}$ inches
The Art Institute of Chicago
Through prior acquisitions of Mary and
Leigh Block

The Teacher (sub a), 1987
Oil on canvas
63 x $78^{3}/_{4}$ inches
Private collection

The Turkish Schoolgirls, 1987
Oil on canvas
63 x $78^{3}/_{4}$ inches
Stedelijk Museum, Amsterdam

The Van Gogh Syndrome, 1987
Ink, watercolor, and pencil on paper
$12^{3}/_{8}$ x $9^{1}/_{4}$ inches
Agnes & Frits Becht Collection, Naarden,
The Netherlands

TV Trance, 1987
Oil on canvas
$27^{9}/_{16}$ x $23^{5}/_{8}$ inches
Collection Rudy Hodel, The Netherlands

Dead Man, 1988
Oil on canvas
$19^{11}/_{16}$ x $23^{5}/_{8}$ inches
Private collection

Defining in the Negative, 1988
Ink and watercolor on paper
Eight sheets: $22^{13}/_{16}$ x $66^{15}/_{16}$
inches overall
Private collection

Flap Your Wings, 1988–89
Ink and watercolor on paper
$11^{13}/_{16}$ x $9^{7}/_{16}$ inches
The Over Holland Collection

The Human Tripod, 1988
Oil on canvas
$70^{7}/_{8}$ x $35^{7}/_{16}$ inches
Centraal Museum, Utrecht

Losing (Her Meaning), 1988
Oil on canvas
$19^{11}/_{16}$ x $27^{9}/_{16}$ inches
Private collection
Courtesy Galerie Paul Andriesse,
Amsterdam

Misinterpreted, 1988
Oil on canvas
$23^{5}/_{8}$ x $19^{11}/_{16}$ inches
A. Batenburg and K. De Leeuw,
The Netherlands

Pregnant Image, 1988–90
Oil on canvas
$70^{7}/_{8}$ x $35^{7}/_{16}$ inches
Collection Jack and Connie Tilton

Snow White and the Broken Arm, 1988
Oil on canvas
$55^{1}/_{8}$ x $118^{1}/_{8}$ inches
Gemeentemuseum, The Hague

*De Wacht-Kamer (The Waiting
Room)*, 1988
Gouache on paper
$11^{5}/_{8}$ x $8^{1}/_{4}$ inches
Städtische Galerie Karlsruhe
Sammlung Garnatz

Waiting (For Meaning), 1988
Oil on canvas
$19^{11}/_{16}$ x $27^{9}/_{16}$ inches
Kunsthalle zu Kiel, Germany

Eaten Up, 1989
Watercolor and ink on paper
12 x $15^{15}/_{16}$ inches
Private collection
Courtesy Galerie Paul Andriesse,
Amsterdam

*Moeder en Baba (Mother and
Baby)*, 1989
Gouache on paper
$15^{1}/_{2}$ x $12^{3}/_{8}$ inches
Städtische Galerie Karlsruhe
Sammlung Garnatz

Warhol's Child, 1989–91
Oil on canvas
$55^{1}/_{8}$ x $118^{1}/_{8}$ inches
Städtische Galerie Karlsruhe
Sammlung Garnatz

*Wounded Man and Pregnant
Women*, 1989
Ink and pastel on paper
$11^{7}/_{16}$ x $16^{1}/_{8}$ inches
Private collection
Courtesy Galerie Paul Andriesse,
Amsterdam

The Binding Factor, 1990
Ink and crayon on paper
$12^{1}/_{2}$ x $9^{1}/_{2}$ inches
CAP Collection

The First People (I–IV), 1990
Oil on canvas
Four panels: $70^{7}/_{8}$ x $35^{7}/_{16}$ inches each
De Pont Museum of Contemporary Art,
Tilburg, The Netherlands

Liberation (1945), 1990
Oil on canvas
$51^{3}/_{16}$ x $43^{5}/_{16}$ inches
Collection of the artist

An African Mickey Mouse, 1991
Ink on paper
$11^{7}/_{16}$ x $8^{1}/_{4}$ inches
Private collection
Courtesy Galerie Paul Andriesse,
Amsterdam

Black Drawings, 1991–92
Ink and watercolor on paper and slate
111 drawings and one slate:
$9^{13}/_{16}$ x $6^{7}/_{8}$ inches each
De Pont Museum of Contemporary Art,
Tilburg, The Netherlands

In the Beginning, 1991
Oil on canvas
$57^{1}/_{16}$ x $78^{3}/_{4}$ inches
Private collection

New Born, 1991
Oil on canvas
$13^{9}/_{16}$ x $10^{1}/_{16}$ inches
Private collection, San Francisco

Schaammeisje (Shy Girl), 1991
Oil on canvas
23 5/8 x 19 11/16 inches
Private collection
Courtesy Galerie Paul Andriesse,
Amsterdam

Girl with Head, 1992
Oil on canvas
9 13/16 x 11 13/16 inches
Collection Mr. and Mrs. Jan Hoet,
Belgium

Give the People What They Want, 1992
Oil on canvas
15 3/4 x 11 13/16 inches
Private collection
Courtesy Zeno X Gallery, Antwerp

Porno as Collage, 1993
Ink on paper
Six sheets: 15 3/4 x 12 3/16 inches each
Friedrich Christian Flick Collection

Sketch for a Monument of Peace, 1993
Lithograph
8 11/16 x 7 7/8 inches
Collection of the artist

Straitjacket, 1993
Oil on canvas
35 7/16 x 27 9/16 inches
Private collection
Courtesy Zeno X Gallery, Antwerp

Baby with Blue Face, 1994
Ink on paper
11 x 5 inches
Collection Jack and Connie Tilton

The Cover-up, 1994
Oil on canvas
78 3/4 x 39 3/8 inches
Scheringa Museum of Realist Art,
Spanbroek, The Netherlands

Cupid, 1994
Oil on canvas
63 x 55 1/8 inches
Pinakothek der Moderne, Munich
Michael und Eleonore Stoffel Stiftung

Jesus—Serene, 1994
Ink, watercolor, and pencil on paper
Twenty-one sheets: approximately
25 9/16 x 19 11/16 inches each
Collection Victoria and Henk de Heus,
The Netherlands

Models, 1994
Ink and chalk on paper
One hundred sheets: 24 7/16 x 19 11/16
inches each
Van Abbemuseum Collection, Eindhoven

Not From Here, 1994
Ink on paper
9 x 4 inches
Collection Anita and Burton Reiner,
Washington, D.C.

The Painter, 1994
Oil on canvas
78 3/4 x 39 3/8 inches
The Museum of Modern Art, New York
Fractional and promised gift of Martin
and Rebecca Eisenberg

Reinhardt's Daughter, 1994
Oil on canvas
78 3/4 x 39 3/8 inches
Private collection

The Secret, 1994
Oil on canvas
78 3/4 x 39 1/4 inches
The Carol and Arthur Goldberg
Collection

Study for Invitation, 1994
Ink on paper
8 3/4 x 4 inches
Collection Ofra and David Bloch

Thumbsucker, 1994
Oil on canvas
78 3/4 x 39 3/8 inches
Collection Blake Byrne, Los Angeles

Magdalena (Manet's Queen), 1995
Oil on canvas
118 1/8 x 39 3/8 inches
Stedelijk Museum, Amsterdam
Friends of the Stedelijk Museum,
Amsterdam

Magdalena (Newman's Zip), 1995
Oil on canvas
118 1/8 x 39 3/8 inches
Stedelijk Museum, Amsterdam
Friends of the Stedelijk Museum,
Amsterdam

*Magdalena (Out of Eggs,
Out of Business)*, 1995
Oil on canvas
78 3/4 x 39 3/8 inches
Stedelijk Museum voor Aktuele
Kunst, Ghent

*Magdalena (Underwear and
Bedtime Stories)*, 1995
Oil on canvas
78 3/4 x 39 3/8 inches
Collection Jerome L. and Ellen Stern

The Model, 1995
Oil on canvas
78 3/4 x 39 3/8 inches
Collection Albert H. Eenink,
The Netherlands

*Homage to Rembrandt's Pissing
Woman*, 1996
Ink and acrylic on paper
24 7/16 x 19 11/16 inches
Collection of the artist

Colorfields, 1997
Oil on canvas
78 3/4 x 59 1/16 inches
Private collection, The Netherlands

Drunk, 1997
Oil on canvas
78 3/4 x 39 3/8 inches
Collection de Bruin-Heijn

Ryman's Brides, 1997
Oil on canvas
51 3/16 x 43 5/16 inches
Collection Jerome L. and Ellen Stern

Young Boy (Pale Skin), 1997
Ink and watercolor on paper
49 3/16 x 27 9/16 inches
Private collection

The Alien, 1998
Watercolor on paper
49 3/16 x 27 9/16 inches
Museum für Moderne Kunst,
Frankfurt am Main

Dorothy D-lite, 1998
Ink and acrylic on paper
49 3/16 x 27 9/16 inches
Collection of the artist
On long-term loan to the De Pont
Museum of Contemporary Art,
Tilburg, The Netherlands, 2002

The Shrimp, 1998
Watercolor on paper
49 3/16 x 27 9/16 inches
Museum für Moderne Kunst,
Frankfurt am Main

D-rection, 1999
Oil on canvas
39 3/8 x 22 1/16 inches
Private collection

Fingers, 1999
Oil on canvas
15 3/4 x 19 11/16 inches
Collection Jan Andriesse

Miss Pompadour, 1999
Oil on canvas
18 1/8 x 19 11/16 inches
Collection Dominic van den Boogerd,
Amsterdam

Suspect, 1999
Oil on canvas
22 1/16 x 39 3/8 inches
Collection Åke and Caisa Skeppner,
Belgium

X-Plicit, 1999
Ink and acrylic on paper
49 3/16 x 27 9/16 inches
Collection Alan Hergott and
Curt Shepard

Cracking the Whip, 2000
Oil on canvas
90 9/16 x 23 5/8 inches
Stefan T. Edlis Collection

German Witch, 2000
Ink and acrylic on paper
90 1/4 x 35 1/2 inches
The Institute of Contemporary
Art, Boston
Fractional and promised gift of
Beth and Anthony Terrana

High Heeled Shoes, 2000
Oil on canvas
19 11/16 x 15 3/4 inches
Private collection
Courtesy Zeno X Gallery, Antwerp

How Low Can You Go, 2000
Ink and acrylic on paper
90 1/4 x 35 1/2 inches
Collection Susan and Leonard Feinstein

Leather Boots, 2000
Oil on canvas
78 3/4 x 39 3/8 inches
Collection of the artist

Helena 2001 nr. 2, 2001
Oil on canvas
78 3/4 x 39 3/8 inches
Private collection
Courtesy Zeno X Gallery, Antwerp

*The Politics of Geometry Versus the
Geography of Politics: After the Woman
of Algiers, After Aurora, After Cathedral,
After Stella, and After Taboo*, 2001
Ink and acrylic on paper
Five sheets: 17 11/16 x 13 3/4 inches each
Fonds régional d'art contemporain de
Picardie, Amiens

The Woman of Algiers, 2001
Oil on canvas
78 3/4 x 39 3/8 inches
The Museum of Contemporary Art,
Los Angeles, and The Nasher Museum
of Art at Duke University, Durham
Partial and promised gift of Blake Byrne

Blindfolded, 2002
Oil on canvas
51 3/16 x 43 5/16 inches
Collection Thomas Koerfer, Zürich

Dead Girl, 2002
Oil on canvas
51³/₁₆ x 43⁵/₁₆ inches
Los Angeles County Museum of Art
Purchased with funds provided by
the Buddy Taub Foundation, Jill and
Dennis Roach, Directors

Duct Tape, 2002–05
Oil on canvas
51³/₁₆ x 43⁵/₁₆ inches
Private collection, New York

Helena 2001 nr. 3, 2002
Oil on canvas
78³/₄ x 39³/₈ inches
Private collection
Courtesy Zeno X Gallery, Antwerp

Imaginary 2, 2002
Oil on canvas
49³/₁₆ x 27⁹/₁₆ inches
Rubell Family Collection, Miami

Male Beauty, 2002
Watercolor on paper
49³/₁₆ x 27⁹/₁₆ inches
Courtesy the artist and Galerie Paul
Andriesse, Amsterdam

The Missionary, 2002–04
Oil on canvas
23⁵/₈ x 90⁹/₁₆ inches
Centre Pompidou, Paris, Musée
national d'art moderne/Centre de
création industrielle
Gift of the Clarence Westbury
Foundation, 2005

After All (Is Said and Done), 2003
Ink, acrylic, and watercolor on paper
24⁵/₈ x 78³/₄ inches
The Museum of Modern Art, New York
The Judith Rothschild Foundation
Contemporary Drawings Collection Gift

After Painting, 2003
Ink, acrylic, and watercolor on paper
24⁵/₈ x 90⁹/₁₆ inches
Collection Craig Robins, Miami, Florida

After Photography, 2003
Ink, acrylic, and watercolor on paper
24⁵/₈ x 90⁹/₁₆ inches
The Art Institute of Chicago
Gift of the Neisser Family

After Stone, 2003
Ink, acrylic, and watercolor on paper
24⁵/₈ x 78³/₄ inches
Collection Craig Robins, Miami, Florida

Death of the Author, 2003
Oil on canvas
15³/₄ x 19¹¹/₁₆ inches
Collection Jolie van Leeuwen

Imaginary 3, 2003
Oil on canvas
49³/₁₆ x 27⁹/₁₆ inches
Collection Craig Robins, Miami, Florida

Imaginary 4, 2003
Oil on canvas
49³/₁₆ x 27⁹/₁₆ inches
Private collection
Courtesy Galerie Paul Andriesse,
Amsterdam

Immaculate, 2003
Oil on canvas
9⁷/₁₆ x 7¹/₁₆ inches
Collection of the artist

The Kiss, 2003
Oil on canvas
15³/₄ x 19¹¹/₁₆ inches
Courtesy the artist and Frith Street
Gallery, London

Measuring Your Own Grave, 2003
Oil on canvas
55¹/₈ x 55¹/₈ inches
Private collection

Stern, 2004
Oil on canvas
43⁵/₁₆ x 51³/₁₆ inches
Tate
Purchased with assistance from
Foundation Dutch Artworks and
Bank Giro Loterij, 2007

Anonymous, 2005
Oil on canvas
27⁹/₁₆ x 19¹¹/₁₆ inches
Garnatz Collection, Cologne

The Believer, 2005
Oil on canvas
51³/₁₆ x 43⁵/₁₆ inches
Stedelijk Museum, Amsterdam
On long-term loan from The Monique
Zajfen Collection of The Broere
Charitable Foundation

Jen, 2005
Oil on canvas
43⁵/₁₆ x 51³/₁₆ inches
The Museum of Modern Art, New York
Fractional and promised gift of
Marie-Josée and Henry R. Kravis

Name No Names, 2005
Ink and metallic acrylic on paper
12³/₁₆ x 8⁷/₁₆ inches
Collection of the artist

Skull (of a Woman), 2005
Oil on canvas
43⁵/₁₆ x 51³/₁₆ inches
Collection de Bruin-Heijn

Man Kind, 2006
Oil on canvas
39³/₈ x 35⁷/₁₆ inches
Centraal Museum, Utrecht, with support
of the Mondriaan Foundation

Moshekwa, 2006
Oil on canvas
51³/₁₆ x 43⁵/₁₆ inches
Courtesy the artist and
Zeno X Gallery, Antwerp

The Pilgrim, 2006
Oil on canvas
39³/₈ x 35⁷/₁₆ inches
Private collection

The Blindfolded Man, 2007
Oil on canvas
39³/₈ x 35⁷/₁₆ inches
Courtesy the artist and David Zwirner,
New York

Dead Marilyn, 2008
Oil on canvas
15³/₄ x 19¹¹/₁₆ inches
Courtesy the artist and
Zeno X Gallery, Antwerp

Dumas working in her studio, Amsterdam, 2004

Selected Exhibition History

Solo and Two-Person Exhibitions

"Marlene Dumas, Elizabeth de Vaal," Edelambachtshuis, Gouda, The Netherlands, 1977

"Marlene Dumas," Galerie Annemarie de Kruyff, Paris, 1979

"Marlene Dumas," Galerie Lambelet, Basel, Switzerland, 1980

"Marlene Dumas and Reinoud Oudshoorn," Felison Beeckestein, Velsen, The Netherlands, 1981

"Unsatisfied Desire," Galerie Paul Andriesse, Amsterdam, 1983

"The Artist as a Young Girl," Flatland Gallery, Utrecht, The Netherlands, 1984

"Ons land licht lager dan de zee," Centraal Museum, Utrecht, The Netherlands, 1984

"The Eyes of the Night Creatures," Galerie Helen van der Meij, Amsterdam, 1985

"Tekeningen en Grafiek," Galerie Terzijde, Bussum, The Netherlands, 1986

"Marlene Dumas and Sigurdur Gudmundsson," Galerie de Expeditie, Amsterdam, 1987

"Mother Explains Life to her Son," Marktzeventien, Enschede, The Netherlands, 1987

"The Private Versus the Public," Galerie Paul Andriesse, Amsterdam, 1987

"Ecco Pier Paolo Pasolini," Filmmuseum, Amsterdam, 1988

"Marlene Dumas: Arbeiten 1986/88" (with Rosemarie Trockel), Stampa Galerie, Basel, Switzerland, 1988

"Marlene Dumas: Nightmares," Galerie Wanda Reiff, Maastricht, The Netherlands, 1988

"Waiting (For Meaning)," Kunsthalle, Kiel, Germany; and Galerie Paul Andriesse, Amsterdam, 1988

"The Question of Human Pink," Kunsthalle, Bern, 1989

"Couples," Museum Overholland, Amsterdam, 1990

"The Origin of the Species," Staatsgalerie Moderner Kunst, Bayerische Staatsgemäldesammlungen, Munich, Germany, 1990

Presentation of a solo commission for the Psychiatric Centre in Het Hooghuys, Etten-Leur, The Netherlands, 1991

"Marlene Dumas—Ausser Reichweite von Kindern," Stampa Galerie, Basel, Switzerland, 1991

"The Origin of the Species," Galerie Paul Andriesse, Amsterdam, 1991

"Ask Me No Questions and I'll Tell You No Lies," Galerie Isabella Kacprzak, Cologne, Germany, 1992

"Marlene Dumas: Insights," AXENÉO7, Hull, England, 1992

"Miss Interpreted," Stedeljik Van Abbemuseum, Eindhoven, The Netherlands; and Institute of Contemporary Art, Philadelphia, 1992–94

"Strips," In Situ/Ardi Poels, Maastricht, The Netherlands, 1992

"Give the People What They Want," Zeno X Gallery, Antwerp, Belgium, 1993

"Marlene Dumas," Goldie Paley Gallery, Moore College of Art and Design, Philadelphia; The Arts Club of Chicago; and Art Gallery of York University, Toronto, Canada, 1993–94

"Marlene Dumas," Kunstverein, Bonn, Germany; and Institute of Contemporary Arts, London, 1993

"Marlene Dumas," Le Case d'Arte, Milan, Italy, 1993

"Marlene Dumas: Land of Milk and Honey," Produzentengalerie, Hamburg, Germany, 1993

"Chlorosis," The Douglas Hyde Gallery, Dublin, 1994

"Männeransichten," Kunst-Station Sankt Peter, Cologne, Germany, 1994

"Not From Here," Jack Tilton Gallery, New York, 1994 Galerie Samia Saouma, Paris, 1995

"Marlene Dumas," Raum Aktueller Kunst, Vienna, 1995

"Marlene Dumas—Love Hurts," Stampa Galerie, Basel, Switzerland, 1995

"Marlene Dumas: Models," Kunstverein, Salzburg, Austria; Portikus, Frankfurt am Main, Germany; and Neue Gesellschaft für Bildende Kunst, Berlin, 1995–96

"The Particularity of Being Human: Marlene Dumas—Francis Bacon," Konsthall, Mälmo, Sweden; and Castello di Rivoli, Museo d'Arte Contemporanea, Turin, Italy, 1995–96

"Marlene Dumas," Tate Gallery, London, 1996

"Marlene Dumas: Youth and Other Demons," Gallery Koyanagi, Tokyo, 1996

"Pin-Up," Stedelijk Museum het Toreke, Tienen, Belgium, 1996

"Marlene Dumas, Wolkenkieker," Produzenten-galerie, Hamburg, Germany, 1997

"Damenwahl, Marlene Dumas, Andries Botha," Kunstverein, Kassel, Germany, 1998

The Living Art Museum, Reykjavik, 1998

"Marlene Dumas: Fantasma, Drawings," Centro de Arte Moderna José de Azeredo Perdigão, Fundação Calouste Gulbenkian, Lisbon, 1998

"Miss World," Galerie Paul Andriesse, Amsterdam, 1998

"Aperture: Marlene Dumas," Fondazione Teseco per l'Arte, Pisa, Italy, 1999

"Diletto—Laudanum, Marlene Dumas—Tracey Moffatt," Le Case d'Arte, Milan, Italy, 1999

"Marlene Dumas 'MD,'" Museum van Hedendaagse Kunst, Antwerp, Belgium; Camden Arts Center, London; and Henie Onstad Kunstsenter, Høvikodden, Norway, 1999–2000

"MD—Light," Frith Street Gallery, London, 1999

"Strippinggirls" (with Anton Corbijn), Theatermuseum, Theater Institute Nederland, Amsterdam; Stedelijk Museum voor Actuele Kunst, Ghent, Belgium; and Institut Néerlandais, Paris, 2000–01

"All Is Fair in Love and War," Jack Tilton/Anna Kustera Gallery, New York, 2001

"Marlene Dumas: Nom de Personne/Name no Names," Centre Georges Pompidou, Paris; The New Museum of Contemporary Art, New York; and De Pont Museum of Contemporary Art, Tilburg, The Netherlands, 2001–02

"Marlene Dumas: One Hundred Models and Endless Rejects," Institute of Contemporary Art, Boston, 2001

"The Paradise [4]: Marlene Dumas," The Douglas Hyde Gallery, Dublin, 2001

"Time and Again," Zeno X Storage, Antwerp, Belgium, 2002

"Marlene Dumas: Suspect," Fondazione Bevilacqua La Masa, Palazzetto Tito, Venice, Italy, 2003

"Marlene Dumas: Time and Again," The Art Institute of Chicago, 2003

"Marlene Dumas: Wet Dreams, Watercolors," Stadtischen Galerie, Ravensburg, Germany, 2003

"Con vista al celestiale" (with Marijke van Warmerdam), Galleria Civica d'Arte Contemporanea di Siracusa, Montevergini, Italy; and "Hin und weiter" (with Marijke van Warmerdam), BAWAG Foundation, Vienna, 2004

"Marlene Dumas: The Second Coming," Frith Street Gallery, London, 2004

"Marlene Dumas: Female," Kunsthalle, Helsinki; The Nordic Watercolour Museum, Skärhamn, Sweden; and Staatliche Kunsthalle, Baden-Baden, Germany, 2005–06

"Marlene Dumas: Selected Works," Zwirner and Wirth, New York, 2005

"MAN KIND," Galerie Paul Andriesse, Amsterdam, 2006

"Marlene Dumas: Broken White," Museum of Contemporary Art, Tokyo; and Marugame Genichiro-Inokuma Museum of Contemporary Art, Japan, 2007–08

"Marlene Dumas: Intimate Relations," Iziko South African National Gallery, Cape Town; and The Standard Bank Gallery, Johannesburg, South Africa, 2007–08

"Marlene Dumas: Light and Dark 1987–2007," Gallery Koyanagi, Tokyo, 2007

"Wave and The Fog of War" (with Marijke van Warmerdam), Le Case d'Arte, Milan, Italy, 2007

Group Exhibitions

"Atelier 15, 10 young artists: Ansuya Blom, Dineke Blom, Mari Boeyen, Rinus van den Bosch, René Daniëls, Marlene Dumas, David Groot, Wim Izaks, Andrew Lord, Geertjan van Oostende," Stedelijk Museum, Amsterdam, 1978 (exh. cat.)

"Ateliers '63: Een keuze uit het werk van deelnemers 1975–1980," Bonnefantenmuseum, Maastricht, The Netherlands; and Museum Fodor, Amsterdam, 1980 (exh. cat. in *Fodor* 4, no. 4 [July–August 1985])

"The Critic Sees (als keuze van Paul Groot)," Museum Fodor, Amsterdam, 1980

"Lis '81," Galeria Nacional de Arte Moderna, Lisbon, 1981 (exh. cat.)

The Second International Drawing Triennale, Wroclaw, Poland, 1981

"Amsterdam 60/80: Twintig jaar beeldende kunst, Buitenlanders in Amsterdam," Stedelijk Museum and Museum Fodor, Amsterdam, 1982 (exh. cat.)

Documenta VII, Kassel, Germany, 1982 (exh. cat.)

"Hemmade kunstuitgave '82," Van Abbemuseum, Eindhoven, The Netherlands, 1982

"Jonge kunst uit Nederland," Gemeentemuseum, The Hague, The Netherlands, 1982

"Junge Kunst aus den Niederlanden: Form und Expression; Young Art from the Netherlands," Kunstmesse, Basel, Switzerland, 1982 (exh. cat.)

"Zeichnung heute: 2. Internationale Jugendtriennale + Meister der Zeichnung," Kunsthalle, Nürnberg, Germany, 1982

"Amsterdam 1983 in Berlin/Berlijn 1983 in Amsterdam: 14 Niederländische Künstler zeigen Werke/14 duitse kunstenaars tonen eigen werk," Kunstamt Kreuzberg, Berlin; and Aorta, Amsterdam, 1983 (exh. cat.)

"De Goddelijke Komedie," Galerie 't Venster, Rotterdam, The Netherlands; and Bonnefantenmuseum, Maastricht, The Netherlands, 1983

"Het Persoonlijke = Politiek," Nederlandse Kunst Stichting, Amsterdam; and Gemeentemuseum, Arnhem, The Netherlands, 1983–84

"Rainer Fetting, Marlene Dumas, René Daniëls, Walter Dahn," Galerie Helen van der Meij/Paul Andriesse, Amsterdam, 1983

"Rest risiko," Bonnefantenmuseum, Maastricht, The Netherlands, 1983 (exh. cat.)

"Reykjavik—Amsterdam, ter weerszijden van de Meridiaan," The Living Art Museum, Reykjavik; and Museum Fodor, Amsterdam, 1983 (exh. cat. in Fodor 3, no. 3 [October 1983])

"Veertien kunstenaars uit Nederland, een keuze van Albert Waalkens," Museum Boijmans van Beuningen, Rotterdam, The Netherlands, 1983 (exh. cat.)

"1984 im toten Winkel," Kunstverein und Kunsthaus, Hamburg, Germany (exh. cat.)

"Amsterdam koopt kunst, 1983," Museum Fodor, Amsterdam, 1984 (exh. cat. in Fodor [1983]: 32)

"Nederlandse prenten en tekeningen uit de collectie van het Stedelijk Museum 1940–1984," Museum Fodor, Amsterdam, 1984 (exh. cat. in Fodor 3, no. 11 [December 1984])

"Op papier: Erik Andriesse, René Daniëls, Marlene Dumas, Wim Izaks," Galerie Paul Andriesse, 1984

"Paravents," Schloss Lörsfeld, Kerpen, Germany; and Galerie Heinrich Ehrhardt, Frankfurt am Main, Germany, 1984–85 (exh. cat.)

"Private Symbol: Social Metaphor," Fifth Biennale of Sydney, Australia, 1984 (exh. cat.)

"Stillevens tien kleurenlitho's 12 zeefdrukken," Polychrome Graphics, Amsterdam, 1984

"Vindsulor: Måleri, Skulptur, Video i Holland," Göteborgs Konsthall, Sweden, 1984 (exh. cat.)

"Art Against Apartheid," De Nieuwe Kerk, Amsterdam, 1985

"Aspecten van Nederlandse Tekenkunst, 1945–1985," Stedelijk Museum de Lakenhal, Leiden, The Netherlands; and Allen Memorial Art Museum, Oberlin College, Ohio, 1985 (exh. cat.)

"Christa Dichgans, Lili Dujourie, Marlene Dumas, Lesley Foxcroft, Kees de Goede, Frank van Hemert, Cristina Iglesias, Harald Klingelhöller, Mark Luyten, Juan Muñoz, Katherine Porter, Julião Sarmento, Barbara Schmidt Heins, Gabriele Schmidt-Heins, Didier Vermeiren," Stedelijk Van Abbemuseum, Eindhoven, The Netherlands, 1985 (exh. cat.)

"Cover/Doppelgänger," Aorta, Amsterdam, 1985 (exh. cat.)

"The Dutch Contribution to the 1985 São Paulo Biennale," São Paulo, Brazil; and Stedelijk Museum, Amsterdam, 1985–86 (exh. cat.)

"Het Avondmaal," Grote of Jacobijnenkerk, Leeuwarden, The Netherlands, 1985 (exh. cat.)

"Original d'Amsterdam: Exposició d'art contemporani holandès," Centre Cultural de la Caixa de Pensions, Barcelona, Spain, 1985 (exh. cat.)

"René Daniëls, Marlene Dumas, Henk Visch," Barbara Jandrig Galerie, Krefeld, Germany, 1985 (exh. cat.)

"Taal in het beeld/The Written Language in the Image," Stichting Makkom, Amsterdam, 1985 (exh. pamphlet in Makkom, no. 2: 37)

"Wat Amsterdam betreft," Stedelijk Museum, Amsterdam, 1985 (exh. cat.)

"6 plasticiens contemporains des Pays-Bas," Musée d'Art Moderne, Villeneuve-d'Ascq, France, 1986 (exh. cat.)

"Amsterdam Notes: Works on Paper," Museum Fodor, Amsterdam, 1986 (exh. cat. in Fodor 5, no. 4 [July–August 1986])

"Grafiek," Galerie Julius Wijffels, Leeuwarden, The Netherlands, 1986

"Innovation und Tradition: Niederländische Kunst der achtziger Jahre," Badischer Kunstverein, Karlsruhe, Germany; Städtische Galerie, Erlangen, Germany; and Centraal Museum, Utrecht, The Netherlands, 1986 (exh. cat.)

"Zeven kunstenaars," Galerie Academisch Ziekenhuis, Leiden, The Netherlands, 1986 (exh. cat.)

"A Choice: Contemporary Art from Europe," KunstRAI 87, Amsterdam, 1987 (exh. cat.)

"A priori tekenen," Stichting Makkom, Amsterdam, 1987 (exh. cat.)

"Art from Europe," Tate Gallery, London, 1987 (exh. cat.)

"Century 87: Today's Art Face to Face with Amsterdam's Past," Schuttersgalerij, Amsterdam Historical Museum, 1987 (exh. cat. and project)

"Hollands landschap," Museum Overholland, Amsterdam; and Grand Palais, Paris, 1987 (exh. cat.)

"The Meaning of Drawing: Drawings by Ten Dutch Artists," organized by The Netherlands Office for Fine Art: Institut Néerlandais, Paris; Städtische Galerie, Nordhorn, Germany; Holbein Haus, Augsburg, Germany; Kunstverein, Mannheim, Germany; Kunstverein, Salzburg, Austria; Graphische Sammlung Albertina, Vienna; Saarland Museum, Saarbrücken, Germany; ULUV Institut, Prague; Forum Gallery Niksic, Montenegro; Moderne Galerija, Ljubljana; Moderne Galerija, Rijeka, Croatia; Galerii Studio, Warsaw; and Kunsthallen Brandts Klaedefabrik, Odense, Denmark, 1987–89 (exh. cat.)

"Nightfire," De Appel, Amsterdam, 1987 (exh. cat.)

"Bluebeard Stills," Shaffy Theater, Amsterdam, 1988

"Nieuwe nederlandse grafiek," Stedelijk Museum, Amsterdam, 1988

"Vijf jaar aanwinsten Hedendaagse kunst," Gemeentemuseum, Arnhem, The Netherlands, 1988

"6 Dutch Artists," The Fruitmarket Gallery, Edinburgh, 1989 (exh. cat.)

"30 anni di disegni," Instituto Universitario Olandese di Storia dell'Arte, Florence, Italy, 1989 (exh. cat.)

"Bilderstreit," Rheinhallen der Kölnmesse, Cologne, Germany, 1989

"Hommage aan Pasolini," Gemeentemuseum, Arnhem, The Netherlands, 1989

"Prospect 89, Eine internationale Ausstellung aktueller Kunst," Frankfurter Kunstverein and Schirn Kunsthalle, Frankfurt, Germany, 1989 (exh. cat.)

"Vijf jaar aanwinsten Hedendaagse Kunst," Gemeentemuseum, Arnhem, The Netherlands, 1989

"Zeichnung + Skulptur," Stampa Galerie, Basel, Switzerland, 1989

"Bevrijdingen, hedendaagse kunst en historische documenten," Joods Historisch Museum, Amsterdam, 1990 (exh. cat.)

"Inconsolable: An Exhibition about Painting," Louver Gallery, New York, 1990 (exh. cat.)

"Stichting Plint: 10 jaar poëzieposters," Van Abbemuseum, Eindhoven, The Netherlands, 1990

"Zelfportretten," Galerie Tanya Rumpff, Haarlem, The Netherlands, 1990 (exh. cat.)

"De dialoog 2," Haagse Kunstkring, The Hague, The Netherlands, 1991 (exh. cat.)

"Forbidden Games," Jack Tilton Gallery, New York, 1991

"Glück auf," Zeche Rheinpreussen, Moers, Germany, 1991

"Individu: Duiding, verboden verbindingen + twijfelachtige verbanden," Internationaal Cultureel Centrum, Antwerp, Belgium, 1991 (exh. cat.)

"Inscapes," De Appel, Amsterdam, 1991 (exh. cat.)

"The Interrupted Life," The New Museum of Contemporary Art, New York, 1991 (exh. cat.)

"Ars pro domo: Zeitgenössische Kunst aus Kölner Privatbesitz," Museum Ludwig, Cologne, Germany, 1992 (exh. cat.)

"Art for ASAP: Kunstmanifestatie voor AIDS preventie," De Beurs van Berlage, Amsterdam, 1992 (exh. cat.)

"Bildnisse Figuren," Stampa Galerie, Basel, Switzerland, 1992

"Brain/Internal Affairs," Beatrixziekenhuis, Gorinchem, The Netherlands, 1992 (exh. cat.)

Documenta IX, Kassel, Germany, 1992 (exh. cat.)

"Alla va eso," Produzentengalerie, Hamburg, Germany, 1993

"Das 21. Jahrhundert: Mit Paracelsus in die Zukunft," Kunsthalle, Basel, Switzerland, 1993 (exh. cat.)

"Dumas, Bächli, Stumpf," Stampa Galerie, Basel, Switzerland, 1993

"Gegenbilder," Lambertikirche, Münster, Germany, 1993 (exh. cat.)

"Gent te Gast: De keuze van Jan Hoet," De Beyerd Museum, Breda, The Netherlands, 1993 (exh. cat.)

"LANORMALITÀ dell'arte," La Galleria del Credito Valtellinese, Milan, Italy, 1993 (exh. cat.)

"Recollections," In Situ/Ardi Poels, Maastricht, The Netherlands, 1993

"They Call It Love," Künstlerhaus Bethanien, Berlin, 1993

"Über-Leben," Kunstverein, Bonn, Germany, 1993 (exh. cat.)

"Zeichnung," Kunsthalle, St. Gallen, Switzerland, 1993

"Der zerbrochene Spiegel: Positionen zur Malerei heute," MuseumsQuartier und Kunsthalle, Vienna; and Deichtorhallen, Hamburg, Germany, 1993

"4 x 1 im Albertinum," Gemäldegalerie Neue Meister, Staatliche Kunstsammlungen, Dresden, Germany, 1994 (exh. cat.)

"10 jaar later, zeefdrukken van...," Arti et Amicitiae, Amsterdam, 1994

"Andries Botha, Marlene Dumas, Sandra Kriel," Galerie Paul Andriesse, Amsterdam, 1994

"Cocido y crudo," Museo Nacional Centro de Arte Reina Sofía, Madrid, 1994 (exh. cat.)

"Dialogue with the Other," Kunsthallen Brandts Klædefabrik, Odense, Denmark; and Konstmuseum, Norrköping, Sweden, 1994 (exh. cat.)

"Du concept à l'image," Musée d'Art Moderne de la Ville de Paris, 1994 (exh. cat.)

"De eeuw van Mondriaan: Nederlandse kunst van de 20ste eeuw," Museum Paleis Lange Voorhout, The Hague, The Netherlands, 1994 (exh. cat.)

"Het getekende gelaat," Hermen Molendijk Stichting Centrum Beeldende Kunst, Amersfoort, The Netherlands; and Museum De Wieger, Deurne, The Netherlands, 1994 (exh. cat.)

"Ik + de Ander: Dignity for All, Reflections on Humanity," Beurs van Berlage, Amsterdam, 1994 (exh. cat.)

"Marlene Dumas—Juan Munoz—Thomas Schutte," Frith Street Gallery, London, 1994

"Marlene Dumas, Mike Kelley, Christopher Wool: Drawings," Galerie Samia Saouma, Paris, 1994

"Morild: Bioluminescence. Doris Bloom and Guest Artists," Gl. Holtegaard, Holte, Denmark, 1994 (exh. cat.)

"Las palabras se pudren en la boca," Galería Antonio de Barnola, Barcelona, Spain, 1994

"Spuren von Ausstellungen der Kunsthalle in Sammlungen zeitgenössischer Kunst," Kunsthalle, Bern, 1994 (exh. cat.)

"Tekenend: Tekeningen van Nederlandse kunstenaars uit de Collectie Becht," Van Reekum Museum, Apeldoorn, The Netherlands, 1994 (exh. cat.)

"Africus: Johannesburg Biennale," Johannesburg, South Africa, 1995 (exh. cat.)

"Ars 95," Museum of Contemporary Art, Finnish National Gallery, Helsinki, 1995 (exh. cat.)

"Carnegie International 1995," Carnegie Museum of Art, Pittsburgh, 1995 (exh. cat.)

"Fémininmasculin: Le sexe de l'art," Centre Georges Pompidou, Paris, 1995 (exh. cat.)

"Hedendaags Zuid-Afrika: 12 kunstenaars uit Zuid-Afrika," Museum 't Coopmanshûs, Franeker, The Netherlands, 1995 (exh. cat.)

"Identity and Alterity: Figures of the Body 1895–1995," Palazzo Grassi, Museo Correr, Padiglione Italia, La Biennale di Venezia, Venice, Italy, 1995 (exh. cat.)

"Jezus is boos—Het beeld van Christus in de hedendaagse kunst," Museum De Wieger, Deurne, The Netherlands; and Museum Catharijneconvent, Utrecht, The Netherlands, 1995 (exh. cat.)

"Des limites du tableau: Les possibles de la peinture," Musée Départemental de Rochechouart, France, 1995 (exh. cat.)

"Marlene Dumas, Maria Roosen, Marijke van Warmerdam," XLVI Biennale di Venezia, Padiglione Olandese, Venice, Italy, 1995

"Ripple Across the Water," The Watari Museum of Contemporary Art, Tokyo, 1995 (exh. cat.)

"Avant-première d'un musée: Le Musée d'Art Contemporain de Gand," Institut Néerlandais, Paris, 1996 (exh. cat.)

"Distemper: Dissonant Themes in the Art of the 1990s," Hirshhorn Museum and Sculpture Garden, Washington, D.C., 1996 (exh. cat.)

"Early Learning," Entwistle Gallery, London, 1996

"Nudo & crudo," Claudia Gian Ferrari Arte Contemporanea, Milan, Italy, 1996 (exh. cat.)

"Paar mal Paar," Helmhaus, Zürich, Switzerland, 1996 (exh. cat.)

"Peinture-peinture," Galerie Samia Saouma, Paris, 1996

"Selbstportrait," Kunsthaus, Mürzzuschlag, Austria, 1996

"Take Two," Centraal Museum, Utrecht, The Netherlands, 1996

"Ver na Vermeer," De Beyerd Museum, Breda, The Netherlands, 1996

"Affinités électives: Peinture européenne en dialogue," Casino Luxembourg, 1997

"Anima e corpo," Museo del Risorgimento, Rome, 1997 (exh. cat.)

"Art of the 20th Century: Flemish and Dutch Painting from Van Gogh, Ensor, Magritte, Mondrian to Contemporary Artists," Palazzo Grassi, Venice, Italy, 1997 (exh. cat.)

"Auf dem Strich: Arbeiten zum Thema Prostitution," Kulturviertel im Sophienhof, Kiel, Germany; Schleswig-Holstein-Haus, Kulturforum der Landeshauptstadt Schwerin, Germany; Landdrostei, Pinneberg, Germany; Galerie am Alten Markt, Hansestadt, Rostock, Germany; Schabbellhaus, Stadtgeschichtliches Museum, Wismar, Germany; and Burgkloster zu Lübeck, Germany, 1997 (exh. cat.)

"Augenzeugen: Die Sammlung Hanck, Papierarbeiten der 80er and 90er Jahre," Kunstmuseum Düsseldorf im Ehrenhof, Germany, 1997 (exh. cat.)

"De Bruiloftsreportage," Centraal Museum, Utrecht, The Netherlands, 1997 (exh. cat.)

"Entgegen: Religion gedächtnis Körper in Gegenwartskunst," Minoriten-Galerien, Graz, Austria, 1997 (exh. cat.)

"Floating Images of Women in Art History: From the Birth of the Feminism toward the Dissolution of the Gender," Tochigi Prefectural Museum of Fine Arts, Utsunomiya, Japan, 1997 (exh. cat.)

"Image and Form: Prints, Drawings, and Sculpture from Southern Africa and Nigeria," Brunei Gallery, School of Oriental and African Studies, University of London; and Edinburgh College of Art, Heriot-Watt University, 1997 (exh. cat.)

"Luoghi: Alla ricerca del territorio," Galleria d'Arte Moderna e Contemporanea, San Marino, 1997 (exh. cat.)

"Von Kopf bis Fuß: Fragmente des Körpers," Ursula Blickle Stiftung, Kraichtal-Unteröwisheim, Germany; and Kunstraum, Innsbruck, Austria, 1997 (exh. cat.)

"A noir," Triennale di Milano, Milan, Italy, 1998

"Auf der Spur: Kunst der 90er Jahre im Spiegel von Schweizer Sammlungen," Kunsthalle, Zürich, Switzerland, 1998 (exh. cat.)

"The Centre Holds," Galerie Gmurzynska, Cologne, Germany, 1998 (exh. cat.)

"Desde el cuerpo: Alegorías de lo femenino," Museo de Bellas Artes, Caracas, 1998

"Eight People from Europe," Museum of Modern Art, Gunma, Japan, 1998 (exh. cat.)

"Das grosse Rasenstück," Stadtgalerie Schwaz, Tyrol, Austria, 1998

"Hungry Ghosts," The Douglas Hyde Gallery, Dublin, 1998 (exh. cat.)

"Ideal and Reality: The Image of the Body in 20th-Century Art from Bonnard to Warhol, Works on Paper," Salzburger Landessammlungen für moderne und zeitgenössische Kunst Rupertinum, Austria, 1998 (exh. cat.)

"Kunst der 80er und 90er Jahre," Kunsthalle, Holderbank, Switzerland, 1998

"S.M.A.K. in Watou: Voor het verdwijnt en daarna," Watou, Belgium, 1998 (exh. cat.)

"Szenenwechsel XIII," Museum für Moderne Kunst, Frankfurt, Germany, 1998

"Toile: Body (re)presentations," Museum Boijmans Van Beuningen, Rotterdam, The Netherlands, 1998 (exh. pamphlet)

"Verzachtende omstandigheden: Wandtapijten in het Paleis van Justitie, 's Hertogenbosch," Museum Boijmans Van Beuningen, Rotterdam, The Netherlands, 1998 (exh. cat.)

"Wounds: Between Democracy and Redemption in Contemporary Art," Moderna Museet, Stockholm, 1998 (exh. cat.)

"Drawing Thinking," Royal Hibernian Academy, Gallagher Gallery, Dublin, 1999

"Examining Pictures: Exhibiting Paintings," Whitechapel Art Gallery, London; and Museum of Contemporary Art, Chicago, 1999 (exh. cat.)

"Face to Face," Fries Museum, Leeuwarden, The Netherlands, 1999

"Figuration," Ursula Blickle Stiftung, Kraichtal-Unteröwisheim, Germany; Museion, Museum für moderne und zeitgenössische Kunst, Bolzano, Italy; and Rupertinum, Museum für Moderne Kunst, Salzburger Landessammlungen, Salzburg, Austria, 1999–2000 (exh. cat.)

"Macht und Fürsorge: Das Bild der Mutter in zeitgenössischer Kunst und Wissenschaft," Trinitatiskirche, Cologne, Germany, 1999 (exh. cat.)

"Negotiating Small Truths," The Jack S. Blanton Museum of Art, University of Texas at Austin, 1999 (exh. cat.)

"Pathologiae: Sechs Frauen—Ein Zufall," Museion, Museum für Moderne Kunst/Museo d'Arte Moderna, Bolzano, Italy, 1999 (exh. cat.)

"Physical Evidence," Kettle's Yard, Cambridge, England, 1999 (exh. cat.)

"Presence: Figurative Art at the End of the Century," Tate Gallery Liverpool, England, 1999

"La realitat i el desig," Fundació Joan Miró, Barcelona, Spain, 1999 (exh. cat.)

"Regarding Beauty: A View of the Late Twentieth Century," Hirshhorn Museum and Sculpture Garden, Washington, D.C.; and Haus der Kunst, Munich, Germany, 1999–2000 (exh. cat.)

"Le Sommeil, ou quand la raison s'absente," Musée cantonal des Beaux-Arts, Lausanne, Switzerland, 1999 (exh. cat.)

"Trouble Spot: Painting," Nieuw Internationaal Cultureel Centrum and Museum van Hedendaagse Kunst, Antwerp, Belgium, 1999 (exh. cat.)

12th Biennale of Sydney, Australia, 2000 (exh. cat.)

"Exorcism/Aesthetic Terrorism," Museum Boijmans Van Beuningen, Rotterdam, The Netherlands, 2000 (exh. cat.)

"Das Gedächtnis der Malerei," Aargauer Kunsthaus, Aarau, Switzerland, 2000 (exh. cat.)

"Het Oorkussen van de Melancholie," Museum voor Schone Kunsten, Ghent, Belgium, 2000 (exh. cat.)

"Kinder des 20. Jahrhunderts," Galerie der Stadt Aschaffenburg, Germany; and Mittel-Rhein-Museum, Koblenz, Germany, 2000 (exh. cat.)

"Mixing Memory and Desire: Wunsch und Erinnerung," Kunstmuseum, Lucerne, Switzerland, 2000 (exh. cat.)

"Premio Michetti 2000: Painting in Europe, Different Perspectives," Museo Michetti, Francavilla al Mare, Italy, 2000

"Présumés innocents: L'art contemporain et l'enfance," CAPC Musée d'art contemporain, Bordeaux, France, 2000 (exh. cat.)

Shanghai Biennial, China, 2000 (exh. cat.)

"Die verletzte Diva: Hysterie, Körper, Technik in der Kunst des 20. Jahrhunderts," Städtische Galerie im Lenbachhaus und Kunstbau, Kunstverein, and Rotunde Siemens Kulturprogramm, Munich, Germany; Galerie im Taxispalais, Innsbruck, Austria; and Staatliche Kunsthalle, Baden-Baden, Germany, 2000 (exh. cat.)

"De Voorstelling: Nederlandse Kunst in het Stedelijk Paleis," Stedelijk Museum, Amsterdam, 2000 (exh. cat.)

"Aspects of South African Art, 1903–1999," Sandton Civic Gallery, Johannesburg, South Africa, 2001 (exh. cat.)

"The Beauty of Intimacy: Lens and Paper," Gemeentemuseum, The Hague, The Netherlands; Staatliche Kunsthalle, Baden-Baden, Germany; and Kunstraum, Innsbruck, Austria, 2001–02 (exh. cat.)

"The Contemporary Face: From Pablo Picasso to Alex Katz," Deichtorhallen, Hamburg, Germany, 2001

"From the Low Countries: Reality and Art, 1960–2001," Charlottenborg, Udstillingsbygning, Copenhagen; Fries Museum, Leeuwarden, The Netherlands; and Stedelijk Museum, Schiedam, The Netherlands, 2001–02 (exh. cat.)

"Head North: Views from the South African National Gallery Permanent Collection," BildMuseet, Umeå University, Sweden, 2001 (exh. cat.)

"Inmensidad intima: Una selección de obras del Museo de Arte Contemporáneo de Gante," Museo Tamayo, Mexico City, 2001 (exh. cat.)

"Painting at the Edge of the World," Walker Art Center, Minneapolis, 2001 (exh. cat.)

"Reconfiguration," Central Academy of Fine Arts Gallery, Beijing; and Modern Chinese Art Foundation, Ghent, Belgium, 2001 (exh. cat.)

"Szenenwechsel XX," Museum für Moderne Kunst, Frankfurt, Germany, 2001

"Watou Poëziezomer 2001: Een lege plek om te blijven," Watou, Belgium, 2001 (exh. cat.)

"234th Summer Exhibition," Royal Academy, London, 2002 (exh. cat.)

"Der Akt in der Kunst des 20. Jahrhunderts," Kunsthalle in Emden, Germany, 2002 (exh. cat.)

"Amsterdam Revisited: A'dam & Eve. On Sex, Tolerance and Other Dependencies," de Appel Arts Centre, Amsterdam, 2002

"Apparition: The Action of Appearing," Arnolfini, Bristol, England; and Kettle's Yard, Cambridge, England, 2002–03 (exh. cat.)

"Babel 2002: Race-Face, Language-Dialogue," National Museum of Contemporary Art, Seoul, 2002 (exh. cat.)

"Barbara Kruger/Tracey Moffatt/Marlene Dumas," Monika Sprüth Gallery, Cologne, Germany, 2002

"Contemporary Art from the Netherlands," European Central Bank, Frankfurt, Germany, 2002 (exh. cat.)

"Extreme Existence," Pratt Manhattan Gallery, New York, 2002 (exh. cat.)

"Fekete Fehér/Gondolsz-e ma Fekete Afrikára?," Mucsarnok Kunsthalle, Budapest, 2002 (exh. cat.)

"Malerisches Denken," Stampa Galerie, Basel, Switzerland, 2002

"Passport to South Africa: Arte contemporanea sudafricana," Centro Trevi, Bolzano, Italy, 2002 (exh. cat.)

"refuge/tilflukt," Henie Onstad Kunstsenter, Oslo, 2002 (exh. cat.)

"20th Anniversary Show," Monika Sprüth Philomene Magers, Cologne, Germany, 2003

"Gogh Modern: Vincent van Gogh and Contemporary Art," Van Gogh Museum, Amsterdam, 2003 (exh. cat.)

"Happiness: A Survival Guide for Art and Life," Mori Art Museum, Tokyo, 2003 (exh. cat.)

"(In Search of) The Perfect Lover: Works by Louise Bourgeois, Marlene Dumas, Paul McCarthy and Raymond Pettibon from the Sammlung Hauser und Wirth," Staatliche Kunsthalle, Baden-Baden, Germany; and MDD Museum Dhondt-Dhaenens, Deurle, Belgium, 2003 (exh. cat.)

"Micropolitics II (1989–1980)," Espai d'Art Contemporani de Castelló, Spain, 2003 (exh. cat.)

"Models and Mavericks," Museum het Domein, Sittard, The Netherlands, 2003

"Pittura/Painting: From Rauschenberg to Murakami, 1964–2003," La Biennale di Venezia, in collaboration with Comune di Venezia/Musei Civici Veneziani, Venice, Italy, 2003 (exh. cat.)

"Supernova: Art of the 1990s from the Logan Collection," San Francisco Museum of Modern Art, 2003 (exh. cat.)

"unHEIMlich," Städtischen Galerie Delmenhorst, Germany, 2003 (exh. cat.)

"94–04: Zehn Jahre Gesellschaft für moderne Kunst in Dresden," Galerie Neue Meister, Staatliche Kunstsammlungen, Dresden, Germany, 2004 (exh. pamphlet)

"Africa Remix: Contemporary Art of a Continent," Museum Kunst Palast, Düsseldorf, Germany; Hayward Gallery, London; Centre Georges Pompidou, Paris; and Mori Art Museum, Tokyo, 2004–06 (exh. cat.)

"Arte termita contra elefante blanco: Comportamientos actuales del dibujo," Museo Colecciones ICO, Madrid, 2004 (exh. cat.)

"Diaries and Dreams: Arbeiten auf Papier," Ursula Blickle Stiftung, Kraichtal-Unteröwisheim, Germany, 2004 (exh. cat.)

"Erik Andriesse/Marlene Dumas," Handmade Prints, Amsterdam, 2004

"Grasduinen I," in het kader van S.M.A.K.-aan-zee, Bredene, Belgium, 2004 (exh. cat.)

"Het offer an intimate I," De Beyerd Museum, Breda, The Netherlands, 2004 (exh. cat.)

"In Bed: Images from a Vital Stage," Toyota Municipal Museum of Art, Tokyo, 2004 (exh. cat.)

"Non toccare la donna bianca: La liberazione delle diversità," Fondazione Sandretto Re Rebaudengo, Turin, Italy; and Castel dell'Ovo, Naples, 2004–05 (exh. cat.)

"The Nude: Ideal and Reality," Galleria d'Arte Moderna, Bologna, Italy, 2004 (exh. cat.)

"Secrets of the Nineties," Museum voor Moderne Kunst, Arnhem, The Netherlands, 2004

"'De wereld deugt, wijzelf helaas wat minder': 'At Year's End, Rethinking The Family of Man'," De Appel Arts Centre, Amsterdam, 2004

"51. International Exhibition of Art: The Experience of Art," Bienniale de Venezia, Venice, Italy, 2005 (exh. cat.)

"Black & White and a Little Bit of Colour: A Selection from the Collection of Works on Paper (1980–2005)," Museum voor Moderne Kunst, Arnhem, The Netherlands, 2005 (exh. cat.)

"The Blake Byrne Collection," The Museum of Contemporary Art, Los Angeles, 2005 (exh. cat.)

"Crysalis: Teoria dell'evoluzione," Castelli Svevo di Bari e Trani, Italy, 2005 (exh. cat.)

"Drawing from the Modern, 1975–2005," The Museum of Modern Art, New York, 2005 (exh. cat.)

"Edizione Straordinaria: Le case d'arte 1985–2005," Assab One, Milan, Italy, 2005

"Getting Emotional," Institute of Contemporary Art, Boston, 2005 (exh. cat.)

"Les grands spectacles: 120 Jahre Kunst und Massenkultur," Museum der Moderne, Salzburg, Austria, 2005 (exh. cat.)

"Identità & Nomadismo," Palazzo delle Papesse, Centro Arte Contemporanea, Siena, Italy, 2005 (exh. cat.)

"Leporello: A Journey through the Collection, 1874–2004," Stedelijk Museum CS, Amsterdam, 2005

"Der Kunst ihre Räume," Kunstverein, Bonn, Germany, 2005

"Miradas y conceptos en la Colección Helga de Alvear," Museo Extremeño e Iberoamericano de Arte Contemporáneo, Badajoz, Spain, 2005 (exh. cat.)

"Munch Revisited: Edvard Munch and the Art of Today," Museum am Ostwall in der Kunsthalle Dortmund, Germany; and Henie Onstad Kunstsenter, Høvikodden, Norway, 2005 (exh. cat.)

"(my private) Heroes," MARTa Herford, Germany, 2005 (exh. cat.)

"Nach Rokytnik: Die Sammlung der EVN," Museum Moderner Kunst, Stiftung Ludwig, Vienna, 2005

"Respect! Forms of Community: Contemporary Art from The Netherlands," Musée Dar Si Saïd, Palais el-Badi, Marrakesh, Morocco, 2005 (exh. cat.)

"A Selection," de Kabinetten van de Vleeshal, Middelburg, The Netherlands, 2005

"Self-Portrait: Renaissance to Contemporary," National Portrait Gallery, London; and Art Gallery of New South Wales, Sydney, Australia, 2005–06 (exh. cat.)

"Slow Art: Contemporary Art from The Netherlands and Flanders," Museum Kunst Palast, Düsseldorf, Germany, 2005 (exh. cat.)

"SOUL: Bezielde Kunst," Grootseminarie te Brugge, Bruges, Belgium, 2005 (exh. cat.)

"Take Two. Worlds and Views: Contemporary Art from the Collection," The Museum of Modern Art, New York, 2005

"The Triumph of Painting (Part 1)," The Saatchi Gallery, London, 2005 (exh. cat.)

"Vervreemdend mensbeeld: Collectie Frissiras Museum Athene," Scheringa Museum voor Realisme, Spanbroek, The Netherlands, 2005

"Very Early Pictures," Luckman Gallery, California State University, Los Angeles, 2005

"2. biennale der zeichnung: Menschenbilder," Galerie in der Alten Post, Kunstverein, Eislingen, Germany, 2006 (exh. cat.)

"The 80s: A Topology," Museu Serralves, Porto, Portugal, 2006 (exh. cat.)

"Altijd Vandaag," Dordrechts Museum, Dordrecht, The Netherlands, 2006

"L'amateur d'estampes," Musée des Beaux-Arts, Tourcoing, France, 2006

"Ecce Uomo: (33+1) artisti contemporanei da collezioni private a Milano," Spazio Oberdan, Milan, Italy, 2006 (exh. cat.)

"Eros in der Kunst der Moderne," Fondation Beyeler, Basel, Switzerland; and BA-CA Kunstforum, Vienna, 2006–07 (exh. cat.)

"Essential Painting," The National Museum of Art, Osaka, Japan, 2006 (exh. cat.)

"Gorge (I): Oppression and Relief in Art," Koninklijk Museum voor Schone Kunsten, Antwerp, Belgium, 2006

"Infinite Painting: Contemporary Painting and Global Realism," Villa Manin Centro d'Arte Contemporanea, Codroipo, Italy, 2006 (exh. cat.)

"Körper, Gesicht und Seele, Frauenbilder vom 16. bis zum 21. Jahrhundert," Leopold Museum, Vienna, 2006 (exh. cat.)

"Le Mépris (or) Contempt," Mediamatic, Amsterdam, 2006 (exh. cat.)

"Nederland 1," Museum Gouda, The Netherlands, 2006

"Resonance," Frith Street Gallery, London, 2006

"Six Feet Under: Autopsy of Our Relation to the Dead," Kunstmuseum, Bern, 2006 (exh. cat.)

"Twenty Five Years, Zeno X Gallery," Zeno X Gallery, Antwerp, Belgium, 2006

"Waanzin is Vrouwelijk," Museum Dr. Guislain, Ghent, Belgium, 2006

"Zurück zur Figur: Malerei der Gegenwart," Kunsthalle der Hypo-Kulturstiftung, Munich, Germany; and Museum Franz Gertsch, Burgdorf, Switzerland, 2006–07 (exh. cat.)

"100 Jahre Kunsthalle Mannheim," Kunsthalle, Mannheim, Germany, 2007

"Accumulations," Institute of Contemporary Art, Boston, 2007

"Artempo: Where Time Becomes Art," Palazzo Fortuny, Venice, Italy, 2007 (exh. cat.)

"CAPE 2007," Look Out Hill, Cape Town, South Africa, 2007

"Contour continuïteit, heden en verleden," Museum Het Prinsenhof, Museum Nusantara, Museum Lambert van Meerten, Delft, The Netherlands, 2007 (exh. cat.)

"A Faithful Eye: Modern and Contemporary Art from The Netherlands, The ABN AMRO Collection," Grand Rapids Art Museum, Michigan, 2007 (exh. cat.)

"I Am as You Will Be: The Skeleton in Art," Cheim and Read, New York, 2007 (exh. cat.)

"Marlene Dumas, Antonietta Peeters, Natasja Kensmil: Sister Sledge," Lieu d'Art Contemporain, Sigean, France, 2007 (exh. pamphlet)

"Mijn Laatste oordeel," Stedelijk Museum De Lakenhal, Leiden, The Netherlands, 2007

"New Acquisitions: Marlene Dumas, Jenny Holzer, Barbara Kruger, Michel Majerus, Richard Prince, Cindy Sherman," Le Case d'Arte, Milan, Italy, 2007

"Painting Now! Back to Figuration," Kunsthal, Rotterdam, The Netherlands, 2007 (exh. cat.)

"The Painting of Modern Life," The Hayward Gallery, London; and Castello di Rivoli, Museo d'arte contemporanea, Turin, Italy, 2007–08 (exh. cat.)

"The Present: The Monique Zajfen Collection," Stedelijk Museum, Amsterdam, 2007 (exh. pamphlet)

"Rocker's Island: Werke aus der Sammlung Olbricht," Museum Folkwang, Essen, Germany, 2007 (exh. cat.)

"Seduced: Art and Sex from Antiquity to Now," Barbican Art Gallery, London, 2007 (exh. cat.)

"Sequence 1: Pittura a scultura nella collezione François Pinault," Palazzo Grassi, Venice, Italy, 2007 (exh. cat.)

"Very Abstract and Hyper Figurative," Thomas Dane Gallery, London, 2007

"What Is Painting? Contemporary Art from the Collection," The Museum of Modern Art, New York, 2007

"Le Musée De Pont à Paris," Institut Néerlandais, Paris, 2008

Selected Bibliography

Monographs, Solo and Two-Person Exhibition Catalogues, and Films

Marlene Dumas: Ons land licht lager dan de zee. Utrecht, The Netherlands: Centraal Museum, 1984. Texts by Marja Bosma, Libuse Brozek, and Jan Debbaut.

Marlene Dumas: The Eyes of the Night Creatures. Amsterdam: Galerie Paul Andriesse, 1985. Texts by Paul Andriesse and Dumas.

Marlene Dumas: Strips. Amsterdam: Stichting één op één, 1987.

Don't Talk to Strangers. Film by Rudolf Evenhuis and Jaap Guldemond. Produced by Stichting Actuele Kunst Documentatie, 1988.

Marlene Dumas: Nightmares. Maastricht, The Netherlands: Galerie Wanda Reiff, 1988.

Marlene Dumas: Waiting (For Meaning). Kiel, Germany: Kunsthalle, 1988. Texts by Ulrich Bischoff, Dumas, and Martijn van Nieuwenhuyzen.

Marlene Dumas. Edinburgh: The Fruitmarket Gallery, 1989. Texts by Dumas and Martijn van Nieuwenhuyzen.

Marlene Dumas: The Question of Human Pink. Bern: Kunsthalle, 1989. Text by Dumas and Ulrich Loock.

Marlene Dumas: Couples. Amsterdam: Museum Overholland, 1990. Text by Dumas.

Marlene Dumas: The Origin of the Species. Munich, Germany: Staatsgalerie Moderner Kunst, Bayerische Staatsgemäldesammlungen, 1990. Texts by Ulrich Bischoff and Dumas.

Marlene Dumas: Miss Interpreted. Eindhoven, The Netherlands: Stedelijk Van Abbemuseum, 1992. Texts by Jan Debbaut, Dumas, Selma Klein Essink, and Marcel Vos.

Marlene Dumas. Philadelphia: Goldie Paley Gallery, 1993. Texts by Dumas and Jolie van Leeuwen.

Marlene Dumas. Bonn, Germany: Kunstverein; and London: Institute of Contemporary Arts, 1993. Texts by Dumas and Annelie Pohlen.

Marlene Dumas: Land of Milk and Honey. Hamburg, Germany: Produzentengalerie, 1993. Text by Annelie Pohlen.

Chlorosis: Marlene Dumas. Dublin: The Douglas Hyde Gallery, 1994. Texts by Dumas and John Hutchinson.

Marlene Dumas/Francis Bacon. Milan, Italy: Charta, 1995. Texts by Marente Bloemheuvel, Maurizio Fagiolo dell'Arco, Dumas, Richard Francis, Ida Gianelli, Elena Gigli, Daniel Kurjakovic, and Jan Mot.

Marlene Dumas, Francis Bacon: Det Unika Med Att Vara en Människa (The particularity of being human). Malmö, Sweden: Konsthall, 1995. Texts by Marente Bloemheuvel, Dumas, Richard Francis, Daniel Kurjakovic, Jan Mot, and Sune Nordgren.

Marlene Dumas/Maria Roosen/Marijke van Warmerdam: XLVI Biennale di Venezia, Padiglione Olandese. Rotterdam, The Netherlands: Witte de With, Center for Contemporary Art, 1995. Texts by Anke Bangma, Wim Crouwel, Chris Dercon, Dumas, Camiel van Winkel, Bart Verschaffel, and Antje von Graevenitz.

Marlene Dumas: Models. Salzburg, Austria: Kunstverein; Frankfurt am Main, Germany: Portikus; and Stuttgart, Germany: Oktagon, 1995. Texts by Dumas, Silvia Eiblmayr, and Ernst van Alphen.

Marlene Dumas. London: Tate Gallery, 1996. Text by Catharine Kinley.

Marlene Dumas: Pin-Up. Tienen, The Netherlands: Stedelijk Museum "het Toreke", 1996. Text by Dumas.

Marlene Dumas: Youth and Other Demons. Tokyo: Gallery Koyanagi, 1996.

Marlene Dumas: Wolkenkieker. Hamburg, Germany: Produzentengalerie, 1997. Text by Jolie van Leeuwen.

Miss Interpreted. Film by Rudolf Evenhuis and Joost Verhey. Produced by MM Productions and The Humanistic Broadcast, 1997.

Damenwahl: Marlene Dumas/Andries Botha. Kassel, Germany: Kunstverein; and Cologne, Germany: Oktagon Verlag, 1998. Texts by Bernhard Balkenhol, Botha, Dumas, and Matthias Winzen.

Marlene Dumas: Fantasma, desenhos. Lisbon: Centro de Arte Moderna José de Azeredo Perdigão, Fundação Calouste Gulbenkian, 1998. Text by Jorge Molder.

Sweet Nothings: Notes and Texts by Marlene Dumas. Ed. Mariska van den Berg. Amsterdam: De Balie, 1998.

Marlene Dumas. London: Phaidon, 1999. Texts by Barbara Bloom, Mariuccia Casadio, Dumas, and Dominic van den Boogerd.

Marlene Dumas: MD. Antwerp, Belgium: MUHKA; London: Camden Arts Centre; and Høvikodden, Norway: Henie Onstad Kunstsenter, 1999. Texts by Dumas, Gavin Jantjes, and Dominic van den Boogerd.

Anton Corbijn, Marlene Dumas: Strippinggirls. Amsterdam: Stichting Actuele Kunstdocumentatie, 2000. Texts by Corbijn and Dumas.

Marlene Dumas/Rineke Dijkstra/Laylah Ali: 2000 ICA Artists Prize. Film by Branka Bogdanov. Produced by The Institute of Contemporary Art, Boston, 2001.

Marlene Dumas: Nom de personne/Name No Names. Paris: Centre Georges Pompidou, 2001. Texts by Dumas and Jonas Storsve.

Marlene Dumas: One Hundred Models and Endless Rejects. Boston: Institute of Contemporary Art; and Ostfildern-Ruit, Germany: Hatje Cantz Verlag, 2001. Texts by Dumas, Jill Medvedow, and Jessica Morgan.

Loud & Clear: Ryuichi Sakamoto + Marlene Dumas + Erik Kessels/KesselsKramer. Amsterdam: Bifrons Foundation, 2002. Text by Dirk van Weelden.

Focus: Marlene Dumas, Time and Again. Chicago: The Art Institute of Chicago, 2003. Texts by Dumas and James Rondeau.

Marlene Dumas: Suspect. Milan, Italy: Skira; and London: Thames and Hudson, 2003. Texts by Jan Andriesse, Dumas, Barbara Poli, Gianni Romano, Dominic van den Boogerd, and Angela Vettese.

Marlene Dumas: Wet Dreams, Watercolors. Eds. Thomas Knubben and Tilman Osterwold. Ravensburg, Germany: Städtische Galerie, 2003. Texts by Jean-Christophe Ammann, Dumas, Knubben, and Osterwold.

Marlene Dumas (The Armory Show New York 2004). Amsterdam: Galerie Paul Andriesse, 2004. Text by Dumas.

Marlene Dumas: The Second Coming. London: Frith Street Books, 2004. Text by Dumas.

Maar wie ik ben gaat niemand wat aan. Ed. Jan Tromp. Breda, The Netherlands: GGZ, Regio Breda, 2005.

Marlene Dumas + Marijke Van Warmerdam. Eds. Dumas and Van Warmerdam. Cologne, Germany: Verlag der Buchhandlung Walther König, 2005. Texts by Dumas, Rudi Fuchs, and Van Warmerdam.

Marlene Dumas: Female. Baden-Baden, Germany: Staatliche Kunsthalle, 2005. Texts by Eberhard Garnatz, Oliver Kornhoff, Maija Tanninen-Mattila, and Matthias Winzen.

Marlene Dumas: Selected Works. New York: Zwirner and Wirth, 2005. Text by Marlene van Niekerk.

Marlene Dumas: MAN KIND. Amsterdam: Galerie Paul Andriesse, 2006. Texts by Paul Andriesse and Dumas.

Marlene Dumas: Supercontemporanea. Milan, Italy: Mondadori Electa, 2006; and Paris: Hazan, 2007. Texts by Ilaria Bonacossa and Francesco Bonami.

Marlene Dumas: Broken White. Tokyo: Museum of Contemporary Art and Tankosha Publishing Co., Ltd., 2007. Texts by Dumas, Yuko Hasegawa, Yuka Uematsu, Jolie van Leeuwen, and Masami Yamamoto.

Marlene Dumas: Intimate Relations. Eds. Dumas and Emma Bedford. Johannesburg: Jacana Media; and Amsterdam: Roma Publications, 2007. Texts by Bedford, Dumas, Marilyn Martin, Achille Mbembe, Sarah Nuttall, and Marlene van Niekerk.

Other Books

Andriesse, Paul, and Gabriele Franziska Götz, eds. *Ipsamas: An Album of Photographs with Texts by John Hutchinson and Ulrich Loock, One-liners by Susan Tiger and Marlene Dumas.* Amsterdam: De Verbeelding Publishing, 2001.

Archer, Carol. "Frames, Flows, Feminist Aesthetics: Paintings by Judy Watson, Cai Jin and Marlene Dumas." Ph.D. dissertation, Hong Kong University, 2006.

Art & Project: Adam Colton, Marlene Dumas, Daniel Groen, Martin van Vreden. Amsterdam: Drukkerij M. Spruijt and Galerie Paul Andriesse, 1987.

Baere, Bart de. "Existential Articulations." In *The Archive of Development*, 62–63. Eds. Annette W. Balkema and Henk Slager. Amsterdam: Rodopi, 1998.

Ballé, Catherine, Elisabeth Caillet, Françoise Dubost, and Dominique Poulot. *L'Art contemporain et son exposition*. Paris: L'Harmattan, 2002.

Barnard, Marcel. "Waiting for Meaning—Psalms in Cult and Culture." In *Psalms and Liturgy*, 1–2, 14. Edinburgh: T&T Clark, 2004.

Bee, Andreas, ed. *Zehn Jahre Museum für Moderne Kunst Frankfurt am Main*. Cologne, Germany: Literatur und Kunst Verlag, 2003.

Bekkers, Ludo, and Elly Stegeman, eds. *Contemporary Painting of the Low Countries*. Rekkem, The Netherlands: Stichting Ons Erfdeel, 1995.

Bierens, Cornel. *Sex doet een weekje nex/Take 1, 2, 3 in 23 Shots*. Utrecht, The Netherlands: Centraal Museum, 1998.

Blomberg, Katja. *Wie Kunstwerte entstehen: Der neue Markt der Kunst*. Hamburg, Germany: Murmann, 2005.

Blotkamp, Carel. "Paul Andriesse fotografeert Marlene Dumas, 1993 en 1994." In *De onvoltooide van Cézanne: 40 korte beschouwingen over moderne kunst*, 75–77. Warnsveld, The Netherlands: Terra, 2004.

——, ed. *Works from Collezione Sandretto Re Rebaudengo*. Milan, Italy: Skira, 2005.

Boon, Sander. *Present: Art for Government Property*. Santa Monica, California: Ram Publications, 2007.

Brandstetter, Gabriele. "Fälschung wie sie ist, unverfälscht." In *Tanz, Bild, Medien*, 85–111. Ed. Gabriele Klein. Hamburg, Germany: Lit, 2000.

Cecco, Emanuela de, and Gianni Romano. *Contemporanee: Percorsi, lavori e poetiche delle artiste dagli anni ottanta a oggi*. Ancona-Milan, Italy: Costa & Nolan, 2000.

Coetzee, Mark. *Not Afraid: Rubell Family Collection*. London: Phaidon Press, 2004.

Cork, Richard. "Staying Power." In *Breaking Down the Barriers: Art in the 1990s*, 321–25. New Haven, Connecticut: Yale University Press, 2003.

Coutts Contemporary Art Awards 1998: Stan Douglas, Marlene Dumas, Edward Ruscha. Zürich, Switzerland: Coutts Contemporary Art Foundation, 1998.

Deepwell, Katy. "Women, Subjects and Objects and the End of History (Painting)." In *History Painting Reassessed: The Representation of History in Contemporary Art*, 131–48. Eds. David Green and Peter Seddon. Manchester, England: Manchester University Press, 2000.

Dewulf, Bernard. *Bijlichtingen: Kijken naar schilders*. Amsterdam: Uitgeverij Atlas, 2001.

Dorfles, Gillo. *Ultime tendenze nell'arte d'oggi*. 2nd ed. Milan, Italy: Feltrinelli Editore IT, 1996.

Dumas, Marlene. "Nightmares of Beauty." In *Erik Andriesse: Schilderijen 1982–1987*. Amsterdam: Galerie Paul Andriesse, 1987.

—— . "From One Dirty Place to Another." In *Innodiging voor Mooie Tentoonstellingen + Trio Eenzaamheid*. Amsterdam: Galerie Paul Andriesse, 1989.

—— . "The Body Guard, Dressed in Exposure." In *Kapriolen: René Daniëls, Fortuyn O'Brien, Rob Scholte, Lidwien van de Ven, Peer Veneman*, 57–59. Munich, Germany: Kulturferrat der Landeshauptstadt München, 1989.

—— . "The Blonde, the Brunette and the Black Woman." In *Der zerbrochene Spiegel: Positionen zur Malerei*, 154–55. Vienna: Kunsthalle Wien, 1993. English translation published in *Sweet Nothings* (1998).

—— . "From One Dirty Place to Another" and "The 7 Year Itch." In *Art Gallery Exhibiting: The Gallery as a Vehicle for Art*, 176–77. Ed. Mariska van den Berg and Minne Buwalda. Amsterdam: Galerie Paul Andriesse/Uitgeverij De Balie, 1996.

—— . "International Biennales." *Manifesta 1: Biennial Exhibition in Rotterdam, The Netherlands, 9 June–19 August 1996*, 7–11. Rotterdam, The Netherlands: Foundation European Art Manifestation, 1996.

—— . "Marijke van Warmerdam (1996)." In *Marijke van Warmerdam: Single, Double, Crosswise*, 52. Ed. Marente Bloemheuvel. Eindhoven, The Netherlands: Lecturis bv, 1997.

—— . "Do the Right Thing." In *Grey Areas: Representation, Identity, and Politics in Contemporary South African Art*, 129–31. Ed. Brenda Atkinson. Rivonia-Johannesburg, South Africa: Chalkham Hill Press, 1999.

—— . "The Tyranny of Reality—Future Perspective." In *Jan Andriesse*. Ed. Moniek Peters. Dordrecht, The Netherlands: Dordrechts Museum; and Nuth, The Netherlands: Rosbeek Books, 2000.

—— . "And God Said—I Told You So." In *Kitsch Unedited: Letters and Texts of Friends Compiled by Jan Andriesse*, 21–23. Tilburg, The Netherlands: De Pont Museum of Contemporary Art, 2006.

—— . "Melissa Gordon: Collateral Damage (or, Paintings of Pictures that Show a Painting Isn't a Picture)." In *Wild at Heart*, 39–45. Amsterdam: Stichting Ateliers '63, 2006.

—— . "Skull of a Mother." In *.ZA: Young Art from South Africa*. Milan, Italy: Silvana Editoriale, 2008.

Eccher, Danilo, ed. *L'Ombra della ragione: L'Idea del sacro nell'identità Europa nel XX secolo*. Milan, Italy: Charta, 2000.

Enwezor, Okuwi. "Collision of Worlds." In *The Archive of Development*, 70–76. Ed. Annette W. Balkema and Henk Slager. Amsterdam: Rodopi, 1998.

Flohic, Catherine, ed. *Ninety: Art des années 90 (Art in the 90s)*. Vol. 32. Charenton, France: Eighty Magazine, 1997.

Frijhoff, Willem, and Marijke Spies. *Dutch Culture in a European Perspective*. Basingstoke, England: Palgrave Macmillan, 2004.

Fuchs, Rudi, and Nelleke van Maaren. *Schilderen in Nederland: De geschiedenis van 1000 jaar kunst*. 3rd edition. Amsterdam: Bakker, 2004.

Grosenick, Uta, ed. *Women Artists in the 20th and 21st Century*. Cologne, Germany: Taschen, 2003.

——, and Burkhard Riemschneider, eds. *Art at the Turn of the Millennium*. Cologne, Germany: Taschen, 1999.

Hartlieb, Elisabeth, and Charlotte Methuen. *Sources and Resources of Feminist Theologies*, 185n6. Kampen, The Netherlands: Kok Pharos, 1997.

Hartog Jager, Hans den. *Verf: Hedendaagse Nederlandse Schilders Over Hun Werk*. Amsterdam: Athanaeum-Polak & Van Gennep, 2006.

Heil, Axel, and Wolfgang Schoppmann, eds. *Most Wanted: The Olbricht Collection*. Cologne, Germany: Verlag de Buchhandlung Walther König, 2006.

Hicks, Alistair. "1990s: Pidgin- and Ultra-Modernism." In *Art Works: British and German Contemporary Art 1960–2000*, 157, 164, 174. London: Merrell Publishers, 2001.

Higgie, Jennifer. *The Artist's Joke*. London: Whitechapel, 2007.

Hoet, Jan, and Bart de Baere. *Catalogus van de Collectie: In Extenso I 1989–1992*. Ghent, Belgium: Stedelijk Museum voor Actuele Kunst, 1992.

——, Ingrid Commandeur, Steven Jacobs, and Els Roelandt. "What's to Happen to Painting? The Eighties and Nineties." In *S.M.A.K.*, 166–67, 170. Ghent, Belgium: Ludion, 1999.

Hutchinson, John. *The Paradise [4]*. Dublin: Douglas Hyde Gallery, 2002.

"'Ik is een allochtoon': A Conversation with Marlene Dumas." In *Citizens and Subjects: The Netherlands, for Example*. Ed. Rosi Braidotti, Charles Esche, and Maria Hlavajova. Amsterdam: Mondriaan Stichting, 2007.

Imanse, Geurt, ed. *De Nederlandse identiteit in de kunst na 1945*. Amsterdam: Meulenhoff/Landshoff and Stedelijk Museum, 1984.

Jackson, Tessa, ed. *Artes Mundi: Wales International Visual Art Prize 2004*. Bridgend, Wales: Artes Mundi and Seren, 2004.

Jansen, Ena. "Spiegelschrift en Sneeuwwitje in Anti-Apartheid Nederland." In *Kunsten in Beweging*, 59–76. Ed. Maaike Meijer and Rosemarie Buikema. Amsterdam: SdU uitgevers, 2004.

Jantjes, Gavin. "Marlene Dumas." In *A Fruitful Incoherence: Dialogues with Artists on Internationalism*, 48–63. London: Institute of International Visual Arts, 1998.

—— . "Mapping Difference." In *Views of Difference: Different Views of Art*, 34. Ed. Catherine King. New Haven, Connecticut: Yale University Press in association with the Open University, 1999.

Kamstra, Sabrina, Simon Knepper, and Johan Kortenray, eds. *AMC Kunstboek*. Amsterdam: Amsterdam University Press, 2003.

Karabelnik, Marianne, ed. *Stripped Bare: The Body Revealed in Contemporary Art, Works from the Thomas Koerfer Collection*. London: Merrell Publishers, 2004.

Laermans, Rudi, and Bart Verschaffel. *Beeldende Kunst 1996/1997/1998 collectie Vlaamse Gemeenschap Aanwinsten*. Brussels: Collectie Vlaamse Gemeenschap Aanwinsten, 2001.

Lavigne, Julie. "L'art feministe et la traversée de la pornographie: Erotisme et intersubjectivité chez Carolee Schneemann, Pipilotti Rist, Annie Sprinkle, et Marlene Dumas." Ph.D. dissertation, McGill University, Montréal, Canada, 2004.

Lucie-Smith, Edward. *Art Tomorrow*. Paris: Editions Pierre Terrail, 2002.

McQueen, Steve, and Marlene Dumas. "The Finger and the Eyes: A Conversation Between Steve McQueen and Marlene Dumas." In *Steve McQueen—Caresses*. Marugame, Japan: MIMOCA, 2006.

Mennekes, Friedhelm. *Triptychon: Moderne Altarbilder in St. Peter Köln*. Frankfurt am Main, Germany: Insel Verlag, 1995.

Mey, Kerstin. *Art and Obscenity*. London: I. B. Tauris, 2007.

Morley, Simon. *Writing on the Wall: Word and Image in Modern Art*. Berkeley: University of California Press, 2003.

Mulder, Anne-Claire. "Divine Flesh Embodied Word." Ph.D. dissertation, Universiteit van Amsterdam, 2006.

Mullins, Charlotte. "The Figure Unraveled." In *Painting People: The State of Art*. New York: Distributed Art Publishers, 2006.

Nairne, Sandy, and Sarah Howgate. *The Portrait Now*. London: National Portrait Gallery, 2006.

Perryer, Sophie, ed. *10 Years 100 Artists: Art in a Democratic South Africa*. Cape Town: Bell-Roberts in association with Struik Publishers, 2004.

Piët, Susanne. *De Emotiemarkt: De Toekomst van de Beleveniseconomie*. Amsterdam: FT Prentice Hall Financial Times, 2003.

Pitrelli, Nico, and Giancarlo Sturloni, eds. *La stella nova: Atti del III Convegno Annuale sulla Comunicazione della Scienza*. Milan, Italy: Polimetrica, 2005.

Reilly, Maura, and Linda Nochlin, eds. *Global Feminisms: New Directions in Contemporary Art*. London: Merrell Publishers, 2007.

Robertson, Jean. "Artistic Behavior in the Human Female." In *Feminine Persuasion: Art and Essays on Sexuality*, 35. Ed. Betsy Stirratt and Catherine Johnson. Bloomington: Indiana University Press, 2003.

Romano, Gianni. *Europa: Differenti prospettive nella pittura*. Milan, Italy: G. Politi, 2000.

Rychlik, Otmar. *Kunsthaus Muerz: Jahresmuseum 1996*. Leobersdorf, Austria: Kunsthaus Mürzzuschlag, 1999.

Sammlung Garnatz: Städtische Galerie Karlsruhe. Karlsruhe, Germany: Städtische Galerie, 1996.

Schwabsky, Barry. "The Essential Character: Portrait of Madame Matisse." In *Matisse: Masterpieces at Statens Museum for Kunst*, 47–63. Ed. Dorthe Aagesen. Copenhagen: Statens Museum for Kunst, 2005.

Steiner, Wendy. *The Trouble with Beauty*. London: William Heinemann, 2001.

——. *Venus in Exile: The Rejection of Beauty in Twentieth-Century Art*. New York: Free Press, 2001.

Stich, Sidra. *Art-Sites Paris: Art, Architecture, Design*. San Francisco: Art-Sites, 2002.

Szenenwechsel XVIII. Frankfurt am Main, Germany: Museum für Moderne Kunst, 2000.

Tessore, Alberto. *Opera d'arte, sì o no?: Arte come modo di vivere*. Naples, Italy: Guida, 2005.

Trasforini, M. Antonietta. "Artiste nel contesto." In *Donne d'arte: Storie e generazioni*, 203–08, 218. Rome: Meltemi, 2006.

Turok, Karina, and Margie Orford. *Life and Soul: Portraits of Women Who Move South Africa*. Cape Town: Double Storey, 2006.

Van Alphen, Ernst. "The Portrait's Dispersal: Concepts of Representation and Subjectivity in Contemporary Portraiture." In *Portraiture: Facing the Subject*, 239–56. Ed. Joanna Woodall. Manchester, England: Manchester University Press, 1997.

——. *Art in Mind: How Contemporary Images Shape Thought*. Chicago: The University of Chicago Press, 2005.

Van den Boogerd, Dominic. *Early Works: De Ateliers 1998–2002*. Amsterdam: Stichting Ateliers '63, 2002.

——, and Elly Reurslag. *Blue Tuesday: De Ateliers 1963–2003*. Amsterdam: Stichting Ateliers '63, 2004.

Van der Heyden, J. C., Johan van der Keuken, Marlene Dumas, Anne-Mie van Kerckhoven, Geurt Imanse, and Ans Zondag. *De Uitputting van de Muze*. Amsterdam: W139, 1990.

Van Niekerk, Tinani. *Marlene Dumas: Analyse der Leitmotive und thematische Hauptthemen anhand ausgewählter Arbeiten*. Munich, Germany: GRIN Verlag, 2007.

Van Os, H. W. "Kunst die verdrongen ideeën en blinde vlekken blootlegt." In *Beeldenstorm/3/druk 1: Close-Ups van kunst uit nederlandse musea*, 66–70, 181. Amsterdam: Amsterdam University Press, 1997.

Visser, Ad de. *De tweede helft gedocumenteerd: 130 teksten en documenten aangaande de beeldende kunst na 1945*. Amsterdam: SUN, 2002.

Von Graevenitz, Antje, and Hans Brand. "2 Liefdesnotities, tijdloos, 3 katernnotities, Amsterdam, 2 taalnotities, Amsterdam, 1985." In *Ander werk: Teksten van kunstenaars in Nederland*. Arnhem, The Netherlands: Akademie voor Beeldende Kunsten, 1998.

Zhu, Qi. "The Third Shaghai Biennale: Nobody Wants [His/Her Works] Not to Be Considered Contemporary Art." In *Chinese Art at the Crossroads: Between Past and Future, Between East and West*, 269–74. Ed. Wu Hung. Hong Kong: New Art Media, 2001.

Articles

Adrichem, Jan van, Paul Groot, and Martijn van Nieuwenhuyzen. "As Far as Amsterdam Goes." *Flash Art*, no. 128 (May–June 1986): 68–70.

Alatalo, Kari. "Pitaa maalata niin etta kuulee sen aanen." *Taide*, no. 3 (2003): 38–41.

Alpers, Svetlana. "Wheel of Fortune." *Artforum* 44, no. 1 (September 2005): 103.

Amer, Ghada. "9 Painters: An On-the-Page Installation." *Modern Painters* 15, no. 2 (summer 2002): 70–79.

Andral, Jean-Louis. "Présumés innocents." *Connaissance des Arts*, no. 574 (July–August 2000): 12.

Anson, Libby. "Marlene Dumas: Tate Gallery." *Art Monthly*, no. 196 (May 1996): 38–39.

Araki, Nobuyoshi. "Marlene Dumas and Nobuyoshi Araki, in Talk Session." *Madame Figaro Japon* 342, 6/5 (2007): 150–53.

Archer, Michael. "'Art from Europe': Tate Gallery." *Artscribe*, no. 65 (September–October 1987): 69–70.

Arnaudet, Didier. "Présumés innocents." *Parachute*, no. 100 (October–December 2000): 3.

Baker, T. "Art from Europe and Art and Language." *The Face* (June 1987).

Barragan, Paco. "Fragmentos de cotidianeidad." *Lapiz* 18, no. 155 (July 1999): 18–31.

Baur, Simon. "Verschenkte Erinnerungen." *Werk, Bauen + Wohnen*, no. 10 (2005): 28–33.

Bayliss, Sarah. "Drawn to the Dark Side." *Artnews* 102, no. 7 (summer 2003): 126.

Beaumont, Mary Rose. "Art from Europe, Tate Gallery." *Arts Review*, 22 May 1987.

Beck, Ernest. "Marlene Dumas: Kunsthalle." *Artnews* 88, no. 10 (December 1989): 178.

Beer, Evelyn. "Retrospect: Marlene Dumas in the Museum Overholland, Amsterdam." *Kunst & Museumjournaal* 1, no. 6 (1990): 41–42.

Beeren, Wim. "Kunst en vuurwerk in Johannesburg." *Vrij Nederland* 18, no. 11 (March 1995): 60–63.

Bellini, Andrea. "Q&A: Emma Dexter." *Flash Art* 39, no. 246 (January–February 2006): 47.

Bergh, Jos van den. "Marlene Dumas: Zeno X Gallery." *Artforum* 32, no. 2 (October 1993): 110.

Bischoff, Ulrich. "Marlene Dumas: The Question of Human Pink." *Das Kunstwerk* 42 (December 1989): 62–63.

——. "Zur Ausstellung 4 x 1 im Albertinum." *Dresdener Kunstblaetter*, no. 1 (1995).

——. "Auf der Suche nach Schönheit." *Kritisches Lexikon der Gegenwartskunst* 33, no. 1 (1996): 12.

Bloemheuvel, Marente, and E. Huyberts. "Kunstenaars en kritiek: Een testcase Marlene Dumas en Rob Scholte in de Nederlandse kunstkritiek." *Kunstlicht* 10, no. 4 (1989): 9–15.

Bolten, Jetteke. "Marlene Dumas." *Dutch Art and Architecture Today* 15 (June 1984): 2–7.

Bosma, Marja. "Marlene Dumas." *Openbaar Kunstbezit/Kunstschrift*, no. 2 (March–April 1985): 68–73.

———. "Marlene Dumas, Talking to Strangers." *Dutch Heights*, no. 3 (September 1990): 13–16.

Bouruet-Aubertot, Véronique. "Le massacre des innocents." *Beaux Arts Magazine*, no. 195 (August 2000): 90–97.

———. "Le renouveau du dessin contemporain." *Connaissance des Arts*, no. 647 (March 2007): 114–17.

Bouwhuis, Jelle. "Interview Gijs van Tuyl: 'Bock mit inhalt.'" *Stedelijk Museum Bulletin* 3 (2005): 22–25, 49–50.

Bracke, Eric. "Het verband tussen kunst en (drie-letterwoord), Beeldende kunst: 'Strippinggirls' van Anton Corbijn en Marlene Dumas in het SMAK." *De Morgen*, 27 September 2000, 30.

Braet, Jan. "Atijd mis." *Knack* 1 (April 1992): 82–86.

Brandstetter, Gabriele. "Dem original Entsprungen über Models, Mimikry und Fake." *Die Neue Gesellschaft Frankfurter Hefte* (July 1996).

Braun, Adrienne. "Eine Enzyklopädie des Weiblichen." *ART: Das Kunstmagazin* 1 (January 2006): 87.

Briggs, Patricia. "Painting at the Edge of the World." *Artforum* 39, no. 10 (summer 2001): 187–88.

Broucke, Nica. "Marlene Dumas over de kunst van het sterven." *De Morgen*, 5 February 2003, 23.

Brügman, Margret. "Madonna or the Janus Head of Femininity." *Ruimte*, no. 4 (1992).

———. "Elke wond is roze, melancholie in het werk van Marlene Dumas." *De schone Waarheid en de steen der dwazen* (1996): 215–25.

Brummer, Willemien. "Ek is nie net close up nie...." *Bylae by Die Burger*, 1 December 2007, 8–10.

Buck, Louisa. "Painting Is Dead, Long Live Painting." *Art Quarterly* (summer 2005): 48–53.

Burmann, Pauline. "The Thread of the Story: Two South African Women Artists Talk About Their Work." *Research in African Literatures* 31, no. 4 (winter 2000): 155–65.

Byrt, Anthony. "Beautiful Game." *Art New Zealand*, no. 116 (spring 2005): 56–59.

Cameron, Dan. "Marlene Dumas: Jack Tilton Gallery, New York." *Frieze*, no. 19 (November–December 1994): 55–56.

Campanini, Cristiana. "Museion ricorda Siena: Con Boccioni, Afro e Flavin." *Arte*, no. 376 (December 2004): 85–86.

Cembalest, Robin. "Fast Forward: Nineteen Artists Whose Works Are Gaining Recognition." *Artnews* 92, no. 9 (November 1993): 122–23.

Chernysheva, Olga. "Moi opyt obucheniya na zapade." *Moscow Art Magazine*, no. 50 (2003): 22.

"Ciudad del Cabo reúne el arte contemporáneo africano." *Lapiz* 26, no. 233 (May 2007): 23.

Conner, Jill. "Marlene Dumas' Name No Names." *NY Arts*, no. 4 (April 2002): 18–19.

Cooke, Lynne. "Review: Rites of Passage, London, Tate Gallery." *The Burlington Magazine* 137, no. 1,110 (September 1995): 634–35.

Cooper, Dennis. "Report from Amsterdam: Art on the Amstel." *Art in America* 75, no. 10 (October 1987): 32–39.

"Corbijn: Peep-Show in Monocromia." *Arte*, no. 337 (September 2001): 193.

Cork, Richard. "Carelines and Growing Pains." *The Times*, 27 August 1993.

Corrigall, Mary. "Nudes Meant to Attract the Viewer, Not to Shock." *Sunday Independent*, 4 November 2007.

———. "Dumas Makes the Voyeur in Us Squirm." *Sunday Independent*, 10 February 2008.

Cotter, Holland. "Ideas from the Air, Wrapped in Paper." *The New York Times*, 19 December 1997.

Couturier, Elisabeth. "Biennale: Les jeus sont faits [*Beaux Arts* chooses eleven artists from the international pavilion of the Venice Biennale]." *Beaux Arts Magazine*, no. 135 (June 1995): 68–73.

Crüwell, Konstanze. "Von der biblischen Magdalena zum Supermodel." *Frankfurter Allgemeine Zeitung*, 11 December 1995.

Czöppan, Gabi. "Kunst-Prospect 1995: Künstler des Jahres." *Focus*, no. 43 (1995): 146–51.

Dagen, Philippe. "Apotheose, mort et resurrection du nu." *Connaissance des Arts*, no. 574 (July–August 2000): 86–93.

Dannatt, Adrian. "Anal Masochism." *Flash Art* (October 1992): 130–31.

Darwent, Charles. "Marlene Dumas." *Modern Painters* 13, no. 1 (spring 2000): 131.

———. "The Beauteous Bandwagon." *Modern Painters* 13, no. 3 (autumn 2000): 90–91.

Davey, Maggie. "Labour of a Dirty Woman." *Mail & Guardian*, 26 November 1999, 8.

Davila, Thierry. "Des flamands sur la lagune." *Beaux Arts Magazine*, no. 156 (May 1997): 70–77.

Davis, Nicole. "Sight, Sin and Redemption." *Artnet*, 18 June 2004, accessed from http://www.artnet.com/magazine/reviews/davis/davis6-18-04.asp.

Defesche, Pieter. "Marlene Dumas: Nachtmerries en onvervuld verlangen." *Limburgs Dagblad*, 19 March 1988.

Denk, Andreas. "Marlene Dumas: Bonner Kunstverein." *Kunstforum International*, no. 123 (1993).

Depondt, Paul. "Marlene Dumas." *De Volkskrant*, 5 November 1988.

———. "Gehalveerde gesprekken, Marlene Dumas en de medeplichtigheid van de toeschouwer." *De Volkskrant*, 20 March 1992.

———. "Verwantschap in een Turyns knekelhuis." *De Volkskrant*, 23 June 1995.

Dewulf, Bernard. "Schilder, schilder 'Trouble Spot Painting': Een tentoonstelling over actuele schilderkunst." *De Morgen*, 21 May 1999, 57–58.

Dexter, Emma. "Painting Fear." *Modern Painters* 16, no. 3 (autumn 2003): 90–91.

Diez, Renato. "Re di denari." *Arte*, no. 380 (April 2005): 106–13.

Downey, Anthony. "Dublin." *Contemporary*, no. 55 (2003): 38–39.

Dröes, Freda. "Art on the Edge: The Painter Marlene Dumas." *Feminist Theology* 14, no. 3 (May 2006): 389–97.

Dumas, Marlene. "Statements." *Dutch Art and Architecture Today* 12 (December 1982): 14–19.

———. "Blinde Vlekken." *De Rijksakademie* 1, no. 3 (November 1987): 13. English translation published in *Sweet Nothings* (1998).

———. "De aarde is plat/The World Is Flat." *De Rijksakademie*, no. 11 (1990): 12–13. English translation published in *Sweet Nothings* (1998).

———. "Tussen God, Kunst en Waanzin. Renaissance. Een bespreking door Marlene Dumas." *Ruimte*, no. 3 (1990): 31–32.

———. "It Is Not 'The Imaginary' We Need Neither Is It 'The Museum' We Desire." *Metropolis M*, no. 3 (January 1990): 16–17.

———. "Grensverleggend" and "Arbeidsongeschikt." *Tirade* 34 (October–November 1990).

———. "The Body Guard: Dressed in Exposure." *Kunst & Museumjournaal* 2, no. 4 (1991): 14–17.

———. "Give the People What They Want." *De Witte Raaf* (March 1993): 10. English translation published in *Sweet Nothings* (1998).

———. "Die Künstlerin: Eine Brille für die Kunst." *Berner Kunstmitteilungen*, no. 289 (March–April 1993): 9.

———. "Not from Here." *Guia Mensual de las Artes*, no. 13 (1994): 1–2. English translation published in *Sweet Nothings* (1998).

———. "Meesterwerken en Miss Wereld." *Openbaar Kunstbezit/Kunstschrift*, no. 6 (November–December 1996). English translation published in *Sweet Nothings* (1998).

———. Artist's project. *Vogue Italia*, no. 570 (February 1998): 330–31.

———. "Marlene Dumas." *Gagarin* 1 (2000): 38–41.

———. "The Right to Be Silent (A Conversation on Elitism and Accessibility)." *Frieze*, no. 80 (January–February 2004): 84–89.

———. "Behold a Muslim at Christmas." *The Guardian*, 21 December 2004.

———. "Waarom Beckmann nu in Nederland," *Bulletin van de vereniging Rembrandt* 18, no. 1 (spring 2008).

Durmusoglu, Ovul. "Marlene Dumas' Private Views." *N.Paradoxa* 19 (2007): 31–37.

Emmerik, Pam. "Broekie uit!" *De Groene Amsterdam*, 16 August 1995.

Enright, Robert. "The Fearless Body: An Interview with Marlene Dumas." *Border Crossings* 23, no. 3 (August 2004): 22–34.

Erdman, Matthijs. "Handel in Nederlandse waar: Dumas, Haagse en Amsterdamse School." *Jong Holland* 21, no. 3 (2005): 30–33.

Falconer, Morgan. "Apparition: The Action of Appearing." *Modern Painters* 16, no. 1 (spring 2003): 116–17.

———. "Africa Remix." *The Burlington Magazine* 147, no. 1,227 (June 2005): 422–25.

Farine, Manou. "Marlene Dumas: Le regard du desir." *L'Oeil*, no. 531 (November 2001): 22–27.

———. "Expressionismes: La grande famille." *L'Oeil*, no. 546 (April 2003): 111.

Feaver, William. "Art for Wets." *The Observer*, 26 April 1987.

Fechter, Isabel. "Ganz Venedig ist Biennale." *Weltkunst* 75, no. 10 (15 September 2005): 88–89.

Feenstra, Karin. "Vrouwelijke erotiek van Marlene Dumas." *Ad Valvas-Cultuur*, 11 November 1988.

Fens, Kees, et al. "Wat is kunst?" *Openbaar Kunstbezit/Kunstschrift* 40, no. 6 (November–December 1996): 6–16, 22–32, 38–54, 60–68.

Fleck, Robert. "Der zerbrochene Spiegel (Broken Mirror): Positionen zur Malerei." *Forum International 4, no. 19* (October–November 1993): 157.

Fliers, Els. "Maria Magdalena." *Knack*, 1 Jan 2003, 84.

"Focus on Art: Looking at Post-Apartheid Issues." *Cape Times*, 28 December 1995, 11.

Fronz, Hans-Dieter. "Marlene Dumas—Female: Kunsthalle Baden-Baden." *Kunstforum International*, no. 179 (February–April 2006): 325–27.

——— . "Eros in der Kunst der Moderne." *Kunstforum International*, no. 183 (December 2006): 380–82.

"Galleries, Downtown: Marlene Dumas." *The New Yorker* (9 July 2001).

Gassert, Siegmar. "Die Bedeutung der Bedeutungen." *Basler Zeitung, no. 162* (14 July 1989).

Geerling, Lee, Hennëtte Heezen, Christiane Schneider, Rob Smolders, Bert Steevensz, and Dominic van den Boogerd. "Documenta IX (review)." *Metropolis M* (August 1992): 29–35.

Geoff, Andrew. "Dutch Courage." *The Guardian*, 20 April 1996.

Gibbs, Micheal. "Para-sites: A Long Walk around Amsterdam." *Art Monthly*, no. 110 (October 1987): 8–9.

Gilli, Jaime. "La doble jaula." *Lapiz* 22, no. 195 (July 2003): 46–55.

Gioni, Massimiliano. "Painting at the Edge of the World." *Flash Art* 34, no. 218 (May–June 2001): 147.

——— . "New York Cut Up: Fragments from the Big Apple." *Flash Art International* 34, no. 219 (July–September 2001): 71–73.

——— . "Marlene Dumas: Ton visage demain." Interview with Dumas. *Art Press*, no. 317 (November 2005): 32–38.

Girling, Oliver. "The South African Age of Enlightenment." *Eye Weekly* (April 21 1994): 41.

Glover, Michael. "The Galleries Show." *Artnews* 101, no. 11 (December 2002): 125.

Glueck, Grace. "Capturing Humanity, Rough and Unrefined." *The New York Times*, 29 March 2002, E38.

Godfrey, Tony. "The Re-Opened Moderna Museet and 'Arkipelag' Stockholm." *The Burlington Magazine* 140, no. 1,142 (May 1998): 352–54.

Goldblatt, David. "To the Art World and Back Again." *Mail & Guardian*, 16 November 2007, 2.

Goto, Shigeo. "Shigeo Goto Meets…Marlene Dumas." *High Fashion* (August 2007): 196.

Gravano, Viviana. "Gli olandesi a Roma." *Next* 10, nos. 32–33 (autumn 1994–winter 1995): 55.

Groot, Paul. "Dumas/Oudshoorn laten zich inspireren door vreemde dieren." *NRC Handelsblad*, 24 September 1981, 6.

——— . "Marlene Dumas: Galerie Paul Andriesse." *Artforum* 27, no. 7 (March 1989): 149–50.

Haak, Bregtje van der. "Marlene Dumas: Interview." *ELLE* (Amsterdam) (December 1997): 22–26.

Haase, Amine. "Berliner Verlobung." *Kunstforum International*, no. 173 (November–December 2004): 292–94.

Haehnel, Birgit. "Skin/Deep: Unterschiedliche Perspektiven in der Repräsentation schwarzer und weisser Frauenbilder in der zeitgenössischen Kunst." *Kritische Berichte* 27, no. 4 (1999): 64–82.

Hafner, Hans-Jurgen. "unHEIMlich." *Kunstforum International*, no. 168 (January–February 2004): 305–06.

"Half a Life in Art." *The Art Bulletin*, no. 47 (December 2006): 30.

Hall, Charles. "Best of the Bad Girls." *Art Review* 45 (December 1993–January 1994): 54–55.

Hartog Jager, Hans den. "Bekende Koppen met onvermoede lagen (Dumas hekelt gemakzuchtig Kijken)." *NRC*, 26 October 2006.

Haw, Penny. "An Artist's Life: It's Okay to Be the Second Sex, It's Okay to Be Second Best." *Business Day Art* (September 2004): 16.

Heckland, S. J. "Short Tour of Europe." *Daily News*, 28 April 1987.

Heerma van Voss, Sandra. "Artistieke ode aan Hofvijver in Den Haag." *De Standaard*, 5 April 2002, 10.

Hendrikse, Mary-Rose. "Beyond Possession: Marlene Dumas and the Mobilisation of Subject, Paint and Meaning." *De Arte*, no. 62 (September 2000): 3–19.

Henle, Susanne. "Der zweite Blick, Gemälde von Marlene Dumas in Köln." *Frankfurter Allgemeine Zeitung*, 12 January 1992.

Herbert, Martin. "No Sex Please." *Contemporary*, no. 59 (2004): 34–37.

——— . "Special Focus: Painting—Spot the Difference." *Art Review*, no. 6 (December 2006): 59–67.

Heuer, Megan. "Marlene Dumas: Name No Names." *The Brooklyn Rail* (early summer 2002).

Hill, Shawn. "Institute of Contemporary Art, Boston—Marlene Dumas: One Hundred Models and Endless Rejects; Rineke Dijkstra: Portraits; and Laylah Ali: 2001 ICA Artist Prize." *Art New England* 22, no. 5 (August–September 2001): 36.

Hixson, Kathryn. "Marlene Dumas [The Art Club of Chicago; exhibit]." *New Art Examiner* 21 (May 1994): 41.

Hodge, Nicky. "Direct Stares: Nicky Hodge on Marlene Dumas." *Women's Art Magazine*, no. 70 (June–July 1996): 29.

Hoek, Els. "Dumas daagt kijker uit." *De Volkskrant*, 15 June 1987.

——— . "Dumas wil naakt nieuw leven inblazen." *De Volkskrant*, 16 April 1993, 10.

Hoffman, Justin. "Marlene Dumas: Staatsgalerie Moderner Kunst." *Artscribe*, no. 81 (May 1990): 87–88.

Hofleitner, Johanna. "Marlene Dumas: Raum aktueller Kunst." *Flash Art*, no. 185 (November–December 1995): 135.

Holmes, Pernilla. "Blast from the Past." *Artnews* 107, no. 1 (January 2008): 96–101.

Hubl, Michael. "(In Search of) the Perfect Lover." *Kunstforum International*, no. 165 (June–July 2003): 329–31.

Ilegems, Danny. "Nederland-België: De Kunst, Interview with Dumas and Luc Tuymans." *DIF 2* (2004): 90–93.

Illes, V. "'De durf om persoonlijk te zijn'—Exposities van Ansuya Blom en Marlene Dumas in Amsterdam." *Elseviers Magazine*, 3 March 1990, 78–83.

Jansen, Bert. "Hollands Landschap in eigentijdse tekenkunst." *Het Financieele Dagblad*, 13 June 1987.

——— . "De getuige als regisseur." *Het Financieele Dagblad*, 17 and 19 March 1990, 15.

——— . "Marlene Dumas." *Jong Holland* 22, no. 1 (2006): 19–21, 60.

——— . "Jongemannen met baarden." *Het Financieel Dagblad*, 21 October 2006.

Jansen, Ena. "Op soek na die ontwijkende werklikheid." *De Kat Johannesburg* (June 1994): 84–89.

Januszcak, Waldemar. "Guerilla Battlefield." *The Guardian*, 27 May 1987.

Jetteke, Bolten. "Marlene Dumas." *Dutch Art and Architecture Today*, no. 15 (June 1984): 2–7.

Jonge, Piet de. "The Subjective as Object." *Dutch Art and Architecture Today*, no. 21 (June 1987): 9–14.

Jourdan, Annie. "Situation néerlandaise: Exubérances calvinistes." *Art Press*, no. 189 (March 1994): 57–66.

"Just People: Marlene Dumas at the New Museum." *Art on Paper* 6, no. 4 (March–April 2002): 36.

Kelly, Niamh Ann. "Marlene Dumas: Douglas Hyde Gallery." *Art Monthly*, no. 253 (February 2002): 43–45.

Kelly, Ruby. "The Ruby Kelly Column." *Art Review* 47 (July–August 1995): 41–42.

Kent, Sarah. "Art from Europe (Tate)." *Time Out London* (16–23 May 1987): 6–13.

Keyser, Gawie. "Betekenis Dumas se Doel én haar Geheim." *Die Burger*, 18 July 1998, 4.

Kilp, Birgit. "Die Gunst der Wochenenden." *Weltkunst* 66, no. 11 (1 June 1996): 9–10.

Kimmelman, Michael. "Death in Venice (at the Biennale)." *The New York Times*, 27 June 1993.

——— . "Venice Biennale: Startling Songs of the Body…" *The New York Times*, 9 July 1995, H30.

——— . "London Embraces Art, Just for the Fun of It." *The New York Times*, 3 May 2001.

——— . "A Global Village Whose Bricks Are Art." *The New York Times*, 16 June 2005.

Kindermann, Angelika. "Der entblosste Mensch." *ART: Das Kunstmagazin*, no. 11 (November 2002): 100–01.

Kino, Carol. "And Then Her Number Came Up." *The New York Times*, 27 March 2005.

Kirshner, Judith Russi. "Marlene Dumas: Art Institute of Chicago." *Frieze*, no. 76 (summer 2003): 110–11.

Klaster, Jan Bart. "Den Haag haalt in, maar Amsterdam ligt te ver voor." *Het Parool*, 4 August 1988, 11.

——— . "Droomprinses met een gebroken arm." *Het Parool*, 28 March 1992.

Koether, Jutta. "Marlene Dumas: Isabella Kacprzak." *Artforum* 30, no. 8 (April 1992): 110–11.

——— . "John Lydon beim Bilder streit." *Spex: Musik zur Zeit* (June 1989): 34.

Kokke, Paul. "De dubbele waarheid van Marlene Dumas." *Eindhovens Dagblad*, 28 March 1992.

Koplos, Janet. "Report from the Netherlands: Lowland Highlights." *Art in America* (December 1994): 40–47.

Kotlomanov, Alexandr. "Marlene Dumas: Akvarel' I devochki-zveri." *Novyi Mir Iskusstva* 1, no. 48 (2006): 59–60.

Kreutzer, Maria. "Positionen der Malerei." *Kunstforum International*, no. 119 (1992): 196–200.

Kruijning, A. "Het pessimisme van Marlene Dumas." *De Telegraaf*, 2 March 1990, 17.

Kruse, Maren. "Eine Frau erzählt Märchen über sich—Marlene Dumas in der Kieler Kunsthalle." *Kieler Nachtrichen*, 12 August 1988.

Kuijken, Ilse. "Documenta IX." *Kunst & Museumjournaal* 3, no. 6 (1992): 1–11.

Kuspit, Donald. "Neo-News Is No News: The Broken Mirror." *Artforum* (November 1993): 87–88, 131.

Laing, Carol. "Marlene Dumas: Art Gallery of York University, North York." *Parachute*, no. 76 (October–December 1994): 61–62.

Lambrecht, Luk. "Ze krijgen wat ze willen." *De Morgen*, 3 April 1993.

——— . "Wrange Marlene Dumas in Zeno X." *De Morgen*, 27 September 2002, 28.

——— . "Power 2005: The Dance, Marlene Dumas." *Art & Auction* 29, no. 4 (December 2005): 105.

Lamoree, Jhim. "Is de promotie van Nederlandse kunst in het buitenland slecht." *Haagse Post*, 25 April 1987.

——— . "Geboren worden, dood gaan en…Marlene Dumas, beeldend kunstenaar. Kunst is, gelijk sex, een ritueel om de dood te ontzenuwen." *Haagse Post*, 19 December 1987, 126–27.

——— . "Die meisie met die spraakgebrek." *Haagse Post*, 24 February 1990, 69.

——— . "Herkent u de buurman." *Het Parool*, 17 October 2006.

Langerwerf, Etienne. "Vrouw in de tijd." *Trends*, 12 December 2002, 28–29.

Laureyns, Jeroen. "Strippende meiden zonder veel body." *De Standaard*, 13 September 2000, 12.

——— . "Kunst te gast in psychiatrisch centrum." *De Standaard*, 10 December 2001, 13.

Lemmens, Christel. "Amerikaanse cultfotografe verrast Parijse kunsttempel: Centre Pompidou toont (recent) werk van Nan Goldin en Marlene Dumas." *De Morgen*, 4 October 2001, 21.

Lentz, H. "Bild der Frau." *Tip-Berlin Magazine*, no. 2 (21 March–3 April 1996).

Leuvennink, Johannes. "Marlene Dumas, Plaaskind op die Prinsengracht." *Sarie*, no. 20 (November 1997).

Levdier, Richard. "51 biennale d'art contemporain: Arsenal, pavillon italien et lieux." *Art Press*, no. 315 (September 2005): 73–76.

Levin, Kim. "Galleries, Downtown: Marlene Dumas." *The Village Voice*, 3 July 2001.

——— . "Marlene Dumas." *The Village Voice*, 7 May 2002.

Lindeheim, P. "Kollision startar dialog." *Skanska Dagbladet*, 17 March 1995, 1, 8.

Llorca, Pablo. "Historia reciente del dibujo." *Lapiz* 23, no. 205 (July 2004): 36–51.

Loock, Ulrich. "Pictures Incomprehensible but Illuminating." *Parkett*, no. 38 (winter 1993): 116–19.

Loyaute, Benjamin. "Que collectionnent-ils?" *Connaissance des Arts*, no. 594 (May 2002): 29.

Lucius, Robert von. "Lieber Sport, Strand und Freizeit." *Frankfurter Allgemeine Zeitung*, 5 January 2007.

Luz, Kathrin. "Malerei ist ein Akt gegen den Tod." *Noëma*, no. 46 (January–February 1998): 40–45.

MacAdam, Alfred. "Drawings 2000." *Artnews* 99, no. 9 (October 2000): 177.

MacKenny, Virginia. "Marlene Dumas at Iziko South African National Gallery." *Artthrob* (7 December 2007), accessed at http://www.artthrob.co.za/07dec/reviews/sang.html.

——— . "Anxious Surfaces." *Art South Africa* 6, no. 3 (autumn 2008): 48–52.

MacRitchie, Lynn. "Second-Hand Images of the Human Body." *The Financial Times*, 6 August 1993.

"Malerei II: Frauenbilder von Marlene Dumas, zu sehen in Baden-Baden." *ART: Das Kunstmagazin*, no. 1 (2006): 87.

"Malerei ist Reflexion: Ein gespräch mit Marlene Dumas." *Artis Zeitschrift für bildende Kunst* 48, no. 6 (1996): 59.

"Marie-Jo Lafontaine, Marlene Dumas en Alison Wilding." *De Limburger*, 26 February 1988.

"Marlene Dumas." *Plug* (December 1986).

"Marlene Dumas: At Helsinki Festival." *Indepth Arts News* (22 August 2005), accessed at http://www.absolutearts.com/artsnews/2005/08/22/33247.html.

"Marlene Dumas: De mens als aangeschoten wild." *Collect-Kunst & Antiek Journaal*, no. 1 (March 2006): 34.

"Marlene Dumas, Mike Nelson, Pamela Golden, Mark Fairrington." Produced by William Furlong. *Audio Arts Magazine* 20, no. 3 (2002).

"Marlene Dumas: There Are Many More Than One Way to Read the Paintings…" *Tableau* 28, no. 1 (2006): 50–57.

Mateer, John. "Intersections: South African Art from the BHP Billiton Collection." *Art Monthly Australia*, no. 160 (June 2003): 3–5.

McCarthy, Cathleen. "About Face." *Art and Antiques* 20, no. 7 (summer 1997): 56–63.

Meiring, Jean. "Dumas Stal in London uit." *Die Burger*, 25 October 2004, 10.

Meister, Helga. "Künstlerin Marlene Dumas: Grosse Menschenbildnerin." *Westdeutsche Zeitung*, 20 December 2007.

Merten, Ulrike. "Nicht nur weiss, nicht nur schwarz (Kunstpreis: Warum Marlene Dumas die 55.000 Euro Max Beckmann widmet, und warum sie Beuys nie getroffen hat)." *Kultur in Düsseldorf*, 20 December 2007.

Meÿer, Fré. "Marlene Dumas: Defining in the Negative." *Ruimte* 6, no. 2 (1989): 12–17.

Minaar, Melvyn. "Skilder Dumas vereer deur internasionale kunsuitgewer." *Die Burger*, 11 June 1999, 4.

——— . "Africa Provides Refreshing Alternative to Europe's Art." *Cape Times*, 5 October 2004.

——— . "Painting Her Way from Farm to Fame." *Cape Times Review*, 23 August 2005, 6.

——— . "Dumas's Emotive Homecoming." *Cape Times*, 20 November 2007, 13.

Morrissey, Simon. "Apparition: The Action of Appearing." *Art Monthly*, no. 263 (February 2003): 25–27.

Müller-Mehlis, Reinhard. "Malerin aus Kapstadt: Ich habe mehrere Gesichter im Leben." *Münchener Merkur*, 17–18 February 1990.

Murken-Altrogge, Christine. "Die Freiheit, sich malend sichtbar zu machen, Das weibliche Aktselbstbildnis des 20. Jahrhunderts." *Kunst und Antiquitäten*, no. 11 (November 1991): 48–55.

Myburg, Johan. "Die doel is ons wys to word." *Beeld-Plus*, 13 February 2008.

Nemeczek, Alfred. "Reisen mit Floh im Ohr." *ART: Das Kunstmagazin*, no. 12 (December 1998): 45.

Nicolaus, Frank. "Im Museum bekam ihre Sammlung ein Gesicht." *ART: Das Kunstmagazin*, no. 8 (August 1998): 52–57.

Nochlin, Linda. "What Befits a Woman." *Art in America* 8 (September 2005): 120–25.

Nolte, M. A. "Voorste Kunstenaar Besoek Karoofees." *Die Burger*, 13 February 1997, 4.

——— . "Uitgelese 'Gaste' in Kassel se Kollig." *Die Burger*, 12 May 1997, 4.

Nordgren, Sune. "Marlene Dumas & Francis Bacon." *Magazin for Malmö Konsthalls Vanner* (1995): 2–7.

Nungesser, Michael. "Misses im Museum: 90 60 90, Museo Jacobo Borges, Caracas." *Kunstforum International*, no. 152 (October–December 2000): 418–20.

Oele, Anneke. "De waarheid van Marlene Dumas." *Ons erfdeel,* no. 4 (September–October 1986): 67–69.

O'Toole, Sean. "Current Shows: Marlene Dumas, South African National Gallery." *Frieze* (November–December 2007).

Ottevanger, Alied. "Marlene Dumas." *Metropolis M* 2, no. 5 (July 1981): 39–50.

——— . "Unsatisfied Desire." *Metropolis M*, no. 1 (March 1984): 54.

——— . "Two Artists with a Way with Paper." *The Financial Times*, 9 April 1996.

Parker, E. "Marlene Dumas langs Van Gogh." *Sarie*, no. 11 (November 2003).

Paroissien, Leon. "Biennale of Sydney 2000: Summarising Art's Diversity After a Century of Modernism." *Art and Australia* 38, no. 2 (2000): 219–22.

Pendock, Neil. "Family Business." *The Sunday Times*, 18 June 2006.

Perrée, Rob. "De passie en haar slachtoffers." *Kunstbeeld* 8, no. 8 (1984): 62–64.

Perry, Grayson. "Grayson does Venice." *Art Review* 54 (September 2003): 126.

Peters, Mark. "Dumas is geloofwaardiger dan ooit." *NRC Handelsblad*, 22 January 1998.

Peters, Philip. "Marlene Dumas: Lof der onzuiverheid." *HCAK-Bulletin* 14, no. 2 (1988).

——. "Writing about Art: The State of the Art." *Kunst & Museumjournaal* 3, no. 4 (1992): 1–3.

Pieters, Rudy. "Een meisje zonder broekie: Overzichtsexpositie Marlene Dumas in het MuHKA." *De Morgen*, 24 September 1999, 21.

——. "Het voordeel van de melancholie." *De Morgen*, 28 Deember 2000, 18.

Pietsch, Hans. "Spielplatz der starken Mädchen." *ART: Das Kunstmagazin*, no. 4 (April 2003): 38–42.

——. "Das wichtigste und vitalste Medium." *ART: Das Kunstmagazin* 2 (February 2005): 78–80.

——. "Fahnenträger in einer engen Nische." *ART: Das Kunstmagazin* 3 (March 2005): 88.

Pohlen, Annelie. "René Daniëls, Marlene Dumas, Henk Visch." *Kunstforum* 83 (April–May 1986): 264–65.

Pollock, Lindsay. "Don't Look Now." *Art Review* 56 (July 2005): 35–36.

Pontzen, Rutger. "Maria, Marlene en Marijke: Nederland in Venetie." *Vrij Nederland* (8 April 1995): 46–49.

——. "Marlene Dumas: Sweet Nothings." *Metropolis M* 19, no. 3 (June–July 1998): 63.

Pople, Laetitia. "Hawelose Dumas nie Skaam oor Taal." *Die Burger*, 4 April 1997, 3.

Powell, Ivor. "$3.34 Million Later: Money and Meaning in Marlene Dumas." *Art South Africa* 4, no. 2 (summer 2005): 24–26.

Prevost, Jean-Marc. "La pintura en un campo abierto." *Zehar*, no. 37 (summer 1998): 22–31.

Quinn, Jim. "Miss Takes on Art and Politics: Marlene Dumas Disturbs Most People. She Ought to Make You Laugh." *Seven Arts: The Philadelphia Cultural Review* (December 1993): 30–33, 51–55.

Ramade, Benedicte, and Philppe Piquet. "Rendez-vous manqué: Venise, le scandale de la peinture." *L'Oeil*, no. 550 (September 2003): 14.

Reitsma, Ella. "Marlene Dumas." *Vrij Nederland* (11 August 1984): 10.

——. "Beel en betekenis in de kunst van Marlene Dumas." *Vrij Nederland* (24 February 1990): 18–22.

Reust, Hans Rudolf. "Der Grund, eine Galerie zu eröffnen." *Kunstforum International*, no. 133 (February–April 1996): 416–18.

——. "Orte der Ortlosigkeit [interview with Ulrich Loock]." *Kunstforum International*, no. 140 (April–June 1998): 449–54.

Reynders, T. "Ophelia maak het water niet vies! Marlene Dumas tussen het persoonlijke en het algemene." *De Groene Amsterdammer*, 21 November 1984, 17.

Riding, Alan. "Past Upstages Present at Venice Biennale." *The New York Times*, 10 June 1995.

Roggeman, Anouchka. "Marlene Dumas: Le nom dit." *Connaissance des Arts*, no. 589 (December 2001): 35.

——. "Boston, prend le chemin de l'art contemporain." *L'Oeil*, no. 584 (October 2006): 88–93.

Roodwijn, Tom. "Ik Schilder het kwaad." *HP/ De Tijd*, 12 January 2007, 45–51.

Roos, Robert. "Marlene Dumas: Museum Overholland, Amsterdam." *NIKE* 8, no. 33 (May–June 1990): 50–51.

——. "Balanceren tussen naakt en lust." *Kunstbeeld* 11 (2007).

Röpke, Gesa. "Tote Frauen mit ein wenig Hoffnung." *Kieler Express*, 17 August 1988.

Roskam, Mathilde. "Betrapt door het penseel." *Het Parool Uit & Thuis,* 27 March 1985, 4.

——. "Marlene Dumas Museum Overholland." *Flash Art*, no. 152 (May–June 1990): 166.

Rubin, B. "Francis skulle inte ha gillat det." *DN Kulture & Nojen*, 18 March 1995, 1.

Ruyters, Marc. "Opzet of Toeval." *Knack*, 6 November 1991, 130.

——, and Bert Popelier. "Een vrouw met lange haren: Expositie 'Maria Magdalena.'" *De Financieel-Economische Tijd*, 11 December 2002, 3.

Sachs, B. "Neundundneuzing Frauer Sabt Schlang." *Frankfurter Allgemeine Zeitung*, 27 December 1995.

Saltz, Jerry. "Bad Biennale: Dictators, Curators and the Problem with the Avant-Garde." *Modern Painters* (September 2005): 32–33.

——. "Seeing Dollar Signs: Is the Art Market Making Us Stupid? Or Are We Making It Stupid?" *The Village Voice*, 18 January 2007.

Samaras, Angelisa. "The Image of Europe." *Zoom*, no. 13 (March–April 1996): 60–67.

San Martin, Francisco Javier. "La sombra de la razon." *Lapiz* 19, no. 165 (summer 2000): 20–23.

Sandgvist, Gertrud. "Venetianska katalogarior." *Paletten*, no. 2 (1995): 56–59.

Satterthwaite, Julian. "Marlene Dumas: 'Broken White'?" *The Daily Yomiuri*, 12 May 2007, 15.

Schaffner, Ingrid. "Snow White in the Wrong Story: Paintings and Drawings by Marlene Dumas." *Arts Magazine* 65, no. 7 (March 1991): 59–63.

——. "Erotic Displays of Mental Confusions: Marlene Dumas at the Van Abbemuseum." *Kunst & Museum Journaal* 3, no. 6 (1992): 26–35.

——. "Dial 970-MUSE: Marlene Dumas's Pornographic Mirror." *Parkett*, no. 38 (winter 1993): 100–05.

——. "Marlene Dumas: Questioning the Limits of Portraiture." *Arts & Antiques* 16 (January 1994): 90.

Schumacher, Rogier. "Cyber-sirenes en melkwitte bruidjes." *Het Parool*, 22 January 2001.

——. "Marlene Dumas: Jack Tilton Gallery." *Artforum* 33, no. 2 (October 1994): 103–04.

——. "Marlene Dumas: Museum van Hedendaagse Kunst, Antwerp." *Artforum* 38, no. 5 (January 2000): 108.

Schwartz, Ineke. "Bij Dumas is snel trekken van conclusies ongewenst." *Trouw*, 23 March 1992.

Schweighöfer, Kerstin. "Eindhoven: Marlene Dumas, Kreative Interpreten gesucht." *ART: Das Kunstmagazin*, no. 3 (March 1992): 108–09.

——. "Marlene Dumas: Kein Platz für tröstliche Klischees." *ART: Das Kunstmagazin*, no. 7 (July 1997): 42–50.

Sciaccaluga, Maurizio. "Biennale di Sydney: Video e installazioni protagonisti assoluti." *Arte*, no. 323 (July 2000): 69.

Searle, Adrian. "A Touch of Dutch Courage at the Tate." *Weekly Mail*, 3 May 1996, 29.

——. "I'm a Dirty Woman. That's Why I Paint." *The Guardian*, 30 March 1999, 10.

——. "A Fatal Attraction." *The Guardian*, 23 November 2004.

Sheets, Hilarie M. "Pathologically Optimistic." *Artnews* 105, no. 8 (September 2006): 60, 62.

"Sie gibt den Frauen Charakter: Geschlechterollen, Geburt und Tod: Die Baden-Badener Kunsthalle zeigt Marlene Dumas." *Saarbrücker Zeitung*, 30 December 2005.

Silva, Arturo. "Art Like 'A Sigh' Still Powerful as Revealed by Koyanagi Show." *The Japan Times*, 10 November 1996.

Simons, R. "Marlene Dumas: Tegenstellingen horen bij mij." *Avenue* (November 1984): 18.

Sinnreich, Ursula, et al. "Inquiry: Learning from 'Documenta.'" *Parkett*, no. 64 (2002): 161–208.

Sirmans, Franklin. "Marlene Dumas: Jack Tilton/ Anna Kustera Gallery, New York." *Tema Celeste* (September 2001).

Skupin, Bernd. "Zarte Wilde." *Vogue Deutsch* (winter 1998): 194–200.

Sluysmans, Christine. "De tekstuele trip van Marlene Dumas." *Jong Holland* 14, no. 3 (1998): 55–56.

Smolders, Rob. "Marlene Dumas, Zeemeermin in Polderland." *Metropolis M* 5, no. 5 (October 1984): 6–9.

——. "Galerie: Marlene Dumas." *NRC Handelsblad*, 5 December 1986.

Smit, L. "Minder is niet lang meer." *Tableau* 7, no. 5 (April–May 1985).

Smith, Dan. "Marlene Dumas: Frith Street Gallery, London." *Art Review* 56 (February 2006): 96.

Snodgrass, Susan. "Marlene Dumas at the Art Institute of Chicago." *Art in America* 91, no. 9 (September 2003): 130.

Spagnesi, Licia. "Luci e ombre del nuovo Sud Africa." *Arte*, no. 343 (March 2002): 144.

Spaninks, Angelique. "De opgewonden Karahters van Marlene Dumas." *Eindhoven Dagsblad*, 29 November 1997.

Sommer, Tim. "Gesichter aus dem Menschenpark." *ART: Das Kunstmagazin*, no. 10 (October 2001): 90–91.

———. "Maria Marshall: Make Believe, Make Like, Make Violence." *Parachute*, no. 123 (July–September 2006): 54–69.

Steenbergen, Renée. "Meer actuele kunst in Arti & Amicitae, Amsterdam." *NRC Handelsblad*, 15 December 1987.

———. "Dumas." *NRC Handelsblad*, 4 November 1988.

———. "Marlene Dumas: Het Kwaad is banaal." *NRC Handelsblad*, 27 December 1991, 6.

Steenhuis, Paul. "Marlene Dumas." *NRC Handelsblad*, 23 May 1991.

Stigter, Bianca. "Ik teken mezelf als een waggelend dik blondje, Marlene Dumas over alle mogelijke betekenissen van het beeld." *NRC Handelsblad*, 20 March 1992.

———. "Les portraits de Marlene Dumas." *Septentrion* 22, no. 1 (March 1993): 26–29.

———. "New Fairy Tales for the Low Countries: About Marlene Dumas, a South African Artist in the Netherlands." *Low Countries*, no. 1 (1993–94): 100–06.

Straus, Cees. "Romantiek van jeugdherinnering, schilderijen, litho's en collages van Marlene Dumas." *Trouw*, 24 October 1984, 4.

Sultan, Terrie. "Contemporary Portraiture's Split Reference." *Art on Paper* 3, no. 4 (March–April 1999): 38–42.

Sussman, Elisabeth. "Candide Cameras." *Artforum* 44, no. 1 (September 2005): 261–63.

Szabó, Erno P. "Hagymahéj a márványlapon." *Uj Muvészet* 16, no. 8 (August 2005): 4–6.

Taylor, Kate. "Art of Dumas One of Ambiguity." *Globe and Mail*, 22 April 1994.

Tegenbosch, Pietje. "Dumas zowel deelnemer als buitenstaander in de kunst." *De Volkskrant*, 15 March 1990, 11.

Thamm, Marianne. "Nog Hier, Nog Daar." *Insig* (August 2002): 58–60.

Thomas, Kelly Devine. "The Most Wanted Works of Art." *Artnews* 102, no. 10 (November 2003): 130–36.

Thornton, Sarah. "The Rear View—What Happened to Bohemia?" *Art Review* 56 (September 2005): 118.

———. "The Power 100." *ArtReview* (November–December 2005): 91.

Tilroe, Anna. "Er moet weer ruimte komen voor illusies, interview met Marlene Dumas." *De Volkskrant*, 26 July 1985.

———. "Veelzijdigheid als handelsmerk." *De Volkskrant*, 13 March 1986, 18.

———. "Een klein blauw mannetje trekt het gordijn opzij." *De Volkskrant*, 18 November 1988.

———. "Amsterdam: Marlene Dumas." *Arena*, no. 1 (February 1989): 103.

———. "The Unfulfillment and the Surfeit." *Parkett*, no. 38 (winter 1993): 94–99.

Trimarco, Angelo, Tommaso Trini, Francesco Poli, Elena Di Raddo, Marisa Vescovo, and Harald Szeemann. "Identità e alterità." *Tema Celeste* (autumn 1995): 50–63.

Turner, Jonathan. "Fast Forward: Amsterdam, Marlene Dumas." *Artnews* 92, no. 9 (November 1993): 129.

———. "Artificial Reasoning." *Art+text*, no. 2 (1995): 33–35.

———. "Double Dutch: Realism & Visual Fraud from the Netherlands." *Art and Text*, no. 47 (January 1997): 18–21.

———. "Sometimes Clever, Sometimes Smutty." *Artnews* 96, no. 1 (January 1997): 98–101.

———. "Mistaken Identity." *Tableau* 20, no. 2 (November 1997): 118–23.

———. "Marlene Dumas" *Artnews* 103, no. 5 (May 2004): 162.

———. "Marlene Dumas: Fondazione Bevilacqua La Masa, Palazzetto Tito." *Artnews* 103, no. 5 (May 2004): 162.

Ursprung, Philip. "Marlene Dumas 'The Question of Human Pink.'" *NIKE* 7, no. 30 (October–November 1989): 50.

Utter, Douglas Max. "A Demon in My View." *Angle: A Journal of Arts + Culture*, no. 13 (2004).

Vaizey, Marina. "Windows onto the Outside World." *Sunday Times*, 3 May 1987.

Van Alphen, Ernst. "Dumas' Denk-Beelden." *Filosofie* 5, no. 4 (August–September 1995): 24–28.

———. "Miss Worlds neue Kleider." *Texte zur Kunst* 8, no. 29 (March 1998): 141–43.

———. "Hoe kleden we het kunstwerk aan?: Bij het recente werk van Marlene Dumas." *De Witte Raaf*, no. 73 (May–June 1998): 12–13.

Van Asseldonk, Wilma. "Kwetsbare Meisjes." *Reflector* (September 1988).

Van Burkom, Frans. "Marlene Dumas: Ik ben niet wat ik dacht ik waren, ik ben onbetrouwbaar..." *Museumjournaal* 29, no. 4 (August 1984): 276–77.

Van de Velde, Paola. "De mensheid volgens Marlene Dumas." *De Telegraaf*, 15 November 2006.

Van den Berg, Mariska. "La bella figura: Over schaalvergroting en verschuiving in Venetië." *Ruimte* 12, no. 2 (1995): 10–15.

Van den Bergh, Jos. "Marlene Dumas: Zeno X Gallery." *Artforum* 32, no. 2 (October 1993): 110.

Van der Endt, Erik. "Aantekeningen bij een werk van Marlene Dumas." *Twentse Courant*, 15 April 1987.

Van Dijk, Anja. "Realistische details met vage vormen, Marlene Dumas veelzijdige kunstenares." *Gooi-en Eemlander*, 10 December 1986, 29.

Van Houts, Cathérine. "Skuldgevoel over verscheurd land." *Het Parool*, 14 May 1983, 11.

———. "Een plaatje van de atoomboom aan de muur." *Het Parool*, 10 February 1990, 49.

Van Hove, Jan. "De keuze van Flor Bex." *De Standaard*, 21 November 2001, 16.

———. "Belgisch paviljoen scoort in Venetië: Kunstenaars van Biënnale op politieke toer." *De Standaard*, 10 June 2005, 10.

Van Niekerk, Marlene. "Tragiek van Onmoontlike Liefdes." *Die Burger*, 26 July 2007.

Van Nieuwenhuyzen, Martijn. "Fifteen Artists [Stedelijk Van Abbemuseum, Eindhoven, Netherlands; exhibit]." *Flash Art International*, no. 124 (October–November 1985): 62–63.

———. "Marlene Dumas: Paul Andriesse Gallery, Amsterdam." *Flash Art*, no. 136 (October 1987): 118–19.

———, and Mathilde Roskam. "Names in Bold: New Dutch Art." *Artscribe*, no. 62 (March–April 1987): 62–67.

Van Zeil, Wieteke. "Bij Dumas is vorm de boodschap." *De Volkskrant*, 28 October 2006.

Veldhoen, Lex. "Wandtapijten als 'verzachtende omstandigheden' Negen kunstenaars ontwierpen wandtapijten voor het nieuwe justitiegebouw van Den Bosch." *De Morgen*, 26 February 1998, 29.

Vendrame, Simona. "Porno?" *Tema Celeste*, no. 77 (January–February 2000): 56–63.

———. "Marlene Dumas." *Tema Celeste*, no. 88 (November–December 2001): 46–51.

Vine, Richard. "Marlene Dumas at Jack Tilton." *Art in America* 82, no. 10 (October 1994): 131–32.

Viso, Olga. "Pourquoi la beaute? Pourquoi maintenant?" *Connaissance des Arts*, no. 566 (November 1999): 104–09.

Vogel, Carol. "Art in the Present Tense: Politics, Loss and Beauty." *The New York Times*, 11 June 2007, 14.

Vos, Paul de. "Kunstenaars van de galerie, galerie Paul Andriesse." *Tableau* (February 1987).

Ward, Anna. "The Fortunes of Anatomy: 1895–1995 Venice Biennale." *Artlink* 15, no. 2–3 (winter–spring 1995): 60–61.

Warner, Marina. "Marlene Dumas: In the Charnel House of Love." *Parkett*, no. 38 (winter 1993): 76–81.

Wavrin, Isabelle de. "Art contemporain: La Cavalcade continue." *Beaux Arts Magazine*, no. 253 (July 2005): 108, 110.

Wegman, Leontien. "Chaos is mÿn Talent: Interview met de kustenares Marlene Dumas." *Elegance* (November 1997): 113–17.

Welling, Wouter. "Omtrekkende bewegingen: Citaten uit brieven van Marlene Dumas." *Artefactum* 6, no. 27 (January–February 1989): 30–36, 61–63.

Weskott, H. "Interview mit Marlene Dumas." *Artis* 48 (June–July 1996): 56–59.

Wesseling, Janneke. "Overblijfselen van een denkproces: Tekeningen en collages van Marlene Dumas in Utrecht." *NRC Handelsblad*, 13 November 1984.

———. "Marlene Dumas: 'Tragiek, liefde, lijden, daarover gaat mijn werk.'" *NRC Handelsblad*, 28 February 1986, 4.

———. "Accent op stilistische verscheidenheid bij Biennale selectie." *NRC Handelsblad*, 15 March 1986.

White, Ian. "Roll Up!" *Art Review* 54 (December 2002–January 2003): 32, 34.

Wilkinson, Veronica. "An Uneasy Return to Home Base." *Cape Argus*, 29 July 2007, 12.

Wilson, Simon. "Erotic Enlightenment." *Royal Academy Magazine*, no. 96 (autumn 2007): 43.

Wilson-Goldie, Kaelen. "The Stripper." *Black Book* (spring 2002): 86–89.

Wingen, Ed. "Jonge Nederlandse kunst als visitekaartje." *De Telegraaf*, 28 March 1986, 19.

"Women Artists at Venice: *Always a Little Further… The Experience of Art*, 51st Venice Biennale, 2005." *N.Paradoxa*, no. 16 (2005): 75–80.

Wulffen, Thomas. "Nach dem Rundgang: Notizen zu Künstlern." *Kunstforum International*, no. 177 (September–October 2005): 475–80.

Zaugg, Fred. "Mensch und Gegenwart in lebendiger Malerei." *Der Bund* (July 1989): 31.

Zimmer, William. "How 20 Artists Treat the Human Body 20 Different Ways." *The New York Times*, 3 January 1999.

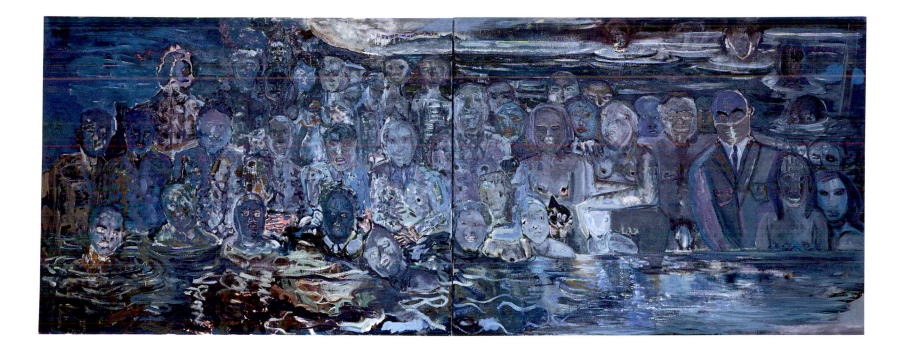

Hell (The People of the Artworld in Monet's Lake of the Searoses), 1987–90; oil on canvas; diptych: 61 x 78 3/4 inches each panel; Städtische Galerie Karlsruhe, Sammlung Garnatz

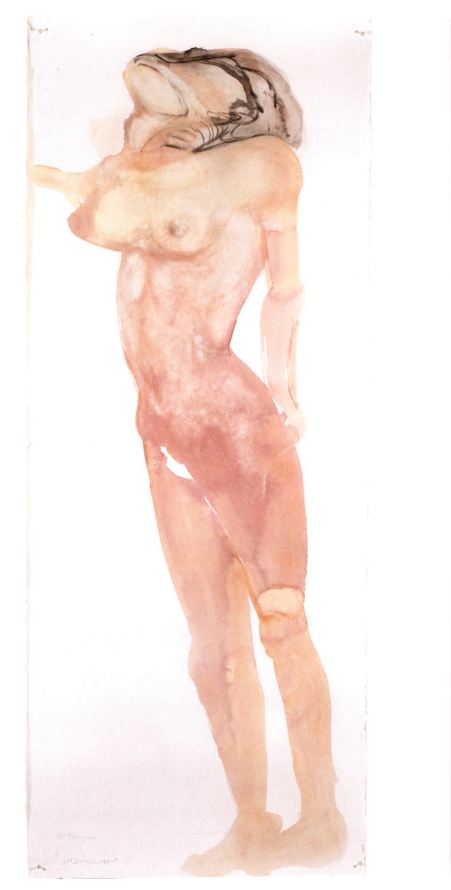

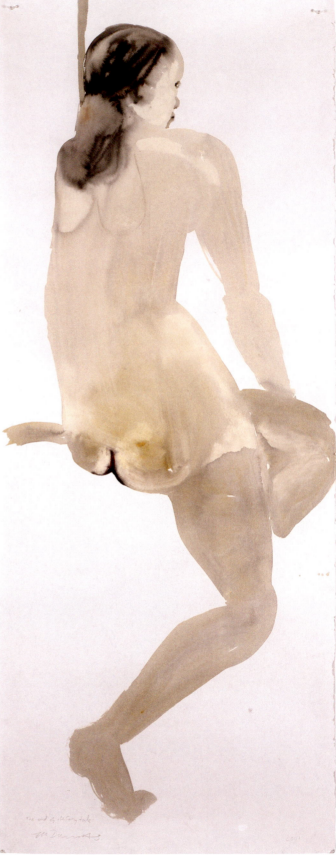

De-Fence-Less, 2001; ink and acrylic on paper, 88 1/2 x 35 inches;
The Museum of Contemporary Art, Los Angeles, purchased with funds
provided by The Buddy Taub Foundation, Jill and Dennis Roach, Directors

The End of the Fairy Tale, 2001; ink and acrylic on paper, 88 1/2 x 35 1/2 inches;
The Museum of Contemporary Art, Los Angeles, purchased with funds provided
by The Buddy Taub Foundation, Jill and Dennis Roach, Directors

This publication accompanies the exhibition "Marlene Dumas: Measuring Your Own Grave," organized by Cornelia Butler, MOCA Ahmanson Curatorial Fellow, for The Museum of Contemporary Art, Los Angeles, in association with The Museum of Modern Art, New York.

"Marlene Dumas: Measuring Your Own Grave" is made possible by generous support from Brenda R. Potter and Michael C. Sandler; Mondriaan Foundation, Amsterdam; Blake Byrne; Mark Fisch; Steve Martin; The MOCA Contemporaries; the Barbara Lee Family Foundation; the Robert Lehman Foundation; the Pasadena Art Alliance; Elizabeth A. Sackler, JCF, Museum Educational Trust; Jack and Connie Tilton; Netherland-America Foundation; Linda and Jerry Janger; Dr. S. Sanford Kornblum and Mrs. Charlene S. Kornblum; B. J. Russell Mylne; and Jerome and Ellen Stern.

EXHIBITION ITINERARY

The Museum of Contemporary Art, Los Angeles
22 June—22 September 2008

The Museum of Modern Art, New York
14 December 2008—16 February 2009

The Menil Collection, Houston
26 March—21 June 2009

Director of Publications: Lisa Gabrielle Mark
Senior Editor: Jane Hyun
Editor: Elizabeth Hamilton
Publications Assistant: Dawson Weber
Designer: Bethany Johns
Printer: Dr. Cantz'sche Druckerei, Ostfildern-Kemnat, Germany

The Museum of Contemporary Art, Los Angeles
250 South Grand Avenue
Los Angeles, CA 90012
(213) 621-2766
moca.org

Co-published by D.A.P./Distributed Art Publishers, Inc.
155 Sixth Avenue, 2nd Floor, New York, NY 10013
Tel: (212)627-1999 Fax: (212)627-9484 dap@dapinc.com

Library of Congress Cataloging-in-Publication Data

Dumas, Marlene, 1953–
Marlene Dumas : measuring your own grave / organized by Cornelia Butler; essays by Cornelia Butler ... [et al.].
p. cm.
Catalogue of an exhibition held at The Museum of Contemporary Art, Los Angeles, June 22—Sept. 22, 2008, and at The Museum of Modern Art, N.Y., Dec. 14—Feb. 16, 2009.
Includes bibliographical references.
ISBN 978-1-933751-08-5
1. Dumas, Marlene, 1953—Exhibitions. I. Butler, Cornelia H. II. Museum of Contemporary Art (Los Angeles, Calif.) III. Museum of Modern Art (New York, N.Y.) IV. Title.

ND653.D87A4 2008
759.9492—dc22 2008014983

Printed and bound in Germany

PHOTOGRAPHY CREDITS

Artwork by Marlene Dumas appears courtesy of the artist. The following list, keyed to page numbers, applies to illustrations for which separate credits are due:

Photo: Andy Keate, front cover, p. 195; photo: Wim Cox, p. 10; courtesy Zeno X Gallery, Antwerp, pp. 25, 49, photo: Peter Cox, pp. 17, 22, 38, 91 top row, 188—89, photo: Felix Tirry, p. 180; photo: Jolie van Leeuwen, p. 35 bottom; photo: Klaus Füssel, p. 39; photo: Bert Boogaard, p. 42; courtesy Photographic Archive, The Museum of Modern Art Archives, New York, photo: Ezra Stoller © Esto, p. 44 left; © Estate of Leon Golub/Licensed by VAGA, New York, courtesy Ronald Feldman Fine Arts, photo: © The Art Institute of Chicago, p. 47; courtesy Galerie Paul Andriesse, Amsterdam, pp. 68—69, 76—77, 85, 89, 96 bottom, 97—98, 119, 130, 154, 166, 251, photo: Peter Cox, pp. 50, 56 bottom, 60, 64—67, 78—79, 82, 87, 106—07, 115, 123, 135, 142—43, 152, 212—13, 234, 246, 249—50, 253, 259, 281, photo: John Stoel, p. 102, photo: Gert Jan van Rooij, p. 180; courtesy Department of Imaging Services, The Museum of Modern Art, New York, pp. 73, 75 bottom, 149, photo: Robert Gerhardt, p. 57, photo: John Wronn, pp. 100—01, 155, photo: David Allison, p. 217; photo: © The Robert Mapplethorpe Foundation/Art+Commerce, p. 70 left; courtesy of the artist and Matthew Marks Gallery, New York, photo: Russell Kaye, p. 70 right; photo: Gert Jan van Rooij, pp. 95 bottom, 108—09, 112, 138—39, 185, 256; photo: Peter Cox, pp. 96 top, 103, 111, 129 bottom, 141, 204, 209, 215, 221, 227, 229, 241, 247; courtesy Lieu d'art contemporain, Sigean, pp. 116—17; photo: Katrin Schilling, pp. 124—25; photo: Albert Eenink, p. 136; courtesy Tilton Gallery, New York, pp. 140, 163, 192—97, 231, 257; photo: Rupert Steiner, p. 157; © The Willem de Kooning Foundation/Artists Rights Society (ARS), New York, p. 164 second from right and far right, photo: Jim Frank, p. 164 second from left, photo: Lee Stalsworth, pp. 164 far left, 174; courtesy David Zwirner Gallery and Zwirner and Wirth, New York, p. 165; courtesy Gallery Koyanagi, Tokyo, p. 169; © The Barnett Newman Foundation, New York/Artists Rights Society (ARS), New York, p. 171; photo: Stephen White, p. 199; photo: Helena van der Kraan, pp. 201, 225 bottom left; © Estate of Alice Neel, photo: Geoffrey Clements, p. 211; photo: Kees Kuil, p. 218; photo: Marlene Dumas, pp. 225 bottom right, 242; photo: Lee Stalsworth, p. 230 left; photo: Tom Warren, p. 230 right; photo: Paolo Pellion di Persano, Turin, p. 240 bottom; photo: Lisa Sulistiawati, p. 255; and courtesy Le Case d'Arte, Milan, photo: © Annalisa Guidetti, p. 284.

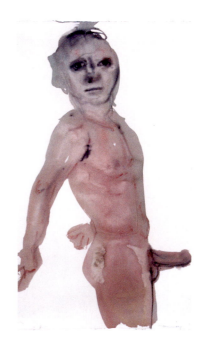

Front cover: *Measuring Your Own Grave*, 2003; oil on canvas; 55 1/8 x 55 1/8 inches; private collection

Frontispiece: *Moshekwa*, 2006; oil on canvas; 51 3/16 x 43 5/16 inches; courtesy the artist and Zeno X Gallery, Antwerp

Back cover: *Flap Your Wings*, 1988—89; watercolor and pencil on paper; 11 13/16 x 9 7/16 inches; The Over Holland Collection

X-Plicit, 1999; ink and acrylic on paper; 49 3/16 x 27 9/16 inches; collection Alan Hergott and Curt Shepard